Pop Trickster Fool

Kelly M. Cresap

University of Illinois Press
Urbana and Chicago

Pop Trickster Fool

*

Warhol

Performs

Naivete

*

1 2 3 4 5 C P 5 4 3 2 1

Library of Congress Cataloging-in-Publication Data
Cresap, Kelly M.
Pop trickster fool : Warhol performs naivete / Kelly M. Cresap.
p. cm.
Includes bibliographical references and index.
ISBN 0-252-02926-7 (cloth : alk. paper)
ISBN 0-252-07181-6 (pbk. : alk. paper)
1. Warhol, Andy, 1928—Criticism and interpretation.
I. Title.
N6537.W28C67 2004
700'.92—dc22 2003024033

This book is dedicated
to Tatsuji Itagaki,
naif-trickster extraordinaire.
I suspect he will never
read these pages, but
he lurks and laughs
behind them all . . .
a fact that he would find,
almost simultaneously,
moving, sweet,
and hilarious.

Stupidity is contemplated: sight penetrates its domain and becomes fascinated; it carries one gently along and its action is mimed in the abandonment of oneself; we support ourselves upon its amorphous fluidity; we await the first leap of an imperceptible difference, and blankly, without fever, we watch to see the glimmer of light return. Error demands rejection—we can erase it; we accept stupidity—we see it, we repeat it, and softly, we call for total immersion.

This is the greatness of Warhol with his canned foods, senseless accidents, and his series of advertising smiles.

—Michel Foucault, "Counter-Memory: The Philosophy of Difference"

I believe that I have found the underlying stupidity to Baudrillard's insights. But what does it mean to be stupid if not to be stupefied, to watch in stupefaction the spectacle before one's eyes, in fascination, gazing upon the object with an (evil) eye as it gazes back in a miasma of vision? When one looks stupidly one looks with stunned desire.

—Thomas L. Dumm, "The Invisible Skyline"

The almost insoluble task is to let neither the power of others, nor our own powerlessness, stupefy us.

—Theodor Adorno, *Minima Moralia*

Contents

Acknowledgments

*

I am immensely grateful to Michael Levenson, mentor and fellow scholar-journalist. His engagement with this project has been a courage-giving force of optimism and insight. I also benefited from extensive discussions with Howard Singerman, Jonathan Flatley, and Eric Lott. Institutional and financial support from the University of Virginia English program was critically helpful in the formative phases of research and writing. I received useful comments during presentations at New York University and George Washington University. Geralyn Huxley and Matthew Wrbican at the Andy Warhol Museum and staff members at the Library of Congress generously assisted my research. Many others have helped to nourish, sustain, and inform these writings, in a variety of ways, at all stages of development. To Steve Warrick, Daniel Rosensweig, Russell Schweller, Daniel Steward, Candice Breitz, Patrick Stejskal, Nancy Hurrelbrinck, Jean Kane, Patricia Gill, Rita Felski, Herbert Tucker, Reva Wolf, Wilson Kidde, Patricia Juliana Smith, Douglas Mitchell, Michael Harrison, Steven Stoltenberg, Carol Bolton Betts, Theresa L. Sears, Don Shewey, Jim Hurley, Tim Carman, Jill Hollingsworth, and Bernard Morin: gratitude, blessing, and a great coyote howl.

Cultivating Naivete,
Conjuring
Postmodernism

After achieving fame as a pop artist, Andy Warhol made a habit of shrugging off the notion that he was either smart or competent. During a televised interview in 1970, he accounted for inconsistencies in his silkscreens by claiming that he "didn't know how to really screen." Of his film output he said, "They're experimental films. I call them that because I don't know what I'm doing." When a critic dismissed pop artists as "pin-headed gum-chewers," Warhol latched on to the term as an honorific. About his civic record, and his manual dexterity, he said in his diary: "I voted once. In the fifties, I don't remember which election. I pulled the wrong lever because I was confused, I couldn't figure out how to work the thing." Of his vocabulary he said, "My mind always drifts when I hear words like 'objective' and 'subjective'—I never know what people are talking about, I just don't have the brains." He repeatedly told an associate, "If I think about things too much, I'll have a nervous breakdown."[1]

How serious or accurate can these statements be? What might have motivated them? They could signal embarrassment or anxiety on Andy's part, or self-criticism, or mental laziness, or perhaps a kind of inverted vanity. Given his renown as an artist, he could be slyly boasting about his ability to accomplish so much with so little brain-power—or conversely, thumbing his nose at smarter people who have less to show for it. If the statements are prompted by modesty, is it the true or false variety? Maybe Warhol got tired of having his abilities overrated and found relief in courting the opposite response. Maybe he was like someone with a secret handicap, and he wanted people to know about it. Maybe it was all a put-on, done for provocation value, out of deviltry or coyness. It could even be an elaborate form of revenge on his alma mater, the Carnegie Institute of Technology, in Pittsburgh, for having threatened to expel him for low grades during his freshman year.

Considering the decade in which Warhol rose to prominence, the option of "put-on" has an added likelihood. During the 1960s the put-on interview became like a compulsory event for many emerging careers, a backhanded way of announcing one's seriousness as an artist. The practice had precedents in earlier decades—artists such as Picasso and Salvador Dali had both dabbled in the form—but its potency in the public sphere waited until the era of hipsters and youth rebellion. Dissimulating for the press was a way of pointing up the inanity of interview questions, of thwarting an audience's search for full access and 360-degree disclosure, and of declaring one's distance from the Establishment power bloc. Warhol's early pop interviews give every indication he was adept at this task. Particularly if he disliked an interviewer,

thinkers such as Michel Foucault, Roland Barthes, Jean Baudrillard, and Fredric Jameson have argued that he is indispensable to an understanding of the present age. How did Warhol become pivotal to discourse about postmodernism, and what does it say about postmodernism that he is its leading mascot?

This study examines the extraordinary implications of Warhol's lifelong penchant for playing the fool. Andy Warhol emerges as an unprecedentedly influential naif-trickster who in a series of cunning ruses helps to catalyze a broad cultural revolution in the West—a revolution that has reversed the balance of power from an entrenched European-based high modernism to a fluid American-based postmodernism. In the process Warhol transforms the historically and conceptually intertwined personae of the naif (or fool) and the trickster, making a clear break both from the pastoral-nostalgic tradition of the naif and from the folk-rural tradition of the trickster. Introducing inflammatory elements such as queerness, hipsterism, and affectlessness to the centuries-old strategy of refusing or pretending not to understand, Warhol arrives at a performative mode whose nature and effects remain nearly unchartable even to the present day.

The naif-trickster persona that would serve Warhol throughout his public career crystallizes in the early sixties in conjunction with the artist's first pop canvases. Between his first exhibit of *Campbell's Soup Cans* in the summer of 1962 and his *Brillo Box* show of spring 1964, the concatenation of traits we think of today as the inevitable Warhol slowly developed the stamp of an official persona: the translucent white skin; the celebrity shades covering a slightly cross-eyed look; the corny silver-blond wig; the reticent, gee-whiz speaking manner; the tendency to respond with an indiscriminate "yes" or "I don't know" to interview questions, or to ask associates for ideas of what to paint; and the autistic blankness of his public demeanor, which could convey both an impermeable chic and a waif-like vulnerability. The shy, working-class quasi-albino kid from Pittsburgh, born Andrew Warhola, emerges at the end of a many-phased transformation act as the walking embodiment of popism. Promoting his own image as assiduously as he does images of Elvis, Marilyn, Coca-Cola, S&H green stamps, car crashes, and dollar bills, he shows great skill adapting to the recognition he gains while alternately impersonating and inhabiting the role of Andy Warhol.

Warhol's naif-trickster persona proves serendipitous to his career in both short- and long-term ways. Forming an intriguing social counterpart to the artist's enigmatically simple images of commercial products and Hollywood stars, it gives him a crucial edge over pop artists who

maintain a more straightforward demeanor; it announces a playful departure from the aggressively masculine postures that typified artists of the then-dominant New York School of painting; and it attracts around Warhol a Pied Piper–like following of media attention and bohemian acolytes. Once established in the public sphere, the persona allows Warhol to maintain a degree of continuity as he moves with startling dexterity among a host of professional and personal interests—filmmaking, rock concert and multimedia promotion, journalism, photography, travel, book publishing, cable television, and art collecting. Of the many artist's assistants Warhol relied on in his career, his persona might be seen as the most metaphorically durable. The trickster aspect of the persona served in many ways to protect the naif aspect; and both aspects critically assisted the artist's being a homosexual in the public eye at a time before being a homosexual in the public eye was feasible. The vacancy he projected made him the ideal emissary for an artistic movement that many perceived as an all-out assault on reason and refinement; and it distracted great numbers of people from implications about his being queer and working-class.

However, in singling him out and adding to his exposure, Warhol's pop persona also made him more vulnerable to attack. An apparent weakling surrounded by various bullies, he became a focus of political, social, and even physical animosity. At the political level, Warhol drew the scorn of critics for whom popular culture and its icons were dangerously linked to practices of social coercion and totalitarianism. Clement Greenberg's cringing dismissal of Warhol in the sixties was anticipated by his influential essay "Avant-Garde and Kitsch" (1939), which voiced concerns over the exploitative potential of artifacts designed for mass consumption. The essay appeared at a time when fascist and communist forces were rallying beneath pop images such as the swastika and the hammer and sickle. Members of Greenberg's intellectual generation, having witnessed the effects of Joseph Goebbels's propaganda ministry on the rise of Nazi Germany, and of the Zhdanovist cultural policies in Stalin's Soviet Union, cast a wary eye toward the instrumental use of images in American industry and media. Since Warhol was promoting kitsch-like artifacts and adopting the public demeanor of a fool, he could not help but spark concern among intellectuals who saw the mass populace as inherently foolish already and incapable of resisting the mind-numbing allure of mass imagery.

At the social level, Warhol was ostracized by artists linked to the New York School of painting. The codes of decorum governing this school were overwhelmingly masculine and heterosexual, which created a

double bind for members or would-be members who did not fit these categories. As a reflection of this double bind, Warhol was shunned even by homosexual artists, who deemed his behavior too effeminate, and who felt he was too upfront about his prior career choice. In keeping with his "What, me worry?" public demeanor, Warhol was serenely unembarrassed about having worked in commercial design and window-dressing during the fifties. This made him a persona non grata among artists who had also supported themselves in these fields, but who wished to live down the stigmas of class and gender that accompanied them.

Beyond these political and social forms of animosity from men, the most shocking display came in physical form from a woman. Valerie Solanas, a would-be playwright and self-styled feminist revolutionary, was the founder and sole member of the Society for Cutting Up Men (SCUM). After trying to interest Warhol in one of her scripts, and appearing in one of his movies, she began to perceive his evasiveness as a personal affront and took out her frustrations with a .32-caliber automatic pistol. One afternoon in June 1968, she came to his office on Union Square West and shot him three times, along with one of his associates. In spite of extreme damage to his internal organs, and his being pronounced clinically dead at one point on the operating table, he was revived, and spent nearly two months in the hospital recovering.

Eighteen-and-a-half years later, his death at age fifty-eight was a result not of animosity but negligence. He died while under the erratic care of a woman who also perceived him as a vacancy—in this case, the woman was a New York Hospital nurse assigned to monitor him after a standard gall-bladder surgery. She knew nothing about his achievements or celebrity and does not seem to have been informed about his medical allergies either.

At Warhol's death in 1987 the naif side of his legacy is commemorated in John Richardson's eulogy, which places the artist sentimentally (and atavistically) in the "yurodstvo" tradition of the Russian village fool.[2] His trickster side is epitomized in Fran Lebowitz's comment, "Andy must be so furious that he is dead."[3] Up to two years after this, in the tabloid-afterlife manner of Elvis Presley, Warhol was reportedly sighted in places as far-removed as upstate New York, Germany, and the Soviet Union.[4] Frequently referred to as an idiot savant,[5] the artist prompted Gore Vidal to say, "Andy Warhol? He's the only genius with an IQ of 60."[6]

The pivotal first phase of Warhol's career as a pop artist, beginning in July 1962 with his pop debut and ending in June 1968 with the shooting, coincides with a period of U.S. history that is unusually susceptible

to his patented, deceptively "lightweight" and "unthinking" brand of tricksterism. The myriad ruses Warhol enacts during this interval rely for their effectiveness as much upon the gullible earnestness and seducibility of key segments of mid-sixties American culture as upon his own authorial ingenuity. It's as if, all across the country, people break their view-finders and apertures while trying to adjust their focus to take in his work. People were beside themselves trying to decide whether his paintings were really art, and if so, whether Warhol could take credit for it. His pop silkscreens revel in their own supreme iconic value, defying audiences to find anything reassuringly deep or serious about them. They seem to treat higher cognitive functions as immaterial, superfluous, hearkening instead to a viewer's pre-verbal childhood memories—the dumb fascination of looking at comic books, with their boldly drawn lines, primary colors, and larger-than-life heroics; or the thrill of a first visit to the grocery store, a parade of brightly colored labels stacked with superhuman neatness on the shelf. In a screwball way such images flattered a nation still held in thrall to supermarket consumerism and postwar prosperity, and a nation that harbored comic-book fantasies about its newfound political position.

Warhol's portraits of matinee idols were also suspiciously easy on the eyes, even though they were not as effortless to create as many viewers assumed. Immensely scaled tributes to Marilyn Monroe, Troy Donahue, Elvis Presley, and Elizabeth Taylor in 1962 capitalized on the *extra*-verbal allure of star power, sex appeal, and the medium of cinema. None of the paintings seemed to have any more intellectual content than a Valentine's Day card. Given Marilyn's recent death, and well-publicized upsets in Liz Taylor's life, their images came with ready-made links to the worlds of celebrity gossip and tabloid exploitation. Elvis and Troy carried an aura of B pictures, teenage fan clubs, and the triumph of photogenic charisma over thespian craft or training; Donahue's head shot was lifted directly from a fan magazine. These silkscreens appeared in the same year as the film critic Andrew Sarris's much-discussed "Notes on the Auteur Theory," but they seemed to have upsettingly little to do either with that document's concerns, or with the most substantive efforts of Hollywood, much less the benchmark achievements of directors such as Bergman, Fellini, Kurosawa, Antonioni, or Truffaut. Even a silkscreen tribute to Marlon Brando the following year had more to do with the actor's value as a leather-clad pinup than with his link to Stanislavsky and the Method. What these paintings spotlighted was not the artistry of film, but the crassness of movies.

Nonetheless, such images appeared in a high-art context, so they

needed to be read with high-art seriousness. They *had* to signify; they had to be *made* to signify. People scrutinized the most minute of artistic gestures. Where audiences in the previous decade had needed to wrangle over the meaning of four or five leaves added to a tree on the stage of Beckett, now they needed to decipher why Warhol had chosen to focus on the "Beef Noodle" variety of Campbell's soup in one painting, or had depicted a corkscrew can-opener inserted into a soup can in another. If viewers often felt teased, even hectored by such paintings, they also felt a barely suppressed joy at having these issues to entertain. It wasn't just that the canvases were more approachable than the cacophonous swirls and squiggles of action painters such as Jackson Pollock. As part of the pop revolt of 1962, Warhol's canvases, and their wide dissemination in other media, generated considerable value in sheer relief, coming as they did at a time of acute international unrest. The first major pop exhibit in New York—including three of Andy's paintings, as well as work by Claes Oldenburg, Roy Lichtenstein, George Segal, Wayne Thiebaud, James Rosenquist, and Tom Wesselmann—opened just three days after the Cuban missile crisis ended.[7]

The underground filmmaking career Warhol launched the following year further amplified concerns about whether he was an artist or a fool or a joker. In the silent black-and-white film *Sleep* (1963), he asked audiences to gaze for five hours and twenty-one minutes at one man engaged in an uninterrupted act of sleeping. The uncredited object of focus—seen unclothed, and half-covered by a sheet—was John Giorno, a poet and stockbroker with whom Warhol was infatuated at the time. Using a single camera mounted on a tripod, Warhol filmed Giorno's body from various angles at twenty-four frames per second in three-minute segments, each segment the length of a hundred-foot reel of film. He instructed that the unedited reels should be spliced end to end and projected at the pace of silent films, sixteen frames per second. Similar methods were used in briefer silent films he developed, such as *Kiss* and *Eat*. Although these films depicted clothed, wide-awake subjects and slightly more kinetic activity, the absence of traditional narrative still kept suspense to a minimum. When Warhol proceeded to his own version of the talkies, he continued favoring people who had no previous film or acting experience. In the more than seventy films he made between 1963 and 1968, he featured dozens of people whose main big-screen credential was that they happened to be hanging out at his studio on the day of filming. As Warhol trains his camera on the uncensored thoughts and untutored, seemingly unrehearsed dance routines of free sixties spirits such as Eric Emerson (*Chelsea Girls*) or Taylor Mead

(*Lonesome Cowboys*), the result is inimitable and disarming. Appearing in the film *Bike Boy* is a woman named Ingrid Superstar, who held special appeal for Warhol because she was not only a nonactor but apparently incapable of dissimulating. As Warhol's film associate Paul Morrissey says, "She couldn't *not* be Ingrid."[8] When Ingrid expresses impatience and disdain for the title character's inexperience and lack of worldliness, something like a second- or third-level order of naivete is involved.

Trickster elements also appeared in layered form, partly because Warhol's films constantly pushed the borders of what was presentable in a public movie-house. During a critical phase of the sexual revolution, his cinema posed a forthright challenge to censorship boards and official bellwethers of decency. In the years between the publication of Helen Gurley Brown's *Sex and the Single Girl* (1962) and David Reuben's *Everything You Always Wanted to Know about Sex* (1969), Warhol was turning out movies in which women as well as men not only talked about all manner of sex—including aspects some viewers may not have wanted to know about—but ardently pursued it for the camera. Where Helen Gurley Brown had cautioned readers to skip her discussion about premarital sex if they were offended by such things, Warhol's characters happily chattered away about topics ranging from group sex and prostitution to homosexuality, transvestism, bestiality, fetishism, voyeurism, and sadomasochism.[9] While engaging in ordinary activities like getting a haircut (*Haircut*), wrestling (*The Loves of Ondine*), showering, or trying on clothes (*Bike Boy*), they managed to raise the cinematic thresholds of same-sex desire. Whole sequences in the films *Bike Boy* and *My Hustler* seem to exist as lessons in how to ogle male flesh while engaging in Olympic-caliber freestyle gay gossip. Witnessing these scenes is like overhearing the jaded commentary of patrons seated in an adjacent booth at a peepshow. In many of Warhol's films, despite all the mayhem and outlandishness, the characters never fully displace a quality of innocence, even as the last vestiges of their innocence are being jauntily displaced. After having his head scissor-pinned between the bared thighs of a male Adonis, a gay man named Ondine exclaims, "College wrestling is so much fun!" Not content merely to talk about his carnal involvement with a sheep, the title character of *Bike Boy* eagerly gets down on all fours in a retail store to pantomime how it was done. The casts of Warhol's films alternately talk about serious political issues while wearing no clothing (*Nude Restaurant*), or intersperse sexual and social forms of intercourse while reclining on a sofa (*Couch*), or perform a kind of striptease while talking

about food preparation (*Bike Boy*), or hurl food at each other while wearing no clothing (*The Loves of Ondine*), or wear formal evening attire while simulating oral sex with a piece of fruit (*Harlot*). It's as if the spirit of "Hey kids, let's put on a show" had somehow gotten mixed up with an experiential tour of the sex underground. In spite of the films' many longueurs and non sequiturs, audiences, particularly gay audiences, were caught between the intrinsic titillation value of what was happening on screen, and the extrinsic titillation value of what Warhol was sneaking past the censors.

Even so, in a decade notorious for its assaults on the senses, Warhol's immense film output cannot be easily organized into a kind of binary Heads-versus-Feds scenario. Some of the "heads" watching his films were extremely upset by what they saw. Tonal shifts in Warhol's films could be every bit as disturbing as the legendary 1969 segue from the Woodstock Festival to Altamont. Depictions of violence or abuse in films such as *Vinyl* or *Chelsea Girls* had a visceral impact that left many viewers distraught long afterwards. It wasn't so much that the films explored themes of sadism and morbidity, but that they appeared seemingly without benefit of a controlling intelligence or coherent vantage point, as if the filmmakers were presenting nihilism for their own amusement. At such times, Warhol's laissez-faire cinematic style seemed to convey contempt not only for audiences but for cast members as well.

The ordinary curiosity surrounding the emergence of a new artist was magnified in Warhol's case first by his work's radical unwillingness to account for itself, and then further magnified by the artist's unwillingness to account for his motives. He didn't appear on screen in his films, so audiences were free to speculate about which forms of kinkiness were shared by the director. Critics in the fine-art world were left to puzzle out whether his stark, silkscreened images of Americana had to do with flag-waving patriotism or rather intellectual nausea, and whether they represented a lowbrow assault on high culture or vice versa. The German art historian Rainer Crone initially went on record about Warhol's paintings as a form of Brechtian alienation; later he registered disgust at what he saw as the artist's "unbelievable" superficiality; and then he shifted positions again by indicating he had been twice duped.[10] In 1995 another observer, perhaps trying to short-circuit the process or hedge his bets, selected Warhol as simultaneously the

most underrated *and* overrated artist of the twentieth century.[11] Reactions to Warhol in the avant-garde film world ran to similar extremes. One filmmaker, referring to Warhol's abilities behind the camera, denounced him as someone "who does absolutely nothing and knows absolutely nothing." Stan Brakhage, a pioneer in underground cinema, became enraged on seeing *Sleep* and *Eat,* declaring that they were the work of a charlatan. On learning that he had seen the films projected at twenty-four frames per second instead of Warhol's preferred rate of sixteen frames, he agreed to watch the films again and then hailed them as transformative works on a par with his own. However, he reversed his position again when Warhol received a coveted annual award from *Film Culture* magazine. Brakhage resigned from the New York Film-Makers' Co-operative over the award, declaring that Warhol's movies promoted forces "among the most destructive in the world today: 'dope,' self-centered Love, unqualified Hatred, Nihilism, violence to self and society."[12] Although Brakhage's response lacks impartiality, it can't be described solely in terms of professional jealousy. Warhol elected not to attend the awards ceremony, and in his absence sent a film that seemed designed to mock the whole proceedings.

If his paintings and films left various doubts in people's minds, his physical appearance and demeanor made it even more difficult to parse his intentions. He could be bodily present in a room and still find numerous ways of not showing up. His pale skin, dark glasses, blank expressions, and preternatural stillness all contributed to this effect. Dealing with the press, he asked interviewers beforehand to tell him what answers to give; he supplied misinformation about things like the year of his birth (six options were available, from 1927 through 1932); he denied having gone to college; he responded elliptically; he answered through a proxy; he said he hadn't given the matter any thought; or he circumvented the process by repeating the same phrase regardless of the question. A German journalist commented during one interview, "It is not fair to make Andy Warhol give this interview. He is suffering. He doesn't want to open up."[13] Although Andy wasn't alone in mocking the format of the celebrity interview, he was the one who merged the no-fault put-on most persuasively with a tabula rasa stance of incomprehension. People may have known he was putting them on, but it took a great while to learn what the put-on was *about*; and it has taken even longer for people to learn to distrust their best-considered initial responses as to what the put-on was about.

Many of Warhol's ruses in the sixties have acquired canonical notoriety. They made immediate as well as long-term impressions; they had

a bovine obviousness and also tugged incessantly at the borders of cultural intelligibility:

— Warhol's 33-minute, silent black-and-white film *Blow Job* (1963), filmed in such a way as to evade both government censorship and prurient audience interest. The camera remains trained on the face of a strikingly handsome, unnamed man wearing a black leather jacket and standing before a brick wall. His gestures give every indication that he is receiving what the title promises, but which the film otherwise refuses to show. Eventually, the film and the man reach what might be called a mutual climax, after which point the man smokes a cigarette. There is no camera movement, and no traditional editing: a trail of white screen indicates where the film ran out on each of nine 100-foot reels. Like Warhol's other early silent films, *Blow Job* was shot at the standard speed but projected at a trance-like sixteen frames per second. At a capacity-crowd film society showing at Columbia University, audience members got restless and yelled obscenities at the screen. The critic Rex Reed wrote, "Some of them began to sing 'We Shall Never Come.' . . . Total chaos finally broke out when one voice (a girl's) screamed: 'We came to see a blow job, and we stayed to get screwed!' Tomatoes and eggs were thrown at the screen; Warhol was whisked away to safety through the raging, jeering, angry mob and rushed to a waiting car."[14] In spite of such responses, and in spite of later work that is more sexually explicit, *Blow Job* remains among the most purely erotic of Warhol's films. As the critic Douglas Crimp writes, "the film is far too sexy to be regarded as primarily comic."[15]

— The spring 1964 New York World's Fair scandal, in which Warhol used old FBI mug shots to create a mural, *Thirteen Most Wanted Men*, for the exterior of the New York State Pavilion. The twenty-by-twenty-foot black-and-white mural was rejected soon after it appeared, on the grounds that it depicted a group of preponderantly Italian men, many of whom had already returned to civilian life after serving their prison sentences. No doubt the World's Fair officials would have taken even further offense if they had picked up on the use of "most wanted men" as a homosexual double entendre. Forced to change the display, Warhol covered the mug-shot depictions with twenty-five identical silkscreen portraits of Robert Moses, the despotic city planner and president of the World's Fair. The likeness reveals Moses in an aggressively cheerful pose. When these portraits were also rejected, Warhol chose to coat the entire mural in silver paint.[16]

— The spring 1964 *Brillo Box* cause célèbre, in which the Stable Gallery on West Fifty-eighth Street in New York took on the appearance

of a supermarket storeroom. With his assistant Gerard Malanga and a team of carpenters, Warhol fashioned hundreds of wood boxes to look precisely like the cardboard cartons used to transport and store products like Kellogg's cornflakes, Mott's apple juice, Heinz ketchup, and Brillo soap pads. The boxes were coated in acrylic paint, silkscreened on all six sides, and then stacked throughout the gallery according to brand name. Visitors had to decide for themselves how the gallery differed from an actual provisions storeroom, what kind of value-added material Warhol had brought to the project, and whether to spend between $200 and $400 purchasing one of the boxes. For their part, art critics had to decide whether Warhol's gesture differed in any way from that of the dadaist Marcel Duchamp, who half a century earlier had brought into a gallery setting readymade "found objects" such as a bicycle wheel and a urinal. During the Stable Gallery exhibition's run, Warhol appeared in *Newsweek* magazine next to the designer of the original Brillo soap pad packaging logo. By sardonic coincidence, the man responsible for the logo was a destitute second-generation abstract expressionist artist who had turned to industrial design to help support himself. Although the *Brillo Box* show was a financial loss and a fiasco in other ways, it was a tremendous publicity coup, giving Warhol his first mainstream national attention, and giving the public its first impressions of his working headquarters on East Forty-seventh Street, a multipurpose studio loft newly covered in silver paint and aluminum foil for an inaugural party. The space henceforth became known as the Silver Factory, or "the Factory": "silver" evoked screen legends of the past and astronauts of the future; and "factory" referred to the studio's former function as well as its present use as the site where seemingly "assembly-line" art work was made. (Tinfoil from the Factory was recently featured in a show at Paris's Pompidou Center.) In spring 1965, boxes from the Stable Gallery show were subject to a 20 percent import duty before they could be sent to Toronto's National Gallery, on the grounds that they were not art. The art dealer for the Toronto exhibition angrily denounced the government for making Canada "the laughingstock of the art world."[17]

— Warhol's sending out a look-alike of himself for a 1967 lecture tour of five colleges. Andy grew tired of speaking engagements that fall and felt that his audiences were expecting a presence of more glamor and pizzazz than he provided. He and his associate Paul Morrissey selected Allan Midgette for the job of impersonating him. Midgette, who had appeared in several of Warhol's films, was part Cherokee Indian and did not at all resemble the artist physically. However, with his hair sprayed silver and every crevice of his face covered in heavy makeup, he was able to fool audiences first at the University of Roch-

ester and then at colleges in Utah, Montana, and Oregon. One Warhol biographer, David Bourdon, writes, "Midgette thought it would be easy to imitate Andy because he could answer almost any question with a typically Warholian 'yes,' 'no,' 'maybe,' 'I don't know,' 'okay,' or 'you know, I really don't think about it.'" After screening two films for students at Rochester, the first question he received was "Why do you wear so much makeup?" Midgette replied, "You know, I really don't think about it." The tour ran into unexpected difficulties. In Utah Allan encountered a shortage of silver hairspray, as well as a high wind that threatened to ruin his disguise as he disembarked from a plane. He was sometimes grilled on specific details about Warhol or requested to provide an answer of "twenty-five words or more." Amazingly, his impersonation was not discovered until four months after the tour was completed, when someone put together photos of Andy and Allan. In the aftermath, a college administrator calling Warhol to complain was suddenly brought up short, saying, "How can I even be sure this is really you on the phone *now?*" After a pause, Andy said, "I don't know." Warhol had to return fees and redo lectures at several universities—the ones that were not completely put off by his scam. During this second tour, officials often went to absurd lengths to verify that they had the genuine article. Recalling the episode years later, Warhol said, "I still thought that Allan made a much better Andy Warhol than I did. . . . Who wants the truth? That's what show business is for—to prove that it's not what you are that counts, it's what they *think* you are."[18]

— Warhol's 1967–68 filming near Tucson, Arizona, of the feature-length *Lonesome Cowboys*, cinema's first gay pornographic Western. The film's shooting was threatened by a series of unforseen arrivals: tourist families drawn by the chance to see a movie being made; a sheriff who flew in by helicopter to supervise the action through binoculars; and technical crew members who, as Warhol recalled later, "formed a vigilante committee to run us out of town, just like in a real cowboy movie."[19] The film's cast includes a cowboy-ballerina, a sheriff who wears rouge and stockings as an after-hours madam, and an outrageously effeminate male nurse (Taylor Mead) given to sudden pirouettes and goofy soliloquies in an exaggerated stutter. The part of the frontier ranch-owner went to the cast's only female— a woman known as Viva (a.k.a. Susan Hoffmann), who had worked as a model in Paris and spent time in a mental hospital prior to Warhol's promoting her into a "Superstar" at his Factory. The love interest for most of the cast is Tom Hompertz, an angelically beautiful blond surfer who was "discovered" during Warhol's lecture tour of San Diego State College. Nudity in the film appears intermittently, sometimes unerotically, and without the buildup or strategic

closeups usually featured in porn. *Lonesome Cowboys* takes the subtext of homoeroticism in traditional Westerns and turns it into the main focus and raison d'être; the tacit male bonding rituals of Hollywood cowboy epics are violated by becoming both sexualized and verbalized. In a post-coital scene, one cowboy says to another, "This is the kind of thing that only men understand." The film's dialogue was loosely improvised, and at times fails to match the action, or is presented out of synch. Scenes skitter haphazardly from one to the next, as in a home movie. The music ranges from scatological ballad to Gregorian chant. At a special midnight film-fest screening in San Francisco in 1968, Taylor Mead told an audience, "We tried to incorporate degenerates from all parts and expand our horizons." *Variety* magazine described *Lonesome Cowboys* as "Andy Warhol's best film to date, which is like saying a three-year-old has graduated from smearing feces on the wall to the occasional use of finger paints." The film's frankly homoerotic content triggered a number of police crackdowns during its theatrical run. Following up on a complaint made about a mock gang-rape sequence, the FBI kept Warhol under surveillance for eighteen months.[20]

Even in anecdotal form such episodes convey a degree of the range and versatility of Warhol's technique, his ability to take traditional habits of the trickster—wiliness, sexually charged invention, boundary-crossing and duplicity, gleeful disruptiveness, insouciant mockery and wit—and put a metropolitan, 1960s, and double-jointedly queer spin on them.

However, individual artifacts and anecdotes in themselves cannot fully account for the epoch-transforming potency of the Warhol sixties. The domain of Warhol's ruses clearly extends beyond the arena in which pop art arises to challenge and parody a New York art world steeped in the self-serious, late-Romantic tradition of abstract expressionism. His ruses are played out on an ideological plain covering vast sedimentary accumulations left by the theories and practices of a waning modernist enterprise. In the face of anxiety over the status of aura in an age of mechanical reproduction, Warhol produces readily duplicated images and says with an alarming blitheness, "I want to be a machine."[21] After Clement Greenberg establishes his dichotomy between avant-garde and kitsch, Warhol makes kitsch avant-garde—or more precisely, he brings to an avant-garde milieu images that lack even the modicum of artistic ambition required for them to qualify as kitsch. To the intellectual preference for art that demands diligent effort and the investment of education, discrimination, and sustained rereadings, Warhol offers unimpeded access to images that are instantly recognizable and readily disposable. Turning his back on gestural accuracy and artistic facility

even more radically than Picasso had, he brazenly plagiarizes the work of unsung photographers and designers and uses automated transfer processes that eliminate the risk of a faulty or labored brushstroke. In an art world devoted to the emergence and recognition of creative genius, Warhol says, "Why do people think artists are special? It's just another job."[22] To a cultural sphere saturated in depth logic in a multitude of formulations—from the aesthetic separation between figure and ground, from the Freudian id and superego to the Jungian sense of numen and the unconscious, from the Marxist oppositions of base/superstructure and proletarian/bourgeois to Herbert Marcuse's critique of an industrialized one-dimensional man, from the allusive density of poetry by Pound and Eliot to the cryptic *agon* of writers such as Borges and Beckett, and from the methods of New Critical myth-and-symbol analysis to the "deep structural" approach of the Levi-Straussian school —to this pervasive, transcendentally oriented depth logic Warhol opposes egregiously superficial artifacts and the suggestion, "Just look at the surface of my films and my paintings and me, and there I am. There's nothing behind it."[23] In a climate of concern about the creeping factory-based conformity of life in the civilized West, Andy sets up shop at a studio called the Factory, turns out grid-pattern silkscreens, and makes pronouncements such as "30 [Mona Lisas] Are Better than One," and "I want everybody to think alike."[24] At a time in U.S. history when normative sex and gender roles remained largely unexamined, and nationalism and machismo were seen as homologous virtues, Warhol sponsors an ongoing gala celebration of homoeroticism, polymorphous perversity, androgyny, and transvestism. In an artistic sphere fostering asceticism and hard-earned integrity, Warhol unleashes a flamboyant dandyism founded in an openly self-promotional style. While avant-gardists and intellectuals endorse the notion of critical resistance, Warhol revels in unapologetic affirmation. While others belabor the distinction between sincerity and authenticity, Andy applies himself to mastering the pseudo-event and the media put-on, and assumes his position as one of the great impresarios of camp taste. As the experimental musician John Cage refines his Zen-influenced aesthetics of silence, Warhol explores the aesthetics of playing pop music at full-blast volume—first on a phonograph in his art studio, the same song dozens of times in succession, and then as a producer of mind-altering, multimedia rock concerts featuring sonic assaults by the pre-punk group the Velvet Underground. Then, lest the rock-music scene become too secure in its masculinity, Warhol's Factory serves as a base camp for the gender-bending forays of glam and glitter rock. Carrying over his endeavors into

the seventies and eighties: In the face of benchmark philosophical diagnoses of the modern condition—regarding history and its burdens (Nietzsche), civilization and its discontents (Freud), Sisyphus and his labors (Camus), nothingness and nausea (Sartre)—Warhol publishes a book of "philosophy" that divulges his views about things such as Poptarts, B-movie actors, fashion accessories, and "underwear power." While literary practitioners labor to preserve the austere standards of the independent small press, Warhol—with the novel *a*, the magazine *Interview*, and *The Andy Warhol Diaries*—generates an entire industry out of formalizing gossip in print.

Ideological ruses such as this, enacted by an artist who pretends to know nothing about modernism, conspire to hasten a complex historical process in which modernism as a cultural dominant, while not precisely "overthrown," is still significantly undermined and unmanned, its premises increasingly seen as contingent and problematic. Lacking a systematic manifesto, Warhol nonetheless assumes revolutionary stature in showing how a modernism that had received official sanction and institutionalization by the postwar era had also become to a large extent calcified and oppressive. Despite Warhol's apparent political apathy, and his not knowing how to pull the lever at a voting booth, he was intimately involved in transforming people's lives during the American sixties. The artist that Bob Dylan dubbed "Napoleon in rags" marshaled an army composed of recycled icons and logos, scandalous movies, and assorted class fugitives; through such unlikely resources he became one of the key creative figures in a decade no less charged and redefining for the United States than the 1790s were for Bonaparte's France. However, that this presumed revolutionary was more firmly devoted to metaphoric pranks than to sustained social critique, and that his relation to rational thought was far more pre- or quasi- rather than post-, should particularly concern those who believe that the sixties were mainly about liberation, that popism has been a marvelous godsend, and that postmodernism constitutes a clear advance over modernism. The ambiguous, both celebrated and lamented results of the process of "post"-ing modernism are manifest in a kind of Greatest Hits form in the person and practices of Warhol, whose effects on contemporary culture continue to incite the most polemical of responses among critical as well as lay communities.

If the above treatment sounds like a grand-narrative account of the relations between Warhol and postmodernism, a number of spoilers need to intrude on the story. The foregoing list is far from being a complete or precise delineation of the themes and agendas of postmodern-

ism; and even if such a list were possible, postmodernism is supposed to *repudiate* grand narratives, not support them.[25] Between efforts to refuse grand or meta-narratives on the one hand, and the need to have at least the skein of a narrative left to talk about, on the other, Warhol has been promoted as a provisional, and conveniently indeterminate, index of what postmodernism was said to be about. The fact that he rarely used the word, much less defended it in public debate, also allowed a convenient separation between exegetists and their favorite primary text. The Marxist critic Fredric Jameson saw in Warhol's work an extreme suppression of depth and context, and evidence of the waning of affect in postmodern culture.[26] The French philosopher Jean Baudrillard saw the artist (along with Michael Jackson) as a next-generation "androgyne," a prosthetic device "which delivered us from sex and aesthetics." The virtue of Warhol's soup can, for Baudrillard, is its ability to "nullify the question of beauty and ugliness, the real and the unreal, the transcendent and the immanent."[27] To Roland Barthes, the repetition in Warhol's silkscreens was initially conceived to depersonalize and destroy art, but it ultimately reveals objects "trembling" in the act of seeking their own essence.[28] Michel Foucault went so far as to say that the element of "stupidity" in Warhol's work was the sign not of its limitation or weakness but rather of its greatness.[29] In the writings of these and other intellectuals, in ways that were never fully acknowledged, postmodernism was the theory, and Warhol was the practice. To the extent that the two entities have been reciprocally defined and interpreted, disentangling them is a delicate operation. There are good reasons Andy is taken as a poster boy for the movement, and also good reasons for resisting this depiction. Warhol and postmodernism have many traits in common—virtues as well as limitations—but they do not serve reliably as stand-ins for each other. Further, set against the postmodernization of Warhol and the Warholization of postmodernism is the question of what relative strength either of them might have without the other.

The virtue of "strength," however, comes up for redefinition during an epoch that is said to countenance not a strong but rather a "weak" ontology, in the sense articulated by the Heideggerian philosopher Gianni Vattimo.[30] Embedded in philosophical modernism, Vattimo argued, was an intellectually self-satisfied tendency toward grandiosity that hastened the movement's demise. Vattimo and others outlined the project of recovering from the hubris of the Western metaphysical tradition, with its roots extending back to Enlightenment rationality, European humanism, Judeo-Christianity, and Platonic idealism. Countermea-

sures were needed in order to dismantle or "unground" modernism's presumptuous claims and foundations; but of course the only candidates for such a project were themselves steeped in modernism's presumptions. Vattimo devised the term "weak thought" (*il pensiero debole*) to describe the contradictory effort of working simultaneously within and against modernist rationality.

This term may sound peculiar, even downright hilarious, in the context of an artist who said, in a devil-may-care manner, "I don't want to think," and "my thinking time isn't worth anything." If Warhol came across as one who had not been much improved by the customs of Western thought, he also gave the appearance of one who had not been greatly damaged by them either. He took as the subject of his art images that many observers found to be almost criminally familiar; and yet his relationship to those images, and to the kinds of sense-making capacity assumed among post-Enlightenment minds, was anything but familiar. There was no way to verify whether he was working within, against, or rather *without* modernist rationality. Warhol was not truly a psychological void, nor were his images in fact Rorschach inkblots (that is, until his wag-the-dog *Rorschach* series in 1984); but that didn't prevent a number of well-placed postmodern thinkers from writing as if they were. Regardless of the validity of their claims, their acts of attribution involved a curious irony: intellectuals who harbored advanced skepticism about objectivity and rationalism found support for their theories in the work of an artist who didn't seem to harbor public skepticism about anything. The principles of "weak thought," in other words, were to some measure based upon the life and art of a man whose thinking capacities were, at least in his own estimation, in fact quite weak.

This is not to suggest that the relationship between artists, art, and art interpreters has ever been fully transparent or stable; nor that an epoch of history could ever be reduced to the contributions of one individual. But *some* explanation is needed for how Warhol's Simple Simon demeanor and images can have introduced a new order of hermeneutic complexity—not only to art history but to other kinds of history as well. Perhaps Andy's collection of wiles and antics was just what Western thought needed in order to liven up the process of cooking itself a home remedy. The meaning of his career, though, shifts depending on which sense of the word "just" is operative: if it's used in the preceding sentence as a synonym for "precisely," or "entirely," then the statement risks conferring superhuman powers upon Warhol. He becomes a true clairvoyant; the CEO of a new cult of the personality; the stone the workmen rejected, uniquely fitted to become the cornerstone

for the entire edifice; or he becomes promoted into a Hegelian prime mover, bearing the torch of History serenely aloft over the vicissitudes of Fate. These options all have a certain seductive appeal. However, if the word "just" is taken to mean "merely," or "happened to be," then a more plausible view emerges, one that leaves a margin for trial and error, for coincidence and serendipity, both on Warhol's side and on the side of his interpreters. In this view, two frequently conflated processes become newly available as independent subjects of inquiry: the rationale behind Warhol's having become "disembodied" through his art and persona, and the rationale behind his art and persona having become re-embodied as theory.

Nonetheless, even if these rationales were perfectly distinct and clear, we would still have reason for asking: What sense of the word "mere" is really applicable? No amount of debunking the myths surrounding him can reverse the effects those myths have had upon material history. Warhol is like some all-time champion of the old radio quiz show "It Pays to Be Ignorant"—not only winning cash prizes and widespread renown, but also dazzling the kind of people who ordinarily scorn quiz shows, and who might otherwise take offense at the idea that displays of ignorance should be reimbursed. Just as Warhol is not sufficient to explain postmodernism, neither is postmodernism sufficient for explaining Warhol. It's as if making sense of him is as subtle and vexed an issue as making sense of the decade in which he burst onto the international scene. Curiously, he receives not even a fleeting mention in the six-hour PBS documentary *Making Sense of the Sixties* (1991). I suspect this is mostly because he doesn't fit the usual grand narratives about the decade. It may be hard to credit the political nature of his energies during a period indelibly marked by sit-ins, teach-ins, freedom rides, rent strikes, and the burning of draft cards; by black uprisings in major cities across the United States; by the formation of the National Organization for Women and the Native American rights movement; by the Chicago Eight, the Black Panthers, the Weathermen, Kent State, and Jackson State. Even Warhol's own near-death experience at the hands of an extreme feminist barely had time to register before national attention was drawn, thirty-five hours later, to the shooting of Robert Kennedy. However, in retrospect one sees his handiwork not only in expansive ideological terms but in a variety of charged street-level arenas. His broadside tracts took the form of film posters depicting naked and seminaked men. The megaphone he used was the sound, light, and film-projection system at multimedia concerts. Everywhere he went, his very appearance trumpeted the cause of gender dissidence;

and this campaign was expertly assisted by a staff of cross-dressers and other refugees from the status quo. His manias were different from those of Beatlemania, although he too promoted and influenced rock music on a grand scale. His counterculture was different from that of the hippies, Woodstock, and the Age of Aquarius, although it too had a major impact on new-bohemian sensibility and fashion.

Clearly the ongoing project of making sense of the sixties needs to include Warhol—either in spite of, or because of, the formal challenges involved in doing so. His widespread influence from the sixties onward is not easily corroborated with his intentions or agenda; but this uneasiness itself comprises a great deal of his cultural revenue and impact. Even now it's hard to say exactly what he had up his sleeve. Warhol's career provides new occasions for examining the nature of ruses and tricks themselves, and for considering how effective they might be at either propelling or diverting the forces of history. We are all well-apprised of the notion that history is not reducible to a matter of kings and wars; but few would subscribe to the alternate notion that it is reducible to a matter of jesters and shenanigans. In various ways, Warhol's trickster approach presents a quandary. If his notion of "just looking at surfaces," for instance, somehow fails to serve as a formidable critique of various forms of modernist depth logic, it may be either that Warhol's surfaces fail, or that something besides formidable critique is involved. To the extent that his proposed surface logic (or antilogic) succeeds, its success may indicate a kind of cunning impertinence, such as is found in a Buddhist koan, or in the vital deception or lie theorized by Nietzsche.[31] Andy once concluded an interview by asking, "Have I lied enough?"[32] Such gestures encourage us to read his livelihood as a manifestation of the liar's paradox. In mathematics, the liar's paradox refers to the person who states "I am lying," and who thereby must be both lying and telling the truth at the same time. Bertrand Russell presents a corollary to this paradox: "The man who says, 'I am telling a lie of order n' *is* telling a lie, but a lie of order $n + 1$."[33] Using this formula, we might say that Warhol is telling lies of order n, and our continuing task remains discerning the nature and contours of order $n + 1$. This task is complicated by the fact that order $n + 1$ bears so many resemblances to order n, as well as order $n - 1$, and none of these orders categorically supersedes another. One of the resemblances between orders $n + 1$ and $n - 1$ has provoked recurrent concern among intellectuals: if postmodernism is trying so hard to rid itself of the negative tendencies of modernist rationality, what prevents it from deteriorating into the same irrationality and superstition that

modernism was trying to overcome? It's one thing methodically to critique and outwit the fallacies of a given epistemological rubric; it's quite another to say, blankly, "I don't want to think."

I contend that Warhol's insistent hold on our imagination rests to a great degree on the artist's two-and-a-half-decade performance as a naif-trickster, and on our strongly conflicted reactions to the new order (call it order $n \pm 1$) that he has helped to establish. Even after his death Andy continues his performance both as a trickster, artfully evading our attempts to pin him down, and as a naif, thwarting our efforts to render him knowable within a familiar intellectual framework. The blankness of the face he habitually exhibited stands in contrast to that of an endearing naif such as comic film legend Buster Keaton, whose visage conveyed pathos, romantic longing, and stoic heroism. Symbolically, Warhol's blankness bears closer resemblance to the effaced or abraded coin in Jacques Derrida's essay "White Mythology"—a coin posited as having both inestimable, and negligible, value.[34] Writing about the task of unriddling the complexities of the contemporary moment, Donna Haraway asserts, "our hopes turn on revisioning the world as coding trickster with whom we must learn to converse."[35] Toward that end we would do well to find new ways of revisioning the world of Andy Warhol, and of learning new ways to converse with him. This is not to say that an effaced coin or a coding trickster should be assigned infinite value. The coin may have elements of fool's gold, and the coding trickster may turn out to be a spineless confidence man. Even postmodernism, on a given Thursday afternoon as the lecture settles into a drone, may seem the most wispy of concepts. But as long as it's been conjured—and who is that odd man behind the curtain anyway?[36]—it's worth keeping up our end of the conversation.

Methodizing Naivete

The artist's reputation as a naif-trickster has become embedded in myth without being subjected to rigorous or sustained scrutiny. At present the writings about this facet of his persona are mostly anecdotal rather than analytical, limited to passing comments and fragmentary accounts. This study will provide the first substantive, scholarly consideration of how the naif-trickster pose functions in Warhol's career. A great bulk of critical material on Warhol has excluded consideration of all but a very narrowly conceived portion of his formal output. This has promoted an excessively calculating and circumspect sense of the artist; it has also left a deficit in terms of the other aspects of his influence.

David E. James usefully divides the contexts in which Warhol appears into four categories: "the psychological one of his personal subjectivity, the social one of his biography, the aesthetic one of his work, and the political one of the historical meaning of Warholization." In a classic study, Ernst Kris and Otto Kurz have shown that legend, myth, and magic also play a significant role in the public's image of artists.[37] By focusing primarily on the psychological, social, political, and legend-based categories, I hope to show how the persona behind the art remains a fecund and underexplored site of meaning. Warhol's naif performance inheres in gestures and vagaries that extend beyond the frame of his painted and filmed images. Understanding those gestures requires making a similar extension beyond the aesthetic qualities of his work. Although the concepts of naivete and tricksterism cannot be fully systematized, a few notes may help to clarify this study's organizing principles and methods.

By characterizing Warhol as a naif, I'm not proposing that his art was naive, at least as this term is usually intended. As a painter Warhol frequently chose naive subject matter, but he is not a naive artist in the strict sense of the term—that is, formally untrained, in the manner of, say, Grandma Moses. His childhood preoccupations do recurrently emerge in his adult art, as other scholars have demonstrated; however, the same might be said of the pop artist Roy Lichtenstein, for instance, without necessarily constituting the most insightful means of assessing his work.[38] On the other hand, Warhol *was* formally untrained in filmmaking. Interestingly, his contributions as a producer and director often involved undermining the serious efforts of his formally trained assistants. A study of the naif-trickster elements in his films might proceed from any number of angles; however, partly because he does not appear on-screen in this body of work, his films do not present an expedient way of examining his persona, and I am choosing not to provide a close frame-by-frame analysis or thorough reassessment of his cinematic oeuvre.[39] His silkscreened and filmed images are not extraneous to his performance of naivete, nor do I make a point of avoiding them; but other material takes precedence here.

Similarly, by characterizing Warhol as a trickster, I'm not proposing that his art amounts to a hoax. It isn't my intent to lend credence to the idea—still persistent in some circles—that Warhol was an impostor in the art world, with no claims to artistic greatness. My argument turns mostly on the fact that he has been *regarded* as an impostor, and on the ways he has both elicited and exploded that identity marker.

By the same token, I am concerned with what may be missing from

valuations about the greatness of his art and the iconicity of his status. He presents a different *model* of artist, which gives such valuations a provisional quality. He now has institutional backing of a kind he never had during his lifetime—in some ways more backing than any other artist has ever had. Since the Andy Warhol Museum opened in Pittsburgh in 1994, he has been the subject of the world's largest museum devoted to one artist. The market value of his work continues to surge and has spawned new product lines of clothing, jewelry, and home furnishings. In summer 2002 he received his own commemorative postage stamp. In the same summer, a retrospective at the Museum of Contemporary Art in Los Angeles prompted a *Newsweek* writer to say, "The exhibit demonstrates why—and this is probably an understatement—Warhol is the most influential artist the world has known since Picasso."[40] (Decades before, Norman Mailer had said, "Warhol's the worst but most importantly influential artist alive.")[41] *Newsweek*'s pronouncement usefully acknowledges that how we see today is imbricated with how Warhol saw, and that this prevents us from taking the full measure of his influence. But the pronouncement also begs for further amplification than is permissible in the article's seven-paragraph length and news-magazine format. Between his being derided as a phony, enshrined as a master, and installed as an institution, there is ample room for investigating further consequences about the nature and extent of his achievement.

The evidence for such a reading is found in material that is overlooked elsewhere, or considered only glancingly—biographical sources such as the artist's public and documentary appearances, and autobiographical sources such as his published memoirs and diaries. This study presents Warhol more often with a tape recorder in his hands rather than a camera or a silkscreener's squeegee. Perhaps it is a disservice to pay closer heed to an artist's words and manners than to his chosen and official métiers. Warhol, as we will see, was a good deal less confident and composed as a user of language and logic than he was as a maker of paintings and films. But in the very unstableness of his verbal utterances and social persona lies a significant, and still inadequately understood, portion of his life-work. Part of this unstableness lies in questions about what he actually said: he is no more the sole creator of his memoirs than he is of his movies and paintings. I proceed on the assumption that what is attributed to him has the *effect* of having originated from him, even if his voice is often "channeled" by editors who were trying, not always successfully, to sound like him.

This shift in emphasis from Warhol's paintings and films to his so-

cial and verbal performance provides a rationale for my decision to avoid elaborate further *agon*-izing over the relations between popism and its European forerunner, dadaism. Discussions about the aesthetic and philosophical resemblances between the two movements too often neglect the wide contextual gap separating pre–World War I Europe from post–World War II America, and corresponding shifts in the social roles available to artists. The dadaists took refuge from their "antirational" art in social and political postures that were, for the most part, eminently sensible and intellectual.[42] By contrast, Warhol's naif performance has a thoroughgoing and seamless quality that would not have been feasible or intelligible in a previous era. The "dumb show" he perpetuates allows for no reassuring separation between the artist and his art, provides no cogently ordered program notes, leaves no distinct pauses for intermission.

In social and historical terms this may be seen as both emancipating and disastrous. The critic John Yau asserts, "In this century we have moved from artists who draw like children (Picasso and Pollock) to the hypersensitive child proclaiming his difficulty adjusting to the demons of the big, bad world (Warhol and Koons)."[43] There may be counterexamples to the trend Yau alludes to, but his basic claim remains hard to disconfirm. I see his comment as less concerned with the working methods of four individual artists than with the social apparatus that supported those methods. It isn't just that the antics of the maladjusted child are no longer limited to the artists' studio; but that childishness and maladjustment have become so widely dispersed in other sectors and livelihoods. In studies from the late seventies to the present, from Christopher Lasch's *The Culture of Narcissism* (1978) and Dan Kiley's *The Peter Pan Syndrome* (1983) to Ken Wilber's *Boomeritis* (2002), analysts on the right as well as the left have addressed the changing nature of maturation and social development in an epoch that offers an enticing variety of alternatives to these processes.[44]

Warhol's persistent influence on present-day culture makes all the more urgent the need for an enhanced understanding of what I refer to as "cultivated naivete." Examining his career seems to me, among other things, an effective shorthand method of addressing several startling facts of contemporary life: that baby boomers and their progeny seem to perpetuate traits of childhood or adolescence further into adult life than their forebears; that they are taking longer to grow up and experiencing phases of adult development later in life than previous generations have; that cultivated naivete has in recent decades acquired the status of a national pastime; and that such trends persist

simultaneously with signs of increasing sophistication and maturation in many other realms, such as the arts, scientific inquiry, academic discourse in a range of disciplines, and information technology and communication. Such forms of uneven development have been endorsed by American ideology for a great while, and will come as no surprise to readers of de Tocqueville or Thoreau, for instance. However, postures of naivete seem today so widely accessible and prevalent, and the need for civic maturity and responsibility so pressing, that the issue calls for redoubled attention. I'm not presenting these traits as precise opposites; nor is my inquiry into the workings of naivete part of a full-scale campaign to eradicate them. But in a polemical vein it is worth asking: What are the political implications and costs of performed naivete? When does it stop being adorable for an adult to behave like a child or adolescent? What becomes of a nation that won't grow up, or can't grow up? While inquiring into one man's life and legacy, I'm aware of raising questions about the country of which he was a citizen; the country that George W. S. Trow, in his essay "Within the Context of No Context," diagnoses as puerile and Ritalin-like; the country whose Warhol-like fixation on popular culture has led to depredations such as those examined in Eric Schlosser's *Fast Food Nation* and Ronald Collins and David Skover's *The Death of Discourse;* and the country that the senior news analyst Daniel Schorr describes, one year after September 11, 2001, as sadder but not wiser. Such questions are impossible to answer satisfactorily; but the stakes involved in failing to ask them are even higher.

Naive Complex

Symptomatic of the primitive state of discourse on naivete today is the frequently invoked term "faux-naivete," with its presumption of a stringent true/false dichotomy, and its facile investment in notions of authenticity and belatedness. The term is often applied to the somewhat whimsical style Warhol employed in his pre-pop work as a New York ad designer. The phrase "second naivete," often associated with Marcel Proust, also implies a misleading sense of linear sequence. I employ the term "cultivated naivete" in an attempt to counter these binary forms of logic and to establish a greater sense of range and complexity. I define cultivated naivete as the strategic withholding, disabling, or refusal of knowledge; an apparent ignorance that nonetheless wields a critical edge. The verb "to cultivate" carries the agricultural sense of fostering, engendering, nourishing, as well as the cultural sense of refining, im-

proving, disciplining. One may cultivate gardens, friendships, good or bad habits. "Cultivate" can mean to improve by labor, care, or study; to seek the society of; to further or encourage.

The word "naivete" is also richly valenced, owing partly to its bifurcated etymology. The diminutive "naive," borrowed from the French contraction of "native" (derived from the Greek *nativum*), appears in English usage in the mid-seventeenth century as an affirmative adjective to describe natural or unaffected mannerisms. The *Oxford English Dictionary* dates the earliest use of "naivete" to 1654. Meaning "inborn" or "natural," the term provided a category for behavior that was nature-*like* while not actually encompassed within the age's definition of nature. It posited the human sphere as an extension of, or as superimposed upon, the biological one. Not until late nineteenth-century usage does the pejorative sense of naive as "gullible" or "contemptibly uninformed" emerge, and thereafter threaten to eclipse prior connotations. Thus an *OED* listing from 1817 reads, "Her manner is . . . delightful, she is very naïve"; but by 1885 a shift is already apparent: "As belief in causality spread, men were not content to rest in the naïve explanations of an uncritical age." To label something as naive today, particularly in an intellectual setting, has become a shorthand method for announcing one's disdain, and for bolstering one's own claims to expertise and superiority. As scholars we are suspiciously eager to distance ourselves from, even as we are professionally intrigued and remunerated by, what Eve Kosofsky Sedgwick in a remarkable essay, "Privilege of Unknowing," has called "the ignorance that is only barely not our own."[45]

Note the secret exhilaration with which people detect and deride naivete, as if they were scolding a favorite pet. In James Thurber's famous *New Yorker* cartoon from the early 1940s, seated dinner guests raise glasses as their host declares, "It's a naïve domestic burgundy, without any breeding, but I think you'll be amused by its presumption." The host seems all too pleased to offer this inferior drink to his guests, since it allows him to display his skill with a distinctively cutting bon mot. The burgundy in question is redeemed in the very act of demoting it. The cartoon assumes a pejorative sense of the initial adjective: naivete is associated with lack of breeding, with presumption, and with experiences that can only be salvaged through condescending laughter. And yet the cartoon does not really target the wine at hand, but rather the conventions of wine criticism and the pretensions of the host. Arguably, it's told at the expense of American taste and character as well, since if either the burgundy or the setting were foreign rather than domestic, the joke is lost.

Alternatively, the joke could be retold on behalf of the burgundy: its naivete is the one truly life-giving force at this dinner party, and the assembled guests should be grateful for the way it liberates them from their stultifying politeness and sophistication. Its naivete is amusing, intoxicating, good for the bones. The host is really saying, "Here's to naivete! May this burgundy help you cease musing and begin the real business of the evening: spirits, merriment, the dinner-party equivalent of a Dionysian revel." The cartoon itself might be said to perform a similar function for readers of the *New Yorker*—the charmingly naive Thurber drawing style offers a visual relief from serried, linear typography; and the element of humor offers a sanctuary from important-sounding news analysis about issues confronting a nation at war.

Maybe deriding naivete is what sophisticates do to hide the fact that they're so exhilarated in detecting it: "aha!" they could be saying; "I've spotted it in someone else, which proves that the world's supply cannot all reside in my own cranium." In spite of its reputation, naivete may be a fellow-feeling; a recognition of shared humanness. Scolding your pet is a form of doting upon it, of proving how much you care.

In addition to a periodic scolding, naivete also recurrently needs to be rescued and protected, particularly when it wanders into a combat zone, as it has often done over the past century. In 1975 the term receives sturdy validation from the elder scientific statesman Buckminster Fuller. He begins his book *Synergetics* with the clarion call "*Dare to be naive*"—implying that the trait requires courage in the face of ridicule. Fuller exhorts readers not to be intimidated by the seeming completeness or permanence of any existing body of knowledge. His message is heartening enough in itself, but especially so at the outset of an 876-page magnum opus. The psychologist Carl Jung writes that naivete needs to be protected not only from outside marauders but internal ones as well: "All too easily does self-criticism poison one's naivete, that priceless possession, or rather gift which no creative man can be without."[46] The creative man referred to in this passage is Sigmund Freud; his protégé combats and praises the elder analyst's naivete in the same breath. Jung asserts it's a good thing that Freud did not criticize his own premises, or recognize the naivete of his own theories; otherwise the world may never have seen them at all. Even though they were naive.

The term "naive" may seem to have strayed far from its etymological pedigree, but family resemblances are still detectable. One December evening some friends and I drove past a prominent front-yard display of the Holy Family and the three wise men. With mock-excitement someone said, "Look at the Christmas naivety!" The line assumes a

certain dry distance toward naivete as well as the yuletide season and its conventional nativity scenes. For all the implied disdain, though, the line conveys a sweet affirmation of all these things, and of malapropisms as well. My friend was proposing a mirthful new function for the outdoor display, one that would be forfeited if he had just said "bah, humbug." His joke only works if the final word is stressed on the second of four syllables, "nah-I-ve-tee," rather than on the last of three syllables, "nah-eev-TAY." However, both pronunciations are acceptable, as are "ny-ee-ve-TAY" and "ny-ee-ve-TEE." A cluster of alternative spellings and diacritical marks (naiveté, naïveté, naivety, naïvety) are connected to the term, like a series of mementoes of the word's leave-taking from its *native* roots.

Paradoxically, naivete cannot exist in a vacuum, but it still constitutes a vacuum of sorts. One cannot be comprehensively or generically naive; rather, one is naive *about* something. The concept of naivete implies both relation and absence. A solitary extraterrestrial cannot be described as naive, except by way of relation to some other being or body of knowledge. (One measure of a rising interest in naivete in recent decades has been the cinematic popularity of extraterrestrials. Such films often revolve around determining the balance of naivete and sophistication among human and nonhuman representatives, and of establishing a new hierarchy among these traits.) Neither can a newborn infant be described as naive, in the sense commonly used today; a certain level of maturity must be achieved before the word can apply. Imagine the proverbial moment at the office when all work and all rational adult behavior cease as an employee or spouse brings in a baby to introduce to the staff. Everyone is cooing, and then a coworker with a slightly worried look says, "Your baby is beautiful, but she's so *naive*." The parent replies with a touch of ruefulness, "I hate to admit it—we were hoping she'd be even *more* naive than she is." One does not only grow out of naivete, but into it as well.

The concept of naivete implies an absence or deficit, which may take numerous forms. Naivete may be couched as an absence of positive qualities (e.g., manners, breeding, intellect, morality, maturity, education, will, social responsibility, competence, savvy); or conversely as an absence of negative qualities (e.g., pretense, stuffiness, hyperintellectualism, moralism, solemnity, overeducation, tyrannical will, legalism, imperiousness, jadedness). It can signal a failure of good education, or a successful protection against bad education. It can denote a dull lumpen resistance to sophistication, or a shrewd underclass tactic against sophistry. A naif can be someone who is solipsistic, unteach-

able, incorrigible—or instead, someone not yet corrupted; someone who is merely unwise, or someone who virtuously avoids becoming *worldly*-wise. Naivete may assist a soldier in battle to remain focused and perform great acts of heroism; but the same trait may prevent him or her from grasping political or moral flaws of the battle in question.

The Naif's Prayer: Lord, give me this day what naivete I need; take from me what naivete I am better off without; and grant me the naivete not to know the difference between them *too well.*

If naivete implies absence, the idea of "cultivated" naivete implies at least a partial return of presence (presence of mind, of wit, of an edge of knowing). To withhold, disable, or refuse knowledge in a strategic rather than haphazard way, one needs to have an inkling of what the knowledge concerns. A degree of will or purposiveness marks the separation between generic ignorance and a dissembled *display* of ignorance. Does one become less naive, then, in the act of cultivating naivete? By going on stage a naif transforms into an ingenue (a word for which there is no male equivalent). Her performance will be judged a success if the character's naivete appears innate rather than manufactured; but if an ingenue is trying too hard to *seem* naive her efforts will be deemed "disingenuous." Like certain houseplants, naivete may well wither if subjected to too much cultivation.

The rule familiar to directors of Shakespeare, that it is difficult to find an actress who is neither too young nor too old to play Juliet, may have as much to do with psychological maturity as with physical attributes or date of birth. On each night of performance, the character of Juliet must convincingly cross the terrain from girlhood to womanhood. How then, we might ask, does a nonactor named Andy Warhol manage to extend his naif performance into his adult years? Numerous factors assist him: his remaining unmarried and living with his mother in a house full of felines; his having an asexual public image; his having unusually pale Caucasian skin; and, by a reverse logic, his being a resident of Gotham City. *Mom, it's you, me, and umpteen cats against the world.*

A playful way of resolving the spatial-conceptual problems inherent in naivete is suggested in the expression, "What that man doesn't know

could fill volumes." The absence implied by naivete now becomes tangible and pliable. To extend the metaphor, we might say that cultivated naivete implies *doing something* with the volumes in question—engaging in some value-added activity like cataloging them, or mislabeling them, or using them to juggle. These activities imply differing levels of engagement, in two senses of the word. The more one engages with the printed content of the volumes, the less outwardly engaging the results may turn out to be. Cataloging the volumes, for instance, involves a moderate engagement with their content, but limited value for spectators. The activity of mislabeling or defacing the volumes may yield more entertainment value, but this will also depend on the degree of engagement with the volumes' content. If the book-defacer is in the Joe Orton category, the results will comment wittily on the original subject matter; if not, the activity may look more like mere violence, or a temper tantrum. Finally, if the volumes are used in a juggling display, their content becomes immaterial—that is, unless the juggler has a sense of humor and can incorporate it into the act, as in a Flying Karamazov Brothers routine. Other frames of reference, such as age, experience, social responsibility, or political motivation, will yield still further forms of valuation. Numerous categories of response may emerge: "Mislabeling books is (a) an exciting challenge to the status quo, (b) a waste of her talents, (c) a sign of immaturity, (d) a sign of creativity, (e) ultimately unhelpful to our literacy campaign." Other possible responses: "He's merely imitating Joe Orton." "She's too old to be juggling—it doesn't suit an adult." "I'm too old to watch juggling." "I'm too young to appreciate this." "Her jokes go over my head."

Naivete and the matter of "not understanding" imply connection with a host of related concepts—among them damaged intelligence, retardation, and stupidity. A proliferation of slang terms (airhead, dummkopf, dunce, cretin, blockhead, bimbo, harebrain, half-wit, simpleton, numbskull, tomfool, pinhead, bonehead, dunderhead, et al.), and of joke telling, often at the intellectual expense of targeted social and ethnic groups, attest to the existence of a universal power struggle in the realm of cognitive ability and corresponding social rank.

Being called naive or stupid brings an immediate and palpable sting; still, the origin, nature, and contours of these terms remain baffling and uncanny. As Avital Ronell warns at the outset of her book *Stupidity*, "Essentially linked to the inexhaustible, stupidity is also that which fatigues knowledge and wears down history." Even the gods cannot combat it, she says. "[It] mutes just about everything that would seek to disturb its impervious hierarchies."[47] Given such a wide-ranging dis-

course, one is reduced to making forays inward from the perimeter, to describing effects rather than circumscribing or taming the subject. However, the fact that stupidity is not tameable or vanquishable needn't lead inexorably toward defeat and despair. In his brilliantly unconventional work *Critique of Cynical Reason*, the German scholar Peter Sloterdijk speaks about stupidity as an invigorating force. In modernity, he writes, "Stupidity loses its apparent simplicity; in it one no longer recognizes a primary state of unenlightened minds but a complicated phenomenon that in itself is many-sided, indeed downright exciting. . . . Stupidity is an act of defiance, a refusal, a not-wanting-to-be-otherwise that advances parallel to enlightenment."[48]

Accompanying such conceptual, semantic, and etymological complications, the social and anthropological roots of cultivated naivete extend to a history that is unlimited both in terms of depth and breadth. Mikhail Bakhtin has shown how "the device of 'not understanding'"—in his analysis epitomized in the low antics of the rogue, clown, and fool—extends into classical antiquity and the ancient Orient and even further, "into the depths of a folklore that pre-exists class structures."[49] Countless manifestations in folklore, theater, literature, and public life attest to the elasticity and inexhaustibleness of this tradition. Various guises include the buffoons and laughter-makers of ancient Greece and the Middle Ages, the fools and court jesters of medieval Europe, the village idiot in Russian lore, the coyote in native American mythology, the signifying monkey in African American vernacular culture, the fox of the Chaco people in South America; and individual figures such as Robin Goodfellow, Pulcinella, Harlequin, Don Quixote, Reynard the Fox, Till Eulenspiegel, Parsifal, the Roman god Mercury, India's Vidusaka, the Barefoot Wandering Taoist, Tibet's King of the Years; Susa-nö-o and Kitsune, from Shinto mythology; Si-Djoha, a court jester in tenth-century Arabia; Nasrudin, jester to the Turkic conqueror Tamerlane; and Loki, the mischief maker from old Norse tales. In this list, the roles of naif and trickster fluctuate and recombine in endless variation. Although the two archetypes are not interchangeable, they typically appear in alloy form, and their histories are thoroughly intertwined.[50] Trickster figures are known to travel and mutate across cultural boundaries. In *The Signifying Monkey*, Henry Louis Gates Jr. examines resemblances among figures in the black mythology of Africa, the Caribbean, and South America, and traces their origins to the Yoruba trickster god Esu, or Esu-Elegbara. In the United States, the trickster hero Whiskey Jack, of the Eastern Woodlands, is anglicized from Wisakedjak, of native American lore;

and the figure of Brer Rabbit descends from trickster tales brought to the New World by African slaves.

With this history in mind, one could extrapolate from Bakhtin's concept of the comic-ironic double to establish the naif's contrapuntal relationship to ordinary discourse. The naif arises as an indispensable element in a system of epistemological checks and balances; recurrently naifs may be seen unwittingly critiquing and counterbalancing the dominant knowledge regimes of a given era.

All of human history may be imagined as an ongoing fracas between the forces of understanding and not-understanding, with the boundaries, weapons, and stakes in perpetual flux. Socrates, for instance, is renowned for having cultivated naivete for the purposes of exposing it. The Socratic ironist makes a pretense of ignorance so as to force an opponent's false conceptions out into the open. However, this presumes the opponent's willingness to engage in rational discourse. Enid Welsford's pioneering 1935 study, *The Fool: His Social and Literary History*, recreates the moment when Socrates was confronted at court with a laughter maker (or buffoon) named Philip:

> Xenophon . . . affords us our first glimpse of the Greek buffoon at work, when he describes how the laughter-maker Philip presented himself uninvited at the famous supper party of Callias and provided welcome diversion from the serious moral discussions led by Socrates. He caused the assembled guests much amusement by parodying the graceful movements of the Syracusan dancers who had also come to entertain them; by exchanging badinage with Socrates; and by indulging in impertinent comparisons and personal remarks directed against the guests. For this impudence he was indeed rebuked by Socrates, but the sage was quite unable to lower the self-satisfaction of the buffoon.[51]

In the face-off between fools and philosophers, between naivete and sophistication, are there any intrinsic advantages? Alas, the boundaries between them are not even clear. Peter Sloterdijk champions the cynic-philosopher Diogenes (412?–323 B.C.), whose love of bodily pleasure and satirical laughter serve as the perfect foil to the refined idealism of Plato. Sloterdijk asks, "And what is it supposed to mean when this philosophizing town bum answers Plato's subtle theory of eros by masturbating in public?"[52] Welsford's account describes philosophers sparring with buffoons to the point of fisticuffs; it also refers to German professors in the eighteenth century augmenting their incomes by playing the fool at court (6, 8). Avital Ronell reminds us that Erasmus, author of *The Praise of Folly* (1549), coined the idea of "foolosophers," and that this

in turn is how Dostoevsky and Kafka characterized followers of Christ and Abraham. In "De l'essence du rire," the poet Charles Baudelaire claims that the ability to laugh at oneself constitutes the very threshold of philosophical consciousness.[53]

The evidence in Ronell's book suggests that the more habitual professional practice is to laugh at someone *else's* expense, especially when the someone else is a fellow philosopher. She notes Jacques Lacan's habit of categorizing his own disciples as imbecilic (38), and of Theodor Adorno and others denouncing Martin Heidegger as "ridiculous" (281). However, it is not by way of insult that Peter Sloterdijk characterizes Freud as the Till Eulenspiegel of Viennese society, wearing Old Master tweed while overturning taboos about sexuality; nor is it a put-down to notice that the Marx in the Slovenian theorist Slavoj Zizek's work is as much Groucho as Karl.[54]

The critic Theodor Adorno deserves special mention in this history. In a moving afterword to their monumental work *Dialectic of Enlightenment*, Adorno and Max Horkheimer speculate about the "genesis of stupidity" in the context of evolution and its material constraints. A condition to which all life forms are prey, stupidity is conceived not as an innate mental feature but as a sign of evolutionary frailty—an enterprising journey curtailed, a venturesome curiosity shrinking back out of fear, or a blind spot marking where hope came to a halt. In *Minima Moralia: Reflections from Damaged Life*, Adorno deems the very cleverness of Adolf Hitler as the mainspring of the dictator's stupidity. He characterizes stupidity as a force of vengeance, leading to the paralysis of intellectual faculties, both in the physiological and social senses of the term.[55] To read very far in Adorno is to wonder whether any form of class aspiration or aesthetic production is immune to the charge of naivete. However, even scholars who are sympathetic to Adorno have doubted whether he is inoculated against his own terms of judgment. The critic Joseph Litvak, in *Strange Gourmets*, asserts that Adorno's brand of sophistication is itself steeped in naivete, in writings that rehearse forms and forces drawn from childhood. The term "sophisticatedly naive critic" finds a place in Litvak's discourse, and makes the project of separating the camps of naivete and sophistication all the more problematic. The only thing lacking in Litvak's analysis is a codicil declaring that his research, too, will someday be exposed as naive.[56] At this point it is well to recall the words of Geoffrey Hartman. Writing about the combination of boyish wonder and mature moral will in the work of Dr. Samuel Johnson, Hartman admits that "all art, indeed all culture, tested against an absolute standard or 'scripture,' could be made to appear puerile."[57]

Can a position avoid being naive about its own naivete? Wayne Koestenbaum offers a possible solution to this impasse: be the first rather than the last person on your block to admit that you are a naive critic. Moments interspersed in his book on opera and homosexuality, *The Queen's Throat*, might be drawn together into a kind of naif manifesto.[58] He writes,

> I don't care about understanding; I want to be pleased . . . (185). I have sacrificed objectivity. In its place, I give you objectivity's opposite: gush, abandon, naïveté (198). . . . I, who possess no special knowledge of music, have blurted out, in public, my experience of living inside a modern queer identity—just my own experience, not everyone's; I've dared to narrow the commonwealth down to my own body, and I've pinned these private, nonuniversal intimations of "queerness" onto opera arias that put me in a trance (240).

At first glance this may appear as a redoubtable critical position: indisputable testimony from a naive-generative subject. However beguiling this stance and the author's style might be, habitual readers of Koestenbaum's work may note that it sacrifices not only objectivity but also possibilities of vigorous critical opposition and circumspect clarity. To exalt "gush, abandon, naïveté" is to forswear or close off other qualities, such as forbearance, moderation, analytical rigor, and credible moments of indignation. While these qualities are not wholly lacking in his writings, they seem neglected in an almost studious way. As these qualities are also characteristically absent from Warhol's repertoire, it is both intriguing and somewhat dismaying to learn that Koestenbaum was given the task of writing a biography of the artist. The resulting volume presents a self-proclaimed naif-critic celebrating the life of a self-proclaimed naif-artist. It's a marvelous ride, but you can't help wondering how it might play on terra firma.[59]

Perceptive readers will have noted the preponderantly male cast of fools and naifs listed thus far. They will also have observed that Welsford's study about the fool concerns *his* social and literary history, not hers. That women are largely ostracized from this official history suggests it is not only knowledge that is gendered, but naivete as well.[60] Note the connotative shift: "What that *woman* doesn't know could fill volumes." The statement's sexist overtones allude to a history of unequal gender positions in intellectual, social, marital, legal, and profes-

sional institutions. A brief foray into this region might look at hetero-sexual teenage dating habits. It would hardly take a comprehensive survey to determine which group, females or males, more often found it necessary to play dumb on a date. Combine this reality with the one referenced in a line attributed to the late actor Yul Brynner: "Girls have an unfair advantage over men: if they can't get what they want by play-ing smart, they can get it by playing dumb."[61] Do teenage females have an advantage in this department because they are smarter than males? because of social codes decreeing that they must not *seem* smarter than males? because playing dumb is deemed nonmasculine? because young men are not gifted enough to pull it off? Which activity takes the greater skill or training, playing smart or playing dumb? The fact that young women are both permitted and expected to play dumb around a less intelligent boyfriend, and are still obliged to help him with his home-work, is only one of the sexual double-standards women have had to negotiate in this arena.

The issue of gender and naivete finds special application in the art world of the early 1960s. As a male naif trying to enter an arena domi-nated by abstract expressionist displays of swagger and machismo, Warhol was fortunate enough to make his artistic presence known in the first place; for women the terrain was largely prohibited, whether they were cultivating naivete or not. Naif-tricksterism as a progressive role was unavailable to women artists until well after the advent of femi-nism. Lynda Benglis's work in the early seventies is a significant pioneer-ing effort. More recent examples include the work of Laurie Anderson, Sherrie Levine, Jenny Holzer, Barbara Kruger, and Cindy Sherman. A full mass-media history would need to consider the alternatively coded performances of women such as Gracie Allen, Marian Jordan (of *Fib-ber McGee and Molly*), Judy Holliday (*Born Yesterday*), Marilyn Mon-roe, Lucille Ball, Jean Stapleton, Carol Burnett, Lily Tomlin, Gilda Radner, and Sarah Michelle Gellar (*Buffy the Vampire Slayer*).

Nor is the issue of naivete less vexed if one opens up questions of race and ethnicity: "What that (black man/Hispanic/Pole/Italian/Mexi-can/native American/immigrant) doesn't know could fill volumes." One indication of what Warhol didn't know in this regard was noted by the activist Angela Davis, who pointed out that his painting *Red Race Riot* does not in fact depict a riot but rather "an attack by southern police-men and their dogs against nonviolent civil rights demonstrators in Birmingham."[62] The magnitude of Warhol's racial unawareness is further glimpsed in his interactions with the graffiti artist and painter Jean-Michel Basquiat. Born to a Puerto Rican mother and Haitian father,

Basquiat has been described as the "wild child of neo-expressionism." He and Warhol were separated by race, sexual orientation, and more than three decades in age. They collaborated on a show that opened in autumn 1985, and whose publicity featured an image of Warhol and Basquiat playfully duking it out in boxing attire and gloves. However, the theme of dueling naivete emerged well before the two artists met. Basquiat idolized Warhol from at least age seventeen, years before they were formally introduced.[63] He tried to arrange a meeting with the older artist, much as a younger Warhol had tried to gain audience with Truman Capote. Warhol rebuffed Basquiat's attempts, apparently out of fear that the dreadlocked and pot-smoking younger artist might mug him.[64] Even after they established closer relations, Warhol's reactions to the younger artist ran through a litany of racial stereotypes, as he recorded impressions in his diaries about Basquiat's body odor, penis size, grooming habits, and overall cleanliness. Warhol played matchmaker between Basquiat and an *Interview* magazine assistant, Paige Powell, but then expressed incredulity that Powell might agree to sleep with him.[65] Although such anecdotes can only hint at the real stakes involved, and do not account for Warhol's more tolerant and magnanimous moments, they do provide a kind of wake-up call about some of the racial attitudes he harbored. In spite of his being "too" white, his skin color did help to offset his more problematic class and gender status. Whiteness was a privilege of which he rarely had to take stock, a way of being racially "unmarked" in North America; and it assisted in his remaining fundamentally ignorant about racial otherness, no matter where or how much he traveled in the world.

In a great many respects, however, cultivated naivete is a politically reversible device, adaptable and manipulable to a host of purposes and agendas. It may serve progressive as well as reactionary ends; may reinforce or thwart the order of the day; may delight as well as offend. It may directly strike an intended target, or meander on the way, or miss the mark entirely, or backfire. In many ways Warhol himself provides a running history of the uses of cultivated naivete in postwar America. It expedites his raids on the Establishment in the sixties as well as his courting of the conservative wealthy in the seventies and eighties. It gives him a protective "cover" both when he produces films about drag queens, hustlers, and drug addicts, and when he crosses a picket line protesting torture in Iran to attend a party at the shah's embassy. In his

sixties memoir *Popism*, he speaks of confusing the film censors on one page and terrorizing flower children on the next.[66] Often in his career the same seemingly naive action will provoke both friend and foe, both the Left and the Right, both status quo and counterculture.

One of his central provocations, though, is that he does *not* perform according to our received sense of how naifs should behave. At an allegorical level he has managed to turn the story of the Emperor's New Clothes into a joke upon the expectations of the emperor's subjects. Accordingly, we would do well to consider where those expectations were fostered, and by what process they have been betrayed.

In *The Reign of Wonder: Naivety and Reality in American Literature* (1965), Tony Tanner establishes the stance of naivete as a characteristic fascination of American authors from the Transcendentalists to the early twentieth century.[67] Tanner examines how authors in the New World, building on the Romanticists' ideal of the naive or innocent eye and its enhanced capacity for wonder, forged a uniquely far-ranging and definitively American literary devotion to the naive vision. Even a cursory glance at this tradition reveals a measure of its fecund variety: it is witnessed in Emerson's fancying himself as a "transparent eyeball," and encouraging others to learn to "wonder at the usual" (45); in Thoreau's declaring that reality is "fabulous," and lamenting that he was not as wise as the day he was born (51); in Whitman's unselfconscious empathy for his subjects, his putting himself on a level with "roughs and little children" (84), his celebration of illiterates and the uneducated; in Twain's vernacular child-narrators, especially Huck Finn, seen in perpetual uncomprehending flight from the forces of "sivilization"; in Gertrude Stein's attempts to represent a form of unfiltered reality, of "seeing without remembering, without associating, without thinking" (191); and in Henry James's candid, wide-eyed New England heroines' attempts to brave their way amid the perplexities of European culture. In an afterword, Tanner examines limitations of the naive vision, concluding that "wonder" as an exclusive response is impoverishing; that it is not always distinguishable from late romantic sentimentality (355); and that mind and intellect are too often cast as the villains in U.S. literature (359). Elaborating on F. Scott Fitzgerald's remark that the lives of American writers have no second acts, he laments what he sees as halted development among the nation's literary practitioners. Similar plaints are heard in volumes such as Leslie Fiedler's *An End to Innocence* (1955) and Norman Mailer's *Cannibals and Christians* (1966), as well as in works about the more general issue of U.S. anti-intellectualism. Despite its closing admonitions, Tanner's study effectively relo-

cates the notion of American naivete from the realm of stereotype to that of archetype.

One of the historical ironies arising from the book, not overtly remarked by Tanner, is the ideological distance separating Twain and James, in spite of their being near-contemporaries. Twain's picaresque *The Innocents Abroad* (1869) may be seen as a characteristically premodernist outworking of the theme of the naive cross-cultural encounter. James's treatment of this theme in *The Portrait of a Lady* (1881) epitomizes the more vexed and recondite concerns of the high modernists. Twain's American bumpkins emerge cheerfully unscathed from their scrapes with sundry guides, coachmen, and merchants encountered during their defoliating tour of the Continent. By contrast, James's ingenue Isabel Archer finds herself, after a promising flurry of eligible suitors, further and further immured in an expatriate married existence she is powerless to understand or control. If we were to look for a postmodernist exemplar in this tradition, we could nominate Isabelle Collin Dufresne, a young society belle who fled her stultifying French-aristocratic origins and eventually became reborn as a Superstar in Warhol's Silver Factory. Blending picaresque and tragic elements in her biography *Famous for Fifteen Minutes: My Years with Andy Warhol* (1988), she chronicles her transformation from a virginal schoolgirl at a strict Catholic convent in rural France to a sixties American celebrity known as Ultra Violet: "Ultra Violet becomes the unleashed exhibitionist, the mad, heedless creature, chasing headlines, totally uninhibited (most of the time), an unabashed freak. She will do anything. At a party in Los Angeles in honor of David Bowie and me, I hold a press conference, reclining in Eve's outfit, my body totally immersed in a bath of milk. That's Ultra in the milk bath, not Isabelle."[68]

To make this transition to the postmodern involves a number of metaphorical leaps—from the genre of fiction to that of self-ironizing, self-promoting auto/biography; from the canonical precincts of Tanner's analysis to a realm that is often extraliterary and even extratextual; and from a domain in which innocence and experience are either comically or tragically opposed to a realm where these elements consolidate in an almost cartoonish or holographic fashion. Such metaphorical leaps are not insignificant, and yet we should not assume prima facie that they are any more radical in their own way than the leap made, for instance, by Samuel Clemens to the persona of Mark Twain; or the leap made by Henry James from the first fifty-five years of his life to the acceptance, at age fifty-six, of his homosexual inclinations.[69] On closer examination we see that none of these transitions

actually qualifies as a leap; instead, they all involve a series of more tentative shuffling or sideways movements. This is true of the transformations Warhol makes as well: the process by which "Andy Warhol" emerges is far from rapid or straightforward; and his seesawing on an issue like sexual identity is an ongoing feature of his life, sometimes occurring within the space of a single utterance. The moniker he adopted as an artist is but a conveniently centralized way of referring to a person who began life as Andrew Warhola and who tried out, or came to be known as, an array of other identities—André Warhola, Andrew Morningstar, Andy Paperbag, Raggedy Andy, Miss Warhol, Drella, the Pope of Pop, and Saint Andrew. At the Factory, his initials also came to stand for "All Witch" and "All Woman."

Without pressing anyone into service as the trustee of an entire episteme, we might still benefit from considering how a meeting of minds among Twain, James, and Warhol might transpire. John Gardner once observed that Mark Twain, if saddled with a cast of characters selected by Henry James, would be quick to maneuver them all into wells.[70] We can far more readily imagine Twain and James making sense of each other—at least knowing *how* to be offended by each other's work and what it represents—than we can imagine either of them making sense of Warhol. What kind of crash course in twentieth-century American history and sensibility would prepare them for a document like the Warhol diaries, for instance? What sense-making capacity could they bring to the diary comment Warhol made, with bland curtness, on seeing his Torso exhibit the day before it opened in Los Angeles, September 23, 1978?: "The show looked good—cocks, cunts, and assholes."[71] How would either author acquire the conceptual framework needed to disentangle the elements of innocence and experience in the diary entry Warhol made one week later? Andy is approached by a group of prostitutes while visiting a New York club on Fifty-fourth Street with his work acquaintance Catherine Guinness, an heir in the Anglo-Irish brewery family:

> And one of the hookers looked at me and said, "Oh my God, oh my God." And then the girls came over and one said, "Oh will you buy me a drink?" And I did—I *(laughs)* didn't know yet that the drinks were $8.50 apiece. And then more girls came and they made me feel really good, like I was straight, and they kept saying to come upstairs, that upstairs was really really really fun. What do you think was up there? Is that where they do it? And the girl told Catherine she would really like it up there, too, she was trying to make Catherine, and I bought drinks for the other girls so that's $3 \times \$8.50$ plus $5 tip ($30.50) and then $8 \times \$8.50$, plus $20 ($88) until

I ran out of money. Then we left and went next door to a gay porno movie. Catherine wanted to see it and it was a glory-hole movie and it was too peculiar and we just stayed for ten minutes (cab $3). (174)

In some ways it will take the length of this study to arrive at an adequate way of reading this passage. The contradictory elements embedded here deserve to be explored more fully: the interweave of self-consciousness and unselfconsciousness, of sophisticated self-humor and unwitting self-disclosure; the sexual fascination/boredom of a man who projected a public image that led many to assume mistakenly that he was asexual; a queer man's childlike excitement about being perceived as straight; and the unscientifically classifiable economics of fame and desire. Warhol's using the words "they made me feel really good, like I was straight," and his planting the suggestion that he had zero interest in a glory-hole movie, provide strong indications of the explosively charged ways that ardent same-sex attraction and prurience coexisted in the artist's psyche with a need to preserve and radiate a prelapsarian, almost golden-boy's-eye-view of human sexuality.

A more classic and accessible example of the artist's naif worldview is found in his 1975 memoir *THE Philosophy of Andy Warhol*, where he offers a program for social maturation considerably decelerated from the norm:

Instead of telling kids very early about the mechanics and nothingness of sex, maybe it would be better to suddenly and very excitingly reveal the details to them when they're forty. You could be walking down the street with a friend who's just turned forty, spill the birds-and-the-bees beans, wait for the initial shock of learning what-goes-where to die down, and then patiently explain the rest. Then suddenly at forty their life would have new meaning. We should really stay babies for much longer than we do, now that we're living so much longer.[72]

This agenda for arrested development and middle-age rejuvenation, like so many of Warhol's other notions, conveys his trademark blend of loopiness and logic. The statement contains perhaps a grain of autobiography—Warhol was shot and nearly killed just two months prior to his *own* fortieth birthday. It also expresses one gay man's oblivious disregard for women's reproductive concerns and the biological clock. (In the same book he says, "When I look around today, the biggest anachronism I see is pregnancy. I just can't believe that people are still pregnant" [118]). More compelling, though, is how it registers the artist's grasp of a universal, if elusive, trend in postwar American life, now come to full fruition with Generation X. His birds-and-bees wisdom may be

Pop Trickster Fool

said to prefigure what a Marxist critic in the late eighties described in more cumbersome language as "the de-Oedipalization of middle-class American life."[73]

Warhol's utterances have a typically quizzical aspect that would understandably baffle not only Twain and James but more contemporary readers as well. Moving from the genres of diary and memoir to that of biography, we locate in Warhol's social manner a mode of behavior that similarly conspires to be amusing, evocative, and bewildering. Tom Hedley, an *Esquire* editor, describes Warhol's encounter with the revered abstract expressionist painter Willem de Kooning during a party in late 1968 hosted by the artist Larry Rivers. Warhol attended with a Factory filmmaker, Paul Morrissey: "Warhol saw . . . de Kooning, made a pilgrimage to him, said, 'Hi, Bill,' and offered his hand. De Kooning was drunk and he suddenly turned to Warhol and said, 'You're a killer of art, you're a killer of beauty, and you're even a killer of laughter. I can't bear your work!' It was a very dramatic, ugly moment, face to face, and became the talk of the party. Andy smiled, turned away, and said to Morrissey, 'Oh, well, I always loved his work.'"[74] The incident raises a number of questions, foremost among them, Who's zooming who? In terms of de Kooning's basic gripe against Warhol, the stakes involved are as much geopolitical as art historical. Given de Kooning's Dutch origins and his classical approach to art, the event plays out like a burlesque form of the clash between European refinement and American-born bumptiousness. At this level, Twain might be tempted to read the incident as an episode of the Innocents Abroad staged in bohemian New York. As Dick Hebdige has said, "In pop . . . Mark Twain and America finally had their revenge on Europe."[75] Pop art was never an exclusively American movement (technically, it began in England in 1956, and then caught on in France); nor has Europe ever truly had a monopoly on refinement; but both sides of the Atlantic have still gotten a huge charge out of subscribing to the caricature version of what divides them. However, the unrefined behavior in this incident belongs to the elder statesman de Kooning, not the upstart Warhol. (They were nearly a quarter-century apart in age.) De Kooning's use of language here is poetically concise, but his manners are ghastly; Warhol, by contrast, carries himself with an aplomb that is almost dapper. The courtesy he extends, both before and after his livelihood is treated with pulverizing rudeness, should help dispel the notion that his famous coolness is merely a matter of hipster detachment. In this instance, it conveys a gracious restraint and tact. This social exchange between two artists is emblematic in ways I will explore further in my chapter on Warhol's relation to

the New York School of painting. But of course it is not really an exchange. Instead, as Strother Martin said in *Cool Hand Luke*, what we've got here is a failure to communicate. Even Twain may not have grasped the moment's full impact. The collision of worlds recalls the surreal climax of Mel Brooks's film *Blazing Saddles*, when a full-scale Western brawl, presumably taking place in a frontier settlement, comes crashing into the Hollywood sound stage where an effete musical number is being filmed.

The Naif in Spite of Himself

The ways in which Warhol disturbs and disrupts traditional notions of cultivated naivete cannot be grasped without recourse to the concept of hybridity—hybridity of role, of sensibility, and of effect. Initially, at least, we seem with Warhol to have entered what Stephen Koch, in *Stargazer: The Life, World, and Films of Andy Warhol*, has called a "region where cynicism and naivety cannot be distinguished."[76] The "contaminated" nature of Warholian naivete obliges us to problematize the "pure" and pathos-invested tradition of the Romantic and neo-Romantic naif. Theorists have customarily formulated cultivated naivete in terms of the temporary halting or reversal of a linear progress narrative. An aura of nostalgia, of the remembrance of things precivilized, adheres both to the Rousseauist cult of the noble savage epitomized in *Émile*, and to the Wordsworthian cult of the child epitomized in "Intimations Ode." Friedrich Schiller, whose essay *On the Naive and Sentimental in Literature* (1795–96) served as a foundational document to the Romantic movements first in Germany and then in England, posits the naif as an embodiment or repository of the pastoral.[77] In his view a modern human may "regain" naivete, or lost simplicity, solely by way of the "sentimental" or speculative. For Schiller, naive literature arises as a "*favour from nature*" (67) and expresses the poetic concept of pastoral innocence. The author's correspondence indicates that the essay arose out of his sense of belatedness before the "noble" example of antiquity, the unbridgeable distance he felt separating him from the spirit of ancient Greek literature (12).

Reflecting and promoting this impulse, the history of naive characters since Romanticism, from Little Girl Lost to Forrest Gump, is saturated in a similarly conservationist and implicitly condescending attitude toward the past. Authors cast the naif as a stand-in for a previous, less "corrupted" state of historical or psychological development. The endearing naif invites those who are more "advanced" to meditate and

mourn over what has been lost in the interim. An enforced nostalgia emerges, in which conservation blends into conservatism; readers and viewers are openly invited to wallow in the discrepancy between a utopian past and a dystopian present. Literary naifs, "cultivated" by their authors, often then serve as handy didactic paragons, unwittingly revealing the injustices of a system devised and perpetuated by those who embody the very qualities the naif lacks—urbane sophistication, adult maturity, normal cognitive development. The naif's best ammunition against the system in which she or he is pitched is the sheer ability not to understand it. Thus William Blake's hapless chimney sweeps argue eloquently (in spite of their speech impediments) against child labor laws, and Harriet Beecher Stowe's Little Eva propounds her case against the institution of slavery.

Warhol provides a potential antidote or revision to this nostalgic and patronizing legacy. In his case we cannot separate the naive subject from the "cultivated" author, as we can in the relation of Shakespeare to King Lear's Fool, or of Wordsworth to the Idiot Boy, for instance. We're obliged to suspend our traditional notions of authorship and subjectivity, and of mastery and naif-erie, as we approach him. In almost every way he plays against type: in his urbanity and queerness, his callous opportunism in relation to celebrities and the media, his remoteness and apparent lack of affect, and his relying during the sixties on a retinue of "crazy, druggy people" to facilitate and inspire his work.[78] Certain notorious Warholisms reveal a side that is jarringly out of keeping with commonly received notions of naif behavior: for instance, his remark about wishing that Freddie Herko, a Factory denizen, had announced beforehand his plans to leap out of a fourth-floor window so that the event could have been captured on film.[79] Remarks like this, although one can hardly applaud them, nonetheless prove useful in isolating the Warholian strain of naivete from Romantic and Victorian varieties still operative in the present. In a sense, it *is* Romantic to have wanted to capture Herko's last moments on film; but not in a way that we usually associate with the authors of "Tintern Abbey" or *Sorrows of Young Werther.* At the same time, behavioral scientists have long recognized sadism as an ordinary component of *puer* psychology. Discovering a streak of cruelty in Warhol's biography should be no more unexpected than finding a similar streak in the life of J. M. Barrie, for instance, the late-Victorian author of *Peter Pan.* Such instances might be used toward a new understanding of the consequences of artificially prolonging or inducing naivete as a human trait.

A related complication is Warhol's predilection for all things abject,

scatological, and pornographic. Perhaps the region Stephen Koch alludes to is marked less by cynicism than perversity. The film *Blow Job* and the statement "cocks, cunts, and assholes" are merely two entries in a long, scandalous parade that includes the viscerally graphic *Death and Disaster* series (1962–63), as well as urine and semen on canvas (1978), and films such as *Taylor Mead's Ass* (1964), *Suicide* (1965), *Bitch* (1965), *Eating Too Fast* (aka *Blow Job #2*) (1966), **** (1966), *Nude Restaurant* (1967), and *Blue Movie* (aka *Fuck*) (1968). Warhol's first taste of artistic notoriety came at age twenty when his autobiographical painting *The Broad Gave Me My Face, But I Can Pick My Own Nose* was rejected from a juried exhibition in Pittsburgh. In the last decade of his life, *The Andy Warhol Diaries* chart, among other things, his recurrent interest in body odor and bad breath, acne, foot fetishism, exhibitionism, the size and visibility of people's genitalia, and who's copulating with whom. Warhol clearly cannot be added like an appendix to any purified or sublime tradition of the naif, in spite of the attempts people have made to do so—the soft-focus fairytale and "holy fool" analogies forwarded by John Richardson and others.

Warhol's devotion to the abject comes encrypted through his ethnic background, class coordinates, and sexual identity. His parents both came from farming families, and grew up in a remote village in the Carpatho-Rusyn region of northeastern Slovakia—a brutally impoverished area with an outlook that has changed little since medieval times. Speaking a strange Hungarian-Ukranian dialect in their working-class neighborhood in industrial Pittsburgh, the Warhola family was seen as inferior even within their "Hunkie" eastern-European immigrant ghetto. Andy was the sensitive sissy of the family, picked on inside as well as outside of the house. The misery potential for this aesthetically gifted queer boy, growing up in the early years of the Depression, is difficult to fathom. Small wonder, then, that the abject becomes so integral to his later livelihood. Throughout his career he stages social and artistic revolts against the conditions of his upbringing. They are part of an underclass boy's need to disabuse polite society of its niceties and pretenses, and of a developing queer sensibility's need to flout the codes of Puritanism and heterosexuality.

The very phrase "devotion to the abject" also stands as an oxymoronic reflection of his religious upbringing. His father insisted that the family walk several miles each Sunday to ninety-minute mass services at a Byzantine Catholic church.[80] The sanctuary in Pittsburgh was laden with religious icons, and in Manhattan, Andy's devout mother, Julia, displayed crucifixes in the apartment she shared with her son.

Warhol never disavowed Catholicism, but he was not among its more pious adherents. Its practices filtered through to him both directly and by way of antithesis. That Warhol made his pop art debut by promoting the iconic value of *secular* images needs to be seen not only as a puckish artist's revolt against the church-going habits and Catholic symbolism of his childhood, but also as the revolt of a still-practicing Catholic against the iconoclastic, antipapal side of Protestantism. His being dubbed "the Pope of Pop" reflects these tendencies, as well as the fact that many of his closest Factory associates came from Catholic backgrounds. In terms that Mircea Eliade would have appreciated, profane and sacred elements in Warhol's career may not be fully sundered.

So also with the terms of focus in this study: Warhol's preoccupation with the abject provides further evidence that his naivete is indissolubly allied with his tricksterism. In an expansive study, *Trickster Makes This World: Mischief, Myth, and Art* (1998), Lewis Hyde posits shamelessness and a "great attraction to dirt" as concomitants of the trickster's role as a creator of culture.[81] Hyde devotes considerable attention to the role of "dirt work" in trickster mythology, basing his analysis on definitions found in Mary Douglas's *Purity and Danger:* "Dirt is matter out of place"; "dirt is the anomalous, not just what is out of place but what has no place at all when we are done making sense of our world" (176). Such definitions prompt us to expand our notion of Warhol's "dirt *oeuvre*" to include the profaning of various *contexts:* his emblazoning brand-name logos in a space reserved for high art; his asking moviegoers to watch a man nibbling on a mushroom for forty-five minutes (*Eat*, 1963); his preserving unedited sessions of gossip in print-based media; and his providing in a book of "philosophy" a detailed account of a shopping expedition in search of underwear.

"Dirt work" might also help to account for the ways Warhol profanes ideology. His ruses, as we saw earlier, might be seen as summarily refuting the tenets of modernism, with depth deposed by surface, aura by mechanism, uniqueness by repetition, and so on. Such reversals can lead to great confusion and chaos, but they also have a potentially tonic effect. They find historical precedent in celebrations such as the Feast of Fools and the Feast of the Ass in medieval Europe. During the extravagantly burlesque Feast of Fools, slaves and serving-maids were put on equal footing with their masters. Underlings in the Catholic clergy performed—and often blasphemously parodied—the duties of their superiors. The Feast of the Ass reversed human and animal functions: an ass (representing the lowly beast of burden that Christ rode on Palm Sunday) was led into the church and given honored treatment while the

priest and congregation all brayed like donkeys. This temporary over-turning of values and hierarchies was sanctioned by the Catholic Church, and persisted even after being suppressed in the fifteenth century. In broad terms, Andy Warhol might be seen as a latter-day incarnation of the Lord of Misrule who presided over such events; and postmodernism might be seen as an ideologically based Feast of Fools revolt against, or reprieve from, the hallowed rituals of modernism.

Hyde argues that dirt work, in being unaccompanied by shame, gives the trickster certain resemblances to the psychopath: "While they are often smart, [the trickster and the psychopath] have a sort of 'rudderless intelligence,' responding to situations as they arise but unable to formulate any coherent, sustainable long-term plan. They are masters of the empty gesture, and have a glib facility with language, stripping words of the glue that normally connects them to feeling and morality" (158). The passage could serve as a précis of what people find most disturbing about Warhol: his seeming incoherence, quick-fix solutions, social and artistic opportunism; his gestural emptiness, glibness, unfeelingness, and amorality; as well as the apparently rudderless way he moves among images (electric chair, Brillo Box, flower, cow, self-portrait, Chairman Mao, dollar sign, skull) and occupations (silkscreener, partygoer, art collector, diarist), as if he were channel-surfing. Turning his ethos into a sustainable social agenda may sound like proposing the Feast of Fools as a steady diet. To many observers, Warhol's entire career presages psychopathological trends in American culture at large. Hyde, however, points out that the trickster performs creative, mythic, sacred, heroic, life-sustaining, and mediatory functions of which the psychopath is incapable. Further, he speculates that the associative leap connecting the two characters may actually be "a defense against the anxiety that trickster's methods can produce" (158–59). Whether the creative and mythic functions Warhol performed outweigh the more disturbing aspects of his legacy, and to what degree our own responses to him may still be based in anxiety and defensiveness—these, like so many other questions raised by his career, remain open to debate.

Coming Out Naive

The Warholian hybrid also thwarts attempts at ascribing intentionality. Is his brand of naivete primarily self-conscious or unselfconscious, willed or unwilled, strategic or unpremeditated? Biographical details range across a host of behaviorisms and guises that resist definitive classification or interpretation. Even as early as his Carnegie Tech years,

he is described as having "the damnedest mixture of the six-year-old child and, yet, all the skills of a well-trained artist."[82] Questions of how smart or mature he was, what he knew or didn't know, are overlaid on a grid of contradictions that make a biographer's task both enticing and maddening. In spite of his trend-setting chic and penchant for drag queens and the bohemian fringe, he lived with his mother and regularly attended Catholic mass. In spite of his shyness, he craved the limelight and asked scores of men to pose naked for him. In spite of his cool demeanor and his phobia about being touched, he seems to have feared solitude almost as much as he feared death. In spite of his incorporating ephemera in his art and espousing fifteen minutes of fame, he spent years accumulating a Tutankhamen-like fortress of possessions. In spite of his making films that flouted every convention of mainstream movies, he remained frustrated and baffled that he didn't catch the attention of Hollywood. His life story invites comparison to numerous myths about triumph over humble beginnings (Horatio Alger, Cinderella, the Ugly Duckling, the stone the workmen rejected), and yet to many his career represents the height of crass opportunism, decadence, blind insensitivity, and unmourned loss. To use the terms of Eve Sedgwick, Warhol deploys "multiple kinds of knowledge and an associated plurality of ignorances." We are thus well advised, in Sedgwick's words, to "give up the sentimental requirement of finding a unitary epistemological field" as we approach him.[83]

As a provisional way of navigating this non-unitary field, I proceed on the conviction that Warhol's naif-trickster mode is manifest not as an occasional role or mask that the artist "put on" or "took off" as would an actor, but in terms of a presiding orientation. The concept of orientation holds particular currency in queer practice and theory, where sexual orientation is discussed as a complex interplay among factors such as genetic predisposition, social conditioning, and self-conscious decision. In this context Warhol might be said to "come out" as a naif in the early 1960s. Although Warhol's naif persona may be glimpsed at earlier points in his life, it takes on a new edge of assertiveness, acquires the feel of a patented modus vivendi in the year following his first pop exhibits in the summer and fall of 1962. A host of factors impinge on this transition: Warhol's ingrained reticence combined with his shrewd ambition; his having undergone a period of intense experimentation in terms of personal style, looking for ways of updating the "Raggedy Andy" image of his commercial art days; the interest and notoriety generated by his first exhibits; and the pressures of newly acquired art-world fame and social prominence. The circumstances of internal and

external demand converge in such a way as to produce the official public persona that Warhol would maintain and modify for the remainder of his life.

The analogy of coming out is not arbitrarily chosen. Warhol's naif-trickster persona represents an outstanding case study in queer performativity. Although scholars have developed this field most fully in the past decade, their work owes a considerable debt to two classic studies by Erving Goffman: *Stigma: Notes on the Management of Spoiled Identity* (1948) and *The Presentation of Self in Everyday Life* (1959).[84] Among the key concepts in the first volume, Goffman speaks of how the effects of a stigma may be potentially reversed through the use of "disidentifiers." He uses the example of someone in a train station who can overcome the appearance of being a loiterer or vagrant through the mere act of reading a newspaper, thus using a "prestige symbol" to counteract the effects of a "stigma symbol" (44). The act of disidentification is by no means infallible, however. The strategy may falter, or bring unwanted consequences of its own; it may leave the root problem unaffected, or even make the problem harder to address. The vagrant in Goffman's analogy may have arrived at a short-term solution, but not one that addresses a more endemic problem: that of living in poverty in a society that shames poverty. Goffman mainly addresses the social and psychological import of disidentification, where subsequent critics have focused on its political and ideological aspects.[85]

Merely having a stigma is not sufficient to having a "spoiled" identity; one must live among people for whom the stigma holds value, and who can perform both overt and covert acts of stigmatization. The notion of stigma and spoiled identity as being *performed* suggests a close link with the themes of Goffman's later volume. *The Presentation of Self in Everyday Life* explores ideas such as the distinction between governable and ungovernable aspects of expressive behavior (7); the distinction between sincere and cynical performance (18); the process of audience mystification (67); and the arts of impression management (208). The titles of Goffman's studies might be cross-linked as a way of describing the lifelong burden Warhol was required to bear: the presentation of spoiled identity in everyday life.

Such a burden might be seen as endemic to the human condition, but it has special application for a man with Warhol's traits and background. The social persona he arrives at in his early to mid-thirties (hipster naif with dark glasses and silver wig) provides him with a way of persuasively disidentifying himself in the public's eye from a variety of stigmas (pale, balding, unattractive, homosexual, born to a working-class

immigrant family at the start of the Depression). We can only imagine what his life might have looked like had he been born in a society where being the gay son of a semi-employed coal-miner/construction worker (who died when Andy was thirteen) did not carry the burden of various stigmas. That he did carry such stigmas meant he needed to draw on extraordinary powers of self-reinvention if his other artistic gifts were ever to reach their full potential. Even apart from these other gifts and achievements, the nature of his self-reinvention, and the extent of the stigmas he had to overcome, qualify as uniquely promising subjects of inquiry.

At the same time, it is not possible fully to isolate the effects of the stigmas he bore. For instance, Warhol was extremely distressed when someone at a book-signing event suddenly grabbed his wig and ran off with it.[86] Only a shortsighted view would interpret this episode, and its aftermath in his diaries, strictly in terms of his feelings about being bald. His ways of responding to the stigma against homosexuality are even more deeply woven into the fabric of his being. His queerness is not separable from any of the symbols associated with him, either of stigma or of prestige; they are part and parcel of his class coordinates, his art, his public manner, his social life, his business ventures, and his outlook on the world. Recent work on queer performativity has taken pains to show that the effects of stigma are ongoing and irremovable.[87] Homosexual subjects may appear to fully reinvent themselves, may be able to transvalue stigma, may locate communities where the stigma symbol itself is promoted into a prestige symbol; but they can never become individuals whose present lives are unconditioned by, unlettered in, or fully quarantined against, queer stigma. Just as Warhol carried resentment for years about having been threatened with expulsion from Carnegie Tech, and this resentment informs his performance as a conscious fool; just as he overcame poverty but never overcame his fear of poverty; so also his hero's journey through a brutalizing queer childhood leaves him with introjected material that prevents the possibility of a full recovery, even as it spurs him toward artistic achievements the world may never otherwise have seen.

Warhol is like a man who miraculously survives a shipwreck: upon his return to dry land and civilization, a strange decree forces him to reclaim a load of flotsam and jetsam from the accident and keep it as a permanent token of his voyage. In the ensuing years he's able to fashion much of it into artistic souvenirs, which bring him great renown. However, much of the load remains an encumbrance that's never entirely accounted for. The shipwreck in this story cannot be reduced to

signifying "homosexuality" or "working-class poverty" alone; nor do the natural causes of a seagoing catastrophe easily translate to a grid of the human factors involved. But the analogy still may help suggest what Warhol faced from an early age, and how it continued to structure and affect, even if not fully determine, his later behavior.

Warhol's naif persona is a significantly stabilizing force in this aftermath, particularly as it inflects same-sex desire. Andy's presenting himself as a naif may be seen as a cunning, ambiguous alternative to coming out as a gay man. Although "coming out" (either as a speech act or as an ongoing self-affirmed orientation) cannot be expected of a man with Warhol's background, and would have been seen at any rate as gratuitous and declassé in the circles he traveled in, and among cognoscenti who saw his movies, he still needed a means of preventing homosexuality from gaining too much ascendancy in his public perception. As my second chapter argues, Warhol's steadfastly maintained "swish" naif performance works simultaneously to identify and disidentify him as a gay man, in ways that are no less relevant today, despite outward changes in the political terrain. He validated alternative sexuality in audacious ways that are still coming to light after his death; and the persona that helped him achieve such validation also provided him with ways of retreating into caution, silence, and a logic marked by homophobia. Such ambivalences underscore the reversible, trans-ideological nature of cultivated naivete. Moreover, they compel further discussion of the potential affinities and antagonisms of queerness and naivete as they appear on a stage setting in which gender and epistemology are irremediably troubled.[88]

Subsequent chapters examine the complex reception history surrounding Warhol's naif-trickster performance—why it has captivated us for so long, and how this captivation has changed us. In chapter 3 I show how the search for Warhol's brain—still inconclusive after a half-century of speculation—has expanded to become a matter of pressing cultural and philosophical inquiry. In ways that both include and surpass Warhol's biography, we continue to be held in thrall to his sustained parody of the kinds of mental gestures that have acquired certification under the modernist reign of *cogito* and *gravitas*.

Chapter 4 examines the impact of Warhol's career by looking at forms of mimicry it has spawned in the culture at large. Practices that seemed enterprising in the Warhol sixties have by now become integrated into the texture of contemporary life. Self-conscious, mocking forms of naivete enjoy unparalleled popularity in today's mass media. Warhol's contribution to this state of affairs may be seen most conspicuously in

his promotion of camp taste. I describe camp as a playful form of in-
duced naivete—a sort of advanced building-block sensibility that in-
volves a cheerful insouciance toward officially imputed meanings. It is
the rich contradictions of camp taste—its being sophisticated and na-
ive, invigorating and decadent, both an esoteric minority code and a
newly exploited cable-access diversion—that make it an effective fo-
cal point for surveying the paradoxical nature of Warhol's legacy.

Between chapters 3 and 4 I present a creative "Open Forum" sec-
tion that offers still further evidence of the far-ranging influence and
paradoxical nature of this legacy. The materials assembled here are de-
signed as a synoptic history of the debate over Warhol—or as much of
it as can be alluded to in a reasonably coherent verbal format. The
forum suggests how diverse and contentious this debate continues to
be, and how closely aligned it is with numerous still-unresolved issues
from the sixties. It may serve as a primer for those less acquainted with
the discussion in progress; as a refresher for those who have followed
it in other contexts; and as a springboard for those who wish to pur-
sue further research.

Put-On/Takeoff

Looking back on his career, Warhol referred to his public persona as a
cartoon-like act that he had managed to keep up for twenty-five years.
He also remarked, "Sometimes it's so great to get home and take off my
Andy suit."[89] His 1975 *Philosophy* book opens with a section titled "B
and I: How Andy Puts His Warhol On." These statements hold an un-
usual intrigue in light of the fact that Warhol was especially *ungifted*
in the traditional thespic arts. His brief theatrical foray in the 1950s
showed that he was an abysmal line-reader, that he was unable to
"project" if a part required imaginative skill, and that he was constitu-
tionally unsuited for a life on the stage. In commercial appearances as
a celebrity he would repeatedly flub the one or two lines he had to re-
member.[90] He was not even able to portray "himself" very convincingly
on camera, as his 1985 guest appearance on the television series *The
Love Boat* demonstrates. His costar in the episode, Marion Ross, recalls
having teased Andy at the time of filming: "I told [Warhol], 'Oh, you're
such a terrible actor.' He really needed to have his hand held."[91] For
psychological as well as practical reasons, Warhol could not have sus-
tained his "cartoon act" as well and as long as he did if the part had
required skilled acting. In arriving at his queer/naif persona he had
managed not to suspend but to *exaggerate* certain existing traits. In his

memoir *Popism*, he recalls how in the early sixties his lightweight, "swish" public persona came as an outgrowth both of given predilection and of his desire to provide a reverse caricature of the "tough," "macho" stances of the abstract expressionists. Warhol says, "I certainly wasn't a butch kind of guy by nature, but I must admit, I went out of my way to play up the other extreme."[92] Warhol was able to "play up" this other extreme precisely because it did *not* take him out of his way. As he implies, it was already in his "nature," or, to use less essentialist language, it preserved and extended familiar patterns of behavior.

Still, his expressing relief at "taking off the Andy suit" indicates that it must also have been confining, or have grown that way over time. Bob Colacello, one of his business associates in the seventies and eighties, describes two sides of Warhol—one side "wistful, touching, unhappy, and smart," revealed in private moments, the other side "cool, coy, campy, and dumb," which he brought out at more public moments, especially when reporters were near.[93] What Colacello saw as the unhappiness behind the campiness, and the smartness behind the dumbness, is unusually relevant to this study. I think that Colacello oversimplifies the case by calling these the "real" and "fake" Warhols; and that the "Andy suit" Warhol himself refers to cannot have been removed as easily or completely as he implies. Colacello's insight seems not to support a case for Warhol's being fully duplicitous or Janus-faced, but to his having created a persona that enabled him in some respects and disabled him in others. There must have been times when the Andy suit felt like a straitjacket; however, it was a *designer* straitjacket, one that took a long time to customize, and one not easily discarded. As much as an "act" sustained over twenty-five years takes on a life of its own, and becomes consolidated with one's overall mode of being, it still needs to be seen as at least partly constructed and contrived. To a certain degree Warhol may have gotten his wish about wanting to be a machine. I suspect that some of the unhappiness Colacello perceived in Warhol stemmed directly from the persona he was expected to exhibit in public, even when it was a drag in every sense of the term.

To emphasize the terms "persona" and "performance" over ones such as "psyche" or "syndrome" is to shift the balance toward a social portrait rather than a clinical one. In one chapter of *Stargazer*, Stephen Koch speaks in poetic, almost mystical terms about the trait of masculine narcissism as it is inflected through what he calls "the politics of Warhol's experience."[94] That he makes almost no direct reference to Warhol's lived experience in the chapter, and that his chosen focus and his method of treating it are not fully aligned, may be seen as virtues

rather than faults. To treat Warhol's life as a scientific case study of the narcissistic personality type would be a disservice, partly because he is so much more interesting than most narcissists. The same might be said of his tendencies as a voyeurist or dandy, terms that also enter Koch's analysis.

Thus it is with some trepidation that I select an alternate way of imprisoning the artist and filmmaker. It would be inadvisable to pretend that the "real" Warhol could ever be fully located within the discourse of a single trope or angle of focus—whether of narcissism, voyeurism, naivete, tricksterism, popism, postmodernism, queerness, Depression-era poverty, Ruthenian Catholicism, Carpatho-Rus ethnicity, or the like. As Lewis Hyde writes, "'Trickster' is abstraction enough, already distanced from particular embodiments like Hermes and Coyote. Actual individuals are always more complicated than the archetype."[95] Douglas Crimp has written that "no categorical statement will do justice to Warhol's range."[96] Even to invoke the trickster and fool and their extensive histories, to allude to Warhol as a latter-day Lord of Misrule or "dirt worker," to call his career an inverted allegory of the Emperor's New Clothes, is to encourage a figurative appropriation of Warhol that will inevitably misrepresent him. Such tropes are useful only to the degree that they may approximate the roles he has performed. It's not easy to invoke and deconstruct them at the same time, but this is also part of why *he* invoked various roles: for the very fact that they *would* misrepresent him, and keep a more private self guarded.

In concentrating on Warhol's naif-tricksterism I do not wish to occlude other facets of his career, but to draw attention to one of its unusually promising points of entry—one that has been as conspicuously overlooked in previous writings as his queerness. Just as the book *Pop Out: Queer Warhol* asks that we look not only at the queer Andy but at the legacy of what Simon Watney calls "obliterative homophobia" in Warhol criticism, so also am I asking that we look not only at the naive Andy but at the naive-phobic legacy of Warhol criticism and of general intellectual practice.[97] (Calvin Tompkins says that an art critic once scolded him for writing uncritically about contemporary artists. The message Tomkins took was, "If you can't bring some intellectual heavy artillery to bear on these imbeciles . . . then stay off the range.")[98] Critics rarely find a convincing way of accounting for the gaping distance between their own savantist practices and the naivist world Andy inhabited. The term "faux-naivete," mentioned earlier, attempts to cover over this distance by hastily repackaging as inauthentic, misleading, and epiphenomenal the problematic and "illogical" realm of na-

ivete. Such thinking betrays not sophistication but rather insecurity and defensiveness. One of the present study's objectives is to discover what has been lost in and through the "rationalization" of our phobic responses to naivete.

Ingenuous Affairs

Let me conclude this introductory chapter, then, on a housekeeping note intended to shed light on, or lighten up, the stakes involved in employing cultivated words and ideas while pursuing the topic of naivete. An author trying to examine and classify naivete inevitably becomes a comic figure—not unlike Melville's Ishmael, taking on the whiteness of the whale, while cravenly needing to hold up a white flag instead. However, there are far more prevalent forms of comedy waged by people who should be smart enough to know better than to do so. Show me a woman or man whose every thought and gesture is refined, informed, rarefied, advanced, acculturated, complex, and I will run for my life in the opposite direction. The fact that a preponderance of those of us who choose to spend otherwise useful hours of the day furthering the goals of intellectual endeavor seem to feel the necessity of comporting ourselves as if our every thought and gesture were refined, informed, rarefied, and so on, only demonstrates how far we have *not* come toward recognizing what Christa Wolf has called "the sense and nonsense of being naive."[99] That we maintain this simplemindedly erudite facade in professional settings while hypocritically carrying on clandestine and therapeutically ingenuous affairs with a thousand extracurricular muses—in the form of taste buds, houseplants, children, animals, popular music, county fairs, genitalia, electronic mail—further exacerbates the problem. Some of us, like the computer Hal in Stanley Kubrick's *2001: A Space Odyssey*, behave as if we would only permit the glimpse of a naive side when faced with the imminent threat of a neural meltdown. In the process of being unplugged, Hal begins singing a song he was taught after he was first assembled. The disarming lyrics come out in an increasingly guttural and enervated voice: "Daisy, Daisy, tell me your answer, do. I'm half . . . crazy, . . . all for the . . . love . . . of . . . you" Perhaps the song emerges because Hal is losing higher brain functions and regressing; or perhaps it's a last, desperate effort, born of his instinct for survival, to break down the resistance of his nemesis, the astronaut Dave. Music, after all, hath charms that Hal's ordinary data-output lacks. Somewhere in his wiring, Hal registers that Dave was once a child and, like other humans, remains irrationally susceptible to

the ploys of children. Whatever the reason for Hal's serenade, in his lapsing final moments he becomes more memorable, more impassioned, more humanly accessible, than at any other time.

It takes humility, and an awareness of complicity, to approach the topic of naivete in a receptive frame. The best outlook to take is one that combines skepticism with open-mindedness. Modeling this approach is the woman in the old television ad for liquid detergent, who in mid-manicure is told by a beautician named Madge, "You're soaking in it."

Notes

1. *Painters Painting,* dir. Emile de Antonio, Turin Film Corp., 1970 (first quote); Mike Wrenn, ed., *Andy Warhol in His Own Words* (New York: Omnibus Press, 1991), 31 (second quote); Andy Warhol, *THE Philosophy of Andy Warhol (From A to B and Back Again)* (New York: Harcourt Brace Jovanovich, 1975), 10 (third quote), 184 (fifth quote); Andy Warhol, *The Andy Warhol Diaries,* ed. Pat Hackett (New York: Warner Books, 1989), 304 (fourth quote); Bob Colacello, *Holy Terror: Andy Warhol Close Up* (New York: HarperCollins, 1990), 374 (sixth quote).

2. John Richardson, "Eulogy for Andy Warhol," in *Andy Warhol: A Retrospective,* ed. Kynaston McShine (New York: Museum of Modern Art, 1989), 454.

3. Victor Bockris, *The Life and Death of Andy Warhol* (New York: Bantam, 1989), 5. I am greatly indebted to Bockris for his superb and indispensable biography.

4. David Bourdon, *Warhol* (New York: Abrams, 1989), 417.

5. See Barbara Rose, quoted in Bockris, *Life and Death,* 116; Thom Jones, "Mosquitoes," *The Pugilist at Rest* (Boston: Little, Brown, 1993), 104; and Hal Foster, "Death in America," *October 75* (Winter 1996): 37.

6. Quoted in Wrenn, *Andy Warhol in His Own Words,* 79.

7. Bockris, *Life and Death,* 115.

8. Quoted in ibid., 194.

9. Helen Gurley Brown writes, "Are you totally, horribly, hideously, irrevocably offended by this whole discussion of sex? Do you feel it is a subject better left for married girls to probe? If so, by all means skip this chapter! Or skip the whole book!" *Sex and the Single Girl* (New York: Random House, 1962), 69.

10. Crone's various responses emerge in the "Discussion" section of *The Work of Andy Warhol,* ed. Gary Garrels (Seattle: Bay Press, 1989), 128–31. Crone's Brechtian reading of Warhol appears in his book *Andy Warhol,* trans. John William Gabriel (New York: Praeger, 1970).

11. The view of Mark Stevens, art critic for the *New Republic,* as reported in Paul Gardner, "Who Are the Most Underrated and Overrated Artists?" *ARTnews* 94 (Feb. 1995): 110–15.

12. Quoted in Bockris, *Life and Death,* 143–44, 158–59.

13. Quoted in Klaus Honnef, *Andy Warhol, 1928–1987: Commerce into Art* (Cologne, Ger.: Benedikt Taschen, 1990), 7.

14. Quoted in Bockris, *Life and Death*, 210.

15. Douglas Crimp, "Face Value," in *About Face: Andy Warhol Portraits*, ed. Nicholas Baume (Cambridge, Mass.: MIT Press, 1999), 114. See also Roy Grundmann, *Andy Warhol's "Blow Job"* (Philadelphia: Temple University Press, 2003).

16. Bockris, *Life and Death*, 150; Bourdon, *Warhol*, 181–82. Richard Meyer offers a fuller analysis of this episode in "Most Wanted Men: Homoeroticism and the Secret of Censorship in Early Warhol," *Outlaw Representation: Censorship and Homosexuality in Twentieth-Century American Art* (New York: Oxford University Press, 2002), 94–157.

17. Based on accounts in Bourdon, *Warhol*, 182–86, and in Bockris, *Life and Death*, 150–52, 162–63.

18. This description is based on accounts in Bourdon, *Warhol*, 266–69, and Andy Warhol and Pat Hackett, *Popism: The Warhol Sixties* (New York: Harcourt Brace Jovanovich, 1980), 247–48.

19. Warhol and Hackett, *Popism*, 262.

20. *Variety*, Nov. 13, 1968, 6. The FBI report is discussed in Bockris, *Life and Death*, 219, and in Margia Kramer's *Andy Warhol Et Al.: The FBI File on Andy Warhol* (New York: UnSub Press, 1988). Simon Watney describes a police crackdown in "Queer Andy," in *Pop Out: Queer Warhol*, ed. Jennifer Doyle, Jonathan Flatley, and José Esteban Muñoz (Durham, N.C.: Duke University Press, 1996), 20–21. The most detailed account of filming conditions appears in Bourdon, "The Way-Out West," *Warhol*, 266–77.

21. Quoted in G. R. Swenson, "What Is Pop Art?" *Art News* 62 (Nov. 1963): 26.

22. Warhol, *Philosophy*, 178.

23. Quoted in Kaspar König, Pontus Hultén, Olle Granath, and Andy Warhol, eds., *Andy Warhol* (Stockholm: Moderna Museet, 1968), n.p.

24. The painting entitled *30 Are Better Than One* is reproduced in McShine, *Andy Warhol: A Retrospective*, 236; the "think alike" quotation is found in Swenson, "What Is Pop Art?" 26.

25. Nor does the account acknowledge other North American contributions to cultural postmodernism—those of architects from Charles Jencks to Frank Gehry, writers from John Ashberry and Donald Barthelme to William Gibson and Lorrie Moore, musicians from Meredith Monk to Beck, theater from the Wooster Group to Suzan-Lori Parks, performers from Laurie Anderson to Madonna.

26. Fredric Jameson, *Postmodernism; or, the Cultural Logic of Late Capitalism* (Durham, N.C.: Duke University Press, 1991), 8–10, 14.

27. Jean Baudrillard, "Transpolitics, Transsexuality, Transaesthetics," trans. Michel Valentin, *Jean Baudrillard* (New York: St. Martin's, 1992), 12, 13, 19. See also "Pop—an Art of Consumption?" and "Beyond the Vanishing Point of Art," both collected in *Post-Pop Art*, ed. Paul Taylor (Cambridge, Mass.: MIT Press, 1989), 33–44, esp. 39–40, and 171–89, esp. 172–80, respectively; *Simulations*, trans. Paul Foss et al. (New York: Semiotext(e), 1983), 151; and *For a Critique of the Political Economy of the Sign*, trans. Charles Levin (St. Louis: Telos Press, 1981), 108–9.

28. Roland Barthes, "That Old Thing, Art . . . ," in Taylor, *Post-Pop Art,* 21–31.

29. Michel Foucault, "Theatrum Philosophicum," *Language, Counter-Memory, Practice,* trans. Donald F. Bouchard and Sherry Simon (Ithaca, N.Y.: Cornell University Press, 1977), 189.

30. Gianni Vattimo, *The End of Modernity: Nihilism and Hermeneutics in Postmodern Culture,* trans. Jon R. Snyder (Baltimore: Johns Hopkins University Press, 1988), 85–86.

31. See Friedrich Nietzsche, "On Truth and Falsity in Their Ultramoral Sense," in *The Complete Works of Nietzsche,* ed. Oscar Levy (New York: Macmillan, 1911), vol. 2.

32. Quoted in Calvin Tomkins, "Raggedy Andy," in *Andy Warhol,* ed. John Coplans (New York: New York Graphic Society, 1970), 14.

33. Bertrand Russell, as quoted in Martin Gardner, *The Sixth Book of Mathematical Games from Scientific American* (Chicago: University of Chicago Press, 1984), 222.

34. Jacques Derrida, "White Mythology: Metaphor in the Text of Philosophy," *Margins of Philosophy,* trans. Alan Bass (Chicago: University of Chicago Press, 1982), 210, 215, 217. See also Friedrich Nietzsche, "On Truth and Falsity in Their Ultramoral Sense," 180.

35. Donna J. Haraway, "Situated Knowledges: The Science Question in Feminism and the Privilege of Partial Perspective," *Simians, Cyborgs, and Women: The Reinvention of Nature* (New York: Routledge, 1991), 201.

36. The Wizard of Oz metaphor also appears in Bourdon, *Warhol,* 225, and in Caroline A. Jones, *Machine in the Studio: Constructing the Postwar American Artist* (Chicago: University of Chicago Press, 1996), 261.

37. David E. James, "I'll Be Your Mirror Stage," in Doyle et al., *Pop Out,* 33. Ernst Kris and Otto Kurz's influential study is titled *Legend, Myth, and Magic in the Image of the Artist* (1934; reprint, New Haven: Yale University Press, 1979).

38. Two studies that establish links between Warhol's childhood preoccupations and his adult art are Jesse Kornbluth, *Pre-Pop Warhol* (New York: Panache Press, 1988), and Michael Moon's essay "Screen Memories, or, Pop Come from the Outside: Warhol and Queer Childhood," in Doyle et al., *Pop Out,* 78–100.

39. Among the book-length works that engage closely with Warhol's film output: Michael O'Pray, ed., *Andy Warhol Film Factory* (London: British Film Institute, 1989); Stephen Koch, *Stargazer: The Life, World, and Films of Andy Warhol* (New York: Marion Boyars, 1973; revised and updated, 1991); Peter Gidal, *Andy Warhol Films and Paintings: The Factory Years* (New York: Da Capo Press, 1991); and Wayne Koestenbaum, *Andy Warhol: A Penguin Life* (New York: Viking Penguin, 2001).

40. Peter Plagens, "What Andy Saw," *Newsweek,* July 8, 2002, 52.

41. Quoted in Gidal, *Andy Warhol Films and Paintings,* 14.

42. In *Postmodernism and the En-Gendering of Marcel Duchamp* (New York: Cambridge University Press, 1994), Amelia Jones examines moments in which the dadaist artist suspended his habitual social demeanor—that of the cigar-smoking, chess-playing intellectual—in favor of a playful androgyny, as instanced in his "Rrose Sélavy" persona.

43. John Yau, *In the Realm of Appearances: The Art of Andy Warhol* (Hopewell, N.J.: Ecco Press, 1993), 71.

44. Christopher Lasch, *The Culture of Narcissism: American Life in an Age of Diminishing Expectations* (New York: Norton, 1978); Dan Kiley, *The Peter Pan Syndrome: Men Who Have Never Grown Up* (New York: Dodd, Mead, 1983); Ken Wilber, *Boomeritis: A Novel That Will Set You Free* (Boston: Shambhala, 2002). See also Aaron Stern, *Me: The Narcissistic American* (New York: Ballantine, 1979); Richard Restak, *The Self Seekers* (Garden City, N.Y.: Doubleday, 1982); Reuben Fine, *Narcissism, the Self, and Society* (New York: Columbia University Press, 1986); and Gail Sheehy, *New Passages* (New York: Random House, 1995), among many others.

45. Eve Kosofsky Sedgwick, "Privilege of Unknowing," *Genders* 1 (Spring 1988), 120. Reprinted in *Tendencies* (Durham, N.C.: Duke University Press, 1993), 23–51.

46. R. Buckminster Fuller, *Synergetics: Explorations in the Geometry of Thinking* (New York: Macmillan, 1975), xix; Carl Jung, *Modern Man in Search of a Soul,* trans. W. S. Dell et al. (New York: Harcourt Brace Jovanovich, 1933), 118.

47. Avital Ronell, *Stupidity* (Urbana: University of Illinois Press, 2002), 3.

48. Peter Sloterdijk, *Critique of Cynical Reason,* trans. Michael Eldred (Minneapolis: University of Minnesota Press, 1987), 495.

49. Mikhail Bakhtin, *The Dialogic Imagination,* trans. Caryl Emerson and Michael Holquist (Austin: University of Texas Press, 1981), 158–59, 164.

50. Scholars vary in describing how the trickster and the naif (or fool) are linked. The volume *The Fool and the Trickster* (ed. Paul V. A. Williams [Totowa, N.J.: Rowman and Littlefield, 1979]), an anthology in honor of Welsford's aforementioned study *The Fool,* addresses the marked resemblances and influences among these two character types. D. J. Gifford's essay, for instance, posits the medieval fool as having evolved from the more sinister figure of the trickster, an archetypal sower of chaos and confusion. Curiously, a quarter-century earlier, Carl Jung, in his essay "On the Psychology of the Trickster-Figure," argued for a reverse lineage. The rogueries of the alchemical figure of Mercurius, Jung writes, "related him in some measure to various figures met with in folklore and universally known in fairytales: Tom Thumb, Stupid Hans, or the buffoon-like Hanswurst, who . . . manages to achieve through his stupidity what others fail to accomplish with their best efforts" (*Four Archetypes: Mother/Rebirth/Spirit/Trickster,* trans. R. F. C. Hull [Princeton, N.J.: Princeton University Press, 1959], 135).

 Robert Pelton asserts that all "tricksters are foolers and fools, but their foolishness varies; sometimes it is destructive, sometimes creative, sometimes scatological, sometimes satiric, sometimes playful. . . . [T]he pattern itself is a shifting one, with now some, now others of the features presented." Quoted in Gerald Vizenor, *The Trickster of Liberty* (Minneapolis: University of Minnesota Press, 1988), xiv.

51. Enid Welsford, *The Fool: His Social and Literary History* (London: Faber and Faber, 1935), 5.

52. Sloterdijk, *Critique of Cynical Reason,* 101.

53. Ronell, *Stupidity,* 15, 298.

54. Sloterdijk, *Critique of Cynical Reason*, 294–95; Rebecca Mead, "The Marx Brother," *New Yorker*, May 5, 2003, 38–47, esp. 46.

55. Theodor Adorno, *Minima Moralia: Reflections from Damaged Life*, trans. E. F. N. Jephcott (1951; New York: Verso Editions, 1996), 106, 122–24.

56. Joseph Litvak, *Strange Gourmets: Sophistication, Theory, and the Novel* (Durham, N.C.: Duke University Press, 1997). See esp. chapter 5, "Expensive Tastes: Adorno, Barthes, and Cultural Studies."

57. Geoffrey Hartman, *The Fate of Reading and Other Essays* (Chicago: University of Chicago Press, 1975), 257.

58. Wayne Koestenbaum, *The Queen's Throat: Opera, Homosexuality, and the Mystery of Desire* (New York: Vintage, 1993).

59. Koestenbaum, *Andy Warhol: A Penguin Life*.

60. Beatrice Otto takes steps toward correcting this gender bias in *Fools Are Everywhere: The Court Jester around the World* (Chicago: University of Chicago Press, 2001).

61. Quoted in John Trimble's *Writing with Style: Conversations on the Art of Writing* (Englewood Cliffs, N.J.: Prentice-Hall, 1975), 115.

62. As paraphrased by Caroline Jones in *Machine in the Studio*, 207. Angela Davis was speaking at a University of California–Berkeley symposium, Apr. 25, 1987.

63. Bockris, *Life and Death*, 328.

64. Colacello, *Holy Terror*, 474.

65. Warhol, *Diaries*, 519, 520, 534, 541.

66. Warhol and Hackett, *Popism*, 231, 232.

67. Tony Tanner, *The Reign of Wonder: Naivety and Reality in American Literature* (New York: Harper and Row, 1965). See also Leslie A. Fiedler, "The Eye of Innocence: Some Notes on the Role of the Child in Literature," *No! in Thunder: Essays on Myth and Literature* (Boston: Beacon, 1960), 251–91; and Peter Coveney, *Poor Monkey: The Child in Literature* (London: Richard Clay, 1957).

68. Ultra Violet, *Famous for Fifteen Minutes: My Years with Andy Warhol* (New York: Avon, 1988), 85. Ultra Violet claims that it was only due to a further conversion that she outlived the excesses of her Warhol years. In the context of all the premature deaths among those associated with Warhol, she writes, "As for me, I survived because I am a Christian, born again of the spirit" (248).

69. A. L. Rowse, *Homosexuals in History* (London: Weidenfeld and Nicolson, 1977), 300.

70. John Gardner, *The Art of Fiction* (New York: Knopf, 1984), 42.

71. Warhol, *Diaries*, 171.

72. Warhol, *Philosophy*, 44.

73. Fred Pfeil, "Postmodernism as a 'Structure of Feeling,'" in *Marxism and the Interpretation of Culture*, ed. Cary Nelson and Lawrence Grossberg (Urbana: University of Illinois Press, 1988), 399.

74. Quoted in Bockris, *Life and Death*, 244–45.

75. Dick Hebdige, "In Poor Taste: Notes on Pop," *Hiding in the Light: On Images and Things* (New York: Routledge, 1988), 119. In this context, Hebdige refers to the art collector Robert Scull as embodying the spirit of pop's being "in poor taste."

76. Koch, *Stargazer*, v.
77. Friedrich Schiller, *On the Naive and Sentimental in Literature*, trans. Helen Watanabe-O'Kelly (Manchester, Eng.: Carcanet New Press, 1981).
78. Warhol and Hackett, *Popism*, 285.
79. Bockris, *Life and Death*, 157.
80. Bourdon, *Warhol*, 17; Bockris, *Life and Death*, 13.
81. Lewis Hyde, *Trickster Makes This World* (New York: Farrar, Straus, and Giroux, 1998), 8.
82. Jack Wilson, quoted in Patrick S. Smith, *Warhol: Conversations about the Artist* (Ann Arbor, Mich.: UMI Research Press, 1988), 8.
83. Sedgwick, "Privilege of Unknowing," 119.
84. Erving Goffman, *Stigma: Notes on the Management of Spoiled Identity* (Berkeley: University of California Press, 1948), and *The Presentation of Self in Everyday Life* (Garden City, N.Y.: Doubleday, 1959).
85. See José Esteban Muñoz's discussion of disidentification as theorized by Slavoj Zizek, Judith Butler, and Michel Pecheux, in "Famous and Dandy Like B. 'n' Andy: Race, Pop, and Basquiat," in Doyle et al., *Pop Out*, 144–79, see esp. 147–51; and in his book *Disidentifications: Queers of Color and the Performance of Politics* (Minneapolis: University of Minnesota Press, 1999). Zizek speaks of disidentification as a factionalizing and immobilizing force, where Butler asserts that it brings a potentially democratizing charge; Pecheux and Esteban Muñoz posit the disidentifying subject as working simultaneously on and against dominant ideology.
86. See Warhol, *Diaries*, 689–90.
87. Among such work is Eve Sedgwick's "Queer Performativity: Henry James's *The Art of the Novel*," *GLQ* 1, no. 1 (1993): 1–16; "Queer Performativity: Warhol's Shyness/Warhol's Whiteness," in Doyle et al., *Pop Out*, 134–43; Judith Butler's "Critically Queer," *GLQ* 1, no. 1 (1993): 17–32; and Muñoz's "Famous and Dandy Like B. 'n' Andy," rpt. in Muñoz's *Disidentifications*.
88. That Warhol was more "out" as a naif than he was as a gay man is witnessed in his rococo self-description in *Philosophy* (10), where he refers to his "childlike, gum-chewing naivete" but makes no overt mention of his homosexuality. Warhol here appropriates the language that critics used to dismiss pop art and artists, who were once denounced as "pin-headed gum-chewers" (quoted in Arthur C. Danto, "The Philosopher as Andy Warhol," in Callie Angell et al., *The Andy Warhol Museum* [New York: Distributed Art Publishers, 1994], 73–74; see also Stephen Koch's *Stargazer*, 11).
 Warhol was open enough about his queerness to have been snubbed by other fifties homosexuals such as Truman Capote and Frank O'Hara, individuals who had, as Simon Watney writes, "dehomosexualized themselves, especially in their *social* role as artists or critics" ("Queer Andy," 25).
89. Quoted in Bockris, *Life and Death*, 328.
90. Patrick S. Smith, *Andy Warhol's Art and Films* (Ann Arbor, Mich.: UMI Research Press, 1986), 75. Later examples of Warhol's thespic incompetence are found in Colacello, *Holy Terror*, 159, 353. Warhol's diary entry of July 10, 1978, begins, "Cabbed up to 44th and Sixth Avenue . . . to the studio of Sire Records to do a commercial for the Talking Heads. I had to do it about twenty times. Afterwards I told Vincent that I can never be an actor—

Pop Trickster Fool

I just don't have it, I get tongue-tied, something happens. All I had to say was: 'Tell 'em Warhol sent ya,' and it came out like I was reading it every time" (*Diaries*, 151).

Warhol's involvement in theater in the 1950s presages his later enthusiasm for cultivating bad acting styles and for sabotaging quality-control efforts on the sets of his films.

In referring to Warhol's acting abilities, I do not wish to collapse the distinction between performativity and performance (see Butler, "Critically Queer," 24).

91. Quoted in *Entertainment Weekly*, Feb. 19–26, 1999, 92. The show was aired on October 12, 1985. *Entertainment Weekly* ranked the episode as ninety-fifth in the "One hundred Greatest Moments of TV."

92. Warhol and Hackett, *Popism*, 13.

93. Colacello, *Holy Terror*, 118.

94. Koch, *Stargazer*, 115.

95. Hyde, *Trickster Makes This World*, 14.

96. Crimp, "Face Value," 119.

97. Watney, "Queer Andy," 21.

98. Calvin Tomkins, *The Scene: Reports on Post-Modern Art* (New York: Viking, 1976), ix.

99. Christa Wolf, "The Sense and Nonsense of Being Naive," trans. Jan van Heurck, in *Critical Fictions: The Politics of Imaginative Writing,* ed. Philomena Mariani (Seattle: Bay Press, 1991), 230.

It took intelligent people years to
appreciate the abstract expressionist
school and I suppose it's hard for
intellectuals to think of me as art.
I've never been touched by a painting.
I don't want to think.

—Andy Warhol

New York School's "Out": Andy Warhol Presents Dumb and Dumber

The naif-trickster persona Warhol fashioned in the early sixties provides a crucial model not only of pop impudence and postmodern inversion but of gender politics and queer visibility. His clothing style and comportment were too idiosyncratic to catch on as an emulated or symbolic "type"—in the manner of fifties types such as the grey-flannel-suited corporate man, the Hugh Hefner male, Norman Mailer's White Negro, or the beatnik. Nor was his outward demeanor, either sartorially or behaviorally, at all in keeping with the easy-going hippie styles and the newly "sensitive" male of the later sixties and early seventies. Nonetheless, with his silver-blond wig, shades, black leather jacket and boots, his soft-spoken manner and dancer's gait, he took hold in the public imagination and helped to challenge the boundaries within which acceptable male conduct is defined.

Andy was audaciously swish by the standards of the time, and yet certain traits suggest that naivete was perhaps a more favored "orientation" for him than homosexuality. The two modalities overlap in ways that are productive as well as problematic—for Warhol himself, for the public he was trying both to engage and to baffle, and for gender studies. Warhol's naif self-presentation may be seen as an intricately coded surrogate for coming out as a gay man. His strategic, though not entirely self-conscious, mimicry of ignorance and immaturity helped him to confront, cope with, manage, articulate, and also deny the complex implications of his queer sexuality. His extraordinary ability to deploy cognitive refusal lies at the core of his provocations in the realms of both pop and queer culture. Warhol's steadfastly maintained swish/naif performance exists simultaneously as an inverted parody of masculinist New York School decorum and ideology; as a critically enabling queer stance in the decade leading up to the gay rights movement in the United States and Britain; and also, paradoxically, as a default system that permitted Warhol to employ de-gaying tactics and the rhetoric of homophobia when he found it expedient. Just as his voice, appearance, and physical manner blended numerous styles and varied according to context, so also did his paintings, films, and books represent composite strategies that alternately foregrounded or backgrounded homosexual codes. While it would be impossible to sort out all of these codes, what follows is an effort to examine patterns among the ones pertaining most centrally to Warhol's naif-trickster performance. I approach this performance first in social terms—the ways it violated received customs of the New York art world during the sixties—and then in more personal terms: the ways it served his shifting circumstances and needs before and after the sixties. His persona in its numerous manifestations

reveals "queer naivete" as a chameleonic performative mode, one that continues to inform present-day pop and queer practices.

Toying with the Artist-Savants

The emergence of abstract art is one sign that
there are still men able to assert feeling in the world.
—Robert Motherwell,
 "What Abstract Art Means to Me"

I don't have strong feelings on anything.
—Warhol, *Andy Warhol in His Own Words*

Warhol demonstrates how the practice of cultivating naivete promotes an incipiently queer agenda by exposing the dynamics of an entrenched masculinist regime of knowledge.[1] In a culture where reason and masculinity are stereotypically linked, a man playing a naif provides a potential critique not only of what is meant by mental competence but also of male potency, even as he exposes himself to attack along these same lines. Warhol's pose of naivete gives a farcical turn to the intertwined machismo and savantism that helped to legitimize the United States' first bona fide homegrown art movement. His "unfeeling, unthinking" stance constitutes a sacrilegious inversion of principles central to the New York School, more famously known as the abstract expressionist movement.

Members of the New York School invested the realm of art with tremendous feeling and expressed the highest aspirations for painting as a mode of philosophy. The movement's intellectualism, as well as its notorious machismo, may be seen in terms of an effort to transform the feminine-identified act of painting into an endeavor virile and robust enough to qualify as a valid pursuit for red-blooded heterosexual American males. Attending lectures at the Eighth Street Artist's Club, and engaging in verbal or physical brawls at the nearby Cedar Tavern, became ways of establishing artistic credentials in the movement. The influential critics Clement Greenberg and Harold Rosenberg, using masculinist and nationalistic terms to champion the new American painters, greatly reinforced the movement's aura of intellectual machismo.[2] Their attempts to "vindicate" art as a male domain could not have come at a more opportune moment. As Jonathan Katz has written, "America has a history of suspicion with regard to its artists and their manliness, and perhaps never more so than in the early 1950's

when the rest of America was rolling up its shirtsleeves and getting down to work to defeat Communism."[3] Given the United States' displays of brawny self-confidence during and following World War II, it should perhaps come as no surprise that art would be newly stigmatized as an effete and emasculating activity, not a pursuit befitting real men. A pioneer in the realm of aesthetics and feeling had less credibility embodying the virtues of a nation so Herculean in strength as to deliver decisive blows to the forces of both Nazism and Communism.

Curiously, though, in the early fifties figures as eminent as Winston Churchill and Dwight Eisenhower became well known as amateur painters and helped to foster a nationwide boom in painting kits for use at home.[4] If the British prime minister and the American president could take to the easel without jeopardizing their masculinity, why would artists in New York be unable to do so without similar risk? Partly it was because they were not themselves celebrated military heros who could relax into brush-and-palette work as a respite from summit-level conferences. Ironically, the arts-and-crafts boom that Churchill and Eisenhower helped to fuel greatly contributed to the revaluation of painting as a harmlessly domestic, bourgeois, leisurely, and, by implication, feminine pursuit. Where before one had gone to museums for art, now one was encouraged to go to a five-and-dime hobby store or make a mail-order purchase, and to create one's own paintings during leisure hours in the privacy of the home.

For New York School artists and their exegetists, the canvas itself needed to be configured as the domain of summit-level decisions. Painting had to be defended as an activity of hard sacrifice and work rather than of self-gratification and repose. Every effort was made to plant in the public's mind the suggestion that the abstract expressionists confronted private battlefields and made decisions as heroic as those made by decorated statesmen. In the face of mounting evidence to the contrary, artists and art critics needed all the more staunchly to argue that painting was in fact a noble and masculine endeavor. A certain backhanded logic underlies Motherwell's pronouncement about men and art and the ability to assert feeling. His statement helps to safeguard an obverse proposition, that the emergence of abstract art in the world was one sign that those who were able to assert feeling were *still men*.

Despite its antiacademic bias, abstract expressionism developed a reputation as a *thinking man's* movement; concomitantly, membership fees rose astronomically for women and effeminate men.[5] Dore Ashton's biography of the New York School recounts the somewhat fraught courtship that developed between artists and intellectuals as they at-

tempted to find common cause in the movement. Speakers who were invited to the Artist's Club sometimes met with scoffery from the membership, but their presence was still regarded as vital. Ashton shows how artists used the club not only to build a visible fraternal gathering-place, but also

> to confirm their widening audience among the educated strata of the society and to establish the visual artist as a member of the intelligentsia on equal footing with writers and composers. No amount of nostalgic disclaiming can disguise the interest the visual artists displayed in attracting the other intellectuals to their bailiwick, and putting them in their place, so to speak. It was with considerable pride that they scheduled such speakers as Hannah Arendt, Lionel Abel, and E. E. Cummings. Though David Hare or Ad Reinhardt, or sometimes de Kooning, would occasionally heckle the august intellectuals who appeared Friday nights at the Club, they were the first to encourage invitations to poets, philosophers, psychiatrists, and critics.[6]

Among the many outspoken voices at the club, Willem de Kooning's carried an unusual weight of authority. The art world in the fifties continued to draw sustenance from the myth of "loft-rat" cosmopolitanism established in de Kooning's early career.[7] Among the mannerisms venerated in this myth were the ability to sound well-read but not bookish or academic, and to wear workingman's garb and provide an air of brave poverty even if money was no longer a problem.

Both the intellectualism and the machismo associated with abstract expressionism helped to establish the movement's famous "heroic" stature. This heroism in turn became used to create a perceptual distance between New York School artists and the millions of newly enleisured Americans who were turning to painting as a form of cheap psychotherapy and home entertainment.[8] Popular-press accounts collaborated in widening this gap. *Life* magazine, for instance, alternated between generating a cult atmosphere around figures like Jackson Pollock and satirizing the implicitly female legion of "peasant-class" painters who were merely "fillers-inners of numbered pictures."[9] (In his 1962 "Do It Yourself" series of partially completed paint-by-number canvases, Warhol jubilantly cast his lot among the peasants.)

As nonprofessional painters with the stature of Winston Churchill advocated a "splash and wallop" painting style that sounded remarkably close to the working methods of the abstract expressionists,[10] apologists for the New York School were increasingly hard-pressed to delineate the movement's claims for distinction. They characteristically used

Continental philosophy as collateral in this effort, and their writings made painting sound more and more like philosophy itself. Ann Gibson has shown how, in spite of abstract expressionism's contrarian emphasis on individual autonomy and its refusal of interpretive systems, the movement relied heavily on a "network of guiding philosophies," among them Jungian psychology, New Criticism, Russian formalism, and existentialism.[11] Ashton's account describes how a quasi-philosophical language of anxiety and alienation (drawn from Sartre), of authenticity (Heidegger), and of notions of the Sublime (borrowed from the Dionysian side of Nietzsche) became ritual in art journals, lectures, and symposiums following the war, carrying over from Artist's Club events to Cedar Tavern discussions (178–87). Such language, employed far more impressionistically than rigorously, helped to provide ballast to artists who were casting about for a sustaining myth in an increasingly consumer-based nation.[12] The intellectuality of postwar art discourse came as a natural outgrowth of the backgrounds and inclinations of many of its artists and writers, and yet also involved a protection-society air of defensiveness. Just as earlier one had "needed" Freud in order to appreciate the surrealists, so also now one somehow "needed" Nietzsche, Jung, Heidegger, Sartre, Kafka, and the poetry of angst in order properly to appreciate abstract expressionism.

One of the great affronts of pop art, then, was that it no longer "needed" high-modernist philosophy and poetry. Even its nomenclature conveyed an indifference toward this tradition. As Allan Kaprow writes, "[T]he word *pop* summoned up at once a native innocence and a deep fear of preoccupation with matters of so-called weight and thought. The whole notion of 'popularity' was (and is) patently anti-European in this sense and anti-intellectual as well."[13] The European roots of disdain for popular culture extend beyond modernism at least as far back as the time of Juvenal, whose phrase *panis et circenses* (bread and circuses) witheringly conveyed his sense of how to quell popular unrest; the phrase also asserted, many centuries before H. L. Mencken, that it was impossible to underestimate the tastes of a national public. "Pop" is a modern repository for attitudes historically extended toward the uneducated hoi polloi, the common rabble, the mob, the ignorant masses, the barbarians at the gates, the lumpenproletariat, the booboisie, the idiot box, the lowest common denominator, the vast wasteland, and the spreading epidemic of kitsch. In the early 1960s this connotative rampage was heading straight toward hitherto-respectable art galleries. Pop appeared in the context of postwar and cold war reasoning that held popular culture to be not just mind-numbing but morally debilitating and crypto-fascist.

German peasants who lacked the wherewithal to read *Mein Kampf* might still be counted on to rally around the spectacle of goose-stepping, swastikas, and Aryan youth; so the logic went. Then there were the Soviet uses of kitsch, and the need for a vigilant American resistance against the encroachments of any and all forms of Communism. Adding to these concerns was a national debate about television, in the days before Marshall McLuhan's celebrations about its participatory functions in a global village. The medium was still in its adolescence, and to many observers it looked as if it would stay there forever.

Thus, although the fine-art manifestations of popism included images that might have seemed innocent at one level, they were in fact strategic weapons used against a prevailing mandarin worldview. The very cuteness of it all was part of the danger: Superman and Little Lulu (Warhol), bubble-captioned cartoons (Roy Lichtenstein), candy-colored cakes (Wayne Thiebaud), and soft-sculpture depictions of everyday household items (Claes Oldenburg). The enlarged comic strips, ubiquitous logos and name-brand products featured in pop art seemed to suspend, even to ridicule, imperatives toward pensiveness and the discerning critical eye. Artists themselves specifically disavowed the twin agenda of *gravitas* and *cogito* that underpinned modernist criticism and art. In Gene Swenson's 1963–64 *ARTnews* interviews on "What Is Pop Art?" Roy Lichtenstein labeled himself "anti-contemplative, anti-nuance . . . and anti all of those brilliant ideas of preceding movements which everyone understands so thoroughly." The painter Robert Indiana professed an aversion toward the high angst quotient of the earlier dadaist movement. He declared that pop was not to be confused with "any neo-dada anti-art manifestation," on the grounds that "its participants are not intellectual, social and artistic malcontents with furrowed brows and fur-lined skulls."[14]

Warhol's stance was more radically unsettling than these, since he not only advocated an anti-contemplative, anti-angst position but acted it out on a daily basis. A quality of self-absorbed naivete traceable to his early childhood became a self-consciously cultivated aspect of his post-1962 pop persona.[15] With his trademark silver-blond wig and cool, expressionless gaze, Andy was seen as the very physical embodiment of pop, and he became the favorite bête noire of New York School artists who found their own work eclipsed by the upstart movement. His habit of looking and behaving like an idiot in public exacerbated the offense of his canvases, whose content was itself regarded by many as egregiously idiotic. In his Warhol biography Victor Bockris writes, "With his dumb-blond image and, as it seemed to many, his dumb paintings,

Andy became the number-one target for anybody who wanted to attack pop art, particularly among the first- and second-generation abstract expressionists and their followers. Reviewers in that camp called Warhol's work, among other things, a 'vacuous fraud.'"[16]

Warhol played the role of vacuous fraud to the hilt, performing a series of ruses or "dupes" upon the ground rules of the previous artistic dispensation. If late-modernist art was promoted as a strenuous, "heroic" undertaking, Warhol proclaimed how easy and fun painting was. In contrast to the image of the isolated genius creating art ex nihilo, he pinched ideas from friends, lifted images wholesale from preexisting photos and logos, and enlisted labor-saving assistants. Where Jackson Pollock forcefully confronted his canvases in a style known as "action" painting, Warhol abandoned painterly gestures in favor of overhead projection, stencil-work, silkscreen transfer, and gridlike repetition. His statement "I want to be a machine" mercilessly deflates the Romantic pretensions of Pollock's statement, "I am nature."[17] As we have seen, Warhol offered an across-the-board dumbed-down makeover of the ideals of late modernism, substituting surface for depth, mechanism for aura, repetition for uniqueness, self-promotion for asceticism, collaboration for autonomy, dissemblance for authenticity, and exultant consumerism for critical negation. When interviewers asked him to account for his intentions, he tended to answer "I don't know," or to treat the Q&A process as a joke:

Q: Do you think pop art is—
A: No.
Q: What?
A: No.
Q: Do you think pop art is—
A: No. No, I don't.[18]

However, the term "vacuous fraud" must also be seen as a double-edged euphemism. Immediately after meeting the artist in the mid-sixties, Francis Sedgwick, the father of the Factory Superstar Edie Sedgwick, said of Warhol, "Why, the guy's a screaming fag." Mr. Sedgwick reportedly said this "with a great sense of relief," since he perceived that Warhol no longer posed a threat to his daughter.[19] That this epithet was not stated publicly by the abstract expressionists did not mean they failed to share the sentiment.[20] Charges of vacuity and fraudulence delivered the same message in a more backhanded, estimable fashion. The terms decorously insinuated Warhol's basic lack of substance, heft, thinking power, authenticity; in a word, of manhood.

At the same time, Warhol himself, unusually skilled at manipulating his public image, may be said to have collaborated in drawing the "lesser" charge.[21] My impression is that, given the era, class, and ethnicity in which he was raised, and the coolness with which his overtly homoerotic art of the fifties was received, Warhol discerned that the role of vacuous fraud would take him much further in life than the role of "known homosexual." He characteristically used the former role as a smokescreen for the latter. A logic of reaction-formation may be said to underpin both the intellectual self-image promoted by the New York School, and the naif self-image promoted by Warhol. Although moving in antithetical directions, both self-fashionings involved a stealthy, crabwise maneuver away from the charged terrain of male effeminacy. Members of the New York School maintained a front of savantism and machismo as a method of guaranteeing that they were still "real men" in spite of being deep-feeling painters; Warhol found refuge in the persona of "empty-headed trickster" as a means of guarding against his being read too quickly, or too exclusively, as a screaming fag.

Artful Dodgers

> Pop came along and said to a lot of people for whom the whole modern aesthetic is just too difficult and too devoid of fun, it said to all these people, anything goes. It released them from a certain kind of seriousness, a certain kind of solemnity, but I think, as an artistic statement, as an artistic vision, it's totally facetious.
> —Hilton Kramer

> Oh, you might think, "Oh, here's this nice little boy who is very naive, and he dresses like a hick from Pennsylvania, and he acts sort of sickly and naively, and he doesn't know what the score is." Well, he *did*. But he was always involved with it on the level of a game or play. And this was very important to him. I mean, he couldn't understand why people were taking things so seriously, or why people had to be so . . . a drama. He loved the theatre.
> —Alfred C. Walters, recalling his meetings with Warhol in the mid-1950s

The "adorability" factor Warhol had played up while establishing his commercial art career in the 1950s, eliciting nicknames such as "Rag-

gedy Andy" and "Andy Paperbag," all but disappeared after his initial pop success.[22] As an art-world insider he no longer had to rely on the latter-day Horatio Alger act that had sustained him in his move from Pittsburgh to New York City. His black leather jacket, wigs, dark glasses, and blank expressions gave a remote celebrity chic to his physical appearance. His artistic output—particularly the jarringly grotesque *Death and Disaster* paintings, exhibited first in 1962—dealt a decisive blow to the "cute-Andy" image held by those who had known him in the fifties and earlier. The naif persona that survived this transition made an impression whose startling incongruity persists to the present day.

The audacity of Warhol's position in the sixties is thrown into relief by the examples set by his immediate artistic predecessors, Robert Rauschenberg and Jasper Johns. Rauschenberg and Johns establish a significant precedent for Warhol—a precedent that, in retrospect, is also significant for the boundaries it did not cross. As breakaway artists from the waning New York School tradition, and as lovers who carried on a closeted six-year relationship, Rauschenberg and Johns showed partial allegiances to a previous era's codes of "urban cowboy" masculinity and savantism, as well as to emerging postmodern codes of gender-blurring and hipster naivete.[23] The two artists provided a heavily coded critique of abstract expressionism while still adhering to many of the movement's articles of faith. Their maneuverings amounted to a kind of epistemo-logical shell game in which the contraband elements of queerness and naivete shuttle among a host of disguises. Kenneth Silver's essay "Modes of Disclosure" shows how their work both "embraces and betrays" abstract expressionism; it parodies the movement's machismo and at the same time stops short of constituting gay art.[24] Silver offers an astute reading of the specifically queer contradictions the two artists maintained. Rauschenberg and Johns suppressed the fact that they had supported themselves by doing commercial window display work, and yet they snubbed Warhol for his having supported himself this way. They ridiculed the swagger and "ballsiness" of abstract expressionism and nevertheless kept Warhol at a distance because they found him too "swish."

Silver concludes his essay by celebrating the "free play of gender, sexuality, and class signification" he sees as Warhol's "special field of knowledge" (202). However, a subsequent look at this field of knowledge shows that it, too, is riddled with queer contradictions. Warhol played the epistemological shell game with alternate stakes, making a shrewd diversion out of his apparent *lack* of knowledge. He promoted the commercialness of his work while suppressing the fact that he had been formally trained in the field of commercial art at Carnegie Tech.

He kept the press and public guessing by providing falsified and inconsistent biographical data about himself, beginning with the date of his birth. He played up the "swish" aspect of his persona, produced semi-pornographic movies, and pursued numerous infatuations with men while still maintaining the air of someone who didn't know the first thing about sex. He was the prime mover of a Factory milieu that served in many ways as Queer Central during the sixties; and, almost by way of compensation or retraction, he generated memoirs that perform an elaborate song-and-dance routine around the matter of his own desires.

The documentary *Painters Painting* reveals some of the key strategies deployed in this epistemological shell game. Made by the artists' agent Emile de Antonio in 1970, and aired on PBS in 1972, it preserves evidence of Rauschenberg, Johns, and Warhol's restless impatience with the kind of male-gendered authority and high seriousness that was considered de rigueur for an artist's image.[25] The studio segments proceed for the most part straightforwardly—the artists interviewed (New York School affiliates Hans Hofmann, Barnett Newman, Robert Motherwell, Willem de Kooning, Kenneth Noland, Helen Frankenthaler, among others) speaking and gesturing no less deliberately and rationally than the critics (Clement Greenberg, Thomas Hess, Hilton Kramer). A certain Old World astringency and unimpeachable reasonableness governs both the content and style of a majority of the interviews.[26]

The segments with Rauschenberg, Johns, and Warhol mark an important departure from this protocol. Rauschenberg and Johns both make attempts to inject the interview format with irony. Rauschenberg alternates between a thoroughly engrossed, brow-furrowed intentness and a winsomely cheerful demeanor that emerges almost like a protest against the other mode. He grins boyishly while describing how he erased a drawing by de Kooning. At other times he smiles inconsequentially, with a defensive shyness, as if the deliberation of his spoken response worked at cross-purposes with an impulse to lighten or josh the interview process.

Johns also seems to catch himself in the act of taking the interview too seriously. At moments he inexplicably erupts in a peremptory laughter, as if to introduce levity by sheer force. At one point he grows particularly morose while speaking about his early work, but then confesses he "became perhaps too serious about what [he] did," and laughs as if in conspiracy against his younger self. He finds great amusement

in recounting the story behind his painted-bronze beer cans, or in telling about how his aunt once wrote him to announce how proud she was of his respect for the American flag. During another reply he dryly interjects, "I will of course tell lies here." But at other times the source of humor is unclear, as if he were entertaining a private joke; or an initial outbreak of laughter clears the way for an extended solemn reply. He openly mocks de Antonio's question, "What about Dada?" Johns says, "'What about Dada?' What kind of question is that: 'What about Dada?'" and proceeds to laugh uproariously. But having made this trickster maneuver, he then capitulates to expectation, providing an elaborate anecdotal account of his work's relation to that of Marcel Duchamp.

Rauschenberg and Johns stage jocular protests against interview convention while still couching their responses in a fundamental seriousness. By contrast, Warhol mounts a full-scale send-up, providing a theatrical example of the "total facetiousness" that Hilton Kramer described as the bane of pop art. Warhol's trickster performance in *Painters Painting* maintains a virtuosic seamlessness, like a joke that never announces itself as such by arriving at a punchline. The seamlessness, however, may also be read in terms of shamelessness. Warhol steps over barriers of civility and courtesy that Rauschenberg and Johns maintain, which further defines the separation between their class backgrounds, generational affiliations, and their relation to the sixties.

Warhol brings his assistant Brigid Polk to the interview and casts her as its tacit authority. (The main prerequisite for becoming one of Warhol's assistants was hanging out at his studio. Although Polk's father was president of the Hearst Corporation, Brigid's fame at the Factory stemmed from her avid use of amphetamines.) With his private tape recorder running, Warhol deflects questions to Polk and to de Antonio, alternating his microphone between the two of them even when *he* is doing the talking. His verbal responses consistently debunk the interview genre's underlying pledges to offer reliable and revealing information, and to show glimpses of a personable, knowable individual. His rumpled, halting delivery itself communicates the antithesis of what is meant by the phrase "weight of authority"; and yet paradoxically, his low-voiced nasal monotone and lack of animation give him a prepossessing air of intellectuality. Warhol dodges the first question, concerning his origins as an artist, by claiming that de Antonio "made" him a painter, then by asserting that he learned about art through listening to de Antonio's gossip: "You used to gossip about the art people, and, uh—uh, that's how I found out about art." Besides revealing a spuriously nonheroic provenance for his career, Warhol's comment damages the

illusion of documentary objectivity—the pretense (upheld by the other interviewees) that de Antonio has no history of personal involvement with the artists he has selected to film. The notion that de Antonio "made" Warhol a painter is misleading, but not wholly so. De Antonio is credited with helping Warhol to see the strength of his unadorned, iconic pop style, at a time when the artist still felt he had to concede to the more painterly look of abstract expressionism.

Warhol's next maneuver is to cast doubt on whether he has an artistic career at all. He flouts the notion of artistic autonomy by insisting that Brigid Polk has been doing his paintings for the past three years. (When Warhol made this claim to a magazine, the report was widely circulated, and generated panic among German art collectors worried that they had purchased Polks instead of Warhols. Andy had to make a public retraction.)[27] Brigid then claims that in fact a certain "Mr. Goldman" is responsible for the paintings, and Warhol, sounding like one of Twain's Innocents Abroad, says, "But Mr. Goldman's dead." Continuing to emphasize his own supposedly "blasé-faire" role at the Factory, his commentary becomes at once both Byzantine and tautological, achieving a unique head-scratching whimsicality: "The reason we can say Brigid does it is because I haven't done any for three years. So, when the papers say that Brigid's done all my pictures, Brigid can say she does all my pictures, which she can say because we haven't done any." By the standards of the day, this is tantamount to saying, "Yes, it's true, I'm a complete fraud." But Warhol's diction and delivery—his straight-faced, almost stricken demeanor—conveys a kind of overdetermined sincerity. It's as if a press release from the Mad Hatter was presented by a functionary from the Circumlocution Office.

Warhol goes on to characterize silkscreening as an effortless process about which he knows next to nothing: "Oh I just, uh, found a picture and, uh, gave it to the man, and he made a print, and I just took it and began printing. . . . And then they came out all different because I guess I didn't know how to really screen." Asked about his Photo-Mat portrait of Ethel Scull, Andy says, "It was just so much fun to do." He estimates he was paid seven hundred dollars for the work, and, when challenged on this amount, takes refuge in "I don't know" and "I'm not sure." Asked why he chose to paint an electric chair, he responds with a startling matter-of-factness: "Oh well—that was the time I think they were, they stopped, uh, killing people in the electric chairs. Wasn't it or before? So, I thought it was an old, uh, image, so that would be nice too." Warhol's replies seem calculated to offend through their very inoffensiveness: "I just took it and began printing"; they were "just so much fun to do"; I

thought the electric chair image "would be nice." In Warholian parlance words like "just," "fun," and "nice" simultaneously convey innocuous pleasantness, an adolescent level of maturity, and an inability or unwillingness to engage in thought. In the way he consciously overrides commonly accepted notions about the difficulty, seriousness, sacrifice, and profundity involved in making art, his utterances—in spite of his deadpan delivery—spring out of the documentary context like coiled jack-in-the-boxes.

Evidence of the artists' homosexuality emerge more surreptitiously in the three interviews. Only after repeated viewings did I take note of the unusually delicate and expressive way that Jasper Johns holds and makes gestures with his hands. A viewer aware of the relationship between Rauschenberg and Johns may read certain clues differently from the uninitiated. Both artists bring glasses of whiskey to the interview, and Rauschenberg in particular shows signs of inebriation. Alcohol serves as a link to the hard-drinking Cedar Tavern image cultivated by the New York School, but it might also be read as a commentary on the price of maintaining a closeted life.

The filmmakers chose not to include one exchange that shows Warhol at a revealingly queer moment. The printed text indicates that de Antonio asked Warhol what he thought of the show recently curated by Henry Geldzahler for the Metropolitan Museum:

de Antonio: Were there any people in Henry's show whose work you didn't like?
Warhol: Oh, no. I like everything.
de Antonio: What did you like best about the show?
Warhol: I never did see the show.
de Antonio: You never went?
Warhol: I went to the opening, but I didn't go inside. I pretended to be Mrs. Geldzahler and invited everybody in. I just stayed on the stairs and didn't go in. So I never did see it.[28]

Art-world aficionados may well read such lightly-tossed-off responses as confirmation of their worst fears: Warhol as a walking composite of the critic who reviews a show without seeing it, the patron who attends an opening without perusing it, and the schlemiel who likes all art without being discriminating about it. But the further role he describes connects to an entirely different fear: the male artist who does psychic drag without worrying about it. (For female artists, doing psychic drag was expected, and the only way to be taken seriously in the male art world.) Here Warhol's naif performance makes a brief foray into the realm of

explicitly queer masquerade. The artist permits a glimpse of himself as the curator's wife, a matronly hostess welcoming visitors to the show. The joke acquires greater resonance through the fact that Geldzahler was gay, and was one of Warhol's closest confidants in the early sixties. Although they were not physically involved, they developed a trust and comradery with each other that gave their friendship some of the outward signs of a successful marriage. In spite of this, the moment in the interview is so fleeting, and so embedded in the larger context of Warhol's otherwise not-explicitly-queer performance, that the cross-dressing display flickers on and off almost subliminally. Queer readers are left to pick up on the reference as connoting queerness; audiences not so inclined are left to read the confession as merely another of his juvenile pranks—Andy playing dress-up with his parents' clothes, for instance; Andy mocking the Met. Here, as at other moments in his career, Warhol's queer performance takes place under the protective aegis of his naif-trickster performance. However, no matter how carefree he may have appeared, and no matter how much protection his adopted persona may have supplied, he was not working in a domain where it is possible for a man to do psychic drag without at least occasionally worrying about it.

To explore the nature of his performance more fully—the desires it addressed, the strains it involved—it's necessary to expand our angle of focus to include not just the prime arena of the sixties but earlier and later moments as well.

Putting Out Secrets

In his 1975 memoir *Philosophy*, Warhol offered a brief anecdotal account of his high school years. "I wasn't very close to anyone, although I guess I wanted to be, because when I would see the kids telling one another their problems, I felt left out. No one confided in me—I wasn't the type they wanted to confide in, I guess. We passed a bridge every day and underneath were used prophylactics. I'd always wonder out loud to everybody what they were, and they'd laugh."[29] Warhol gives the impression that asking about used prophylactics was the highlight of his otherwise dreary walks home during high school. The first time he asked, he may not have known the answer, although this is not to say the question was asked in innocence even then. That he continues asking makes it clear he wants something besides information. He says he felt left out and that he wanted people to confide secrets to him; his strategy for winning social favor was to make a game out of asking about

used prophylactics. What he devised could be called a "savvy-innocent" act, in which he presents himself as an innocent, but everyone is in on the joke that he's really not innocent. He says his companions laughed, but he doesn't say they became his close friends; the joke worked on its own terms but apparently didn't fulfill the other goal he had in mind. A few paragraphs later in *Philosophy*, Warhol talks about still feeling "left out and hurt" at age eighteen while living with roommates (22). Soon after that he talks about eventually giving up his search for confidants, turning instead to the companionship offered by a new television set and tape recorder (23–27).

The high school story serves as a template for Warhol's later behavior in several regards. The humor of the anecdote arises out of the ironic distance between taboo sexual content (used prophylactics) and the pretended innocence of the questioner. Each time Andrew repeats the question, his "innocence" gets to be newly violated. This "violation" is also a source of humor: the automaton who keeps asking the same question and can't retain the answer is a staple of classic comedy. But since the joke didn't help him with his original goal, the repetition also has an element of pathos. Perhaps the savvy-innocent act he devised, and the response it elicited, became more engaging to him than the search for intimacy. Just as the innocent act was not exclusively a pretext for the joke, so also the joke was not exclusively a pretext for making friends. The joke was also a coded way for a teenager to reveal that he was captivated by his own dirty thoughts, and at the same time to check whether other people had such thoughts too. A "code" was needed not because there was a stigma against having dirty thoughts (his audience, after all, consisted of fellow teenagers), but because such thoughts couldn't be spoken directly unless there was a close bond already established with the audience.

The story's message changes depending on the angle from which it is viewed. It could be lifted out and used as a scene from a teenage sex comedy, along the lines of *Porky's* or *American Pie;* it could also function in a more austere study in alienation—for instance, a queer variant on the Joycean portrait of the artist as a young man. Who tells the story, and what reasons they have for telling it, makes all the difference.

Warhol's savvy-innocent act underwent a host of permutations in later years, based on numerous factors: (a) how much savvy or innocence was needed in a given context; (b) changes in Warhol himself, and in what he wanted or needed from an audience; (c) changes in the audience, and in their responses; (d) changes in the nature of the taboo material involved; and (e) changes in the codes for presenting

taboo material, based on the need for distance or impunity. Adding the element of homoerotic desire or depiction to this schema complicates each of these factors, both socially (for Warhol) and epistemologically (for a critic).

The critic's position deserves a moment of scrutiny: by what hubris does a scholar conjecture that a "gay" artist felt such-and-such for so-and-so, or suppressed Knowledge A for Motives B and C? Even to offer the above interpretation of Warhol's account of his high school years, I am overlooking the fact that, like almost everything else in his published memoirs, the incident is possibly either misremembered, exaggerated, inaccurately transcribed, or apocryphal. What sustains me in making the interpretation is an intuitive sense that it did happen, and a storyteller's sense that it *should* have happened. Even if it didn't happen that way to Andrew, it happened to countless other queer boys (and girls) who also needed to test social limits among peers. This itself supplies a rationale for the story to be told.

Both Warhol and I tell stories. The ones I'm telling are about the ones he tells, and about how they inspire me, and how they sometimes leave me impatient or unconvinced, or intuitively conjuring an alternate version.

The material dealt with here involves stories about secrets. Andy is always *putting out secrets* of one kind or another, in one way or another. When he's not busy extending them, he's busy extenuating them. Sometimes he does both at the same time; sometimes it's hard to tell which is which.

Paradoxically, it wasn't until after Warhol found effective disguises for his gayness that he became a vigorous force in gay culture. Warhol's pop breakthrough in the early sixties is intimately linked with his ability to make his gay intentions illegible to the public at large. The Bockris biography indicates that the reception of his exhibit of frankly homosexual *Drawings for a Boy-Book* in 1956 came as a bitter object lesson about the constraints within which he had to work in order to gain attention in the fine-art world.[30] Not incidentally, 1956 was also the year he underwent nose-job surgery, an operation that brought disappointingly minor results; and the year in which, after extended travels with Charles Lisanby, he complained that he had "gone around the world with a boy and not even received one kiss."[31] By the early sixties he devised ways of getting around all these obstacles: his pop canvases avoid the

explicitness of his earlier drawings while still managing to convey gay messages for those who had eyes to see them; his fashion and persona makeovers circumvent the problem of his unattractiveness; and his collaborative working methods and expanded social sphere meant that a stream of beautiful men was now trailing after him. Further, soon after making his pop statement he embarked on a filmmaking career that allowed him to showcase a staggering variety of gay content. However, as Jonathan Flatley demonstrates in his essay "Warhol Gives Good Face," fashioning a public image involves both face-giving and face-taking gestures and does not come without cost, particularly for someone from a minority subgroup.[32] Flatley shows how the popism movement provided the auspices by which a "faggy, pasty-white, working-class queer from Pittsburgh" could become transfigured into the public sphere, even as it disembodied him, and failed to mourn what was lost in the bargain. A double concealment occurred, in which the working-class queer agreed to camouflage aspects of his stigmas, and the public at large agreed to overlook the traces of stigma that couldn't be fully camouflaged. On Warhol's side, the camouflage was provisional, partial, and inconsistent from one context to the next. On the public's side, agreeing to overlook the artist's stigmas, to the extent that it occurred, was not a function of courtesy, but of maintaining normative and dominant ways of seeing. Warhol's transformation into a pop person does not entail his fashioning a new closet for himself. Instead, it provides him a way of toying with the dominant culture's way of reading everything according to its own mandates. For Warhol as for anyone else, the practices of playing dumb about being gay are concomitant with the practices of an audience playing dumb about recognizing gayness. These practices, entrenched as they are in heterosexual and middle-class norms, have not significantly altered since the sixties, in spite of the post-Stonewall civil rights movement and outward changes in the social-political landscape.

It's worth reiterating that "coming out" in the ordinary sense of the term cannot be expected of someone with Warhol's background. This does not merely owe to his being accustomed to the homosexual codes of the fifties, but reflects his domestic arrangements and ethnicity as well. Except for brief interludes, such as when he first moved to New York, he spent his first forty-two years living with his mother, Julia. She witnessed a parade of attractive men at the house, but it's doubtful whether

she and Andy ever openly discussed his being gay.[33] Julia was nearly thirty before she left the remote village of Miková, in northeastern Slovakia near the border to Poland, to join her husband, Andrei, in Pittsburgh. To watch *Absolut Warhola* (2001), Stanislaw Mucha's documentary tour of the impoverished region she and Andrei grew up in, is to gain a new appreciation for the ethnic and class obstacles Andy had to overcome in order to achieve any degree of self-esteem as a homosexual man in New York. Featured in the film are a cross-section of Miková townspeople, including several of Andy's aunts and cousins. His relatives all reject the notion that Andy was gay, even when the interviewer challenges them on the point. They seem to have no mental concept of homosexuality, even to the extent of fearing it. One cousin says Andy's main failing is that he never married, and so didn't provide offspring who would have inherited his fortune. A male relative bets his *life* on the fact that Warhol wasn't a "you-know-what"; he can't have been, another says, because he was "a good person." Julia Warhola, née Zavacky, was born in Miková in 1892 and carried its customs and outlook indomitably through her remaining years in Pittsburgh and Manhattan.

Thus it should come as less of a surprise that Andy failed to become a "good gay subject"—the honored grand marshal of a gay pride parade striding down the streets of Manhattan, an AIDS ribbon pinned to his lapel, waving to onlookers alongside his devoted mother, herself a pioneer for the cause of PFLAG—than that he *succeeded* in generating so much queer-positive and sex-positive output during his adult life. Now that that story is at last being told, other stories, formerly untellable, may begin to surface.

Certain elements in Warhol's body of artistic work have become canonical symbols of sixties queer culture: the silkscreens of Elvis, Troy Donahue, and Marlon Brando (1962–64); the New York World's Fair mural of *Thirteen Most Wanted Men* (1964); the films *Sleep* (1963), *Blow-Job* (1963), *Haircut* (1963), *My Hustler* (1965), *Lonesome Cowboys* (1967), *Chelsea Girls* (1968), and *Flesh* (1968); the wrestling lesson in *The Loves of Ondine* (1967), the shower and changing-room scenes in *Bike Boy* (1967); and, more generally, the Factory's zealous promotion of drag queens, camp taste, underground style, and mind-altering experiments in gender, consciousness, rock music, and urban atmosphere. The Factory on East Forty-seventh Street (1963–68) was an alternative haven even for people who never got to see first-hand its silver-decor interior. It gave sustenance to people who didn't fit the molds of either the mainstream culture or the officially sanctioned styles of the counterculture. It was queer in certain ways that are no longer accessible

today. Of the work that is still viewable, Warhol's films in particular still retain their startling homoerotic impact. Their gayness inheres not only in their worshipful display of the male physique and their open explorations of same-sex attraction, but in their mesmeric allure, their avid dirty-mindedness and sex talk, their passion for low gossip and high bitchiness, their witty upside-down relation to mainstream Hollywood film, and their outrageous lack of outrage toward the acts and images they depict. Although same-sex desire among men appears more frequently than among women in this body of work, and generated more notoriety, films such as *Tub Girls*, *Women in Revolt*, and the "Hanoi Hanna" segment in *Chelsea Girls* also raised the ante for lesbianism in cinema. Wherever these films were shown they gave visible proof that queer sensibility was alive and well in America.

Writers such as Simon Watney, Mandy Merck, Michael Moon, Thomas Waugh, Jonathan Flatley, Jennifer Doyle, José Esteban Muñoz, Trevor Fairbrother, Fred Lawrence Guiles, Kathy Acker, Mark Finch, Richard Dyer, John Giorno, Matthew Tinkcom, Wayne Koestenbaum, Richard Meyer, Roy Grundmann, and Steven Watson all attest to the profoundly validating effects Warhol's art and livelihood had on emerging queer affinities and self-awareness.[34] In Warhol's formal output and beyond—in his prolific creation of cult icons and the settings in which they could be revered, in his establishing a refuge for gender misfits, in his sexually explicit post-pop work of the late seventies and eighties, in his courting and photographing countless men who crossed his path, in his serving as a visible model to other gay artists, and encouraging their work—in all of these ways and others, Warhol's contributions to queer identity and expression during and after the sixties can hardly be overstated.

To argue that Warhol also performs maneuvers of gay avoidance or removal, then, may invite charges of ingratitude, pettifoggery, or 20/20 hindsight. This argument is by no means my entire dossier, but the very idea may still seem perverse, given that Warhol was so much more exposed, shunned, and vilified as a queer presence than were other eminent homosexual men of his generation. Thomas Waugh calls him "the most visible gay filmmaker" of the sixties; Simon Watney writes, "Warhol was the one great homosexual artist in New York who refused to dehomosexualize himself."[35] My purpose in considering avoidance strategies on Warhol's part is not to distribute gay lib bonus-and-demerit points, nor to add insult to injury. Rather, it is to examine the complicated interplay between Warhol's homosexuality and the trickster and naif personas that he employed like personal retainers. This interplay

generates a structure of behavior that remains largely undetected and unexamined in readings of Warhol; and in turn it provides clues about how queer identities are managed today.

The anthology *Pop Out: Queer Warhol* (1995) has performed the invaluable service of demonstrating how queer Warhol's work is in the first place, and how art criticism and the mass media have pointedly and institutionally ignored this basic insight for decades. Wayne Koestenbaum's biography (2001) expands on this project, urging us to hunt in the margins, to look again at Warhol in relation to his assistants, his attachés, his Superstars, his mother, his movies, paintings, and photography, and to see gay desire saturating everything. The editors of *Pop Out* momentarily acknowledge that Warhol himself engaged in "de-gaying and strategic silences" as a way of surviving in a homophobic culture; and also, paradoxically, that the position he located in the straight art world gave him authority from which "he could sponsor and nourish queer communities, projects, and energies" (4). Their scholarship makes a further look at this contradictory terrain both possible and necessary. What might be learned from noticing the ignorance effects and trickster ploys Warhol used in his early pop work and his later memoirs? What did these gambits accomplish for him? In what ways might queer awareness and behavior still be marked (or enabled or hampered) by such strategies?

The Warhol who presides over and disseminates such a wealth of homophile material in the sixties is also supremely adroit at omitting *incontrovertible* evidence about his own desires. His career is a classic illustration of Eve Sedgwick's recurrent postulate about how the codes of gay "knowingness" are imbricated with codes of gay deniability.[36] Simultaneously Warhol carries the mantle of being the most notoriously swish and notoriously naive member of the New York artistic elite. As a homosexual artist making insurgent raids on a heavily guarded macho terrain, Warhol relies on "unwittingness" as his most valuable defense—a quality capable of charming friends and baffling enemies, and a form of damage control taken out against the more scandalous implications of his work.

Warhol finds cunning refuge in the very popism of his pop images, hiding himself in an audience of millions. Elvis and Troy radiate international box-office appeal, which diverts attention away from the specific attractions they held for the man who silkscreened them. These

"star attractions" are further distanced from the realm of homoerotic self-disclosure by the boy-girl logic Warhol promotes through finding female counterparts both for his male film idols (Marilyn, Natalie, Liz, Jackie) as well as for his own public appearances (Superstars Edie, Ultra Violet, Viva). By way of a double-entendre, Warhol's "most wanted men" ask to be scrutinized and pursued not only by the FBI and "concerned" citizens but also by gay men savvy enough to get the joke. And yet all these audiences are conceived impersonally, demographically: the mural depicts the popularly and generically *most* wanted men, not necessarily the men most wanted by Warhol.

At first glance, a grain of this logic of "mass mediation" may appear to filter through the more explicitly homoerotic film material. Everybody, and therefore not *particularly* Warhol, is wild about Paul America in *My Hustler*, Tom Hompertz in *Lonesome Cowboys*, and Joe Dallesandro in *Flesh*, *Trash*, and *Heat*. However, the audience for Warhol's films was much smaller and savvier, and this only begins to account for the ways that the double-codedness of his films differed from that of his early pop paintings. Warhol's was invariably the first (and usually only) name to appear on the theater marquis and in posters and ads; in print media it often appeared larger than the title. Even though Warhol, like the director John Waters, elected not to appear bodily onscreen in his films, what his films depict makes it impossible to set up a case for queer disavowal. The films give him queer agency at a second remove, where he could express it in terms other than his own needs, fantasies, and desires. What is queer about them is not that "Andy has sex like that" but rather "Andy makes movies like that."[37] Critics have likened the give-and-take, tantalize-and-withhold dynamic of his films to the erotically charged activities of winking, teasing, and cruising.[38] Warhol's film career, emerging in the year following his pop art debut at the Ferus Gallery, might be seen as a way of recasting his 1956 *Drawings for a Boy-Book* into a different medium and a much larger scale. If the fine-art world thwarted his desire to present images of gay desire before the public, it did not thwart him for long.

Although the social style he evolved in the early sixties didn't spare him from being ostracized in certain quarters, it did permit him a greater leeway in many regards, and afforded him new ways of toying with how he was received. His claim to having no feelings (the ultimately unconvincing stratagem of a delicate mama's boy)[39] conveniently helped him to dodge the question of whether his artistic output ever recorded *his* feelings. Andy's claim of also having no memory ("My mind is like a tape recorder with one button—Erase")[40] had a more genuine ring, despite

his exaggerating and joking about it. My sense is that this claim helped him explain his own sometimes-stymied, sometimes-pleased sense that his synapses didn't retain data.

Still, having no feelings or memory also precludes having any *gay* feelings or memory, and his statements might be seen as a form of political self-exemption. This may or may not have been part of the intent, but his comments certainly have a different flavor than, for instance, the title of one of Jasper Johns's paintings, *In Memory of My Feelings—Frank O'Hara* (1961). To acknowledge this is not to declare Johns as the more socially daring individual, but to allude again to the social gap separating the two artists, and to the alternative stakes they were working with. Having a naif public persona furnishes Warhol with a ready alibi of naughty-boy "innocence"—the impression that he was compelled to make his images and narratives out of childish curiosity rather than adult arousal; that he was drawn to a realm he could always, if challenged, claim not to understand. Transforming the open secret of his gay sexuality into a personal playground, Warhol manages during the sixties to be outrageously, notoriously gay as well as to carry himself with an air of someone who has no inkling of what he's doing. Warhol's flamboyant artistic output, his cryptic authorial presence, and the series of dislinkages he creates between them— these elements are both enacted and corroborated through the logic of naif-trickster performance.

Warhol's pose becomes more disjunctive and atavistic in the seventies and eighties, more like a Vegas lounge-act version of the virtuoso turn he maintains with seeming effortlessness in the sixties. The shooting in 1968 leaves him more cautious and circumspect, ages him, forces him to abandon his open-door policy at the Factory. In its new Union Square location the Factory takes on a guarded and entrepreneurial air. A phalanx of white-collar middlemen materializes to handle Warhol's expanding professional affairs, and the Factory ceases being a magnet for the kind of bohemian drop-ins that had previously inspired and assisted his work.

As Warhol's career migrates from painting and filmmaking to the realm of publishing, his now-you-see-it, now-you-don't relation to his gayness occasions provocative forms of contradictory self-assertion. In his self-revisionist writings he patents a two-fold de-gaying strategy— of seeking refuge from gayness in a master dialect of naif-tricksterism, and of spotlighting behavior that is even more outrageously gay than his own. The antics of Warhol in print, particularly in *Philosophy* and *Popism*, provide memorably autobiographical outworkings of his ap-

proach-avoid, assert-erase tactics. The books present a kind of scrap-book-album reverie on Warhol's greatest moments of the sixties, permitting both a nostalgic return to the heyday of the Silver Factory as well as an opportunity to doctor the record on his behalf. Finding refuge in both the historical and authorial removes permitted by memoir writing, Warhol presents a subtly altered account that soft-pedals and de-sexualizes his image.

Warhol's published works involve many layers of formal sleight-of-hand as well. Of primary relevance here is how the artist's tape-recorded monologues, filtered through the alembic of Pat Hackett's literary sensibility, gained a degree of polish and intelligence in the process. Bob Colacello writes of Hackett's editing, "She was brilliant at fixing Andy's sentences ever so slightly, so that he sounded less infantile, more articulate."[41]

The artist's famous celebration of drag queens as the "living testimony to the way women used to want to be" appears in *THE Philosophy of Andy Warhol (From A to B and Back Again)*, published in 1975.[42] Warhol says, "I'm fascinated by boys who spend their lives trying to be complete girls, because they have to work so hard" (54). The "because" clause here helps to preclude further discussion of what else about boys might fascinate Warhol. The intrigue of drag queens, Warhol asserts, lies in the fact that they work so hard, not that they are boys trying to be girls; or that they are boys, period. The passage is emphatic about the value of arduous labor: "What I'm saying is, it is very hard work. You can't take that away from them. It's hard work to look like the complete opposite of what nature made you" (54). While ostensibly celebrating drag culture, the passage manages to perform a dual sanitizing operation. It exonerates drag performance by establishing links to a redemptive work ethic; and it exonerates Warhol by countermanding the implication that his interest in drag queens might be prurient or sexual. Warhol positions himself as an ordinary member of the general public, effectively quarantining himself from the drag queens he previously welcomed at the Factory: "Drag queens are reminders that some stars still aren't just like you and me" (55). As the critic Caroline Jones writes, "Warhol's 'you and me' may have been a wished-for distance from the drag queens that was never as great as he hoped."[43] Casually inserting himself into the company of his readers, Warhol implies that all non–drag queens together form a cozy, homogeneous interpretive community. If there are homosexuals in this community, their presence is unheralded, seemingly uninvited.

The arts of inclusion and of exclusion crisscross each other in *Phi-*

losophy, ensuring that no direct, sustained access is granted to the matter of Warhol's sexual orientation. *Philosophy* includes a smattering of Warhol's offhand remarks about gay individuals: "that lesbian" (179); "Fags with dykes" (191); "She married a staple-gun queen" (47).[44] The offhandedness of such remarks precludes discussion of their homosexual content. Here Warhol constructs what D. A. Miller in his essay on Hitchcock's film *Rope* has called "a homosexuality of no importance."[45] The fact of someone's being gay is treated as a source of fun or derision but is not allowed to intrude on the narrative in any substantive way. Warhol's objectifying rhetoric develops the stamp of a full-fledged private lexicon in *Popism,* discussed below.

Warhol's female phone-partner in *Philosophy*, referred to as "B," does in fact speak hypothetically about Andy's attraction to men. B imagines Warhol at the White House as "the first non-married President"; she amends this impression by adding, "if you were President right now, there'd be no more First Lady. Only a First Man" (14). Later, B becomes upset when Andy abruptly leaves the phone without explanation; she accuses him of going off "to another part of the house with the delivery boy or the plumber" (225). These marvelous throwaway moments wittily insinuate same-sex attraction as Warhol's native domain, and present sturdy obstacles to any reading of *Philosophy* as a text consistently de-gaying itself. They typify the kind of low-voltage camp humor that is found throughout the book. At the same time, they are, technically, *thrown away* by Warhol; he neither confirms nor disconfirms the insinuations but lets the remarks pass without comment. B's attribution of Warhol's same-sex desire remains in the realm of hypothesis, awaiting substantiation by the individual reader.

While speaking about himself, Warhol characteristically remains guarded and surreptitious, careful to reserve a de-gayable space in the folds of his authorial persona. After remarking that he finds a man adorable, he asks B for permission to do so: "'Is it okay for guys to be adorable?'" (172). He speaks of having an affair with his TV set, and of his tape recorder as his wife (". . . my first tape recorder. My wife. My tape recorder and I have been married for ten years now" [26]). The admission is so deadpan that it is impossible to discern whether "wife" is used with hard- or soft-edged irony. One could say it has the campy air of the word "girlfriend" as used among gay men today; but this is not consistent with the passage's tone or with Warhol's use of gender-specific language in other contexts, such as the diaries. Even the nonmechanical love interests of his life are heterosexually coded. He uses a feminine pronoun while referring to his "romances" (50); he conjectures about

going to a female prostitute ("If I went to a lady of the night, I'd probably pay her to tell me jokes" [49]); and he mockingly refers to the role of "bringing home the bacon" (46, 92). He reports being "fascinated-but-horrified" when a renowned fashion model happens to share his bed one night (36).

The kind of dual logic played out in such accounts might be likened to that found in the romantic comedies of Cary Grant. The classic Grant hero has been predominantly viewed as a "harmless" straight man who presents an endearing alternative to traditional forms of male bluster. To a more trained and initiated viewer, however, he may be seen as a man of dubious sexual orientation who is having a good laugh at heterosexual convention while avoiding a too brazen display of gay intention. Warhol's working methods, of course, are far removed from Grant's. Grant relies on suave, outgoing courtliness, where Warhol recedes into an oddly boyish and enciphered nonchalance. Warhol, shuffling laconically between mutually opposed impressions, generates a more disturbingly indeterminate presence. The reader, presented with a series of artful dodges, is left to hash out a kind of multiple double negation: Don't mistake me for someone who isn't gay, but don't abandon the idea that I might not be gay.

Such negations are more than matched on the receiving end by forms of heterosexualizing logic practiced tacitly by readers: don't insist on being gay and we won't insist on seeing you that way. If this receptive logic ever threatens to become conscious, it has a safeguard: our not insisting on seeing you as gay has to do with tact and tolerance, not with their opposites. This act of reader "charity," however, extracts a toll: although we will politely look the other way on this issue, we still reserve the right to criticize you for failing to live up to heterosexual norms. Thus, the ways Warhol misidentifies himself have everything to do with a public's reciprocal investment in misrecognizing him. This is not to say that everyone agrees to look the other way, or that they are tactful about it. The list of those who weren't tactful with Warhol ranges from his father, to neighbors and school-kids who harassed him in childhood, to the gallery owners, art directors, and fellow-artists who shunned him because his art was too homoerotic, or his manner too swish and overt.

Nor is it a complete response to say that such maneuvers on Warhol's part are the exclusive result of internalized homophobia. D. A. Miller writes about similar maneuvers in the career of Roland Barthes: "Though always the effect of homophobia, however, such disappearing acts are not always performed homophobically."[46] After attending a fashion show

in Paris with his photographer friend Chris Makos, Warhol reported to his diary, "Christopher and I decided that we should start telling people that despite how we look and talk, that we're not gay. Because then they don't know what to do with you."[47] There can be no clearer indication that Warhol wanted actively to avoid being commodified by any publicity machine, or by the social matrix that lay behind it. He wanted exposure, of course, but on his own terms; and those terms involved actively baffling not only the press but any other corps that might otherwise "know what to do with" him. Such baffles were not part of an attempt to remake himself as a straight man in the public's eye, nor to barricade himself in a closet. They were a means of avoiding a politics of identity in favor of an aesthetics of mobility. The trail of false clues Warhol leaves behind him conveys the ambivalence of his relation to dominant heterosexual as well as to emergent homosexual cultures. Warhol's resistance to the post-Stonewall gay liberation movement, with its extroverted pride marches, rallies, and publicized outings, may be attributed to a host of inhibiting factors—among them shyness, envy, incomprehension, apoliticism. It is hard to imagine an artist accustomed to the homosexual codes of the 1950s not feeling a complex sense of disappointment and loss at the constricting labels and slogans, the procrustean options and anti-bohemian tones of the fledgling seventies gay movement.

In a profounder way, though, it's similarly hard to imagine someone of Warhol's temperament being able to thrive without a constantly maintained and revisited locus of inward retreat. Michael Moon points to the artist's vision of himself in *Philosophy*—a "cartoon idyll of happy solitary play"—as crucial to the adult Warhol's self-rehearsed sense of identity.[48] The passage appears early in chapter 1:

> I had had three nervous breakdowns when I was a child, spaced a year apart. One when I was eight, one at nine, and one at ten. The attacks—St. Vitus Dance—always started on the first day of summer vacation. I don't know what this meant. I would spend all summer listening to the radio and lying in bed with my Charlie McCarthy doll and my un-cut-out cut-out paper dolls all over the spread and under the pillow.
>
> My father was away a lot on business trips to the coal mines, so I never saw him very much. My mother would read to me in her thick Czechoslovakian accent as best she could and I would always say "Thanks, Mom," after she finished with Dick Tracy, even if I hadn't understood a word. She'd give me a Hershey Bar every time I finished a page in my coloring book. (21–22)

Victor Bockris reports that, according to Warhol's brothers, "Andy greatly exaggerated his bouts of St. Vitus' dance: He came down with

it seriously only once, and was really too young to have been worried about it. . . . Yet the emphasis Andy gave his illness in later life indicates how important the experience was to him" (20). Stephen Koch and Ultra Violet's biographies corroborate Bockris and Moon's conviction that Warhol never wandered far from his secret childhood *imaginaire*.[49] Such places of secrecy, as D. A. Miller has shown, are extraordinarily vital in terms of psychological self-preservation. Miller writes: "In a world where the explicit exposure of the subject would manifest how thoroughly he has been inscribed within a socially given totality, secrecy would be the spiritual exercise by which the subject is allowed to conceive of himself as a resistance: a friction in the smooth functioning of the social order, a margin to which its far-reaching discourse does not reach."[50] Warhol's imaginative childhood idyll, circa 1936, may be seen as the primary source of his "resistance" both to a work ethic fueled by 1950s conformism as well as, two decades later, to an ethic of social protest fueled by the human rights movement and Stonewall activism. His *imaginaire* was a realm safeguarded from, and antecedent to, the emergence of the homosexual, in both the psychological and historical senses of the phrase. Revisiting this site, dwelling there, granted Warhol a double immunity. It was a means of protecting the ludic and open-ended region of childhood sexuality over against the heavily partitioned domain of "responsible," "coherent" adult sexual identity; and it was a means of protecting a pre-politicized sense of homosexuality as relating to acts but not persons—or at least, not himself.

The kinds of about-faces and double-reversals Warhol performs, thus, cannot be metabolized to produce a cohesive political stance or a stock set of motives. Habitually, as is seen in two indicative passages from *Philosophy*, he seems both to posit and retract a gay identity almost simultaneously.

> At a certain point in my life, in the late 50s, I began to feel that I was picking up problems from the people I knew. One friend was hopelessly involved with a married woman, another had confided that he was homosexual, a woman I adored was manifesting strong signs of schizophrenia. I had never felt that I had problems, because I had never specifically defined any, but now I felt that these problems of friends were spreading themselves onto me like germs. (21)

The final hygienic term suggests that even if Warhol has not "specifically defined" adultery, homosexuality, or schizophrenia, he is in fact strongly repelled by the idea of "catching" them, and regards them ipso facto as problems rather than merely the problems three of his friends happen to

be facing. If the middle of these terms, homosexuality, is pried loose from its protective setting, the passage may be rendered as a series of four interconnected propositions: (a) being a homosexual is a problem; (b) I didn't have any problems; (c) I had never specifically defined any problems; and (d) now people's problems were spreading onto me like germs. Reading these propositions syllogistically, a number of possible corollaries emerge: (e) I'm not gay; (f) I'm not gay, but I'm catching it by hanging around gay people; (g) I'm gay, or I might be, but I'm not to blame because I caught it from a friend. Even without his making proposition (c) explicit, Warhol leaves a strong impression that he hasn't thought the issue through with any degree of rigor; and at the same time, that he is more than peripherally aware of boundaries of self-disclosure he must not cross.

The narrative continues as Warhol subsequently explains that wondering whether he had problems led him to seek psychiatric treatment (21); that his psychiatrist never called him after the first appointment (23); and that on the way back from this first and only session, he went shopping at Macy's, bought his first television set, brought it home, kept it on "all the time," and "right away I forgot all about the psychiatrist" (24). This follow-up material drives home a basic lesson: Warhol appears happy to go back to having no problems and no worries again, to the pattern he established before people contaminated him with their problems, and before he had to exert mental effort defining what their (or his) problems were. Warhol's brief foray into the uncertain terrain of troubled friends and unresponsive psychiatrists leads him back to the solaces of selfhood. The new television set Warhol buys thus becomes the literal and figurative medium by which he can barricade himself from caring and worrying about others. It serves as a latter-day manifestation of the radio, cutout paper dolls, and chocolates he depicted as the primary comforts of his bedridden childhood summers. Now, though, in spite of his light, deadpan tone, his stance carries an edge of boredom, apathy, cynical expediency, and callousness: "I kept the TV on all the time, especially while people were telling me their problems, and the television I found to be just diverting enough so the problems people told me didn't really affect me any more. It was like some kind of magic" (24). The "contagious problems" episode recounted in *Philosophy* mimics the movement charted by the book's subtitle, *From A to B and Back Again:* it traces the comically abortive journey of a bashful solipsist back to his own original state of blissful, and sexually unincriminated, naivete. Whether the episode stands to absolve or vilify Warhol depends on whether it is read sympathetically, as comedy, or against the grain, as something more akin to tragedy.

In a later passage, Andy simultaneously posits and retracts a gay identity while using a voice that anticipates Forrest Gump: "Mom always said not to worry about love, but just to be sure to get married. But I always knew that I would never get married, because I don't want any children, I don't want them to have the same problems that I have. I don't think anybody deserves it" (46). As before, the word "because" serves a truncative function, foreclosing on other reasons against marriage. The passage leaves a strong hint of other statements Warhol also might have made about himself, or seems to want his readers to infer: "I'm unmarried because I don't want children, not because I'm gay"; "Not wanting children is the only thing that prevents me from getting married"; "I'm not gay." However, remembering that, as Bob Colacello points out in his biography, "Having a problem was Andy's code word for gay,"[51] the alternative readings implied in the passage become more complex: I don't want to have children because I don't want them to be gay; I'm gay, and therefore I don't want to have children; being gay is hereditary; I wouldn't want to be burdened with a gay child; I wouldn't want a child of mine to be burdened with a gay father; nobody deserves to be burdened with a gay child or parent; nobody deserves to be gay; I hate myself because I'm gay. These are not statements that can or should be attributed directly to Warhol; yet the slippery imprecision of his language makes it impossible to disattribute them either. The characteristic spareness and seeming uninformedness of his utterances open the door for whole freightloads of associative meanings, meanings that context can neither confirm nor deny.

How, for instance, does one gauge the seriousness, irony, or campiness in a typical Warhol line such as "Beautiful jails for Beautiful People" (71), or "Ghetto space is wrong for America" (155)? Even an arsenal of literary and linguistic theories cannot account for the network of hearsay, misunderstanding, amusement, bafflement, and outrage Warhol's utterances are capable of generating. It's not just that he was, as Andrew Ross has said, "the bane of the intentionalist critic's existence,"[52] but that his statements actively refuse certain forms of stabilized meaning, and recurrently do so along the hetero/homosexual divide.

Warhol's diary entries also tend to defy epistemological closure, although this is an odd thing to say about a document that, at a more basic level, beggars description. In the last decade of his life Andy telephoned

his personal secretary, Pat Hackett, on a daily basis and mused out loud over events of the previous day. During this period Hackett transcribed a total of twenty thousand pages of this material, selecting eight hundred pages for publication after Warhol's death. Even in this compressed state, the diaries give ample room for Andy to linger over details of almost unfathomable banality. When they appeared in 1989, the diaries looked to many reviewers and parodists like an avalanche of minutiae about the wealthy and famous. Few were willing to see Warhol's formidable habit of name-dropping and celebrity schadenfreude as linked to the deprivations he had suffered while growing up, and the insecurities he still harbored as an adult.

The diaries can be punishingly short on insight, and yet in key passages Andy's refusal to explain himself becomes an evocative, even fecund presence. A 1981 entry illustrates Warhol's self-styled methods of wriggling as he tries to express, celebrate, reconcile himself to, and disconfirm same-sex desire: "I love going out with Jon because it's like being on a real date—he's tall and strong and I feel that he can take care of me. And it's exciting because he acts straight so I'm sure people think he *is*."[53] The object of affection here is Jon Gould, an attractive and outgoing young executive for Paramount Pictures in New York. Warhol met and fell in love with Gould in the spring of 1981, carrying a torch for him until Gould died of AIDS in September 1986, five months before Warhol's death. His interest in Gould stemmed at least partly from his long-thwarted desire to crack into legitimate filmmaking in Hollywood.[54] Warhol's diary entries record wide fluctuations of mood over Jon in the early months, from intense devotion and awkwardness to paranoid sensitivity and suicidal depression (367–83). At one point his excitement leads to machinations that make him sound like a young teenager: "I've offered Chris [Makos] a reward—this wristwatch he wants—if he can get Jon Gould to fall for me" (371). Both the Bockris and Colacello biographies argue that the relationship was unconsummated, although Warhol's housekeepers reported that Andy and Jon slept in the same bed.[55]

In the entry above, Gould seems to assume momentary status as the consolidated Mr. Right in Warhol's imagination—Gould kindles a host of responses, satisfies a host of needs, fulfills a host of fantasies. He is like the ideal answer to longings half-articulated not only in Warhol's subconscious but in a legion of contemporary gay personal ads. Such longings might be rearticulated as a kind of master statement of gay male desire in its passive form: "in search of someone to watch over me, to protect and overpower me, to be my personal bodyguard; someone

to relieve me of the burden of feeling queer all the time, and of growing old by myself; someone to reassure and authenticate me; a take-charge, type-A man to whom I can offer acquiescence and gratitude; someone who's a good date, who won't embarrass me in public; someone younger, taller, more attractive, more muscular and virile than I am; someone who likes men as much as I do but who maintains a seamless and absolutely convincing straight public performance." Beyond the desire to overcome queer isolation, and all it entails, the Gould diary entry hints at other longings as well: the thrill of dating, seducing, and corrupting a man who not only looks straight but *is* straight. At certain moments Warhol speaks with a remarkable candor, even if he resorts to a self-created vernacular that stubbornly shies away from taking stock of its own implications.

The entry may also be read in terms of the thrill of appropriating straight-appearing images for gay purposes; that is, Andy's excitement may lie in his being the only one in a crowd who knows Gould is not what he appears to be. This has to be counted as one of Warhol's life-long pleasures—the gay meanings he was able to extricate from, or superimpose upon, a wide range of male personas. These include Dick Tracy, Howdy Doody, Troy Donahue, Elvis Presley, and Joe Dallesandro, as well as Chairman Mao, Nikolai Lenin, Richard Nixon, Muhammad Ali, and a group of men wanted by the FBI.

Beyond this, the diary entry contains an audible sigh: "After a long day at the Factory, you'd be so nice to come home to." During the early 1980s Warhol was often socially isolated at the Factory, and at home he still felt the absence of another beautiful man, Jed Johnson, with whom he had lived for more than a decade, but who had moved out in December 1980. Andy also missed the motherly attentions of Julia, who had died in 1972. But his desire to acquiesce to a straight-looking man also may be taken as a sign of longing for his father—or at least *a* father, if not the remote disciplinarian he grew up with and came to fear from an early age. What Andrei left behind to his youngest son was a composite legacy—thirteen years of strict behavior and physical intimidation, followed by the three-day trauma of a corpse in the house, and then permanent absence, except in the form of financial provision.

Jon Gould did move into Warhol's townhouse in March of 1983, although he retained a separate residence, and by March 1985 he was staying with Andy only during business trips from Los Angeles. By the end of that year, those visits had ceased, and he was not even phoning Andy when he was in town. The break-up left Warhol bitter and despondent. In the face of so many absences, he managed to keep going mostly

by throwing himself into his work. Included in this work was the task of carting around a persona all day: the role of Andy Warhol was itself labor-intensive.

As the title suggests, *Popism: The Warhol Sixties*, published in 1980, shows a greater degree of social consciousness than do *Philosophy* or the diaries. It forgoes stylistic idiosyncrasies and indulgences in favor of a more self-possessed and historically grounded approach. By the same token, the book gives such scant attention to definitive elements in a great many other people's experience of the decade—such as protests against the war in Vietnam, the continuing civil rights movement, the political plight of blacks and women—that readers might assume these things were happening in a different country. Although the title may suggest that Warhol had a proprietary interest in the decade as well as the pop movement, the book's tone is easygoing and even-tempered rather than self-important. Both in small detail and in overall scope, *Popism* is assured and deliberative in ways that Warhol's other print-based works are not. Much of this owes to the education and writing skills of Pat Hackett; she is listed as coauthor, even though the book is ostensibly told from Warhol's unwavering first-person voice. *Popism* might more accurately have been billed as an "as told to" memoir, except for lingering doubts about who told what. According to David Bourdon, Hackett "did most of the writing, basing the text on her interviews with Andy's friends and colleagues."[56] Thus Warhol is credited with having said things he likely never even *heard* first-hand. (Again, I refer to statements attributed to Warhol in *Philosophy* and *Popism* as having originated from him, not just for convenience's sake but because, with his name on the label, they have the *effect* of having originated from him.)

Although *Popism* frequently refers to the homosexual element at the Factory, it also presents in more polished form Warhol's ability simultaneously to denote and disclaim gay desire. The book's celebrated anecdote, in which he learned that Robert Rauschenberg and Jasper Johns were snubbing him because he was too commercial, too swish, and too forward about being a collector of art, shows how Warhol uses naif-trickster methods to de-gay himself even while recounting an episode in which he stands accused of being swish.

And as for the "swish" thing, I'd always had a lot of fun with that—just watching the expressions on people's faces. You'd have to have seen the

Pop Trickster Fool

way all the Abstract Expressionist painters carried themselves and the kinds of images they cultivated, to understand how shocked people were to see a painter coming on swish. I certainly wasn't a butch kind of guy by nature, but I must admit, I went out of my way to play up the other extreme. (12–13)

What possible sense can be made of Warhol in 1980 pretending that being swish in the sixties had "always" been "a lot of fun"? As the passage unfolds in *Popism*, no sooner does he finish indicating how much it hurt him to be snubbed by Rauschenberg and Johns at the time, than he speaks as if he had no recollection of suffering from their homophobic ostracism and contempt. Further, no sooner does he quote de Antonio as saying that "the post-Abstract Expressionist sensibility is, of course, a homosexual one" (12), than he presents a transpositionally degayed version of his own image. The rhetoric he uses—"fun," "just watching the expressions," "play up the other extreme"—is closely reminiscent of his *Painters Painting* rhetoric and casts him firmly in the role of inspired mischief-maker rather than of desiring gay subject. The term "swish" itself has a substitutional or euphemistic effect, since it is more closely linked to the fifties vernacular of effeminacy and being a "window-dresser type" than it is to a specifically *sexualized* identity.[57] The timbre of "swish" in the fifties was primarily professional: in the crude logic of the period, it helped explain why certain men gravitated toward the fields of window-dressing, flower arrangement, hairdressing, and interior decoration. Being "swish" in Warhol's book is connotatively divorced from being gay, from being (as he says in a later passage in *Popism*) "so gay you can't believe your eyes" (222).

Warhol characteristically establishes a distance between his own desires and the attractions of the men he describes. Introducing Freddie Herko, he says, "The Judson dancer I was absolutely fascinated with was a very intense, handsome guy in his twenties" (55). The phrasing implies that his fascination with Herko owes more to the man's chosen profession than to his other attributes. Recurrently *Popism* reveals Warhol's objectified way of describing other men as attractive while avoiding the suggestion that he in particular is attracted *to* them. As presented in the book, male pulchritude mostly exists in a realm from which the author seems to be hermetically sealed. Discreetly entranced, Warhol watches and records from a safe remove: "a tall, good-looking Harvard guy with blond hair and green eyes" (112); "unbelievably good-looking—like a comic-strip drawing of Mr. America" (124); "very cute, very sexy lead singer" (190); "young,

good-looking, and beautifully tailored" (214). A number of Andy's given tendencies—his shyness, his acute consciousness of his own appearance, his fraught relation to sexuality, his bafflement about gay politics—collude with the conventions of first-person omniscient narrative voice to make certain self-disclosing locutionary structures unspeakable. He never says anything as sexually incriminating as "I loved his eyes," "I was intensely drawn to him," "I fell for him on sight," "I couldn't get him out of my mind."[58] Warhol retains a circumspect and passive stance even when presenting more subjective information, describing a party attended by a number of young Hollywood actors as "the most exciting thing that had ever happened *to* me" (42, emphasis added).

He refers to the gay element in his entourage and films with a preemptive, unconcerned dryness: "The Factory A-men were mostly fags" (62); "It was the story of an old fag" (125); "a movie about a one-woman all-fag cowboy town" (259). In these passages "fag" appears as a self-contained, self-explanatory term needing no gloss, as if it were beneath further mention. Often Warhol signals gay behavior ventriloquistically, like a smart-aleck grade-school kid maintaining a straight face while smuggling dirty words into a class oral presentation. He seems to take particular delight in repeating stories that feature homophobic epithets and gay-bashing: "This friend got busted for something like 'sodomy in a steam bath' and lost his teaching job" (53); "Ondine came out from the back holding a huge jar of Vaseline and launched into a whole big tirade against drag queens and transvestites" (101); "Then she added, 'Good luck with that fairy'" (104); "'don't think we're going to forget you're still our queen!'" (187); "Then the group of sightseers marched in to 'You fags! You queers!'" (261); "'you're all a bunch of fags!' . . . 'Listen, you fag bastard!'" (267–68). In such accounts the phenomenon D. A. Miller describes as a "homosexuality of no importance" is promoted into a louche form of storytelling. The casualness with which these anecdotes are conveyed has an edge of cruelty; it's as if Warhol, or Drella, as he was also known, had devised a cunning new form of blood sport.

As if to compensate for this, Warhol devotes a prominent section to defending gay men at the Factory against outside attack. Referring to the press's moralizing put-downs of Factory homosexuality and drug use, Warhol wonders aloud, "Why are they attacking *us?*" (222). But in the very attempt to vindicate this targeted group, he appears to set the group up as a different kind of target. Again, the pronouns "us" and "we" silently morph into "it" and "you":

Naturally, the Factory had fags; we were in the entertainment business and—That's Entertainment! Naturally, the Factory had more gays than, say, Congress, but it probably wasn't even as gay as your favorite TV police show. The Factory was a place where you could let your "problems" show and nobody would hate you for it. And if you worked your problems up into entertaining routines, people would like you even more for being strong enough to say you were different and actually have fun with it. (222)

In less folksy language, the logic communicates, "We are not gay. However, we are in the entertainment business, and we bring gay people to the Factory because they provide such a rich source of entertainment. It's true, their homosexuality is a problem, but here at the Factory, we refuse to hate anyone on the grounds of homosexuality alone. On the contrary, a person could transform his homosexuality from a problem into a virtue, provided he was able to make it sufficiently entertaining. Then we would reward him for having the courage to promote and redeem his otherwise problematic minority status." A charitable view of the passage would acknowledge how it posits tolerance and creative self-transformation as Factory virtues. But the language Warhol uses conveys the impression that the tolerance is repressive and the transformation coerced. In the effort to advocate for gay men at the Factory, Warhol winds up advancing a gay Uncle Tom stereotype.

To acknowledge this stereotype, however, is not to erase Warhol's effort to challenge stereotypes. He goes on immediately to say, "What I mean is, there was no hypocrisy at the Factory, and I think the reason we were attacked so much and so vehemently was because we refused to play along and be hypocritical and covert." Warhol's plea for less hypocrisy and covertness in the public domain may be seen as all the more poignant because of the hypocrisy and covertness of the plea. Implied in the passage is yet another covert plea: "Let there be greater leeway and openness in this matter so that all of us, myself included, can enjoy greater leeway and openness in this matter."

Warhol in print does sometimes allow himself greater leeway in this matter, and such moments have a miraculously tonic effect—not just because of the social resistance to them but because of what appears elsewhere as his own psychological resistance to them. Near the end of *Popism*, after alluding to the "big nude theater craze" of '69, Warhol offers a jarringly frank account of his most prurient interests. Notably absent is the hermetic seal and the other subtly de-gaying, de-sexualizing protective stances Warhol employed, such as we saw in chapter 1 in his diary entry on Catherine Guinness and going to a porn theater.

For whatever reason, he is able here to discard customary roles such as the passive receiver, the innocent bystander, the helpless naif, and the ventriloquist dummy:

> During this period I took thousands of Polaroids of genitals. Whenever somebody came up to the Factory, no matter how straight-looking he was, I'd ask him to take his pants off so I could photograph his cock and balls. It was surprising who'd let me and who wouldn't. Personally, I loved porno and I bought lots of it all the time—the really dirty, exciting stuff. . . . (I was so avid for porno that on my first time out of the house after the shooting I went straight to 42nd Street and checked out the peep shows with Vera Cruise and restocked on dirty magazines.) I'd always wanted to do a movie that was pure fucking, nothing else, the way *Eat* had been just eating and *Sleep* had been just sleeping. So in October '68 I shot a movie of Viva having sex with Louis Waldon. I called it just *Fuck*. (294)

Here Warhol reveals himself with uncharacteristic directness as someone having an unquenchable craving for male nudity, social provocation, and hard-core pornography.[59] Although Warhol is accompanied by a woman on his Forty-second Street venture, and doesn't vouchsafe why his film inspiration had to involve a heterosexual couple rather than a same-sex one, he still leaves no doubt about his attraction to men's genitalia, his voyeuristic passion, and his voracious dirty-mindedness. I realize that not all readers will see his voicing these attractions as similarly laudable ways of affirming queer identity; and also that throwing off hypocrisy and covertness can bring a new set of problems. But given the kinds of obstacles Warhol faced—from external factors having to do with a sex-phobic, Puritan-based society, to a host of internal factors thrown into the bargain—this passage still amounts to a courageous, even miraculous assertion of desire.

Further compounding such incongruities, the publications of *Philosophy* in 1975 and *Popism* in 1980 are interspersed with the most homoerotically explicit visual work of Warhol's career: the *Athletes* and *Torso* series (1977), which includes closeup shots of anal penetration; drawings such as *Untitled (Boys Kissing)* (1980), which recall his 1956 *Drawings for a Boy-Book;*[60] a poster for the Fassbinder film *Querelle* (1982); and the portrait *Keith Haring and Juan DuBose* (c. 1983). Another form of daring self-exposure during this period includes a series of photographs he posed for, wearing women's wigs, lipstick, eyeliner, mascara, rouge, and false eyelashes (1980–82). These portraits, as well as the *Andy Warhol's TV* show begun in the late seventies, give evidence that he outlived whatever compunctions kept him from want-

ing to appear in front of the camera. Is it more remarkable that he created this visual work, or that he still felt he needed to project a tamer, more distanced view of himself in his memoirs? It is as if desires that could at last be proclaimed directly through images needed to be retracted through the subterfuge of words.

Warhol was canny about the effects his words created, and yet he was hampered by them in a way he was not with images. As the next chapter articulates, in many ways it's surprising that he chose to record himself in words at all, since he recurrently noted how poorly he used them. Bob Colacello has remarked that Warhol "tended to get convoluted when he went beyond ten or twelve words, as if English were his second language."[61] Wayne Koestenbaum writes, "Warhol's intensest experiences were visual, not verbal, yet he remained fascinated by his own difficult, hampered process of verbalization."[62] Is it unfair, then, to analyze his words so closely, or to use them against him? This may be akin to asking a man gifted and trained as a musician to account for himself in terms drawn from linguistic philosophy. But despite recurrent qualms about his language abilities, Warhol did choose to present his utterances in published form. Whether one reads them with or against the grain, whether they are reasonable facsimiles of his thoughts or marred by the presence of intervening editors, the words attributed to him reveal structures of behavior that are enduringly relevant to gay experience: to how alternative sexuality remains explosively charged, and produces ways of speaking in which sexual identity is managed, divulged, and retracted, sometimes all at once.

It must be remembered that Warhol's published accounts circulated long after he had cut himself off from all the "crazy, druggy people" who had sustained his work in the sixties; by this time he had begun professionally courting the likes of Imelda Marcos and the shah of Iran. By the seventies and eighties he had also lost the fervor of his great adversarial relation to the New York School. At no point does Warhol's career present a smooth, coherent front, either politically or otherwise. The methods he uses in his autobiographical writings must be seen in the context of his other output at the time and placed on a continuum with methods he had employed in the sixties and earlier. Warhol discovered novel and contradictory applications for cultivated naivete throughout his life, and as he did so, he crossed and recrossed traditional political, social, and epistemological demarcations. To the public it must seem that he did so in a spirit of amiable insouciance; but behind the playfulness there is evidence of a more fraught reality. In his most productive period his ruses revealed untruths (or half-truths)

about an entire Western episteme; and yet these ruses retain a symbiotic link with later ploys that revealed untruths (or half-truths) primarily about himself.

Returning to the quotation that begins this section, one could say that, after high school, Warhol found ever more devious methods of wondering out loud—"always," "every day," to "everybody"—what used prophylactics were. His repeating the joke about used prophylactics day after day, even when it failed to win him close friends, may come as a further indication of how he wanted to be a machine, or at least settled for being one in public. Maybe the savvy-innocent act he devised did indeed come to engage him more than the intimacy he had supposed it would lead to. Wondering about prophylactics provided him with ways of attracting people and also holding them in abeyance; of putting secrets out and then half-retracting them; of having dirty thoughts and still coming off like a cherub.

The material examined here offers new inroads into the enigma of the private Warhol, but it also presents rich terrain for exploring the special affinities and antagonisms that exist more generally between cultivated naivete and queerness. Warhol is far from alone in having invented myriad uses for naivete as an instrument of personal and social self-preservation. Witness the conspicuously unattached male employee who plants clues around the office about his after-hours girlfriend; the lesbian activist softening her image at a family gathering; the bisexual Latina teenager who politely endures her father's traditional and peremptory dating advice; the man who actively resists admitting to himself, let alone his wife of many years, that he is sexually attracted to men; the member of a women's support group who valiantly wants to uphold her "questioning" status in the face of everyone else's assuming she's a dyke; the same-sex couple recoding their apartment in preparation for a visit from relatives; this couple's relatives, who assume they are being cued to ignore something that has been obvious to them for quite some time; the young man who knows his mother knows he is gay, and the same mother who knows her son knows she knows—both of whom are firmly committed never to broaching the topic, no matter how layered, intertwined, or obsessive their knowledge about each other's knowledge becomes. Without benefit of coach or tutor, each of these people becomes a master of ignorance effects—effects which they may only be passingly aware of using. The unmaskings and remaskings of the performers Paul Reubens/Pee-Wee Herman and Michael Jackson further attest to the inherently volatile nature of queer/naif celebrity in a culture of knowingness.

In a much quieter way, so does the suspiciously de-gayed and self-exculpatory voice of the gay writer Andrew Sullivan, whose chiseled, unimpeachably civil prose style in *Virtually Normal* carries a detectable undertone of Catholic choirboy innocence.

A central chord in the culture of knowingness, as Eve Sedgwick has written, is the "reserve force of information, the reservoir of presumptive, deniable, and unarticulated knowledge in a public that images itself also as a reservoir of ever-violable innocence."[63] This culture's labor-intensive maintenance of its own sense of innocence and violability, particularly regarding sex and sexuality, creates endless new doublebinds for individuals who will not or cannot abide by its strictures. Such a culture mandates the activity of performative naivete, and it presents inordinate challenges to citizens who attempt to safeguard and cultivate a queer sensibility. In a host of ways today, queer individuals still feel the imperative to make certain disclosures inaccessible, certain questions unaskable, and certain answers unintelligible. They are also shrewdly alert to the progressive and transforming uses of naivete, whether it is employed unobtrusively or flamboyantly, whether to expose prejudice or to tweak convention, whether it be in the guise of the Socratic ironist or the uncomprehending clown.

Notes

The epigraph for this chapter is a statement by Andy Warhol that appeared in the *New York Herald-Tribune* and was quoted in Victor Bockris, *The Life and Death of Andy Warhol* (New York: Bantam, 1989), 106.

1. The epigraphs to this section are from the following sources: Robert Motherwell, "What Abstract Art Means to Me," *Bulletin of the Museum of Modern Art* 18:3 (Spring 1951), rpt. in Herschel Chipp, *Theories of Modern Art* (Berkeley: University of California Press, 1968), 562; and Andy Warhol, in *Andy Warhol in His Own Words,* ed. Mike Wrenn (New York: Omnibus Press, 1991), 33.
2. See Amelia Jones, *Postmodernism and the En-Gendering of Marcel Duchamp* (New York: Cambridge University Press, 1994), 20–21.
3. Jonathan Katz, "The Art of Code: Jasper Johns and Robert Rauschenberg," in *Significant Others*, ed. Whitney Chadwick and Isabelle de Courtivron (New York: Thames and Hudson, 1993), 192.
4. Karal Ann Marling, "Hyphenated Culture: Painting by Numbers in the New Age of Leisure," *As Seen on TV* (Cambridge, Mass.: Harvard University Press, 1994), 64–65.
5. On the near-impossibility of being a female abstract expressionist, see Michael Leja, "Gender and Subjectivity," *Reframing Abstract Expressionism* (New Haven: Yale University Press, 1993), 253–68; and Anne M. Wagner's

essays "Lee Krasner as L.K.," *Representations* 25 (Winter 1989): 42–57, and "Fictions: Krasner's Presence, Pollock's Absence," in Chadwick and de Courtivron, *Significant Others,* 222–43.

6. Dore Ashton, *The New York School: A Cultural Reckoning* (New York: Viking, 1973), 198.

7. Ibid., 166–68.

8. Marling, "Hyphenated Culture," 67.

9. Ibid., 62. On the gendering of mass culture as feminine, see Andreas Huyssen, "Mass Culture as Woman: Modernism's Other," *After the Great Divide: Modernism, Mass Culture, Postmodernism* (Bloomington: Indiana University Press, 1986), 44–62; and A. Jones, *Postmodernism,* 18–21.

10. Marling, "Hyphenated Culture," 67.

11. Ann Gibson, *Issues in Abstract Expressionism: The Artist-Run Periodicals* (Ann Arbor, Mich.: UMI Research Press, 1990), 3, and "Abstract Expressionism's Evasion of Language," in *Abstract Expressionism: A Critical Record,* ed. David and Cecile Shapiro (New York: Cambridge University Press, 1990), 198–205.

12. See Ashton, *New York School,* 189–92.

13. Allan Kaprow, "Pop Art: Past, Present and Future," *Malahat Review* (July 1967); rpt. in Carol Anne Mahsun, *Pop Art: The Critical Dialogue* (Ann Arbor, Mich.: UMI Research Press, 1989), 63.

14. Gene Swenson, "What Is Pop Art?" *ARTnews,* Nov. 1963 and Feb. 1964; rpt. in Mahsun, *Pop Art,* 112, 124.

15. See Andy Warhol, *THE Philosophy of Andy Warhol* (New York: Harcourt Brace, 1975), 21–22; Bockris, *Life and Death,* 18–22; and Michael Moon, "Screen Memories, or, Pop Comes from the Outside: Warhol and Queer Childhood," *Pop Out: Queer Warhol* (Durham, N.C.: Duke University Press, 1996), 78–100.

16. Bockris, *Life and Death,* 117.

17. Jackson Pollock's celebrated claim is quoted in Barbara Rose, *American Art since 1900,* rev. ed. (New York: Praeger, 1975), 212. For a fuller contrast between Warhol and Pollock, see Amelia Jones, "The 'Pollockian Performative' and the Revision of the Modernist Subject," *Body Art/Performing the Subject* (Minneapolis: University of Minnesota Press, 1998), 53–102. Jones effectively deconstructs Pollock's public image and its investment in American notions of individualism and masculinity, and in late-Romantic notions of genius and transcendence.

18. Bockris, *Life and Death,* 120.

19. Quoted in Jean Stein, *Edie: An American Biography* (New York: Knopf, 1982), 257. Warhol prompted a similar response from Frederick Eberstadt in the early sixties: "Here was this weird coolie little faggot with his impossible wig and his jeans and his sneakers and he was sitting there telling me that he wanted to be as famous as the Queen of England! It was embarrassing" (quoted in Bockris, *Life and Death,* 102).

20. John Giorno, one of Warhol's sexual partners in the early sixties, and the model for his film *Sleep,* writes, "The art world was homophobic. . . . De Kooning, Pollock, Motherwell, and the male power structure were mean straight pricks. No matter their liberal views, they deep down hated fags. Their

disdain dismissed a gay person's art. On top of it, those guys really hated Pop Art. . . . I am a witness to their being cruel to Andy Warhol." Giorno, *You Got to Burn to Shine* (New York: High Risk Books, 1994), 132–33.

Homophobic epithets were readily available at the Factory as well, as is seen when Brigid Polk explodes at Warhol in 1971, "You're nothing but a fucking faggot! You don't care about anyone but yourself!" Quoted in Bob Colacello, *Holy Terror: Andy Warhol Close Up* (New York: Harper, 1991), 66.

21. Jennifer Doyle, Jonathan Flatley, and José Esteban Muñoz, the editors of *Pop Out: Queer Warhol* (Durham, N.C.: Duke University Press, 1996), write that "with few exceptions, most considerations of Warhol have 'de-gayed' him" (1).

22. The epigraphs for this section are from the following sources: Hilton Kramer, quoted in Emile de Antonio and Mitch Tuchman, *Painters Painting* (New York: Abbeville Press, 1984), 119; Alfred C. Walters, quoted in Patrick S. Smith, *Warhol: Conversations about the Artist* (Ann Arbor: UMI Research Press, 1988), 144. For the discussion of the nicknames "Raggedy Andy" and "Andy Paperbag," see Calvin Tomkins, "Raggedy Andy," *The Scene: Reports on Post-Modern Art* (New York: Viking, 1976), 35–54.

23. See Charles Harrison and Fred Orton, "Jasper Johns: 'Meaning What You See,'" *Art History* 7:1 (Mar. 1984): 76–101; Katz, "The Art of Code," 188–207; and Kenneth E. Silver, "Modes of Disclosure: The Construction of Gay Identity and the Rise of Pop Art," in *Hand Painted Pop: American Art in Transition, 1955–62*, ed. Russell Ferguson (New York: Rizzoli International, 1992), 178–203.

24. Silver, "Modes of Disclosure," 180.

25. The documentary (which de Antonio produced for Turin Film Corp.) later appeared in retrospective book form (Emile de Antonio and Mitch Tuchman, *Painters Painting* [New York: Abbeville Press, 1984]). Quoted material from this section refers to the film version, unless noted by a page number from the printed text (the book includes minor inaccuracies of transcription).

A stable reading of Rauschenberg, Johns, and Warhol's participation in the documentary is hampered by a number of factors: (1) editing cuts introduce the problem of reconstructing an accurate sequence; (2) de Antonio selected the context in which the artists were filmed, and to some extent elicits command performances; and (3) Rauschenberg and Johns are both seen with drinks in hand, and Rauschenberg in particular shows signs of inebriation (see de Antonio's description of the conditions of filming, pp. 22–23). I've tried as much as possible to accommodate these factors in my reading.

26. Frankenthaler's appearance in the documentary is a model of self-composure, elegance, and restraint. See the passage in chapter 1 on gender and naivete in relation to the New York School.

27. Andy Warhol and Pat Hackett, *Popism: The Warhol Sixties* (New York: Harcourt Brace Jovanovich, 1980), 248–49.

28. The show referred to is New York Painting and Sculpture: 1940–1970. The exchange appears in the text on pp. 129–30.

29. The quotation that opens this section is from Warhol, *Philosophy*, 22.

30. Bockris, *Life and Death*, 84.

31. Quoted in ibid., 87.
32. Jonathan Flatley, "Warhol Gives Good Face: Publicity and the Politics of Prosopopoeia," in Doyle et al., *Pop Out,* 101–33; see esp. 102–4 and 113–16.
33. However, during a bizarre interview Mrs. Warhola once blurted out her hopes about Andy marrying "one of the boys" and getting "a little baby." See Caroline A. Jones, *Machine in the Studio: Constructing the Postwar American Artist* (Chicago: University of Chicago Press, 1996), 247.
34. The first seven authors listed contributed to *Pop Out: Queer Warhol,* and many of them have written material on Warhol elsewhere. Other authors in *Pop Out* include Eve K. Sedgwick, Brian Selsky, Marcie Frank, and Sasha Torres. See also Trevor Fairbrother's essay "Tomorrow's Man," in *"Success Is a Job in New York . . .": The Early Art and Business of Andy Warhol* (Pittsburgh: Carnegie Museum of Art, 1989), 55–74; Fred Lawrence Guiles's *Loner at the Ball: The Life of Andy Warhol* (New York: Bantam, 1989); Kathy Acker's "Blue Valentine" and Mark Finch's "Rio Limpo: 'Lonesome Cowboys' and Gay Cinema," in *Andy Warhol: Film Factory,* ed. Michael O'Pray (London: British Film Institute, 1989), 62–65 and 112–17, respectively; Richard Dyer's *Now You See It: Studies on Lesbian and Gay Film* (New York: Routledge, 1990), 149–62; John Giorno's *You Got to Burn to Shine;* Matthew Tinkcom's "Warhol's Camp," in *Who Is Andy Warhol?* ed. Colin MacCabe et al. (London: British Film Institute and Andy Warhold Museum, 1997), 107–16; Wayne Koestenbaum's *Andy Warhol: A Penguin Life* (New York: Viking Penguin, 2001); Richard Meyer's "Most Wanted Men: Homoeroticism and the Secret of Censorship in Early Warhol," *Outlaw Representation: Censorship and Homosexuality in Twentieth-Century American Art* (New York: Oxford University Press, 2002), 95–157; Roy Grundmann's *Andy Warhol's "Blow Job"* (Philadelphia: Temple University Press, 2003); and Steven Watson's *Factory Made: Warhol and the Sixties* (New York: Pantheon, 2003), among many others.
35. Thomas Waugh, "Cockteaser," in Doyle et al., *Pop Out,* 68; Simon Watney, "Queer Andy," ibid., 25.
36. See Sedgwick's writings on Wilde, Henry James, and Proust in *Epistemology of the Closet,* and her essay, cowritten with Michael Moon, "Divinity: A Dossier, a Performance Piece, a Little-Understood Emotion": "the rabid frenzies of public deniability are an inextricable part of the same epistemological system as the sophisticated pleasures of public knowingness." Sedgwick, *Tendencies* (Durham, N.C.: Duke University Press, 1993), 223.
37. I am indebted to Michael Levenson for this insight.
38. Waugh, "Cockteaser," 60–62. The critics alluded to are Stephen Tropiano, Bruce Brasell, and Waugh himself. In this regard Caroline Jones's assertion that Warhol's films prior to 1968 are "silent on the subject of the author's homosexuality" is technically accurate but shortsighted (*Machine in the Studio,* 256).
39. See Warhol, *Philosophy,* 111.
40. Ibid., 199.
41. Colacello, *Holy Terror,* 75.
42. Warhol, *Philosophy,* 54–55. The "literary assembly line" production of

Warhol's *Philosophy* is discussed in Bob Colacello's biography *Holy Terror,* 207–8; its public and critical reception is discussed in Bockris, *Life and Death,* 292–93. Colacello describes the manuscript's circuitous editorial journey from himself to Warhol to Brigid Berlin to Pat Hackett, back to Warhol, and finally on to the publisher, Harcourt Brace Jovanovich. At times, Warhol's voice gets lost in the shuffle. A statement in a prepared-lecture style, such as "Drags are ambulatory archives of ideal moviestar womanhood" (54), sounds patently unlike anything Warhol would have ever said.

43. C. Jones, *Machine in the Studio,* 231.

44. "Staple-gun queen" was Warhol's pejorative term for Johns and Rauschenberg during the seventies (see Colacello, *Holy Terror,* 26). The staple-gun was a tool all three of them had used earlier as window decorators. The term seems to serve an expiatory function, allowing Warhol to out the two artists as well as to have a good laugh at their more closeted situation. As seen earlier, Johns and Rauschenberg were closeted in numerous senses: in their being homosexually inclined, in their being romantically involved, and in their supporting themselves as window decorators. Warhol's phrase bears testament to his lingering resentment over how they treated him during the sixties.

45. D. A. Miller, "Anal *Rope,*" *Representations* 32 (Fall 1990): 116.

46. D. A. Miller, *Bringing Out Roland Barthes* (Berkeley: University of California Press, 1992), 14.

47. Andy Warhol, *The Andy Warhol Diaries,* ed. Pat Hackett (New York: Warner, 1989), 369.

48. Doyle et al., *Pop Out,* 81.

49. Stephen Koch, *Stargazer: Andy Warhol's World and His Films,* 2nd ed. (New York: Marion Boyars, 1985), ix; Ultra Violet, *Famous for Fifteen Minutes* (New York: Avon, 1988), 94.

50. D. A. Miller, "Secret Subjects, Open Secrets," *The Novel and the Police* (Berkeley: University of California Press, 1988), 207.

51. Colacello, *Holy Terror,* 42.

52. Andrew Ross, *No Respect: Intellectuals and Popular Culture* (New York: Routledge, 1989), 168.

53. Warhol, *Diaries,* 377.

54. David Bourdon, *Warhol* (New York: Abrams, 1989), 387, 392, 394.

55. See Colacello, *Holy Terror,* 438–42, 467–73; and Bockris, *Life and Death,* 321–22, 334–35.

56. Bourdon, *Warhol,* 386.

57. Truman Capote, among others, applied the implicitly derisive term "window-dresser type" to Warhol (Bockris, *Life and Death,* 90).

58. An exception proves the rule in this case: in the *Diaries,* Warhol tonelessly registers a passing infatuation with a player for the Los Angeles Rams: "Fred Dryer's 6'6" and he's so good-looking I fell in love with him. He wants to go into acting. I was embarrassed when he asked me what number he was and I didn't know" (330).

59. Interestingly, the parenthetical sentence on the aftermath of the assassination attempt in '68 finds parallel in the gay German film *Taxi zum klo* ("Taxi to the john"), released in the United States the same year *Popism* appeared.

108

60. Bourdon, *Warhol*, 372.
61. Colacello, *Holy Terror*, 251.
62. Koestenbaum, *Andy Warhol*, 164.
63. Sedgwick, *Tendencies*, 227.

One of the major difficulties Trillian experienced in her relationship with Zaphod was learning to distinguish between him pretending to be stupid just to get people off their guard, pretending to be stupid because he couldn't be bothered to think and wanted someone else to do it for him, pretending to be outrageously stupid to hide the fact that he actually didn't understand what was going on, and really being genuinely stupid. He was renowned for being amazingly clever and quite clearly was so—but not all the time, which obviously worried him, hence the act.

—Douglas Adams, *The Hitchhiker's Guide to the Galaxy*

Anti-cogito:

The Search for

Warhol's Brain

Counting Marbles

Andy Warhol's performance of naivete is no less charged in basic intellectual terms than it is in matters of gender identity and professional self-presentation. The workings of his brain have concerned people from a variety of spheres for more than half a century now. From the artist's childhood to the present, his intimates and critics have persisted in trying to describe what they saw, or thought they saw, in how his mind operated. How smart was he? How smart did he let on to being? Was he in fact intelligent at all? What kind of intelligence did he have? Few among his family members, friends, teachers, business associates, and Factory acquaintances were able either to avoid pondering such questions or to reach conclusive answers. Many years after his death Warhol continues to polarize experts much the way he divided the faculty of schools he attended in his youth. In recent years scholars have alternately characterized Warhol as a sixties intellectual; as someone who had the saving grace of being "never in the least intellectual"; and as "the great idiot savant of our time."

Efforts both to credit and discredit Warhol's intelligence, as well as to marvel at, decry, account for, and extenuate his apparent lack of intelligence have resulted in a fascinating genre of speculation. Whether Warhol could think or not, whether he was really as fatuous as his behavior frequently led people to believe—by now such issues have surpassed the realm of celebrity biography and become matters of compelling cultural and philosophical inquiry. By a process of conjuring, his mind has become a primary medium through which people of all ranges of intelligence attempt to discern, engage, and grapple with their responses to the present era.

The sheer range of opinions registered about Warhol's brainpower suggests the extreme intrigue his mind exerts. A former college classmate speaks of Warhol's having had no intellectual capacity either in his student years or subsequently.[1] A close friend from the early days of pop art says Andy was "ferociously intelligent and well-informed. He knew a hell of a lot."[2] A fashion editor who hired Warhol as an illustrator in the mid-1950s says, "Andy is a fabulous observer of our times. . . . I think he sees better than almost anybody."[3] A Factory Superstar writes, "Andy loves to play dumb—the village idiot, the global idiot. . . . it's part of his flattery."[4] Norman Mailer once said Warhol was "the most perceptive man in America."[5] The artists' agent Emile de Antonio said, "He was an incredibly intelligent person, extraordinarily incisive. Santayana once defined intelligence as the ability to see things as they are quickly. That's

precisely what Andy had."[6] Although Warhol's difficulties with language would almost certainly classify him today as dyslexic, commentators have also referred to Warhol as "quasi-autistic" and "catatonic."[7] A prominent philosopher wrote in 1994 that for three decades he had felt Warhol "to possess a philosophical intelligence of an intoxicatingly high order."[8] In 1996 a well-known art historian asked, "Is anybody home, inside the automaton?"[9]

Why this ongoing rage to describe Warhol's mind? How did the topic become such a hotbed of speculation? The various responses have the look of entries in an official public contest. Imagine a designer glass jar in the shape of Andy's head, half-filled with brightly colored marbles, placed in a department store display window next to a sign proclaiming "Guess How Many Marbles." The display causes a commotion: crowds gather around, people queue up to place their bets, a line extends around the corner. There is excitement and confusion, banter among passers-by, complaints from storefront merchants. Intense debate centers around questions like, Is the jar half full or half empty? What's the prize? Is the contest rigged? Why'd they choose Andy? A curmudgeon wanders past muttering a line from P. T. Barnum. Before long, news cameras arrive, and CNN picks up the story as a human interest feature. The search for Warhol's brain goes international.

Warhol's is not the only brain in recent times to have caused such a stir. Prior to the White House career of George W. Bush, and of Vice President Dan Quayle before that, during the eighties there was great concern, voiced in Garry Trudeau's *Doonesbury* and elsewhere, about the general mental capacity of Ronald Reagan. For people who believed that Warhol and Reagan were mentally incompetent, the enormous fame these men enjoyed was a galling daily presence, like a nagging flaw in the scheme of things, or a latter-day reworking of *The Dunciad*. It hardly improved matters to learn that Warhol and Reagan courted each other early in the decade. Warhol was a nonvoting liberal Democrat, but his associate Bob Colacello persuaded him that gaining access to the new Republican power bloc could be a source of cachet as well as portrait revenue. The two of them visited the White House in October 1981 so that Nancy Reagan could pose for photographs and divulge her opinions for the year-end cover story of *Interview* magazine. Shortly after the issue appeared, the leftist journalist Alexander Cockburn wrote a parody for the *Village Voice* in which Andy and Bob chat amiably with Adolf Hitler. After hearing him recite long passages from *Mein Kampf*, they follow up with questions like "Did you enjoy being Führer?" and "Do you miss the Third Reich?"[10] Cockburn's piece appeared within two

weeks of a truculent essay on Warhol in the *New York Review of Books*, in which the conservative art critic Robert Hughes likened the artist to Chance the Gardener, the imbecile hero of Jerzy Kosinski's novel *Being There.*[11] Nonetheless, the backlash against Warhol was generally less scathing than it was against Reagan, partly because Andy was not a titular head of state responsible for setting national and foreign policy. Where there were protests following reports of the President's semi-illiteracy and his habit of napping during advisory meetings, or of Nancy's using taxpayer revenue for the services of an astrologer, the response of outrage against Warhol hardly seemed appropriate when Andy himself openly invited people to categorize him among the mentally challenged. He said that "my thinking time isn't worth anything." "I really love English—like I love everything else that's American—it's just that I don't do well with it." "I have no memory. . . . Every minute is like the first minute of my life."[12]

If Warhol did have no memory, it's reasonable to ask why he chose to publish two book-length memoirs. Recording his diaries, perhaps, was his way of rescuing each passing day before it slipped into oblivion. His most famous statement acknowledges the severe limits placed on public memory in an accelerated age; by setting the fame timer at fifteen minutes per person, he gave history itself the feel of a mechanically driven talent show. Warhol in fact possessed a keen memory in some regards—he seems never to have forgotten the pain of nearly being expelled from Carnegie Tech, for instance, or of being shunned by key figures in the art world as he was trying to get started there.

In the face of Warhol's pronouncements about himself, people skeptical of his mental competence have tended to express not contempt and outrage but rather their opposites, endearment and protective concern, shades of the maternal instinct. In this respect Warhol's actual mother could be nominated as the artist's ideal reader. A peasant-like woman who lived with her youngest son for most of his life, Julia Warhola was Andy's most longstanding and devoted audience member. She conveyed an urgent protectiveness about him in her final words to her oldest son, Paul. "Promise me you'll take care of Andy," she entreated him. "I want you to look after him because sometimes I wonder if he don't have a childish mind."[13] She was eighty years old at the time; Andy was forty-four.

Warhol's ability to generate concern about his intelligence easily qualifies as one of the most inspired and effortlessly self-regenerating publicity stunts of his career—a nearly irresistible tactic for attracting an audience and holding it in his spell. At the same time, his tactics often

foundered or backfired; and even when they did succeed, Andy himself cannot take any more than partial credit for them. No one, not even an inveterate trickster like Warhol, has ever had supreme control over the presentation or reception of his or her intelligence. Among Factory associates who refused to take Andy's know-nothing act at face value, the most notorious was his would-be assassin, Valerie Solanas. To distract her from constantly nagging him about producing a script she'd sent him, Warhol offered Solanas a small part in one of his movies. After several meetings with the artist, Solanas told a friend, "Talking to him is like talking to a chair." Eventually she took to regarding his inattentiveness as an insidious form of manipulation. As is well known, she shot Warhol three times on June 3, 1968, having decided, as she told police that evening, "He had too much control of my life."[14]

Between the extremes of Mrs. Warhola's shielding maternalism and Solanas's homicidal rage are more moderate responses of impatience, resignation, and amusement. Pat Hackett once suggested making a joke disco tune out of Andy's favorite expressions: "Oh Gee, Oh Wow, Oh Really / It's All Fred [Hughes]'s Fault, It's All Bob [Colacello]'s Fault."[15]

The search for Warhol's brain is marked on one side by the intense magnetism of a mind with chameleonic strangeness, and on the other, by a reception history so checkered and far-ranging as to be virtually unchartable. The extreme responses his mental behavior elicits raise questions not only about Warhol but about the performative nature both of intelligence and of the methods by which intelligence is gauged. Intelligence—in the ways it is recognized, calibrated, affirmed, transmuted—could be likened to a form of interactive theater. As with all forms of theater, there is no guarantee that performers and audiences will mesh with any degree of precision: an actor's clearest gestures will still be misinterpreted, and a spectator's keenest responses will still betray faults of perception. The uncertainty principle governing both performance and reception has special relevance in the realm of intelligence, where no form of evaluation, no individual assessment, may claim the distinction of being definitive. In this regard Julia Warhola's choice of words is instructive. As she voices concern about the childishness of her son's mind, her phrase "sometimes I wonder if" suggests a response that is prudently qualified, tentative, and subjective. Even a child, we might say, does not display a childish mind *at all times*, or in a way that is incontrovertible or unsusceptible to misreading. Nor, for that matter, is there a consensus on what constitutes childishness or maturity in mental behavior.

Our gauges in such matters remain stubbornly clumsy and imprecise,

partly because of our reluctance to acknowledge the hybridized and oscillatory nature of human intelligence. There exist widely varying forms of intelligence and ignorance, and they are thoroughly enmeshed and intimately dependent on each other in ways we are only beginning to understand.[16] By offering an overview of Warhol's mental life and the ways it has been received, my aim is to locate organizing patterns in the epistemological maelstrom surrounding Warhol, and in doing so to explore paradigmatic ways in which knowing and unknowing, knowledge and the principled refusal of knowledge, animate one another in a contemporary setting.

Search Methods

What methodology or psychological model would most favorably serve such an endeavor? Following the psychoanalyst Félix Guattari, we would do well to ask which of the various mental cartographies we have at our disposal are best suited to accommodate the polyphonic crosscurrents and fluctuations that characterize human subjectivity. Theorists such as Michel Foucault, Jean Baudrillard, Roland Barthes, and Fredric Jameson specifically invoke Warhol as hailing a radically altered modality of experience which we are still largely unequipped to comprehend or conceptualize. Jameson in particular singles out Warhol as putting an atavistic spin on Freudian models of psychopathology and high modernist indices of experience.[17] Ritually conferring sui generis status on Warhol is not without various risks, however. Mandy Merck in the *Pop Out: Queer Warhol* anthology rightly points out that in efforts to turn Warhol into a paradigm there is a manifest tendency to lose track of his actual psychological makeup.[18] Warhol's having been designified into the ozone has made it easier for critics and noncritics alike to overlook basic facts of his biography, such as his homosexuality. In spite of this caveat, it is equally clear that the attempt to interpret his life by recourse to a received, cohesive model of analysis (family romance, will to power, early trauma, mirror stage, dreams and the unconscious, and so on) will necessarily bring distortion and concealment along with whatever insights it might generate.

For Guattari, the task of finding a methodology that is faithful to present-day experience is not primarily an intellectual but an ethical matter:

How can a mode of thought, a capacity to apprehend, be modified when the surrounding world itself is in the throes of change? . . . Contempo-

rary upheavals undoubtedly call for a modelisation turned more toward the future and the emergence of new social and aesthetic practices. . . . We are faced with an important ethical choice: either we objectify, reify, "scientifise" subjectivity, or, on the contrary, we try to grasp it in the dimension of its processual creativity.[19]

I interpret the latter of these options to mean assessing day-to-day biographical material and commentary with a critically informed eye, but suspending the tendency to read findings within the confines of a specific psychoanalytic theory. Such assessment necessarily involves selection and judgment, and does not eliminate the potential for misrepresentation. Also, the choice of methodology is not as either/or as the passage suggests: no contemporary thinker can ever become fully disentangled from existing scientific methods and maps. Having acknowledged this, I find myself inclined toward Guattari's latter option for a number of reasons: because Warhol is himself an artist, someone whose engagement in processual creativity is intensely personal and professional; because his influence continues to be so widespread and active in the present; because he is such an effective spoiler of doctrinaire opinion and conceptual models; and because my own training lies in culture and language study rather than in clinical psychology or the hard sciences.

However, nothing could argue more potently against using the objective, "scientific" approach here than a working knowledge of Warhol's own interaction with the psychiatric community. Of psychiatry he once said, "It could help you if you didn't know anything about anything."[20] As we saw in chapter 2, Warhol was unfazed by his encounter with a Greenwich Village psychiatrist and immediately turned his attention to his first television set. His rejection of psychiatric evaluation is, of course, psychiatrically revealing. His diary entry of May 9, 1978, reveals that his "forgetting" about psychiatry was perhaps a more fraught and self-protective gesture than he was willing to admit: "Chris Makos called about the interview with the psychiatrist who's doing a book on famous people's IQs and he wants to give me the IQ test but I've decided I'm not going to take it. I mean, why should I let anyone know how stupid I am. And the release this guy sent was too much—it practically said he'd own my brain cells."[21] Anyone tempted to read this entry in summary clinical fashion—as signaling avoidance behavior, shame, intellectual closetedness, defensiveness, territoriality, in neat categories— should recall the episode, narrated in *Popism*, where Warhol stormed the 1966 annual banquet of the New York Society for Clinical Psychia-

try. Invited to speak at the black-tie event, Andy decided to bring along a motley group of his associates. While the vocalist Nico and the Velvet Underground blasted the assembly with a wall of amplified sound, Warhol's film crew circulated throughout the banquet floor asking members and their guests questions like "What does her vagina feel like?" "Is his penis big enough?" "Do you eat her out?" One of the next day's headlines read, "SHOCK TREATMENT FOR PSYCHIATRISTS."[22]

In light of such developments, we are well advised to exercise caution as we approach Warhol with our ready-made maps of the human mind.

To date, the search for Warhol's brain has taken place largely in a contextual void. Like party guests concerned primarily with getting in their own witticisms, commentators have shown a strange reluctance to build on or respond to each other's findings. A number of factors contribute to this:

1. *Bon mot syndrome.* Once it has been stated that Warhol is a "brilliant dumbbell" (Edmund White), or "the only genius with an IQ of 60" (Gore Vidal), there presumably remains little left to say about the matter.[23] The mode of utterance itself clears away skepticism, forbids further inquiry. Hal Foster begins an article by calling Andy "the great idiot savant of our time," but he offers little further explanation of the import of this phrase in the course of the essay.[24] It's as if rendering Warhol's intelligence into an adroit catchphrase were tantamount to uttering the last word on the topic. The oft-applied term "idiot savant" also partakes of a truncating logic, gaining in efficiency what it loses in precision and descriptive texture. (Andy was skilled at disarming such attempts to pigeonhole him. When told that the art critic Barbara Rose called him an idiot savant, he reportedly asked, "What's an idiot *souvent?*")[25]

2. *Tricksterism.* The task of assessing Warhol's mental life presents all the difficulties expressed in the Douglas Adams passage that serves as this chapter's epigraph: multiple and interspersed roles and role playing; the practice of refusing to understand mobilized as a game with constantly shifting rules; the overlapping or simultaneous presence/semblance of cleverness and stupidity; the auxiliary component of public reputation and its complicating effects on both the subject observed and the critic observing; and the temporality and intermittence of these qualities.

3. *Unreasonableness.* In spite of his numerous published autobiographi-

cal works, Warhol rarely resorts to direct self-explanation or deductive reasoning. In a later passage from *The Hitchhiker's Guide*, Adams remarks of the character Zaphod, "He never appeared to have a reason for anything he did at all: he had turned unfathomability into an art form. He attacked everything in life with a mixture of extraordinary genius and naive incompetence and it was often difficult to tell which was which.[26]

4. *"My Andy."* Even people who have never met Warhol tend to think and write about him in a personal and self-sequestering fashion.

5. *Insult to injury.* Especially in Western cultures, questioning someone's intelligence is considered harmful enough; lingering to assess the details carries a levy of unnecessary cruelty.

6. *Catch-22.* A naif-trickster can be an unsettling presence only in an interpretive community that is oriented toward intelligence and straightforward earnestness; such communities tend not to have unusually sophisticated, readily available vocabularies or predilections for discussing naivete and tricksterism.

7. *Nonobjectivity.* Valuations of intelligence and perceptiveness always necessarily reflect the nonobjective standards of the system within which they are formed. Such valuations often reveal more about the evaluating subject than the subject being evaluated.

8. *Tower of Babel.* Even if freight-loaded terms such as "intelligent," "intellectual," "idiot," "stupid," "ignorant," "naive," "smart," "clever," "perceptive," and "genius" could be clearly demarcated and stabilized in the realms of semantics and etymology (which they manifestly cannot), they still assume myriad and relativized functions in everyday usage.

This list applies not only to the search for Warhol's brain but to related issues of how knowledge and inquiry are pursued, and to what conditions and patterns of thought characterize the present age. The above items might be extrapolated to serve as reasons for what Fredric Jameson has called the demise of critical distance under postmodernism.[27] The episteme in which we are currently engaged is experienced as unreasonable, as a series of tricks and Catch-22's; it provides no sturdy footholds or handrails, no wayside vistas from which to survey the surrounding terrain. While I ultimately find Jameson's obituary for critical distance premature, I still perceive sociological effects that correspond to the condition he describes. In response to bewildering stimuli at various levels of our physical and cognitive existence, we sequester ourselves; we behave like party guests too focused on our own anecdotes; we take refuge in bon mots like the word "postmodern." Such behavior is reinforced by a sense of smug uniqueness about our

own historical predicament and its apparently complete novelty. Old models need not apply. Given the peculiar homologies connecting Warhol and the historical period he inhabits, it is unsurprising and even wittily appropriate that he should become a favored mascot and bête noire of the age, that he should be able to implicate himself so thoroughly in the ways people talk and think about the present era.

At the broadest level of social and philosophical impact, Warhol's "childish mind" may be seen as a focal point in the turns that continue to be negotiated and contested under postmodernism. The forms of cultural discourse that enabled René Descartes to proclaim "I think, therefore I am" in Europe in 1637, and Barbara Kruger to proclaim "I shop, therefore I am" in the United States in 1987, are crucially linked in Warhol, who said in 1975, "Buying is much more American than thinking and I'm as American as they come."[28] This is not to say that thinking has somehow become passé and that Andy now presides over a postmodern, uniquely American confederacy of dunces. Rather, Warhol's cognitive life has thrown into relief many of the pretenses and pieties of high modernism, and his worldview continues to unfold upon contemporaneity with powerfully dissonant effects. Warhol serves as a key catalyst to an episteme in which the principle of cogito is unmasked as a fossilized axiom and a form of intellectual complacency, a device newly deprived of its ability to guarantee self-authentication. An inquiry into Warhol's mental life, *pace* Mandy Merck, cannot help but also speculate about the function and fate of intelligence under the present order.

The forms of impudence Warhol unleashes have a fundamentally bracing effect that marks him as a "satyr capable of thinking," to borrow a phrase used by Peter Sloterdijk in *Critique of Cynical Reason*. This satyr, in Sloterdijk's formulation, "takes up a position against whatever might loosely be called 'high thinking': idealism, dogmatics, grand theory, weltanschauung, sublimity, ultimate foundations, and the show of order."[29] The coined word "anti-cogito" could serve as a way of referring to this stance in philosophical terms. Anti-cogito is not the opposite of thinking but rather a form of cognitive opposition, a method of startling and unfettering thought out of its customary habits and garb. The word implies an impatience with the modernist platitude "I think, therefore I am." Anti-cogito inquires, Where is the stable, distinct "I" who thinks? Does the word "therefore" bring anything to the equation besides hubris? Whose concept of thinking or being is implied? Descartes's? Heidegger's? Derrida's? This position also takes a skeptical view of Rousseau's answer to Descartes, *je sens, donc je suis*. Andy

would have us believe that option is closed: "I don't care. I don't care about anything. That's what my work is about."[30]

Anti-cogito, however, doesn't constitute a complete or autonomous stance, nor is Warhol's special brand of not caring recommended as a general life philosophy. Much of the value of these positions lies in their calling the bluffs of actions that are already in play, and in clearing the air of platitudes left from an earlier regime. They're fully capable of generating brave new platitudes of their own, which will call for still further counterstrategies in future.

Mental Portrait

From an early age Andrew Warhola showed evidence of a peculiar, and peculiarly rich, mental life. A neighbor of his recalls that as a child, "Andy was so intelligent, he was more or less in a world all his own."[31] In elementary school he was a perennial teacher's pet, but his illness and physical awkwardness led to taunting from classmates that made him terrified of going to school. Victor Bockris's biography describes the loss of motor and speech coordination Andy sustained at age eight during a severe bout of chorea, a disorder of the central nervous system. During long days of bedridden solitude, Warhol's inner fantasy life began to assume paramount importance. Although his brothers said that Andy inflated the importance of this illness, the inflation itself bears testimony to its having made a lasting impact. As we saw earlier, Bockris conjectures that Warhol never fully recovered either physically or psychologically from this episode but "would always remain the two-sided eight-year-old who emerged from the cocoon of his illness." However, Bockris also quotes Andy's brother John as saying their father's death (from hepatitis, after a West Virginia mining trip) marked Andy at age thirteen more severely than anything else in his childhood. Family accounts suggest that he was less traumatized by the death itself than by the presence of his father's corpse in the house as the family held a traditional three-day vigil. When the body was brought in, Andrew hid under his bed, cried, and begged not to have to see his dead father.[32]

Andy skipped eleventh grade and became the only member of his family to attend college, his tuition bankrolled by his father's savings. As a teacher at the Carnegie Institute of Technology recalls, "Andy was never very strong in his academics, but that had nothing to do with his intelligence."[33] A later business associate reports that Andy polarized the faculty at Carnegie: "his art teachers and professors were completely split down the line—50-50. Half of them thought he was a genius and

half of them thought he was an absolute zero. But both groups were absolutely positive."[34] Warhol would later similarly polarize exhibition jurors in Pittsburgh with his painting *The Broad Gave Me My Face, But I Can Pick My Own Nose.*

During his freshman year at Carnegie Tech, even though he received help from friends, Andy failed a course entitled Thought and Expression, and his other grades were low enough that his enrollment was jeopardized. A sympathetic faculty member found him in tears and encouraged him to take a summer course to put him back in good standing. Warhol did retake Thought and Expression and earned a D, but his difficulties at Carnegie Tech left him severely wounded. In later interviews he would deny ever having attended college.[35]

Warhol moved to New York City after graduating in 1949. His early years in Manhattan are marked by a subtle transition between his *being* a wide-eyed kid from Pennsylvania and his consciously *playing* this role. Robert Fleisher, an art director, recalls that "you felt this *tremendous* sense of protecting this poor, innocent waif, who is going to get strangled in this big city. And he *used* it. Now originally he was that way. I'm *sure* he was that way, but as time goes on, I saw him using it. Rather knowingly, he used it because he was really the guy who was manipulating."[36] A painter who shared an apartment with him in the early fifties said Andy had a bizarre way of seeking work in commercial art. He would call up art directors and say things like, "I planted some bird seed in the park yesterday. And would you like to order a bird. And do you have any work for me?"[37] He considered renaming himself "Andy Paperbag," in keeping with his habit of giving people birdseed packets with instructions of how to plant seed so that a bird would grow.

Nathan Gluck, a close associate of Warhol's at the time, suggests that what Andy didn't know about art history could fill many volumes. He exclaims, "I'd love to be proven wrong because I have this conception of this *terribly naive* person."[38] During this period Warhol developed an almost debilitating obsession with the writer Truman Capote, himself a homosexual outsider who used the stance of naivete as a protective armor. (Capote's *In Cold Blood* and Warhol's *Death and Disaster* series may be seen as analogous attempts to break out of, or complicate, the public's perception of the naif.) Both men were transplants to New York who lived with their mothers there for many years. In an extended comparison of the two men, the critic John Yau writes that their trademark affectations "hint at the likelihood that both men felt it was in their best interest to play the role of the court jester as well as

the fool. For only by acting outrageous could they both gain the atten-
tion they felt was their due, and hide who they were."[39]

Incidents from his early years did not assume full significance, how-
ever, until the teenage Andrew Warhola transformed himself into the
adult Andy Warhol. He dropped or outgrew his "Raggedy Andy" persona
from the 1950s but persisted in behaving like someone who had just
flunked a course in Thought and Expression—or who, having flunked
the course, chose to make a life mission out of appearing thoughtless
and expressionless. During and after his pop fame Warhol was fond of
saying things like "It's too hard to think about things. I think people
should think less anyway"[40] and "My mind is like a tape-recorder with
one button—Erase."[41] Warhol professed that he couldn't remember who
the murderer was even when watching the same movie whodunit on
consecutive nights.[42]

A visitor to his studio in 1961 said Andy claimed not to understand a
pop song until he'd heard it one hundred times, playing it on a phono-
graph over and over at full volume. Warhol explains, "The music blast-
ing cleared my head out and left me working on instinct alone."[43] Five
years later he was able to realize this practice on a grander scale with
his promotion of rock-concert multimedia events, a 1960s-style version
of the rational disordering of the senses. An April 1966 ad in the *Village
Voice* proclaimed, "COME BLOW YOUR MIND. The Silver Dream Factory Pre-
sents The Exploding Plastic Inevitable with Andy Warhol/The Velvet
Underground/and Nico."[44] The Velvet Underground included the musi-
cians Lou Reed and John Cale, who went on to long independent ca-
reers. Warhol and the Velvets are often cited as driving factors behind
the emergence of seventies punk rock. The phrase highlighted in the
advertisement, of course, also served as an invitation to bring your own
hallucinogens. Such an invitation was gratuitous, given the times, the
event, and the Factory's reputation as a place for mind-altering drug use.
Warhol himself mostly kept a distance from illicit substances, prefer-
ring instead to take prescription diet pills such as Obetrol. The drug's
expansive effects help to account for Warhol's superhuman work hab-
its during the sixties and may at times have contributed to his semi-
dazed, preternaturally agreeable public demeanor.

Another link between Warhol and the era's rock musicians was their
deployment of the put-on interview. Warhol's style was a curt and mono-
syllabic variation on the form, far removed from that of a practitioner
such as Bob Dylan. Two more-different put-on approaches would be
difficult to imagine, and it's worth contrasting the two men's approaches
for clues about their personal styles. Dylan's aggressive mid-sixties put-

on style involved elaborate metacommentary about the interview process: avidly and at great length he cross-examined journalists about what they hoped to accomplish, or he inquired about the nature of their values and the state of their soul. "Putting them on" involved pointedly disabusing them of professional and personal falsehoods. In *Don't Look Back*, Dylan verbally confronts a *Time* reporter, holding him personally accountable for how his magazine misrepresents artists.[45] However, to a younger, less-experienced journalist he lightens his touch, even courteously suggesting to the flustered young man that he's being put on. Such forms of overt intellectual critique and litigious fury are notably absent from Warhol's interviews—and indeed, from social habits throughout his life. By comparison he was a Zen minimalist, capable of shutting an interview down with a series of staccato interjections—a blankly repeated "No," "Yes," "Gee," or "I don't know." Even when he offered longer responses, they tended to be unrevealing. Warhol later obviated the interview process by traveling with an entourage and letting others speak for him. In retrospect, Warhol's method seems mostly to be about preserving his shyness and privacy, where Dylan seizes the moment for political contestation and the chance to promote his alternative message.

In spite of Warhol's playing the role of naif in public, other factors partly belie the image he promoted. He owned hundreds of books and attracted a great many poets and intellectuals to the Factory. Included among the poets were his longtime assistant Gerard Malanga; John Giorno, his model in the film *Sleep;* and his recurring film actor Taylor Mead. He was on congenial enough terms with Marcel Duchamp, the poets John Ashberry and Allen Ginsberg, the critic Ted Berrigan, and the poetry teacher Willard Maas for them to consent to sit for his screen tests.[46] However, the Factory was not a salon setting in the traditional sense, and when Warhol and his entourage frequented the restaurant Max's Kansas City on Park Avenue South, they were known for generating noise and antics, not debate and critique. Warhol often became anxious and flustered around intellectuals, as during a 1980 reception when he was approached with probing questions about his portrait series on Jewish geniuses.[47]

The book purporting to be Warhol's "philosophy," published when he was forty-six, betrays scant evidence of his having been trained either in that field or any other and registers only a tenuous, haphazard grasp of standard English. Its typographical effects (beginning with the title), its shaggy-dog-story whimsicality, and the comic solipsism of its narrator give it a passing resemblance to Laurence Sterne's *Tristram*

Shandy, from eighteenth-century England; an alternative title could be *Hobby-Horses for a New Age. Philosophy* is a thicket of grammatical gaffes and irregularities, logical fallacies, faulty syntax, sentence fragments and run-ons, tautological reasoning, and unsupported claims.[48] Many of the observations have the feel of Jack Handey's "Deep Thoughts," once featured on *Saturday Night Live;* only the punch line is missing. The book's shortest chapter, "Death," consists of forty-six words, expressing the speaker's regret, disbelief, and unpreparedness about the topic at hand, but not in such a way that readers have clamored to hear more. However, some of the book's observations are memorably witty. A few examples: "I believe in long engagements. The longer, the better" (46). "I believe in low lights and trick mirrors. A person is entitled to the lighting they need" (51). "I always run into strong women who are looking for weak men to dominate them" (56). The book's longest chapter, both in terms of page number and readability, records the clinically detailed monologue of a woman who compulsively cleans first her apartment and then herself, and then masturbates with a vibrator.[49] The book culminates in a chapter recording the minutiae of the author's foray in search of underwear. Like Warhol's other books, *THE Philosophy of Andy Warhol (From A to B and Back Again)* was not in fact "written" by him but sifted and shaped by editors with a knack for making his tape-recorded monologues sound less infantile, more articulate than they really were.[50] (Bob Colacello once remarked, about editing one of Warhol's interviews, "Brigid [Polk] and I labored over it for hours, trying to make Andy sound as if he knew what he was talking about.")[51]

Warhol's habit of bad-boy disporting in public—the *puer* side of trickster behavior—makes it hard to gauge how much he developed in the realms of social knowledge and tact. Outside of the Factory he relied heavily on his male attachés to facilitate his official interactions and rescue him from the most basic social scrapes. Inside the Factory he often pitted these same associates against each other. As late as the seventies he had a habit of publicly asking famous women the size of their husband's penis.[52] By the same token, he didn't have the problems with alcohol that could make public appearances by Tennessee Williams or Truman Capote so unpredictable. In spite of his potent anxieties and jealousies, many found him disarmingly approachable, and capable of great charm and generosity. Even after the shooting, he could be surprisingly accessible to the public. He frequented flea markets and thrift stores, he loved passing out free copies of *Interview* on the street, and he often worked at a soup kitchen on holidays.

Further clues about his mental gestalt are seen in the kinds of art and entertainment that Warhol patronized. Before his conscious transformation into a gum-chewing pop person, he had a subscription to the Metropolitan Opera and played classical music in his studio.[53] However, for someone who made a major impact on underground cinema, his taste in other people's movies was far from avant-garde. For instance, he reported to his diaries that he fell asleep from boredom at the art-house film *My Dinner with André* (445), but was "the only one awake in the theater" when he saw the mainstream Madonna/Sean Penn vehicle *Shanghai Surprise.* He's one of few people to go on record as saying the latter movie "isn't bad" (762).

An incident from Warhol's later years shows that he was capable at times even of outsmarting himself. When asked by *Entertainment Tonight* who he voted for in the 1984 presidential election, Warhol said, "For the winner." The interviewer said, "Who's that?" and he replied "The winner is the winner." Later that day he remarked in his diary, "*I* don't even know what I meant. If they ever put all the clips they've ever gotten of me together they'd see that I'm a moron and finally stop asking me questions."[54] The moment reveals public and private modes of intelligence at variance with each other, and it presents a glimpse of Warhol the riddle-maker confounded by one of his own riddles. As a celebrity whose televised ad libs returned to haunt, embarrass, and/or secretly excite him, he found refuge not in the modernist creed of "That is not what I meant," favored by Eliot's J. Alfred Prufrock, but rather in the postmodern position of "What did I mean by that?" or, more colloquially, "What was I thinking?" The implied subject position is not tragic alienation from others but comic dislocation from oneself.

The degree of mental or social maturity Warhol achieved in his last decade is open to speculation. To the end of his life Warhol retained his uncanny problem-solving abilities, his keenly intuitive understanding of people, his passionate absorption in celebrity goings-on, and his formidable art-world acumen. He remained someone who had great business sense and almost no street sense.[55] Pat Hackett argues in her introduction to the *Diaries* that Warhol mellowed in his later years, finally outgrowing a delayed adolescence and a tendency toward deliberate provocation and schoolkid pranks.[56] On his ventures into New York society, he made an engaging dinner companion and conversationalist— startling people not only with his physical presence but with his presence of mind. Even so, the record shows he still reverted to old habits on occasion: making his usual insipid remarks in public, lying about his date of birth, autographing a man's penis at a celebrity party in L.A., and

indulging in behavior that earned him nicknames like "The Great Denier" and "Pollyanna Warhol."[57]

Occasionally in the diaries his old ploys and evasion tactics seem merely pathetic. A man at a party tells him he's been on a cruise with a socialite, and Warhol recounts that "when I just asked if he fucked her he got upset, I don't know why."[58] At a gallery opening a month before he died, Warhol went out of his way to avoid a fellow artist who had AIDS: "Bruno [Bischofberger] wanted to sit with Robert Mapplethorpe but I didn't want to. He's sick. I sat at another place."[59] Given what was known medically about AIDS by 1987, this entry comes as a sad reminder of the extreme concerns Warhol nursed about his own health; it's also a commentary on the varieties of loss, social as well as physical, brought on by the epidemic. At the same time, his noting the incident in his diary indicates that it may have upset him more than he lets on. If Warhol had been fully dedicated or consistent in the role of "Great Denier," even in his diaries he might have pretended to a more respectable reason for avoiding Mapplethorpe.

In the mid-eighties, Warhol's growing regard for forms of New Age spiritualism, particularly his belief in the protective and healing power of crystals, shocked his friends who remembered his droll disregard for the hippie movement and Flower Power during the sixties.[60] Beginning in 1984 Warhol regularly sought the counsel of a man known as Dr. Bernsohn, who convinced him for a period that his problems with cockroach infestation could be solved by placing a specially programmed crystal in his kitchen. There is no evidence of irony in Warhol's repeatedly noting in his diary that the method failed to help matters and actually seemed to make them worse.[61] In another context, however, he admits ruefully, "I'm starting to think that crystals don't work. . . . But I've got to believe in *something*, so I'll continue with the crystals."[62] This statement suggests that, in spite of his attending Catholic mass regularly, the "something" he believed in toward the end of his life was not entirely the religion of his youth. No doubt many will see the cockroach episode in terms of Warhol's susceptibility to quackery, or as the sign of a seriously impaired bullshit detector. More affirmatively, though, his foray into New Age beliefs suggests he still had a refreshing openness, in his sixth decade, to new ideas and experiences. One of my favorite photographs of the artist shows him standing in a park with a group of friends, holding umbrellas against the rain, observing Hands Across America, the May 1986 initiative against hunger and homelessness. It's among very few photographs to show the adult Andy in the company of children.[63]

One could say that throughout his life Warhol was engaged in playing the fool, but it is more insightful to say that from an early age he was engaged in fooling himself into the activity of play. New Age crystals might be placed in the context of a long procession of toys that for him held apotropaic value. They were accessories in a private, moveable playground where he was able to fuse the activities of creation and recreation, and where he was granted immunity from hostile forces such as those he had endured in childhood. The working persona Warhol forged for himself is profoundly linked to his need to construct a world around him that presented an alternative to his immigrant working-class upbringing—to the etiolating effects of poverty, the ugly squalor of industrial Pittsburgh, and the harassment that came with being a sissy mama's boy. The accouterments, both animate and inanimate, that Warhol latched onto and surrounded himself with may be seen as his ammunition in an ongoing, and never fully victorious, battle against insecurity and early deprivation. These include cutout dolls, comic strips, drawings, slapstick cartoons, matinee heros, fellow art students, coloring-party friends, pop icons, Factory assistants and Superstars, film crews, tape recorders, telephones, discotheques, wealthy and famous patrons, and New Age crystals, among others. No account of Warhol's mental life can avoid acknowledging the fortifying and validating effect such things had for him. They constitute what could be regarded as his primary form of literacy. Bob Colacello has remarked that Warhol's sentences "tended to get convoluted when he went beyond ten or twelve words, as if English were his second language."[64] One may think of Warhol's first language as neither English, which he freely admitted wasn't his forte,[65] nor the east European dialect he heard at home, but rather a language of his own devising. This language was absorbed intuitively from the presences of the things and people he enjoyed seeing from day to day—things such as Dick Tracy and Superman comic books, movie-star posters, shoes, wigs, and Campbell's soup cans; and individuals from his adult life such as Charles Lisanby, Gerard Malanga, Joe Dallesandro, Edie Sedgwick, Candy Darling, and his two long-term boyfriends, Jed Johnson and Jon Gould. Whatever lay outside of Warhol's inner private cosmology had to be dealt with indirectly, tangentially, through an arduous process of translation.

Andy's naif-trickster persona may be seen as a kind of agent or bodyguard to help him in negotiations with the inimical outside world. Naif-tricksterism, one could say, is Warhol's navigational bearing, his way of both validating and fictionalizing himself. His ability to shuttle between, and hybridize, the roles of naif and trickster, making it impossible to get

a clear or stable picture of his actual cognitive abilities, allowed him to play the roles of doe-eyed ingenue and merry prankster simultaneously. The stance helped him garner attention in the early days of pop art, as well as to hold people at a distance. When he'd established alternate headquarters at the Factory, and the Factory came to be seen as an organized assault on status quo virtues, his persona helped him to preserve a semblance of calm innocence amid chaotically perverse surroundings. The pose afforded him the kind of protection and renown usually granted only to characters in a story; indeed, Warhol often does seem more like a hero in a fiction than a man of corporeal reality. The kind of fiction Warhol finds himself in might be called a novel of miseducation, in which learning itself is treated as a form of low burlesque. How that burlesque played out to audiences now becomes the subject of our further inquiry.

Critical Impasse

How could the same individual be described by two different scholars as a "sixties intellectual" and also as "never in the least intellectual"? Can the word "intellectual" perhaps serve as its own antonym? Closer examination reveals that the views of Andrew Ross and Simon Watney, respectively, are not in fact categorically opposed. Both men, for that matter, are leftist cultural studies scholars whose outlooks are significantly informed by their origins in the United Kingdom. The benefit of juxtaposing their positions lies not in setting them up as diametric adversaries but instead in allowing their alternate methods and emphases to give us a broader view of the territory marked by the search for Warhol's brain. The variance in their approaches helps to account for why this search extends over such an unmappably diverse landscape. The guessing game about Warhol's mind, treated in miniature form in this chapter, plays itself out in vastly dissimilar contexts and across a full political gamut. Ross's and Watney's views constitute two of the more thoroughly engaged, progressive, and sophisticated positions offered in this search, and they diverge in ways that will enhance and expand our sense of the field.

In *No Respect: Intellectuals and Popular Culture*, the Scots emigré and Marxist critic Andrew Ross depicts Warhol as a sixties pop intellectual, someone whose achievements place him in the company of figures such as Buckminster Fuller, Susan Sontag, Leslie Fiedler, and Abbie Hoffman.[66] The term "sixties intellectual" carries an oxymoronic charge in his analysis, the adjective "sixties" adding a kind of contra-

band element to the more traditional sense of the public intellectual received from the fifties. Ross posits the "camp intellectual" as a sub-species of this category. Speaking in general and methodologically loose terms about the role and function of intellectuals, he portrays the emergent camp intellectual as an offshoot from, and parodic commentary upon, the traditional and organic species of intellectual formulated by Antonio Gramsci. Ross bestows a unique status upon Warhol in this emergent category, but in doing so he places him paradoxically in the "central" position of a marginal cultural space. Ross characterizes the camp intellectual as someone who prizes rather than laments his marginal status, making "a self-mocking abdication of any pretensions to power" (146). Nonetheless, he still depicts Warhol as "the figure who singlehandedly generated so many of the shifts of sixties taste" (165). A kind of juggling act with the roles of margin and center emerges from Ross's analysis.

The shifts of taste Warhol generated, Ross suggests, derived power from the stupefaction value of his basic stance, conveyed in utterances such as the line mentioned above, "Buying is much more American than thinking." The patriotic elevation of buying above thinking came as a mockery to erudite, serious pop thinkers to whom Ross is sympathetic. But Warhol's aphorisms, Ross is quick to note, need to be seen within a camp context in which their claim to seriousness is always already rejected. Warhol emerges in Ross's account as one who is able to revolutionize American taste from the sidelines; and whose status as a camp intellectual is greatly fortified by his ability to *sound* anti-intellectual, to tease and provoke serious-minded people.

The contrasting remark made by the London-based writer and gay activist Simon Watney also serves to reprimand critics who read Warhol too earnestly. In his essay from the collection *Pop Out: Queer Warhol*, Watney ridicules previous scholarly attempts to establish a lineage of Warhol's intellectual influences. Warhol, he says, "was never in the least intellectual, which is, perhaps, one of his saving graces."[67] Watney inserts this broad claim into his assessment of Andy's late-1940s student days at Carnegie Tech. Watney portrays Warhol as a "working-class queer aesthete" whose poverty separated him from his fellow art students; "if he felt helpless, he was clever enough to realize that helplessness can be an effectively manipulative design for living" (23). In Watney's view Warhol thus relies on the redemptive possibilities inherent in being both clever *and* unintellectual. This combination of mental traits allows Warhol to compensate for, to make virtues of, the poverty of his background and the queerness of his temperament. Watney's

formulation closely parallels that of George Hartman, an art director, who said of Warhol, "He's *extremely* clever but *not* in an intelligent way."[68] Watney's phrasing, "if he felt helpless, he was clever enough to realize," suggests a cognitive/affective pattern in which realization comes to the aid of feeling. In Watney's view, clever realization (rather than applied logic or self-conscious introspection, for instance) is the tool Warhol uses to convert the feeling of helplessness into a form of social mobility. In this formulation intellect is seen as an encumbrance or obstacle to be cunningly avoided.

Taken together, Ross's and Watney's positions establish a useful problematic and argue for a methodology that resists announcing a conclusive victor in the game of estimating Warhol's I.Q. Ross's critique posits sixties-style political dissent as the basis for the principled disrespect shown by Warhol and others toward intellectual traditions established during the cold war. The inversions Warhol performs in the realm of camp taste, Ross contends, resonate with the efforts of other pop intellectuals to break up the cartel represented by liberal-pluralist cultural regimes that were solidified during the fifties. Writing a half-decade or so after Ross, Watney suggests that much is sacrificed in Ross's efforts to strap Warhol securely onto a pop-intellectual bandwagon. Watney sharply objects to the implication in Ross's argument that camp is an entirely voluntary position, a "conscious cultural posture." To Watney, the origins of camp are not found in a transatlantic power struggle but in the sheer instinct for survival felt by gay people from an early age. Recovering a personalized sense of Warhol after the broader strokes of Ross's analysis, Watney locates class repudiation and queer desire as the mobilizing forces behind the artist's pop self-transformation. Watney's endeavor to compensate for a history of readings that have de-gayed Warhol, however, has brought out a tendency toward hyperbole. Warhol, we learn, was not only "never in the least intellectual" but also "never an ironist" (24), and "never in any sense a didactic artist" (27). Warhol was certainly not Brechtian, as some critics originally thought, but if he was not an ironist at all, he would have been content to see Campbell's soup cans only in a kitchen, not in an art gallery. Moreover, his "Vote McGovern" portrait of a demonic-looking Richard Nixon prior to the 1972 election is arguably both ironic *and* didactic. Holding to a caricatured view of one aspect of the Warhol mother-son dynamic, Watney unhesitatingly seconds the opinion that Warhol's mother "made him feel that he was the ugliest creature God put on this earth" (25). He concludes that the artist lived with his mother so as to "guarantee the undermining of any sexual self-

confidence he might achieve" (29). Watney clearly breaks new ground in the critical assessment of Warhol, but he does so by recurrently overstating his case.

Both within and between the two scholars' views there are hints of the richly contradictory mental life Warhol sustained. In a larger sense, there are also hints of the richly contradictory stunts he pulled. Without trivializing either position, it might be pointed out that the tension set up between Ross's and Watney's arguments is a productive tension of a kind that Andy himself habitually and instinctively courted during his life. He loved to create mayhem by giving interviewers conflicting reports about his past, by meddling with filmmaking conditions so as to sabotage the efforts of a director or a script writer,[69] and by pitting Factory assistants against each other for his approval. His whole career, as we have seen, may be likened to a series of raids on Pandora's box. The fascination Warhol exerts is registered not so much in the accuracy and depth of commentary about him but in its vehemence and free-ranging breadth. He is hardly the first artist to have incited major controversy among scholars; and yet few can claim to rival his ability to incite controversy *within* scholars. In chapter 1 I alluded to how Rainer Crone's and Stan Brakhage's positions underwent various reversals, and to the critic who selected Warhol as the most underrated *and* overrated artist of the twentieth century. To make such valuations is to read Warhol as a phenomenon rather than an individual; as Stephen Koch has said, "Warhol became famous by ceasing to be a person and becoming instead a presence."[70] Perhaps this is the crux of the variance between Ross and Watney: one writes about Warhol the presence, the other endeavors to reclaim Warhol the person.

The question of how intelligent Andy was cannot be fully pried loose from the question of how intelligent his *effects* were. Much of Warhol's cultural revenue lies in his creating or unleashing effects that present a siren-like receptivity toward the interpretive gesture. His fondness for enigma is literalized in his formal output with images such as the Mona Lisa (1963, 1979, 1986), the human skull (1976), shadows (1979), Rorschach inkblot tests (1984), Botticelli's Venus (1984), and camouflage portraits (1986). But the enigma of Warhol's own persona may belong to a different order, one suggested in Paul Barker's observation about mass art: "Its secret depth is that it has no secret depth."[71] Warhol's intrigue, one could say, lies not in his depths but in his flatness, his being "A sphinx without a riddle," as Truman Capote once called him.[72] The enormous benefit of examining Warhol and the aura surrounding him lies not so much in the prospect of arriving at an objective assessment

of his career or temperament, but in expanding the very field in which epistemological appropriations are made.[73]

Appropriating the Sphinx

> He is very much *sharper* than anybody knows.
> —Seymour Berlin,
> Warhol's printer during the fifties

> People thought he was dumb,
> but he was anything but dumb—
> he was more brilliant than even he knew.
> —Charles Lisanby,
> recalling his contact with Warhol in the fifties

> I'm not more intelligent than I appear.
> —Andy Warhol

As commentators circle and circle in their attempts to grasp and describe Andy's contradictions, one catches glimpses of this epistemological expansion in progress.[74] Perhaps the most revealing entries in the search for Warhol's brain are not those that register a fixed and conclusive position, but those that vacillate, temporize, and equivocate as they attempt to do so. One sees in such responses the fervent desire to categorize Warhol's mind, running into interference with the inability to do so confidently or coherently. Nathan Gluck, one of Warhol's art assistants, expresses candid astonishment about being unable to provide a stable reading of Andy's behavior, even as he declaims more emphatically than Watney did that Andy was not an intellectual. In a 1978 interview Gluck expressed amazement that Warhol should even be found in the *company* of intellectuals: "There was a *naivete* about Andy that was *incredible*. . . . Andy was *really* not an intellectual. This, in a sense, is what is so phenomenal about him because he is *today meeting* all these intellectuals, and I'm always flabbergasted because I'm always thinking, 'What on earth is he talking to them about because, *unless* since the sixties Andy has developed an intellectual curiosity and background, he would rather be a rather naive kind of person.'"[75] It's hard to ascertain what Gluck finds more incredible about Warhol: his naivete, his consorting with intellectuals without being one himself, the discrepancy between his past and present behavior, or the possibility that Warhol has managed by stealth to turn himself into an intellectual. In his claim

to being "always flabbergasted," Gluck conveys a palpable inability to credit his senses, a realization that Warhol presents material not adaptable to existing explanatory models of behavior. Gluck's response itself revealingly wavers between such existing models, shifting between the philosophies of nature and nurture, and between essentialist and constructionist notions of intellectualism and naivete. Warhol, he asserts, is really "not an intellectual" unless he has *developed* an intellectual curiosity since the sixties; there was a naivete "about" Andy and he *preferred* being that kind of person.

Another interviewee, George Klauber, one of Warhol's friends at Carnegie, articulates a more outwardly puzzled form of wavering. Comparing Andy to his classmate Philip Pearlstein, Klauber asserts that "intellectually, Philip was more astute, it seems to me. I used to think of Andy as somewhat . . . 'simpleminded' [is] misleading . . . but not very articulate. . . . And sometimes I think that he is very brilliant."[76] Klauber's response is even more illuminatingly tentative than Julia Warhola's. His use of the terms "somewhat" and "sometimes," his resorting to negation, and particularly the way he pauses before, ironizes, and then disqualifies the term "simpleminded": all of these suggest a fundamental uneasiness and irresolution about the matter at hand.

No doubt there are as many ways of being puzzled by Warhol's brain as there are people to be puzzled. Our search could go on indefinitely and still produce only a partial and premature assessment. For our present purposes, however, two interrelated methods of coming to terms with Andy's intelligence warrant further discussion. What cannot be precisely charted or definitively assessed may still be appropriated through the realms of metaphor and sentiment. Using metaphor, as it turns out, is a preferred shorthand method both of sentimentalizing and de-sentimentalizing Warhol as a subject.

In the Thom Jones short story "Mosquitoes," for instance, Andy is likened to a radar during an argument in which he is de-sentimentalized by one side and re-sentimentalized by the other:

> "Warhol," Victoria said pompously, "the early Warhol, before he was shot—"
>
> "Where would America be without Andy Warhol?" I said. "He put his stamp on American culture. He invented superstars and all of that shit. It didn't quit with the Tomato Soup Can. Andy Warhol was a genius. He— what he had, was this great radio antenna. Picked up on all of the cos-

mic vibrations. He just did it, I don't think he knew the half of it. He was one of those idiot savants, I'm thinking. Your paintings are too goddamn vague, Vick. I can't get a reading on them."[77]

The passage implies that knowing only "the half of it" is what empowers Andy; that if he knew the "whole" of it, he would no longer be nearly as capable of acting on his instincts. Instinct and action are seen as covalent entities, prized not just as alternatives to, but opponents of, cerebral effort and meditative repose. Thus the radar metaphor is offered both as a gloss on the term "genius" and as a graphic means of vindicating Warhol for the cognitive abilities he lacked. Jones's choice of metaphor is echoed among many commentators. Klaus Honnef writes that Warhol had "a highly developed personal radar which enabled him to register latent social trends and expectations earlier than his contemporaries." Calvin Tomkins refers to Warhol as someone "in phase with certain signals not yet receivable by standard equipment."[78]

Writing after Warhol's death, the art critics John Richardson and Arthur Danto pursue metaphors that contribute mythic and quasi-religious overtones to the Warhol persona. The eulogy Richardson read at the artist's memorial service places him in the tradition of the Russian village idiot or holy fool: "Andy made a virtue of his vulnerability. . . . In his impregnable innocence and humility, Andy always struck me as a 'yurodstvo'—one of those saintly simpletons who haunt Russian fiction and Slavic villages." The eulogy paints Warhol as a devout church-goer, philanthropist, and converter of lost souls; the name of Prince Myshkin, the hero of Dostoevsky's *The Idiot*, is invoked. "The callous observer," Richardson insists, "was in fact a recording angel."[79] In a similar vein, Arthur Danto writes that Warhol operated "under the guise of the simple son of the fairy tale, seemingly no match for his daunting siblings."[80] By recourse to folklore and fable, Richardson and Danto make bids for radically altering the contexts in which Warhol is traditionally seen. His native domain is moved from postindustrial America to preindustrial Europe, from postliterate image culture to preliterate oral culture, from fabulous wealth and fame to unassuming poverty and obscurity, from the ephemeral pop present to once upon a time, and from the metropolis in which the artist died to the peasant Carpatho-Rus village in which his parents were born. The two writers, both members of the Andy Warhol Museum Advisory Committee, set themselves up in a kind of fairy godfather capacity to the artist, waving a magic wand that invests him not just with innocence but with an apotropaic quality, his simplicity, gentleness, and meekness serving as

a halo of protection against uncongenial surroundings. The gestures seem almost calculatedly atavistic and gilt-edged. In terms of mythic attribution, there is more cunning and substance in the campy nickname Andy received at the Factory from people who spent much more time around him: "Drella," a compound of Dracula and Cinderella.[81]

For Danto, however, the fairy-tale guise belies a different state of affairs. Danto's is the most famous of the arguments that Warhol was not only intelligent but possessed of *extreme* intelligence. In his 1994 essay "The Philosopher as Andy Warhol," written for the official hardcover *Andy Warhol Museum* companion-book, Danto maintains that for three decades he has felt Warhol "to possess a philosophical intelligence of an intoxicatingly high order. He could not touch anything without at the same time touching the very boundaries of thought."[82] Danto's response recalls the intense emotiveness of Gluck's. The impression left is that Danto himself has been intoxicated by Andy's intelligence for three decades; that thinking about Warhol catapults *him* to "the very boundaries of thought."

The hagiographic and celestial extremes of Richardson's and Danto's portraits find their counterpoint in numerous attempts to *dis*enchant and *dis*intoxicate the Warhol legacy. As we saw earlier, many commentators have looked askance at Andy's mental behavior, arguing that he consciously exploited people's predilection to see him as a foolish innocent. Like Valerie Solanas, they regarded his facade of ignorance as a passive form of control and took pains to unmask or "de-aurify" him. Warhol's first commercial art assistant, Vito Giallo, said, "He was very canny once you got past the 'Oh, this is fabulous' routine—he always had to appear an imbecile because that would give him the edge."[83] Paradoxically, the effort to pierce Warhol's mask usually results not in reducing his aura but in transposing or expanding it. Robert Hughes, in the process of likening Warhol to the mentally impaired hero of Jerzy Kosinski's novel *Being There*, describes the artist in phantom-like terms and arrives at a household metaphor that manages to be both cozy and discomfiting: "Like Chauncey Gardiner . . . [Warhol] came to be credited with sibylline wisdom because he was an absence, conspicuous by its presence—intangible, like a TV set whose switch nobody could find."[84] Similarly, the painter Joseph Groell draws a portrait of Warhol as a kind of supernatural Zorro figure, while at the same time crediting him with cunning deliberation: "Andy was this strangely bizarre sort of person who would always drift in and out of these places, and people would make of him what they chose. . . . Andy was successful because he was a focal point for various peoples' fantasies. . . . He was smart and

shrewd and knew what he was doing. . . . He was—I don't know—a mystery man."[85] In a passage from her Factory biography *Famous for Fifteen Minutes*, Ultra Violet briskly deflates the metaphor from Richardson's eulogy. First she is dryly dismissive, then sympathetic as she considers whether playing the fool served an autodidactic purpose for Warhol: "Andy loves to play dumb—the village idiot, the global idiot . . . it's part of his flattery. He wants you to think he's learning from you. Later, I see he takes it a step further—he actually learns many things that way."[86] Robert Pincus-Witten, a close friend of Warhol's during the mid-sixties, sees his naivete as an enacted routine that became less convincing the older he got. He classifies Warhol as "Maybe averbal, but he's not dumb, or he may be antiverbal, even. It's not a function of his being thick-headed. Certainly, it's now 20 years later and, certainly, there was a cunning behind it, which is perfectly conscious. In fact, it's perfectly repellent today. . . . the pose has been translated from something that was authentic to something that is merchandise."[87]

Even when Warhol's pose falters, though, it rarely seems describable as something that is *merely* merchandise. Or if so, then it is merchandise with a difference: a TV set without a switch, a radar antenna with a cosmic range. The metaphors Warhol applied to himself also manifest this specialty-retail quality and leave impressions that simultaneously sentimentalize and de-sentimentalize him. By likening his mind to "a tape recorder with one button—Erase," he seems to invite responses of laughter, endearment, bathos, and derision all at once. Here the helpless naif and the self-mocking clown join forces. The metaphor's wit arrives by way of contrast. A long literary tradition demands that the mind be likened to things that are layered and tiered, profound, organic, evocative, sublime: palaces and caverns (St. Augustine), the labyrinth (Francis Thompson), the kingdom (Edward Dyer), the ocean (Coleridge), the thoroughfare (Keats), the palimpsest (Thomas de Quincey), the garden (Horace Walpole), the mountainous landscape (Gerard Manley Hopkins), the forest (John Fowles). Andy's lowly, dysfunctional tape recorder swiftly deflates this romantic legacy. Moreover, the prospect of losing one's memory, often linked with a tragic fear for one's sanity, seems to leave Warhol serenely unperturbed.[88]

Elsewhere in *Philosophy*, Warhol takes the concept of merchandise as self-metaphor to surreal lengths, arriving at a position that seems to serve as a parody both of his brain and of the extreme lengths people

have gone to in order to search for it. In a chapter titled "Atmosphere," he likens his mind to a large condominium and describes its features with great élan: "The condominium has hot and cold running water, a few Heinz pickles thrown in, some chocolate-covered cherries, and when the Woolworth's hot fudge sundae switch goes on, then I know I really have something. (This condominium meditates a lot: it's usually closed for the afternoon, evening, and morning.)"[89] Although far from being the most illuminating comment about Warhol's intelligence, the passage adds a needed element of farce to the undertaking at hand. In light of such extraordinarily minute detail and indisputable authority, who would dare to offer further assessment or critique? Warhol here offers a parody—both anticipatory and retroactive—of the process of determining his intelligence once for all. It's as if he's taken out a zany classified ad promoting the features of his cerebral cortex: *"Intellectual property! Unique furnishings! Suite-with-the-sour!"* The ad, however, only leads prospective buyers to a blank storefront with a sign that reads *"Sorry, we're closed."* The condominium reveals itself at last as a classic real estate swindle—or perhaps instead a carnival fun-house, whose bright surfaces can only reflect back distorted and hilarious images of our own appraising grimaces and furrowed brows.

For it is not just Warhol's but also the intellectual's role that is performed and dissembled in this process, and it is a matter of no small consternation to the audience for whom it is played. The epigraph that begins this chapter might well be turned back on itself and made to address a corresponding set of epistemological dilemmas, presupposed by, exacerbated by, superimposed upon, and intricately implicated with the search for Warhol's brain:

> One of the major difficulties people experience in their relationship with intellectuals is learning to distinguish between their pretending to be smart just to get people off their guard, pretending to be smart because they can't be bothered to do real work and want someone else to do it for them, pretending to be outrageously smart to hide the fact that they actually don't understand what is going on, and really being genuinely smart. They are renowned for being amazingly clever and quite clearly are so—but not all the time, which obviously worries them, hence the act.

Notes

The epigraph for this chapter is from Douglas Adams, *The Hitchhiker's Guide to the Galaxy* (New York: Harmony Books, 1979), 98.

1. Patrick S. Smith, *Warhol: Conversations about the Artist* (Ann Arbor, Mich.: UMI Research Press, 1988), 14.
2. Henry Geldzahler, quoted in the essay by Julia Markus, "Two Years after His Death, the Curtain Rises on Andy Warhol," *Smithsonian* 19:11 (Feb. 1989), 70.
3. Geraldine Stutz, as quoted in Smith, *Conversations*, 106.
4. Ultra Violet, *Famous for Fifteen Minutes: My Years with Andy Warhol* (New York: Avon, 1988), 93.
5. Quoted in Victor Bockris, *The Life and Death of Andy Warhol* (New York: Bantam, 1989), 169.
6. Quoted in Mike Wrenn, ed., *Andy Warhol in His Own Words* (New York: Omnibus Press, 1991), 11.
7. Hal Foster, "Death in America," *October* 75 (Winter 1996): 41; George Hartman, in Smith, *Conversations*, 122. References to Warhol and dyslexia include Mary Woronov, *Swimming Underground: My Life in the Warhol Factory* (Boston: Journey Editions, 1995), 59–60; Wayne Koestenbaum, *Andy Warhol: A Penguin Life* (New York: Viking, 2001), 31, 164; and Steven Watson, *Factory Made: Warhol and the Sixties* (New York: Pantheon Books, 2003), 7, 104, 186.
8. Callie Angell et al., *The Andy Warhol Museum* (New York: Distributed Art Publishers, 1994), 74.
9. Foster, "Death in America," 41.
10. Alexander Cockburn, *Corruptions of Empire* (New York: Verso, 1987), 278–81; rpt. from the *Village Voice*, Mar. 2, 1982.
11. Robert Hughes, "The Rise of Andy Warhol," in *The First Anthology: Thirty Years of the New York Review of Books*, ed. Robert B. Silvers (New York: New York Review, 1993), 220; rpt. from the *New York Review of Books*, Feb. 18, 1982, 6–10.
12. Andy Warhol, *THE Philosophy of Andy Warhol* (New York: Harcourt Brace, 1975), 149, 148, 199.
13. Quoted in Bockris, *Life and Death*, 270.
14. Ibid., 207, 232.
15. Quoted in Bob Colacello, *Holy Terror: Andy Warhol Close Up* (New York: HarperCollins, 1990), 352; see also 290–91, 328. In addition, see Ultra Violet, *Famous for Fifteen Minutes*, 93.
16. See, for instance, the aforementioned essay by Eve Sedgwick, "Privilege of Unknowing," *Genders* 1 (Spring 1988): 102–24; and Avital Ronell's book *Stupidity* (Urbana: University of Illinois Press, 2002).
17. Fredric Jameson, *Postmodernism; or, the Cultural Logic of Late Capitalism* (Durham, N.C.: Duke University Press, 1991), 8–10, 14.
18. Mandy Merck, "Figuring Out Andy Warhol," in *Pop Out: Queer Warhol*, ed. Jennifer Doyle, Jonathan Flatley, and José Esteban Muñoz (Durham, N.C.: Duke University Press, 1996), 224–37.
19. Félix Guattari, *Chaosmosis: An Ethico-Aesthetic Paradigm*, trans. Paul Bains and Julian Pefanis (Bloomington: Indiana University Press, 1995), 12–13.
20. Quoted in Bockris, *Life and Death*, 96.

21. Andy Warhol, *The Andy Warhol Diaries,* ed. Pat Hackett (New York: Warner Books, 1989), 133.

22. Andy Warhol and Pat Hackett, *Popism: The Warhol Sixties* (New York: Harcourt Brace Jovanovich, 1980), 146–48.

23. Quoted in Arthur Danto, "The Philosopher as Andy Warhol," in Angell et al., *The Andy Warhol Museum,* 81; Wrenn, *Andy Warhol in His Own Words,* 79.

24. Foster, "Death in America," 37.

25. Quoted in Bockris, *Life and Death,* 116.

26. Adams, *Hitchhiker's Guide,* 110.

27. Jameson, *Postmodernism,* 48–54.

28. Warhol, *Philosophy,* 229.

29. Peter Sloterdijk, *Critique of Cynical Reason,* trans. Michael Eldred (Minneapolis: University of Minnesota Press, 1987), 288.

30. Quoted in Wrenn, *Andy Warhol in His Own Words,* 33.

31. Quoted in Bockris, *Life and Death,* 16.

32. Ibid., 18–22, 25.

33. Ibid., 35.

34. Eleanor Ward, interviewed in Smith, *Conversations,* 205.

35. Bockris, *Life and Death,* 37. See also Bennard B. Perlman, "The Education of Andy Warhol," in Angell et al., *The Andy Warhol Museum,* 153, 156.

36. Quoted in Smith, *Conversations,* 115–16.

37. Ibid., 30 (quote, from Joseph Groell), 68.

38. Ibid., 72.

39. John Yau, *In the Realm of Appearances: The Art of Andy Warhol* (Hopewell, N.J.: Ecco Press, 1993), 116. See also Gerald Clarke, *Capote: A Biography* (New York: Simon and Schuster, 1988), 118, 165, 169, 263, 470.

40. Quoted in Wrenn, *Andy Warhol in His Own Words,* 83.

41. Warhol, *Philosophy,* 199.

42. Ibid., 116–17.

43. The studio visitor is Ivan Karp, whose comments appear in Smith, *Conversations,* 211; the artist's comments appear in Warhol and Hackett, *Popism,* 7.

44. Bockris, *Life and Death,* 186.

45. *Newsweek*'s 1963 exposé, in which Dylan was revealed as a middle-class Jew instead of an orphaned, Woody Guthrie-style hobo, was still a potent memory.

46. See Reva Wolf, *Andy Warhol, Poetry, and Gossip in the 1960s* (Chicago: University of Chicago Press, 1997).

47. See Colacello, *Holy Terror,* 444; Warhol, *Diaries,* 236; David Bourdon, *Warhol* (New York: Abrams, 1989), 385.

48. Warhol's position on typographical errors shifted over time. He was delighted by the typos in the manuscript for *a: a novel* (New York: Grove Press, 1968) and insisted on keeping them in the published version. He registers a markedly different response in his diary entry of December 14, 1981: "I went in to *Interview* and stood there finding typos in the Nancy Reagan issue. I just don't see why there should be even one. And it's something people really notice" (421).

49. Barbara Goldsmith provides this plot summary in the *New York Times Book*

Review, Sept. 14, 1975, 3–5; rpt. in *The Critical Response to Andy Warhol,* ed. Alan R. Pratt (Westport, Conn.: Greenwood Press, 1997), 111–14.

50. Colacello, *Holy Terror,* 75, 251.
51. Ibid., 452.
52. Ibid., 109, 209, 226.
53. Klaus Honnef, *Andy Warhol, 1928–1987: Commerce into Art,* trans. Carole Fahy and I. Burns (Cologne, Ger.: Benedikt Taschen, 1991), 30.
54. Warhol, *Diaries,* 613.
55. Bockris, *Life and Death,* 150.
56. Warhol, *Diaries,* xix–xx; Fred Lawrence Guiles, *Loner at the Ball: The Life of Andy Warhol* (New York: Bantam, 1989), 347.
57. Warhol, *Diaries,* 172, 697, 781; Colacello, *Holy Terror,* 375, 389, 413.
58. Warhol, *Diaries,* 779.
59. Ibid., 793.
60. Ibid., 622.
61. Ibid., 656, 663.
62. Ibid., 697.
63. The photo appears in Wrenn, *Andy Warhol in His Own Words,* 91. For other material on Andy's interaction with children, see his nephew James Warhola's book, *Uncle Andy's: A Faabbbulous Visit with Andy Warhol* (New York: Putnam, 2003).
64. Colacello, *Holy Terror,* 251.
65. Warhol, *Philosophy,* 148.
66. Andrew Ross, *No Respect: Intellectuals and Popular Culture* (New York: Routledge, 1989), 114.
67. Simon Watney, "Queer Andy," in Doyle et al., *Pop Out,* 23.
68. Quoted in Smith, *Conversations,* 123. Discussing what Warhol knew at the height of his sixties scene, Stephen Koch writes, "I am sure he knew it only intuitively. I'm equally sure he never allowed that knowledge to mature beyond the point where it threatened this astonishingly passive man's astonishing capacity to act." Koch, *Stargazer,* 2nd ed. (New York: Marion Boyars, 1985), 16.
69. Koch, *Stargazer,* 76; Smith, *Conversations,* 311, 314.
70. Stephen Koch, "The Once-Whirling Other World of Andy Warhol," *Saturday Review* 22 (Sept. 1973): 20–24; rpt. in Pratt, *The Critical Response to Andy Warhol,* 94–102 (quote, 96).
71. Quoted in Dick Hebdige, "In Poor Taste: Notes on Pop," *Hiding in the Light* (New York: Routledge, 1988), 135.
72. Quoted in Jesse Kornbluth, *Pre-Pop Warhol* (New York: Panache Press, 1988), 27.
73. I borrow this phrase from Leo Bersani's study of Caravaggio, "Caravaggio's Secrets," presented at a lecture on January 27, 1997, at the University of Virginia.
74. The epigraphs for this section are from Smith, *Conversations,* 159; Bockris, *Life and Death,* 81; and Peter Gidal, *Andy Warhol Film and Paintings: The Factory Years* (New York: Da Capo Press, 1971), 9, respectively.
75. Quoted in Smith, *Conversations,* 58–59.
76. Ibid., 25.

77. From the story "Mosquitoes," in Jones's collection *The Pugilist at Rest* (Boston: Little, Brown, 1993), 104; rpt. as the epigraph to Danto's essay, "The Philosopher as Andy Warhol," 73.

78. Honnef, *Andy Warhol*, 93; Calvin Tomkins, "Raggedy Andy," *The Scene: Reports on Post-Modern Art* (New York: Viking, 1976), 50.

79. Richardson's eulogy is reprinted in Kynaston McShine, ed., *Andy Warhol: A Retrospective* (New York: Museum of Modern Art, 1989), 454.

80. Danto, "The Philosopher as Andy Warhol," 81.

81. Bockris, *Life and Death*, 149.

82. Danto, "The Philosopher as Andy Warhol," 74.

83. Bockris, *Life and Death*, 320.

84. See note 11 above.

85. Quoted in Smith, *Conversations*, 34–5.

86. Ultra Violet, *Famous for Fifteen Minutes*, 93.

87. Quoted in Smith, *Conversations*, 230.

88. By way of contrast, see Jorge Luis Borges's story "Shakespeare's Memory," translated by Andrew Hurley, in the *New Yorker*, Apr. 13, 1998, 66–69.

89. Warhol, *Philosophy*, 143. The connection between architecture and Heinz pickles is not actually a stretch for someone, like Warhol, who was raised in Pittsburgh, where the manufacturer has its headquarters. But there is an even more inspired reason for Warhol's making this connection. Nathan Gluck recalls in an interview, "in 1935 or 1936, when we had the first World's Fair in New York, there was a Heinz Pickle Pavilion, and they gave everybody little pins that were Heinz pickles, and everybody wore them. And Andy had evidently seen these or heard about it or something and thought, 'Wouldn't that be great. For this year's [1964] World's Fair to do a Heinz pickle.' *Then* he thought of the *Ten Most Wanted Criminals*. And I thought, 'Andy, you are out of your mind!' And he went ahead and did it" (quoted in Smith, *Conversations*, 68).

Now [Ken] Kesey is standing up facing
the judge with his arms folded and the
judge is giving him a lecture. . . .
He may be a great literary lion and
a romantic figure to some misguided
youth but to this court he is a childish
ass, an egotist who never grew up, a
. . . the judge is pouring it on, pouring
it down his throat like cod-liver oil, but
it's obvious it's just a buildup to saying
he's going to grant bail anyway under
the circumstances.
—Tom Wolfe,
 The Electric Kool-Aid Acid Test

"free andy"
open forum:
tracking a man
without a rudder

opening salvo

1. He's a totally facetious, effeminate lightweight, without any depth or heft. He's an annoying poseur in the art-world. (Hilton K. C. Greenberg)[1]

2. "He has been able to take painting as we know it, and completely change the frame of reference of painting as we know it, and do it successfully on his own terms. These terms are also terms that we may not understand." (Larry Bell)[2]

3. "'Andy' . . . has carried the ongoing de-definition of art to the point at which nothing is left of art but the fiction of the artist. . . . Warhol's mask is a bit too awry to be a face. The interesting question is why the art world has been so eager to be taken in by it." (Harold Rosenberg)[3]

4. His Brillo Box show is "an ideological tour de force, with the dry goods distinguishing its essential nihilism. . . . The visual emptiness of it all is the price he seems willing to pay for an instant of sublime but compulsive negation." (Sidney Tillim, critic/painter)[4]

5. "It is an art that may be a mockery or may not be a mockery, that seems most a mockery when most fashionably accepted, most subversive when most a fad." (Philip Leider)[5]

6. "Warhol's nontransformation of his subjects meant copying, and copying meant faking. . . . If his works were meant to be fakes, they could be viewed as emblems of inauthentic art and, by extension, inauthentic being, which was taken to be the fate of the individual in a consumer society." (Irving Sandler)[6]

7. "Warhol's serial photo silk-screens of Marilyn Monroe are about as sentimental as Fords coming off the assembly line." (Ron Sukenick)[7]

8. "To notice the renunciation of emotion in the content of Warhol's work does not logically lead to the conclusion that he 'committ[ed] emotional suicide.' Warhol's libidinal and emotional investment in his work was enormous. But rather than making a direct transfer from his 'inner-emotional' self to his work, Warhol attempted to transfer this transference from the work to the viewer." (Peggy Phelan)[8]

9. "His much-talked about indifference looks more like a condition of a seamless albino humour that created uncertainty about his every move, so that even when he insisted he had nothing to hide, we were sure he was hiding something." (Ralph Rugoff)[9]

10. "What he has . . . is an absolute genius for self-promotion. . . . I think that Andy has taken a light, limited talent and turned it into an *enormous* thing. I mean, I admire it. It's incredible." (Buddy Radish, art director)[10]

11. "It will take a long time for the American media culture to fabricate a guru dandy of this caliber, or a Peter Pan with all that charm—sulfurous at times—yet knowing how to address, in all simplicity, the world of man, as a man of the world." (Pierre Restany)[11]

philosopher

12. Warhol brought artistic practice to a level of philosophical self-consciousness never before attained. He invalidated some two millennia of misdirected investigation about distinctions between high and low art, and between art and reality. Warhol violated every condition

thought necessary to something being an artwork, but in so doing he disclosed the essence of art. (Arthur Danto, "The Philosopher as Andy Warhol")[12]

13. "Danto . . . has fashioned Warhol into a serious, original, and daring philosopher. . . . However, it cannot be said without qualification that Warhol is philosophical any more than it can be said that he is critical or psychologically deep or even interpretively subtle. What can be said without qualification about Warhol is exactly nothing, and even that gesture of nonassertion is inappropriate because it is unengaged." (Daniel Herwitz, "Andy Warhol without Theory")[13]

14. "Andy took every conceivable definition of the word art and challenged it. Art reveals the trace of the artist's hand: Andy resorted to silk-screening. A work of art is a unique object: Andy came up with multiples. A painter paints: Andy made movies." (Edmund White)[14]

movie-maker

15. "So static were his early movies that a succession of frames, taken out of context and printed like an enlarged contact sheet, looked very much like the repeated images on his canvases." (Marco Livingstone)[15]

16. "Andy Warhol is taking cinema back to its origins—to the days of Lumière—for a rejuvenation and a cleansing. . . . The world becomes transposed, intensified, electrified. We see it sharper than before."[16] (Citation for 1964 Sixth Independent Film Award, sponsored by Jonas Mekas's *Film Culture*)

17. "*Couch, Blow Job* and the other early films are . . . not just about breaking the taboo on seeing gayness, but exposing some of the aesthetic mechanisms of the pro-

scription and the lifting of it." (Richard Dyer, *Now You See It*)[17]

18. "The attractiveness of utter cool passivity has been a factor in the success of some of the homosexual-exploitation films—the ads for *Flesh* featured [Joe] Dallesandro with the words 'Can a boy be too pretty?'—and I guess we're supposed to find his blotchy, beat-out quality, the big muscles and the lice in the hair, both attractive and funny, but his apathy enervates this movie. . . . What is sometimes called decadence may be just lack of energy." (Pauline Kael)[18]

19. "[Dallesandro's] affectless manner and his laid-back personality created a sexually ambiguous canvas of flesh and muscle on which every assorted fantasy from every assorted audience member could find expression and meaning." (Michael Ferguson, on the film *Flesh*)[19]

20. "All of the males in the cast [of *Lonesome Cowboys*] displayed homosexual tendencies and conducted themselves toward one another in an effeminate manner. Many of the cast portrayed their parts as if in a stupor from marijuana, drugs or alcohol. . . . There were suggestive dances done by the male actors with each other. These dances were conducted while they were clothed and suggested love-making between two males. There was no plot to the film and no development of characters throughout." (*The FBI File on Andy Warhol*)[20]

21. "Secretive, after-midnight viewings of Warhol's *Lonesome Cowboys* and *Bike Boy* at obscure art theaters released my adolescent libido. . . . Andy provided the raw ingredients for our psyches." (Benjamin Liu, a.k.a. Ming Vauze)[21]

22. "Sexually and aesthetically, [Warhol's *Haircut*] was the hottest film ever made." (Amy Taubin)[22]

23. "He demythologizes the taboo: lesbians, homosexuals, hustlers, pushers. The world he works with is the world he can communicate with, the world most of us have been unable to communicate with. Or else we communicate with it in a paternalistic, 'liberal' fashion." (Peter Gidal)[23]

24. "It is time for permissive adults to stop winking at [Warhol's films'] too-precocious pranks and start calling a lot of their cut-ups—especially this one—exactly what they are. . . . So let's get it said without quibbling that this seamy *The Chelsea Girls* is really nothing more than an extensive and pretentious entertainment for voyeurs." (Bosley Crowther, *New York Times*)[24]

25. Actually, there *has* been a lot of quibbling about *Chelsea Girls,* but for other reasons. Some say Warhol lost his grip on the medium shortly after making that film (1966); others argue the reverse, that he came of age as a filmmaker when he began collaborating with Paul Morrissey. (David E. James)[25]

26. "Much of the movie [*Poor Little Rich Girl*]—like most of his works it was filmed one day, processed the next, and screened the day after—is out of focus, but nobody knows better than Warhol that this merely increases the mystique." (John Wilcock)[26]

paradoxical gestures

27. "Despite the breadth and scope of his art, Warhol's chief creative endeavor was always himself. . . . Embracing paradox, he self-consciously crafted an image at once immensely sophisticated and unbelievably naive, part debutante and part social critic." (Jonathan Katz)[27]

28. "Warhol's 'act,' as it were, pivoted precisely around the refusal to gel as a definable artistic subject in any coher-

ent way in relation to what was expected of him by others." (Amelia Jones)[28]

29. "The negation of the private, individual self in both Warhol's portraits and his own public persona not only subverted assumptions cherished in the 1950s about the self, but also, paradoxically, served as one means through which a new generation of consumers defined its identity in the swinging sixties." (Cécile Whiting)[29]

30. "Warhol feeds his high-art intentions on mass culture's denials that such intentions count. Having gerrymandered several regions of media-land and made them into a coherent work of art, his private duchy, he finds that he may only rule it if he plays its shy buffoon, wan and childish in his devotions." (Carter Ratcliff)[30]

31. "Andy had said he wanted to end his painting career with those silver pillows [1966], to let them fly away from the rooftop, but they didn't really fly away. It was a grand gesture; he was a master of the grand gesture." (Ronnie Cutrone)[31]

disarming critics

32. "The real difficulty in any approach to Warhol's works is that we do not have the tools with which to discuss his importance. He has been very inventive with his lack of inventiveness." (John Perreault)[32]

33. "Warhol arrived at a point where judgments of art critics were irrelevant to his reputation." (Rainer Crone)[33]

34. "We [are] in the midst, at the moment, of an accelerating cult of enthusiasm, a movement of the sensibility which might be called 'Warholism,' in which nothing has to be

proved or justified, and which is designed to invalidate . . . the critic." (Max Kozloff, 1965)[34]

35. "Andy's gotten more than his share [of criticism]. He's done it by very, very clever adverse public relations. I still to this day don't know if he's got a pro working with him or not. In other words a super-pro who's advised Andy. In other words, the super-pro would then be the artist." (Buddy Wirtschafter, Factory cameraman)[35]

duchamp legacy

36. "His strategies could appear to be scandalous only in the face of the New York School climate of the late fifties and that generation's general indifference, most often fused with aggressive contempt—as exemplified by Clement Greenberg—for the Dada and Duchamp legacy." (Benjamin Buchloh)[36]

37. "Duchamp himself was largely kitschified by Andy Warhol." (Matei Calinescu)[37]

38. "Warhol has engaged public fascination in a way Duchamp never did; he has become a leading symbol and shaper of the very culture." (John Coplans)[38]

39. "If you take a Campbell's Soup can and repeat it fifty times, you are not interested in the retinal image. What interests you is the concept that wants to put fifty Campbell's Soup cans on a canvas." (Marcel Duchamp)[39]

retinal image

40. With all respect, Mr. Duchamp, you mustn't discount the retinal image. "The effect of Warhol pointing to commercial art as a source of visual energy and his use of violent colour overlay in his screenprints can be seen in

every art college, every fashion magazine in the Western world. In purely visual terms he affected the language of art more than anyone else of his generation." (Alastair Mackintosh)[40]

41. The images are a site of formal innovation—his silkscreen printing process, repeated-image abstraction, off-register colors, quirky imperfections, and so on. He's "one of the shrewdest of the new wave of post-Modernists, displaying—once again—a cool, ironic attitude toward all aesthetic camps." (David Bourdon)[41]

queer rusyn wit

42. "[Pop art] was, from beginning to end, an ironic, a camp, a literary-intellectual assertion of the banality, emptiness, silliness, vulgarity, et cetera of American culture, and if the artists said, as Warhol usually did, 'But that's what I like about it'—that only made the irony more profound, more cool." (Tom Wolfe)[42]

43. He's not an ironist, he was never in the least intellectual. He was a working-class queer aesthete, tenaciously heroic, and a mass of contradictions, vulnerabilities, and profound projective anxieties. His being camp was no more a matter of conscious volition than his queerness. Cans of soup are only "banal" to those who didn't have to grow up on canned food. (Simon Watney, "Queer Andy")[43]

44. It's true that people go to bizarre extremes to avoid seeing him as gay. This is most noticeable among his relatives and fellow Rusyns in the Eastern Slovakia region where his parents were raised. But by saying Andy wasn't an ironist, it sounds as if you're depriving him of a sense of humor. His same relatives back in Slovakia, with their peasant spryness and cockeyed wit, provide clues about

the kind of humor he had . . . (*Absolut Warhola*, directed by Stanislaw Mucha)

45. "Almost everything he does is of a comic nature. He refuses to be serious. But being comical is one of the most serious things." (Paul Morrissey)[44]

46. Notice the ingenious way during the fifties that Andy throws "coloring parties" and gets people to do his paid advertising work for nothing, as an amusing pastime, in the manner of Tom Sawyer. (Patrick S. Smith)[45]

47. Plus there's the humor in his pre-pop visual design: "he could kid the product so subtly that he made the client feel witty." (Calvin Tomkins)[46]

shoes and acrostics

48. That raises a different issue for me. Warhol's role as mediator between product and client in his early commercial design indicates how his work turns centrally around commodification. Given this close advertiser-client connection, it's paradoxical that his later work does not organize even a minimal place for the viewer. Note the painting *Diamond Dust Shoes* (1980), "whose glacéd X-ray elegance mortifies the reified eye of the viewer." It's impossible to restore the lived context of such images; they repudiate modernist depth logic and serve as exemplars of a radically unsettling postmodern modality. (Fredric Jameson, *Postmodernism; or, the Cultural Logic of Late Capitalism*)[47]

49. On the contrary, it *is* possible to restore the lived context of such images, and to do so, you need to see him as a gay artist appropriating popular images and infusing them with his own queer meanings. Among the contexts for *Diamond Dust Shoes* are tacky sidewalk sales in

Manhattan's garment district, and Warhol's fondness for drag queens and their apparel. (Mandy Merck, *Pop Out: Queer Warhol*)[48]

50. "I've always thought that in one way or another Warhol was always in a kind of drag." (Ingrid Sischy)[49]

51. "His class origins and his sexual preferences could be expressed in one utterance, for on the common ground of 'camp,' that is to say in popular culture, the working class and the homosexual meet." (Kenneth Silver)[50]

52. "Warhol's honesty about homosexuality was restricted to a largely hidden code for the bulk of his career (not surprising given the homophobia of pre-Stonewall America). . . . much of what [Trevor] Fairbrother correctly identifies as Warhol's homosexual imagery [of the mid-1950s] remained closeted as far as the general public was concerned. The 'homosexuality' of these works functioned as a kind of in-group acrostic. If one didn't know the puzzle was there to be played, one never could have decoded it." (Caroline Jones, *Machine in the Studio*)[51]

53. "I would stress the partial nature of Warhol's suppression of homosexuality in his Pop art of the early 1960s. Rather than silencing same-sex desire outright, Warhol 'smuggled' it, all but imperceptibly, into selected paintings." (Richard Meyer, *Outlaw Representation*)[52]

54. "Part of the utopian impulse behind his homoerotic films, paintings, drawings, and photos was the desire to turn galleries, museums, movie theaters, art studios, and other places into queer counterspaces. What was disturbing to some and nourishing and exciting for others was the way that Warhol resisted being fit into stock roles by changing, mocking, or exploding them while at the same clev-

erly and persistently promoting himself in the public eye." (Jonathan Flatley, *Pop Out*)[53]

trickster pose

55. His ability to affirm gay meanings in his sixties pop work is imbricated with his ability to deny them at the same time. His career is greatly enabled and safeguarded by the naif-trickster pose he worked up as a kind of master dialect or conjurer's spell. (Kelly Cresap)

56. "You Andy Warhol are the greatest put-on since P. T. Barnum." (Barry Farber, radio host)[54]

57. "It was so close to a put on. It takes a very active thing, the way a lot of artistic breakthroughs do, from time to time and a really fantastic act of faith to believe in what Warhol was about, and every time it proved that he wasn't a charlatan. I think people were justified in being suspicious." (Mario Amaya)[55]

58. He may not have been a charlatan, but he generated many of the *effects* of one. The way I see it, he lacked moral clarity and social responsibility, and his pose never fully conceals this.

59. The ethos of the 1950s desperately needed infusions of moral ambiguity and social irresponsibility. Sexiness too. Warhol provided a great service.

the sixties exploding

60. You had to be there. Anyone who ever got high at one of Warhol's Exploding Plastic Inevitable (EPI) shows doesn't need to have the experience parsed out in moral or academic terms.

61. "The sound is a savage series of thrusts and electronic feedback. The lyrics combine sadomasochistic frenzy with free-association imagery. The whole sound seems to be the product of a secret marriage between Bob Dylan and the Marquis de Sade." (Richard Goldstein, reviewing an EPI performance in the *Village Voice*)[56]

62. "It will replace nothing except maybe suicide." (Cher, on the EPI sound, after a performance in Los Angeles)[57]

63. Attending an EPI event, "it came home to me how the 'obliteration' of the ego was not the act of liberation it was advertised to be, but an act of compulsive revenge and *resentment* wholly entangled on the deepest levels with the knots of frustration. . . . Liberation was turning out to be humiliation; 'peace' was revealing itself as rage." (Stephen Koch)[58]

64. "Andy created multimedia in New York. The whole complexion of the city changed. Nothing remained the same after that." (Lou Reed, former lead vocalist for the Velvet Underground)[59]

65. "The Factory was more than just ground zero for Warhol's world view; it was, in the end, at the dead center of 1960s desublimatory politics—that magical place where artistic labor and libidinal labor merged in the war against repression and the hatred of sex and sexual difference." (Maurice Berger)[60]

66. There's a lot that wasn't magical about it. You can't say the fifties needed infusions of irresponsibility like it was a homeopathic dose or part of some visionary movement. Desublimatory politics, articulated by thinkers such as R. D. Laing, Norman O. Brown, and Timothy Leary, had other consequences besides liberation from bourgeois

constraints. I'm not saying there was no magic at all, just that some of the consequences were disastrous.

67. That's the case with all creative enclaves and social revolutions. It's always possible to go back, subtract the genius and the animating force, and see only chaos, immorality, and various abuses of freedom. But that misses the point.

white male

68. Before this gets further out of hand, someone needs to say that from the start, the Factory was a white male power base. The so-called "Superstars" were unpaid second-class citizens there, even during their allotted fifteen minutes. For all the talk about sixties liberation, Andy had no insights about racism or feminism. He made serious blunders whenever he went near these topics, as in the misnomer title of his *Red Race Riot* painting, or his statement in *Philosophy* about the biggest anachronism today being pregnancy.[61]

69. The whole pop art movement itself had ingrained gender and race biases. Dominant tastes ruled, even when they were being served up with a dose of irony.

70. "No one is as white as Warhol: he offers himself . . . as the literalizing allegory of whiteness. . . . Whiteness and shame are closely intertwined for Warhol. . . . Warhol's casual and more-than-casual racism: how to situate it in this connection? I would just briefly call special attention here to his distinctive (and, of course, in some ways profoundly limiting) strategy of 'childlikeness.'" (Eve Kosofsky Sedgwick)[62]

71. His being childlike also came up a lot in his dealings with women. There was a mother-son charge not only at home

with Julia but at the Factory, with the older Superstars. Somehow, though, it doesn't seem complete to say he had "no insights" about feminism. Maybe not him personally, but think for a moment about all the women he featured in his movies, and all the juicy girl-talk he enabled, both on and off screen. Many of Warhol's films included long sections in which women got to speak candidly about sex and politics and "stuff," often in an all-female setting. Name another pop artist or independent filmmaker of the time who promoted anything remotely like this. At the Factory, at Max's Kansas City, countless women found validation, of a kind they couldn't find anywhere else.

female admirers

72. "I had so much affection for Andy. He wasn't a big talker, but he had a certain, extraordinary charisma that gave you a kind of license to be freer than I'd ever been able to be." (Susan Bottomly, a.k.a. International Velvet)[63]

73. "The reason I liked Andy so much was I never felt out of place in the Factory, even though, given my personality at the time I should have felt very out of place. . . . When I think about it, it's funny that I didn't run out screaming." (Maureen Tucker, former drummer for the Velvet Underground)[64]

74. "Warhol's use of artistic form and genre to make a political statement and reality, his refusal in either his form or content to distinguish between élite and scum, between high and low, in any way, his radical refusal to pay any attention to the notions of fine art taught by the academy, his amazing clarity and courage, and his overt proud homosexuality . . . all these positions, for every artistic position is also a moral and political one, deeply influenced

both me and my work. And I wasn't the only one. His
later work . . . but everything and everyone, conscious-
ness, changes." (Kathy Acker)[65]

shooting and aftermath

75. *(A shrill voice cuts through the assembly:)* I want to ad-
dress the SCUM Élite! "If a large majority of women were
SCUM, they could acquire complete control over this
country within a few weeks by simply withdrawing from
the labor force, thereby paralyzing the entire nation."
(Valerie Solanas, *The SCUM Manifesto*)[66]

*(A commotion ensues, during which security apprehends
Solanas and escorts her from the premises. Pause.)*

76. "We were horrified when she shot Andy Warhol in 1968,
just to make a point, to wit, that man's world is corrupt
beyond redemption and must be physically defeated, cap-
tured and colonized by women if it is to be saved from
self-destruction." (Editors of *The SCUM Manifesto*)[67]

77. "The Factory had always been open to any kind of per-
son. Suddenly it was very difficult to come in. Video cam-
eras were installed. You were screened. It had a very,
very serious effect on his health and on his life. It left him
very frightened." (Bianca Jagger)[68]

78. "The shooting polarized feelings about Andy Warhol. At
one extreme were those for whom he had now attained a
Christlike martyrdom. . . . At the other pole were the
feminist revolutionaries." (Victor Bockris)[69]

79. "After he was shot he came back as, I was convinced,
half angel or all angel." (Jane Holzer, former Superstar)[70]

80. "It was fun! Absolute fun every time I worked for him. . . . I just can't couple myself with those people anymore. I can't hack it." (Ondine, longtime Factory associate)[71]

81. "It was a maelstrom for me. There was so much mischief and stuff going on. It was always lighthearted and fun to be around Andy. Others were not quite as light. Others were a bit more bitchy about their fun. That's when I bailed out." (John Cale, former musician for the Velvet Underground)[72]

82. "'You're going to be a big star,' he told me before the film was completed. And to think I believed that crap. . . . As I look back on it now, I wish that I were smarter and put a clause in the contract that I would have gotten a percentage." (Holly Woodlawn, former Superstar, on her work in the film *Trash*)[73]

83. "Andy was shocked that I would betray him as an artist— this is why he felt hurt when I brought suit against him. He assumed that I should excuse all faults and all shortcomings. . . . he would rather beat me out of this than give me what I deserved." (Ronald Tavel, unpaid writer for fourteen Warhol film scripts)[74]

revaluing down and up

84. "Warhol was a vandal. . . . His pictures might just as well have been made by anyone else, and indeed they often were. . . . But Warhol's real crime is that he threw away what Marcuse called the power of art to break the monopoly of established reality. In his hands, or rather out of them, painting came close to being a mere reflection of the prevailing ideology and the dominant mode of production." (Peter Fuller, 1980)[75]

85. "There is nothing from the late 1960s or after comparable to the Marilyns, death-and-disaster series, or even the Campbell's soup cans. . . . The existential edge that marked his best art and films seems to have disappeared before the shooting. Others have argued that by 1968 Warhol had said what he wanted to say." (Bradford R. Collins, 1988)[76]

86. "*Career* is a truly bad word, suggesting that the fame Warhol sought and attained also explains and justifies the great artist he was, at least between 1961 and 1968." (Thierry de Duve, 1989)[77]

87. The later portraits "were as radical as anything Andy ever did. . . . Andy's idea of art included the art of socializing and the art of conversation and what some non-artists coined 'the art of the deal.'" (Glenn O'Brien, 1996)[78]

88. "From the utter vacuity of the camera-oriented smile of the wife of an international banker to the startling disclosures of moods fit for private diary, these painting-snapshots add up to a Human Comedy for our time." (Robert Rosenblum, 1979)[79]

89. At one extreme, Rosenblum credits Warhol with the contemporary reinvention of the humanist portrait; at the other, [Benjamin] Buchloh credits him with its demise in the 1960s and its phony restoration as commodity in the 1970s and 1980s. . . . Ultimately, Andy Warhol's portraits not only revive the genre for the late twentieth century, they also take it apart, and with brilliance and wit, turn it on its head." (Nicholas Baume, 1999)[80]

punk and glitter

90. Critics who dismiss Warhol's post-sixties work "cannot explain the continuities between Warhol's purportedly

critical avant-gardism of the 1960s and his later commercialism except by resorting to myths of selling out. Warhol's most politicized progeny exploited the critical possibilities he opened up in his work. Punk, for example, whose debt to the Factory is important, continued in the realm of pop music and street style the investigation of alienation, blankness, and aggressiveness that Warhol articulated in his movies." (Juan A. Suárez)[81]

91. "As Warhol and members of the Factory entourage began to interact with rock and roll musicians such as Lou Reed, David Bowie, and Iggy Pop, the concepts that would guide glitter rock began to surface. . . . through the medium of glitter rock, young people adopted 'incorporated versions' of Warhol's pop ethos and the Factory's subcultural attitude and style." (Van M. Cagle)[82]

pop and postmodern

92. Critics from a variety of outlooks—social, philosophical, and cultural—have shaped the debate that leads directly from the pop movement into postmodernism. Among the key intellectuals reframing the debate on Warhol's contribution are Lawrence Alloway, Harold Rosenberg, Barbara Rose, Max Kozloff, Susan Sontag, Ihab Hassan, and Andreas Huyssens. (Sylvia Harrison)[83]

93. The principal issues of "simulation and appropriation" and "commodification of the artwork" in Warhol's pop especially . . . coincided with those at the heart of the postmodernist controversy of the eighties. (Lynne Cooke)[84]

94. "Andy Warhol was a premodern in a modern world struggling with postmodernity. Along the way, he cracked some eggs and smashed many icons." (Raymond M. Herbenick)[85]

95. "Attunement to the audience is all for Warhol. He personifies the psychotic theatricality that prevails in and is perhaps definitive of postmodernist society." (Donald Kuspit)[86]

pathology and defense

96. Postmodernism, schmostmodernism. Andy had psychopathic tendencies—he was incoherent, empty, glib, unfeeling, amoral—and he promoted similar tendencies in American culture at large.

97. As a trickster, though, Warhol provided elements—creative, mythic, sacred, heroic, life-sustaining, and mediatory functions—of which the psychopath is incapable. His "shamelessness" and "great attraction to dirt" are mere concomitants of the trickster's role as a creator of culture. Further, your reaction may be a defense against the anxiety that a trickster's methods can produce. (Lewis Hyde, *Trickster Makes This World*)[87]

98. But is the defensiveness *only* a function of the anxiety? Metaphorically speaking, just because I'm paranoid about Warhol doesn't mean he's not out to get me.

muse guru priest

99. I'd like to know what elements he provided were sacred. So what if he was Catholic and he painted icons—does that make his work "sacred"? I've read a lot of fancy criticism about the *Death and Disaster* series, and I still say that his depiction of the car crash victims and suicides is a sacrilege. He sets himself up as performing last rites and supreme unction for them, and he is not spiritually qualified to do that. Sacred work needs mentors and muses, not just "crazy, druggy people" and white-collar middlemen. I think there was too much static at the Fac-

Pop Trickster Fool

tory for Warhol to hear the counsel of a latter-day Virgil or Beatrice.

100. You should have met Jed Johnson . . . and seen his effect on Andy. People forget that Jed and Andy lived together for twelve years.

101. "I was sort of his photographic guru. So many people ask me about me being inspired by Andy. It was really quite the opposite. Andy was inspired by me and by all of us." (Chris Makos)[88]

102. "Retentia [the muse of the Retained Image] helps the artist freeze or seize the apt image from the overwhelming plethora of possibilities in our very image-retentive time. . . . From [1953] till the end of his life, Andy Warhol made great use of Retentia's skills." (Edward Sanders)[89]

103. "I'd like to recall a side of Andy's character that he hid from all but closest friends: his spiritual side. Those of you who knew him in circumstances that were the antithesis of spiritual may be surprised that such a side existed. But exist it did, and it's the key to the artist's psyche." (John Richardson, in his eulogy for Warhol at St. Patrick's Cathedral, April 1, 1987)

104. "Is [John] serious? But what can you say at St. Patrick's? You have to glorify the dead. Is it possible that Andy changed? I think of his last work, *The Last Supper*, painted exclusively in red, as if sealed in Andy's blood, his final legacy. What was its meaning; was it serious or a mockery?" (Ultra Violet, former Superstar)[90]

105. "Warhol's juxtaposition here of the Christ of Leonardo with the motorcycle, our age's symbol of untrammeled freedom, power, and sexuality, results in a brash and

commanding painting. Two sides of Warhol, his piety and his deep involvement in the aspects of the culture that are inimical to that piety, are here asserted and held in an unresolved tension." (Jane Daggett Dillenberger, on Warhol's painting *The Last Supper (The Big C)*, ca. 1985)[91]

106. "The nucleus of the Warhol debate is ultimately the issue of iconoclasm, in other words, the clash between iconophiles who call his art 'beauty,' and iconoclasts who call it 'commodity' with the qualities of a fetish." (Peter Kattenberg, *Andy Warhol, Priest*)[92]

critic dupe cynic

107. Actually, I see three rival verdicts. "The debate over Warhol centers on whether his art fosters critical or sub-versive apprehension of mass culture and the power of the image as commodity, succumbs in an innocent but telling way to that numbing power, or exploits it cynically and meretriciously." (Thomas Crow)[93]

108. So, in short, he's either a critic, a dupe, or a cynic. Or an iconoclast, unless he's an iconophile. Could it be he's just noncommittal, or in love with baffling the public? I don't buy the notion that he was involved in everything at a second-order level of mastery.

109. He could be an extraterrestrial . . . someone outside our sign-system.

(Pause.)

con games and smoke signals

110. This trickster business is tricky. I once knew a man who conned money out of prostitutes. He admitted to me,

"You see, the trouble is you can get *con-goofy*. You don't know where the con is anymore *in your own head*." (George W. S. Trow)[94]

111. That sounds like the art world of the eighties.

112. "Warhol's immense popularity taught artists everywhere that cleverness is enough . . . Emerging painters and sculptors [today], working with the fervor of admen, continue to concentrate on thinking up gimmicks that will shock just enough to make their work desirable." (Bradley Block, 1989)[95]

113. Eighties-style con games weren't limited to the art world. I can't forgive Warhol for sucking up to the Reagans, Imelda Marcos, and the shah of Iran in *Interview*. The cynicism of it is staggering.

114. "Andy thought the Shah of Iran was charming and amusing. He thought it was glamorous to know a head of state. But he could not think about whether he was a good guy or not." (Susan Sontag)[96]

115. *Interview* showed some promise when it started out in '69 as *inter/VIEW*, a semi-serious monthly film journal. Then it became the pioneer for the fatuous, style-obsessed, celebrity-driven magazines of the eighties, *People* and Co. I think of Warhol as a one-man strip-mining operation.

116. He was wiser to the problem than people realize. In his 1985 book *America*, Warhol reveals that he "was not quite as enthusiastic about celebrity as his public image suggested. . . . Even though a publisher himself, he indicates that this business is insidious, cynical, and more interested in fads than in truths." (Trevor Fairbrother)[97]

163

117. "It was the magazine more than anything else that kept Andy from passing into sixties history. Meeting creative new people—especially young kids—was always important to him; he thrived on it. . . . By 1976 *Interview* had a cachet of sophisticated self-mocking silliness that made celebrities actually *want* to be in it." (Pat Hackett, editor of *The Andy Warhol Diaries*)[98]

118. "*Interview* was like smoke signals out to the hinterlands for the very hip and the very gay, 'Look,' *Interview* said in a kind of code, 'We know you—come on down!'" (Marc Balet, former *Interview* art director)[99]

119. Warhol transposed gossip from the private realm to a public one where it *deliberately* provoked audiences. He may conform in some ways to the stereotype of the homosexual as a gossip, but he actively made people confront that stereotype. (Reva Wolf, *Andy Warhol, Poetry, and Gossip in the 1960s*)[100]

diarist

120. "The diaries go far beyond idle gossip. They are a re-creation of a time and a place in America." (*Detroit News*)

121. "No study of Manhattan society in the strobe-lit 1970s or in the shadow of AIDS will be possible without consideration of *The Andy Warhol Diaries*, which provides an unforgettable portrait of what a set of people imagined themselves to be and of what they really were." (*Baltimore Sun*)[101]

122. "In New York in the summer of 1989, the question is, 'Are you in the book?'" (Jay McInerney)[102]

123. "Why Bianca Is Suing Over Warhol Diary" (Headline, July 12, 1989)[103]

124. "Finished reading *The Andy Warhol Diaries*. Well, now we know the speed of shallow. Actually, I came to rather like Warhol. And his art." (Ken Wilber)[104]

125. "[Pat Hackett] could have edited them down to six pages and little would have been lost." (Don Gillmar)[105]

126. "While it records his encounters with the rich and famous, Warhol's diary is no mere trail of name-droppings. He has an instinct for telling stories, with a style all his own—a preference for anticlimax and disappointment as resolution, an undercurrent of anxiety, a love of paradox and the bizarre combined with an absence of irony and a total rejection of decorative flourishes. . . . The diary may have begun as notations for the IRS, but it goes far beyond that, showing, along with his other books, that he aspired to some sort of identity as a man of letters." (Phyllis Rose)[106]

climbing and sinking

127. "He is the ultimate social climber." (Viva, former Superstar)

128. He was "not a social climber. He was Mount Everest, people climbed him." (Henry Geldzahler)[107]

129. "The more destroyed you were, the more likely he was to use you." (Taylor Mead)[108]

130. He represents "the final decline and total collapse of the American avant-garde." (Cover of *Esquire*, May 1969, with Warhol depicted sinking into an open can of Campbell's Tomato Soup)

131. Would this be a good moment to pass out complimentary copies of *Interview?* Gauge the decadence for yourself!

Plus, the Bruce Weber photos this month are really hot. Any takers? *(Numerous hands go up.)*

factory scene

132. While we're paused, I'd like to run a clip from my movie on Jim Morrison. You'll see that Warhol was not only con-goofy, he was debauched and foppish. His Silver Factory was a psychedelic nightmare peopled by vampires. (Oliver Stone, director of *The Doors*)

133. "It wasn't really like that. At a certain time in New York, if you were of any significance in the cultural scene, you would go to the Factory. . . . When Morrison would come over we would feel really great about it because we knew that he wouldn't go just any place and that we had a place where people of his caliber met. Rudolf Nureyev and Judy Garland and Tennessee Williams weren't slumming or anything when they came to the Factory, they were just meeting peers." (Billy Name, Factory habitué and photographer)[109]

134. "Oliver Stone's 1991 filmic biography *The Doors* used Warhol to metonymically signify Jim Morrison's (played by Val Kilmer) degradation. . . . Crispin Glover's Warhol is only on the screen for a few moments, but that scene is sufficiently hyperbolic to define the macho, drug-induced spirituality of the Doors in contrast to the perverse and sinister Factory." Warhol in fact had a galvanizing effect on numerous careers. (Editors of *Pop Out: Queer Warhol*)[110]

135. As a case in point: "[Jean-Michel] Basquiat and Andy served as divas for each other, divine creatures who inspired and enabled each other through queer circuits of identifications." (José Esteban Muñoz, *Pop Out*)[111]

136. "Andy's pets, in the 1980s, were young artists, whose career he advanced, even as, Drella-style, he sucked nutrients from them. These friendships—advocacies—included Francesco Clemente, Keith Haring, and Jean-Michel Basquiat." (Wayne Koestenbaum)[112]

137. That doesn't fully account for the giant sucking sound you hear at the Factory. Edie Sedgwick, Eric Emerson, Freddie Herko, Jackie Curtis, Candy Darling, Tom Baker, Tiger Morse, Taxi, Tinkerbelle, Danny Williams, Ingrid Superstar, Andrea Feldman, Basquiat himself . . . there were so many early deaths among those whose careers Warhol "advanced."

edie

138. "Andy Warhol would like to have been a charming well-born debutante from Boston like Edie Sedgwick." (Truman Capote)[113]

139. "Edie & Andy! . . . Both wearing the same sort of thing—boatneck, striped T-shirts. . . . Edie was pasted up to look just like him." (René Ricard)[114]

140. "Warhol really fucked up a great many young people's lives. I was a good target for the scene. I bloomed into a healthy young drug addict." (Edie Sedgwick, 1943–71)[115]

141. "But you'd better lift your diamond ring,
 you'd better pawn it babe
You used to be so amused
At Napoleon in rags and the language that he used
Go to him now, he calls you, you can't refuse
When you got nothing, you got nothing to lose."
(Bob Dylan, "Like a Rolling Stone," 1965)[116]

142. "I got on Warhol about Edie. It was at Max's Kansas City. . . . I said to Warhol, 'You suck, you know that? You make these chicks into superstars and then you go off into your own thing and you drop them . . . literally, like that. You pick these little birds out and make superstars out of them. And look what happens to Edie!' I really got on his ass." (Gregory Corso)

143. (*In a whisper*) "Gregory, you're laying too much weight on this man. It's really not his fault. Don't you think you should apologize to that man?" (Allen Ginsberg)[117]

144. "Andy did not, as one whole school of thought has it, *exploit* people. He never coerced you to do anything you didn't want to do. What it was was a conviction of his vision, his permissiveness, where he *allowed* people to do as much as their compulsions made them do." (Tally Brown)[118]

145. "Warhol became a hero to many young people in the sixties because he seemed to be the ultimate anti-parent. Anything you did was O.K., even if you killed yourself doing it. . . . What took place inside the Factory was a pressure-cooker version of certain trends in the culture at large—for example, the disavowal of male authority." (*New Yorker*)[119]

146. "Though lesser members of his Factory descended into stoned orgies and ruinous addictions, he remained wrapped in a prophylactic innocence, going home every night (until 1972) to his mother." (John Updike)[120]

mama's boy bachelor workaholic

147. "You'd be nice for my Andy—but he's too busy." (Julia Warhola, Andy's mother, on her first meeting with Pat Hackett, Andy's editor)[121]

working-class
catholic

148. During the 1930s in Pittsburgh, "Julia spent most of her free time at church. . . . Andy almost always went to church with his mother. For hours on end, he sat and stared at the iconostasis, the screen that closes off the inner altar in Eastern Rite churches. It was covered with icons of the saints, flat two-dimensional portraits." (Bob Colacello)[122]

149. "In the last two years of his life, I would often meet him at St. Vincent's Church at 66th and Lexington. He'd go every Sunday, even though he didn't stay for the whole mass. He sat in the back far left pew." (Paige Powell)[123]

150. "Though it seems at times that he wandered far from his church, we do not judge him." (Monsignor Peter Tay, in Warhol's eulogy)[124]

151. Warhol's life makes no sense if you judge it by middle-class standards of morality. He spent his childhood in poverty and daydreaming, and his adulthood in wealth and anxiety. He's like a street person who wins the lottery and never recovers from it.

152. Since when are artists judged by middle-class standards anyway? Quite the reverse, I should think. When Jackson Pollock pees into the fireplace during a party at Peggy Guggenheim's, I don't hear people talking about the end of Western civ.

153. "Warhol went from the bottom of the heap to the top without ever passing the middle, so it's like he was completely free of the middle-class perspective." (Ron Sukenick)[125]

169

154. Plus, he was a gay man living in New York City. Case closed.

155. "Andy Warhol's own gliding adaptability . . . informed him with a mysterious classlessness and, at the same time, a kind of polysocial desirability." (Joseph Masheck)[126]

156. "His underclass childhood somehow left him amoral as a man and incorruptible, because profoundly indifferent as an observer. It is not necessary to like him to appreciate what, with his art, he gives us." (Peter Schjeldahl)[127]

saint mephistopheles

157. "While the other pop artists depict common things, Andy is in a sense a victim of common things: he genuinely adores them. How can you describe him—like a saint— Saint Andrew." (Ivan Karp, art dealer)[128]

158. Some critics see him as a Mephistophelian anti-Christ, others see him as Saint Andy. To me, "his pageant has always seemed a Passion, his Catholicism a living matter and not a camp." (Barbara Rose)[129]

159. "The Factory resembled a sect, a parody of Catholicism. . . . In it, the rituals of dandyism could speed up to gibberish and show what they had become—a hunger for approval and forgiveness. These came in a familiar form, perhaps the only form American capitalism knows how to offer: publicity." (Robert Hughes)[130]

160. "The Factory was a church. The Church of the Unimaginable Penis, or something. Andy was the father confessor, the kids were the sinners. Which is why he didn't need to be involved with them when they finished confessing. The sanctity of the institution and its rituals is what's important, not personal salvation." (Gary Indiana)[131]

collapsing distinctions

161. "Warhol's refusal to censor, to censure, or even to create hierarchies bespeaks a toleration, simultaneously ethical and aesthetic, that inheres in all his most characteristic gestures—his collapse of the distinctions between surface and depth, between life and art, between reality and artifice, between high society and the underworld." (Douglas Crimp)[132]

162. "The only benefit gained from Andy Warhol's Campbell soup can (and this benefit is immense), is to nullify the question of beauty and ugliness, the real and the unreal, the transcendental and the immanent." (Jean Baudrillard)[133]

163. "If there was a Warhol revolution in 'arts and entertainment' in the sixties, then it was because his definition of the conditions of *celebrityhood* was aimed at showing that nothing intervened between the realms of arts and entertainment." (Andrew Ross, *No Respect*)[134]

164. Warhol's work "licenses relativism of any and every hue, relentlessly collapsing the gap between the fake and the real, between artifice and artistry, between the consumer and the thing consumed." (Henry Hitchings)[135]

165. Before we throw out distinctions altogether, I need to say I'm dubious about the prospect of ethics "without hierarchy." Also about the conflation of life, art, entertainment, artifice, reality, fakery, surface, depth, beauty, ugliness, scum and élite, consumer and consumed, high and low. All these collapsing gaps sound like art-world insularity, or something from an undergrad term paper. Aren't some of the gaps worth preserving? Once such things are collapsed, it clears a space for opportunists and hucksters. If Warhol does license all manner of relativism, this will

be taken for freedom and tolerance and emancipation, but in fact represents their opposite.

166. He just created images. That's what artists do. He can't be responsible for getting them to stop signifying.

nothing and both

167. "Warhol's films and his art mean either nothing or a great deal. The choice is the viewer's. . . . The more that is left out, the more can be seen of what is left." (Lucy Lippard, 1966)[136]

168. "Lippard never mentions whether or not she thinks Warhol is a social critic. . . . Flash forward more than twenty years to a discussion about Warhol by key curators and art historians of the day, sponsored by the Dia Art Foundation. How little things change. The critical dimension of Warhol's work is still perceived to be as ambiguous as ever. Either Warhol is politically provocative yet neutral, or his political statements are facetious yet serious. Warhol is the ultimate and/both conundrum. . . . While Warhol and his work may have been an inspiration for radical thinking, this thinking itself is not contained in his work, as open-ended as it may be." (Steven Kurtz)[137]

169. I have no problem with any art that inspires radical thinking. Does it really matter whether it was "contained" in his work? As for the Dia exchange, it's no different from any other public discussion: it gives voice to many perspectives and doesn't insist on consensus.

170. "His extraordinary ambivalence provides a unique critical vantage point. . . . there is still much to be learned about Warhol, as well as ourselves, even if what we learn leaves us feeling somewhat like the artist—ambivalent." (Jonathan P. Binstock, "Andy Warhol: Social Observer")[138]

171. It seems to me there's a difference between "living with ambivalence," a phrase that Zygmunt Bauman links to postmodernism, and cultivating ambivalence for its own sake, as a career-furthering device. Aesthetically, I think Warhol was way too accommodating.

172. "Warhol's timely shift from the modernist realm of the innocent eye to the postmodern realm of everything is valid suggests the price he (and others) paid to be a darling of the art world; like a good butler or child, he would do what he was supposed to do, which was to be peripheral, but necessary." (John Yau)[139]

173. "People would make of him what they chose. . . . Andy was successful because he was a focal point for various peoples' fantasies." (Joseph Groell)[140]

sites for projection and shopping

174. "Both camps make the Warhol they need, or get the Warhol they deserve; no doubt we all do. (What is it, by the way, that renders Warhol such a site for projection? He posed as a blank screen, to be sure, but Warhol was very aware of these projections, indeed very aware of identification *as* projec—" (Hal Foster)[141]

175. —Hold it. "He early on said please don't look beneath the surface, it is completely superficial. And as soon as we start to look beneath the surface, we begin to sit here, and hours go by and all the stores close and we can't go shopping." (Charles Stuckey)[142]

176. On the topic of shopping: "Many of us thought Andy's real aspiration was to become Charles Foster Kane. Box after box, bag after bag, furniture, paintings, fixtures, everything was 'collected.'" (John T. O'Connor)[143]

177. All the more for us to sort through. (The Andy Warhol Museum)

178. "It had been well over six and a half years since Warhol had died, and, despite all of the legal and financial maneuvers that had taken place during that time, maneuvers that had run up millions of dollars in fees of various sorts, the Estate of Andy Warhol was still not settled." (Paul Alexander)[144]

(Pause.)

naive art

179. I need to say I'm not feeling very settled either. Look, call me naive, but when did the images *start* signifying? Coke bottles? Brillo boxes?

180. Okay—you're naive. A refresher course in Western art will show you that the iconic value of pop images took center stage in the sixties . . .

181. But it's also naive to suggest that popism is confined to art history. It includes figures as far removed as Marshall McLuhan, Tom Wolfe, Pauline Kael, Abbie Hoffman, Bob Dylan, John Lennon—the list goes on—all of whom were arguing in their own ways for the primal charge found in popular culture, and the need for an educated audience for pop. Incidentally, none of these people were saying that pop should become the only game in town, which unfortunately is what's happened today.

182. So, how do we get off the bandwagon? Or even slow it down?

koons and shakespeare

183. Speaking of bandwagons—what is it with Jeff Koons? I mean, I love his work—the Michael Jackson & Bubbles ceramic sculpture, the gigantic blue "balloon" twisted into the shape of a dog. But is there some insight I'm missing? It seems he's being parasitical upon a career that was already parasitical in the first place.

184. I think you need to go back and see Michael & Bubbles again. Ask yourself: race, gender, sexuality, celebrity, species . . .

185. The parasitical issue presumes a myth of originality. Look at Shakespeare—his plays are based on other source material.

186. "Astoundingly, [Warhol] seems to have accelerated history: It's taken centuries for us to become as unsure about Shakespeare as we are of Warhol." (Jonathan Keats)[145]

187. Let's for a moment charitably disregard the problem of using those two names in the same sentence. The more pressing question is, Where does the uncertainty get us? Warhol may in fact "hail a radically altered modality of experience which we are still largely unequipped to comprehend," but just because we can't comprehend it doesn't mean it's ahead of its time and worth tracking.

crashing the forum

188. Anyway, why track a man who thought he was a moron?

189. He was not unintelligent; he had a "rudderless" intelligence.

190. Rudderless? He was gormless.

191. How do you track a man without a rudder?

192. Why should I care? He jacked up image and self-promo-tion over substance in the art world and blackballed later artists who refused to play the publicity game.

193. Hey, that's out of line. This is turning unruly.

194. *(Hefting a folding chair overhead)* I'll show you unruly.

195. One thing we do agree on—we frankly don't feel well represented by the format of this debate. (Bell, Rosenberg, Tillim, Leider, Sandler, and Co.)

196. Neither do we. (Warhol associates and critics not invited to the forum, after crashing the security barrier)

197. A debate? Is that what this is? It looks more like a ma-nipulated dialogue to me, with a lot of animatronic opin-ions.

198. Would that make it qualify as a put-on, or a pseudo-event?

199. In either case, it's another publicity stunt for the artist.

(A cascade of floating silver Mylar pillows is released into the room.)

200. Actually it's a bail hearing. We're trying to spring Andy out of jail.

Notes

The epigraph for this forum is from Tom Wolfe, *The Electric Kool-Aid Acid Test* (New York: Bantam, 1969), 333.

1. This improvised open forum provides an overview of many of the key positions, themes, and defining moments in the debate on Warhol, interspersed with reflections about his life and career. Quotation marks signal where a speaker's remarks are preserved verbatim; where they are absent, I have resorted to paraphrase or abbreviation. Most of the disagreements registered here are a matter of public record. However, for the sake of argument and continuity, in some cases (e.g., James, Mackintosh, Hyde, Binstock) I position one speaker in relation to another, and spell out an implied overlap or conflict between them. Unattributed comments are ones of my own invention; inevitably they reflect my own interests and priorities, but they are not meant to signify "my" standpoint per se. My interest lies in giving voice to a representative sampling of perspectives in a format approximating the rhythms and contradictions of a lively public exchange.

 The first entry blends critical stances suggested by the influential art critics Hilton Kramer and Clement Greenberg. By yoking their names, I am lightly mocking the issue of attribution at the outset. Given the various contextual and editorial liberties I've taken, readers may want to imagine quotation marks around the names of subsequent speakers in the forum.

2. Larry Bell, on first seeing an exhibition of Warhol's work, in September 1963. His statement was reprinted in *Artforum*, Feb. 1965, and in *Pop Art Redefined*, ed. John Russell (New York: Praeger, 1969), 115.

3. Harold Rosenberg, "Warhol: Art's Other Self," *Art on the Edge: Creators and Situations* (New York: Macmillan, 1975), 98, 102.

4. Sidney Tillim, "Andy Warhol," *Arts Magazine* 38 (Sept. 1964): 62.

5. Philip Leider, "Saint Andy: Some Notes on an Artist Who, for a Large Section of a Younger Generation, Can Do No Wrong," *Artforum*, Feb. 1965, 27.

6. Irving Sandler, *American Art of the 1960s* (New York: Harper and Row, 1988), 154.

7. Ron Sukenick, quoted in Mike Wrenn, ed., *Andy Warhol in His Own Words* (Omnibus Press, 1991), 16.

8. Peggy Phelan, "Andy Warhol: Performances of *Death in America*," in *Performing the Body, Performing the Text*, ed. Amelia Jones and Andrew Stephenson (New York: Routledge, 1999), 224.

9. Ralph Rugoff, "Albino Humour," in *Who Is Andy Warhol?* ed. Colin MacCabe (London: British Film Institute, 1997), 97–98.

10. Buddy Radish, as interviewed in Patrick S. Smith, *Warhol: Conversations about the Artist* (Ann Arbor, Mich.: UMI Research Press, 1988), 123.

11. Pierre Restany, "Andy Warhol: 'Less Is More,'" in *Andy Warhol, 1928–1987: Works from the Collections of José Mugrabi and an Isle of Man Company*, ed. Jacob Baal-Teshuva (New York: Neues Publication Co., 1993), 135.

12. This material is culled from Arthur Danto's "The Philosopher as Andy Warhol," in Callie Angell et al., *The Andy Warhol Museum* (New York: Distributed Art Publishers, 1994), 73–90 (quotes, 74, 78–80). Danto's views on Warhol also appear in *Beyond the Brillo Box: the Visual Arts in Post-Historical Perspective* (Berkeley: University of California Press, 1998), and elsewhere.

13. Daniel Herwitz, *Making Theory/Constructing Art: On the Authority of the Avant-Garde* (Chicago: University of Chicago Press, 1993), 268.

14. Edmund White, quoted in Danto, "The Philosopher as Andy Warhol," 80. The quotation continues: "Art is divorced from the commercial and the utilitarian: Andy specialized in Campbell's soup cans and dollar bills. Painting can be defined in contrast to photography: Andy recycles snapshots. A work of art is what an artist signs, proof of his creative choice, his intentions: for a small fee, Andy signed any object whatever" (80–81).

15. Marco Livingstone, "Do It Yourself: Notes on Warhol's Techniques," in *Andy Warhol: A Retrospective,* ed. Kynaston McShine (New York: Museum of Modern Art, 1989), 73.

16. The French brothers Louis and August Lumière were pioneers in 1890s cinema.

17. Richard Dyer, *Now You See It: Studies on Lesbian and Gay Film* (New York: Routledge, 1990), 157.

18. Pauline Kael, *Deeper into Movies* (New York: Little, Brown, 1973), 198.

19. Michael Ferguson, *Little Joe Superstar: The Films of Joe Dallesandro* (Laguna Hills, Calif.: Companion Press, 1998), 83.

20. Margia Kramer, *Andy Warhol et al.: The FBI File on Andy Warhol* (New York: UnSub Press, 1988), 35, 37.

21. John O'Connor and Benjamin Liu, *Unseen Warhol* (New York: Rizzoli International, 1996), 9.

22. Amy Taubin, quoted in *Pop Out: Queer Warhol,* ed. Jennifer Doyle, Jonathan Flatley, and José Esteban Muñoz (Durham, N.C.: Duke University Press, 1996), 61.

23. Peter Gidal, *Andy Warhol Films and Paintings: The Factory Years* (New York: Da Capo, 1991), 12.

24. Bosley Crowther, *New York Times,* Dec. 11, 1966, sec. 2, p. 1.

25. David James, "The Producer as Author," in *Andy Warhol Film Factory,* ed. Michael O'Pray (London: British Film Institute, 1989), 138. Beginning with *Lonesome Cowboys* (1968), Warhol ceded much of the directing duties to Morrissey.

26. John Wilcock, *The Autobiography and Sex Life of Andy Warhol* (New York: Other Scenes, 1971), n.p.

27. Jonathan Katz, *Andy Warhol* (New York: Rizzoli Art Series, 1993), n.p.

28. Amelia Jones, *Body Art/Performing the Subject* (Minneapolis: University of Minnesota Press, 1998), 69.

29. Cécile Whiting, *A Taste for Pop: Pop Art, Gender, and Consumer Culture* (New York: Cambridge University Press, 1997), 146.

30. Carter Ratcliff, "Starlust, Andy's Photos," *Art in America* (May 1980): 120–22; rpt. in *The Critical Response to Andy Warhol,* ed. Alan R. Pratt (Westport, Conn.: Greenwood, 1997), 132–39 (quote, 135).

31. Ronnie Cutrone, in O'Connor and Liu, *Unseen Warhol*, 59. Cutrone was Warhol's painting assistant from 1972 to 1982.

32. John Perreault, "Andy Warhola, This Is Your Life," *ARTnews* 69:3 (May 1970): 52.

33. Rainer Crone, *Andy Warhol*, trans. John William Gabriel (London: Thames and Hudson, 1970), 46.

34. Max Kozloff, *The Critic and the Visual Arts: Papers Delivered at the Fifty-second Biennial Convention of the American Federation of Arts in Boston, April 1965* (New York: American Federation of Arts, 1965), 51; see also Sylvia Harrison, *Pop Art and the Origins of Post-Modernism* (New York: Cambridge University Press, 2001), 151.

35. Buddy Wirtschafter, quoted in Wilcock, *Autobiography and Sex Life*, n.p.

36. Benjamin Buchloh, "Andy Warhol's One-Dimensional Art: 1956–66," in McShine, *Andy Warhol: A Retrospective*, 56.

37. Matei Calinescu, *Faces of Modernity: Modernism, Avant-Garde, Decadence, Kitsch* (Bloomington: Indiana University Press, 1977), 255; quoted in Amelia Jones, *Postmodernism and the En-Gendering of Marcel Duchamp* (New York: Cambridge University Press, 1994), 21.

38. John Coplans, *Andy Warhol* (Greenwich, Conn.: New York Graphic Society, 1970), 5.

39. Marcel Duchamp, quoted in Rosalind Constable, "New York's Avant Garde and How It Got There," *New York Herald Tribune*, May 17, 1964.

40. Alastair Mackintosh, *Contemporary Artists*, 5th ed., vol. 2, ed. Sara Pendergast et al. (New York: St. James Press, 2002), 1797.

41. David Bourdon's comments are culled from his book *Warhol* (New York: Abrams, 1989), 418, and from his essay "Andy Warhol and the American Dream," in Baal-Teshuva, *Andy Warhol, 1928–1987*, 11.

42. Tom Wolfe, *The Painted Word* (New York: Farrar, Straus, and Giroux, 1975), 90.

43. Simon Watney, "Queer Andy," in Doyle et al., *Pop Out*, 20–30.

44. Paul Morrissey, quoted in Wilcock, *Autobiography and Sex Life*, n.p.

45. Patrick S. Smith, *Andy Warhol's Art and Films* (Ann Arbor, Mich.: UMI Research Press, 1986), 32.

46. Calvin Tomkins, *The Scene: Reports on Post-Modern Art* (New York: Viking, 1976), 38.

47. Fredric Jameson, *Postmodernism; or, the Cultural Logic of Late Capitalism* (Durham, N.C.: Duke University Press, 1996), 8–9.

48. Mandy Merck, "Figuring Out Andy Warhol," in Doyle et al., *Pop Out*, 224–37.

49. Ingrid Sischy, quoted in A. Jones, *Body Art/Performing the Subject*, 70.

50. Ken Silver, "Modes of Disclosure: The Construction of Gay Identity and the Rise of Pop Art," in *Hand Painted Pop: American Art in Transition 1955–62*, ed. Russell Ferguson (New York: Rizzoli International, 1992), 198.

51. Caroline A. Jones, *Machine in the Studio: Constructing the Postwar American Artist* (Chicago: University of Chicago Press, 1996), 244–45.

52. Richard Meyer, *Outlaw Representation: Censorship and Homosexuality in Twentieth-Century American Art* (New York: Oxford University Press, 2002), 128.

53. Jonathan Flatley, "Warhol Gives Good Face: Publicity and the Politics of Prosopopoeia," in Doyle et al., *Pop Out,* 105.

54. Barry Farber, quoted in Wilcock, *Autobiography and Sex Life,* n.p.

55. Mario Amaya, quoted in Wilcock, *Autobiography and Sex Life,* n.p. Amaya is the art critic and curator who happened to be visiting Warhol's office on the day the artist was shot. Amaya was also wounded in the attack.

56. Richard Goldstein, quoted in Victor Bockris, *The Life and Death of Andy Warhol* (New York: Bantam, 1989), 187.

57. Cher, quoted in a newspaper account in Bourdon, *Warhol,* 234.

58. Stephen Koch, *Stargazer: The Life, World, and Films of Andy Warhol* (New York: Marion Boyars, 1991), 72.

59. Lou Reed, quoted in Bockris, *Life and Death,* 187. A historical note: Warhol's first multiscreen light shows in April 1966 were preceded in San Francisco by Bill Ham's psychedelic light shows in June 1965, and by the three-day Trips Festival at the Longshoreman's Hall in January 1966.

60. Maurice Berger, "Andy Warhol's 'Pleasure Principle,'" in Jonathan P. Binstock, *Andy Warhol: Social Observer* (Philadelphia: Pennsylvania Academy of the Fine Arts, 2000), 29.

61. This comment is suggested by observations made by Caroline Jones and Angela Davis. See Jones's chapter on Warhol in *Machine in the Studio.* The statement about pregnancy is found in Andy Warhol, *THE Philosophy of Andy Warhol* (New York: Harcourt Brace, 1975), 118.

62. Eve Kosofsky Sedgwick, "Queer Performativity: Warhol's Shyness/Warhol's Whiteness," in Doyle et al., *Pop Out,* 138–40.

63. Susan Bottomly, quoted in Lynne Tillman, *The Velvet Years: Warhol's Factory 1965–67* (New York: Thunder's Mouth Press, 1995), 107.

64. Maureen Tucker, quoted in Tillman, *The Velvet Years,* 71.

65. Kathy Acker, "Blue Valentine," in O'Pray, *Andy Warhol Film Factory,* 65. Additionally, Camille Paglia counts herself and Robert Mapplethorpe as admirers: "Mapplethorpe has a long and varied artistic lineage. Like me, he was also an admirer of Andy Warhol, whose silver-lined Factory overflowing with tramps, studs, transvestites, and Superstars I regarded, from the far distance of an upstate New York college, as my spiritual home in the Sixties." "The Beautiful Decadence of Robert Mapplethorpe," *Sex, Art, and American Culture: Essays* (New York: Vintage, 1992), 42.

66. Valerie Solanas, *The SCUM Manifesto* (New York: Olympia Press, 1968), 70.

67. From the book's back cover advertisement, as quoted in Laura Winkiel, "The 'Sweet Assassin' and the Performative Politics of *SCUM Manifesto,*" in *The Queer Sixties,* ed. Patricia Juliana Smith (New York: Routledge, 1999), 74. Warhol's would-be assassin, Valerie Solanas, took vigorous exception to the published form of her manifesto, particularly the editors' framing comments on the cover. Solanas distributed a defaced version of *SCUM Manifesto,* in which (as Winkiel writes), she "vigorously blacked out the phrase 'just to make a point' and remarked, 'lie'" (ibid.).

68. Bianca Jagger, quoted in Wrenn, *Andy Warhol in His Own Words,* 45.

69. Bockris, *Life and Death,* 236.

70. Jane Holzer, quoted in O'Connor and Liu, *Unseen Warhol,* 48.

71. Former Factory actor Ondine, as interviewed in Smith, *Conversations,* 270.

72. John Cale, quoted in Tillman, *The Velvet Years,* 63.

73. Holly Woodlawn (with Jeff Copeland), *A Low Life in High Heels: The Holly Woodlawn Story* (New York: HarperCollins, 1992), 163; and quoted in Smith, *Conversations,* 247.

74. Ronald Tavel, quoted in Bockris, *Life and Death,* 265.

75. Peter Fuller, *Beyond the Crisis in Art* (London: Writers and Readers, 1980), 21; quoted in Van M. Cagle, *Reconstructing Pop/Subculture: Art, Rock, and Andy Warhol* (Thousand Oaks, Calif.: Sage Publications, 1995), 74.

76. Bradford R. Collins, "The Metaphysical Nosejob: The Remaking of Warhola, 1960–1968," *Arts Magazine* 62 (Feb. 1988): 47–55; rpt. in Pratt, *Critical Response,* 168–92 (quote, 183–84).

77. Thierry de Duve, "Andy Warhol, or The Machine Perfected," trans. Rosalind Krauss, *October* 48 (Spring 1989): 4.

78. Glenn O'Brien, "A Portrait of the Portrait Artist," in O'Connor and Liu, *Unseen Warhol,* 12–13.

79. Robert Rosenblum, "Andy Warhol: Court Painter to the 70s," in *Andy Warhol: Portraits of the Seventies,* ed. David Whitney (New York: Random House, 1979), 18.

80. Nicholas Baume, "About Face," in *About Face: Andy Warhol Portraits,* ed. Baume (Cambridge, Mass.: MIT Press, 1999), 86, 98.

81. Juan A. Suárez, *Bike Boys, Drag Queens, and Superstars: Avant-Garde, Mass Culture, and Gay Identities in the 1960s Underground* (Bloomington: Indiana University Press, 1996), 256–57.

82. Cagle, *Reconstructing Pop/Subculture,* 42, 45.

83. See Harrison, *Pop Art and the Origins of Post-Modernism.*

84. Lynne Cooke, as paraphrased by Harrison, *Pop Art and the Origins of Post-Modernism,* 208. Cooke's views appear in "The Independent Group: British and American Pop Art, a 'Palimpcestuous' Legacy," in *Modern Art and Popular Culture: Readings in High and Low,* ed. Kirk Varnedoe and Adam Gopnik (New York: Abrams, 1990), 206–7.

85. Raymond M. Herbenick, *Andy Warhol's Religious and Ethnic Roots: The Carpatho-Rusyn Influence on His Art* (Lewiston, N.Y.: Edwin Mellen Press, 1997), 111.

86. Donald Kuspit, "Fame as the Cure-All: The Charisma of Cynicism—Andy Warhol," *The Cult of the Avant-Garde Artist* (New York: Cambridge University Press, 1993), 75.

87. Adapted from Lewis Hyde, *Trickster Makes This World* (New York: Farrar, Straus, and Giroux, 1998), 158.

88. Chris Makos, quoted in O'Connor and Liu, *Unseen Warhol,* 116.

89. Edward Sanders, "Andy Warhol and the Glyph," *Andy Warhol: Series and Singles* (Riehen/Basel: Fondation Beyeler, 2000), 33.

90. Ultra Violet, *Famous for Fifteen Minutes: My Years with Andy Warhol* (New York: Avon Books, 1988), 263.

91. Jane Daggett Dillenberger, *The Religious Art of Andy Warhol* (New York: Continuum, 1998), 92.

92. Peter Kattenberg, *Andy Warhol, Priest: "The Last Supper Comes in Small, Medium, and Large"* (Boston: Brill, 2001), 129. Kattenberg's subtitle is drawn from the entry for July 9, 1985, in *The Andy Warhol Diaries,* ed. Pat Hackett (New York: Warner Books, 1989): "Sent Benjamin out on a simple errand and it cost me a thousand dollars! I'd given him $2,000 to go get the large-size sculpture of the Last Supper that we'd bargained the guy down from $5,000 to $2,000 on. So he went there and it wasn't there anymore. The Last Supper comes in small, medium, and large. So then at this other place, I'd gotten the guy down from $2,500 to $1,000 for the medium. But Benjamin forgot we'd gotten them *down,* and he bought the medium one for $2,000!. . . . [A] thousand dollars is a lot to waste. I just couldn't believe it, after I'd haggled so hard" (662).

93. Thomas Crow, "Saturday's Disasters: Trace and Reference in Early Warhol," in *Andy Warhol,* ed. Annette Michelson (Cambridge, Mass.: MIT Press, 2001), 49. In Crow's analysis, these three views are exemplified, respectively, in Crone, *Andy Warhol;* Carter Ratcliff, *Andy Warhol* (New York: Abbeville Press, 1983); and Robert Hughes, "The Rise of Andy Warhol," *New York Review of Books,* Feb. 18, 1982, 6–10.

94. George W. S. Trow, *Within the Context of No Context* (Boston: Little, Brown, 1981), 98.

95. Bradley Block, "On Art, Where Warhol Failed," *New Leader* 72:6 (Mar. 20, 1989): 23.

96. Susan Sontag, quoted in Bockris, *Life and Death,* 317–18.

97. Trevor Fairbrother, "Mirror, Shadow, Figment: Andy Warhol's *America,*" in Binstock, *Andy Warhol: Social Observer,* 33.

98. Warhol, *Diaries,* xv.

99. Marc Balet, quoted in O'Connor and Liu, *Unseen Warhol,* 100.

100. Reva Wolf, *Andy Warhol, Poetry, and Gossip in the 1960s* (Chicago: University of Chicago Press, 1997), 24.

101. *Detroit News* and *Baltimore Sun,* quoted on the back cover of *The Andy Warhol Diaries.*

102. Jay McInerney, "Did Andy Warhol Overlook Me?" *New York Times,* June 30, 1989, A29.

103. *San Francisco Chronicle,* July 12, 1989, E1.

104. Ken Wilber, *One Taste: The Journals of Ken Wilber* (Boston: Shambhala Publications, 1999), 68.

105. Don Gillmar, quoted in Faiyaz Kara, "Pop Prose: The Critical Reponse to Warhol Literature," in Pratt, *Critical Response,* 273.

106. Phyllis Rose, "Literary Warhol," *Yale Review* 79:1 (Autumn 1989): 26, 29.

107. Henry Geldzahler, quoted in Julia Markus, "Two Years after His Death, the Curtain Rises on Andy Warhol," *Smithsonian* 19:11 (Feb. 1989): 70.

108. Taylor Mead, quoted in Ultra Violet, *Famous for Fifteen Minutes,* 246.

109. Billy Name, *All Tomorrow's Parties: Billy Name's Photographs of Andy Warhol's Factory* (New York: Distributed Art Publishers, 1997), 22.

110. Jennifer Doyle, Jonathan Flatley, and José Esteban Muñoz, "Introduction," *Pop Out,* 13.

111. José Esteban Muñoz, "Famous and Dandy Like B. 'n' Andy: Race, Pop, and Basquiat," in Doyle et al., *Pop Out,* 153.

112. Wayne Koestenbaum, *Andy Warhol: A Penguin Life* (New York: Viking Penguin, 2001), 204.

113. Truman Capote, quoted in Bockris, *Life and Death*, 167.

114. René Ricard, quoted in *Edie: An American Biography*, ed. Jean Stein, with George Plimpton (New York: Knopf, 1982), 182.

115. Edie Sedgwick, quoted in Wrenn, *Andy Warhol in His Own Words*, 40.

116. This verse is commonly taken as referring to the dynamic between Sedgwick and Warhol ("Napoleon in rags"). Sedgwick and her troubles exacerbated the border tensions between Warhol's and Dylan's alternate scenes in mid-sixties New York. Many believe Edie served as the inspiration for the Dylan songs "Just Like a Woman," "Leopard Skin Pillbox Hat," and "She's Your Lover Now."

117. Corso (previous entry) and Ginsberg are quoted in Stein, *Edie: An American Biography*, 347.

118. Tally Brown, quoted in Smith, *Conversations*, 251–52.

119. Obituary in "Talk of the Town," *New Yorker*, Apr. 27, 1987, 27.

120. John Updike, "The Sweatless Creations of Andy Warhol," *New Republic* 200:13 (Mar. 27, 1989), 27. Julia Warhola actually left for Pittsburgh in 1971, after suffering a stroke. She died there the following year.

121. Julia Warhola, quoted in Hackett's introduction to *The Andy Warhol Diaries*, xi.

122. Bob Colacello, *Holy Terror: Andy Warhol Close Up* (New York: HarperCollins, 1990), 17.

123. Paige Powell, quoted in O'Connor and Liu, *Unseen Warhol*, 172.

124. Monsignor Peter Tay, quoted in Bockris, *Life and Death*, 352.

125. Ron Sukenick, quoted in Bockris, *Life and Death*, 121.

126. Joseph Masheck, "Warhol's Early Manipulation of the Mundane: The Vanderbilt Cookbook of 1961," *Art in America* 59 (May–June 1971): 54.

127. Peter Schjeldahl, "Warhol and Class Content," *Art in America* 68 (May 1980): 119.

128. Ivan Karp, quoted in *Newsweek*, Dec. 7, 1964, 103A.

129. Quoted in Bourdon, *Warhol*, 310.

130. Hughes, "The Rise of Andy Warhol," 6.

131. Gary Indiana, "I'll Be Your Mirror," *Village Voice* 111: 1 (May 5, 1987); rpt. in O'Pray, *Andy Warhol Film Factory*, 184.

132. Douglas Crimp, "Face Value," in Baume, *About Face,* 122.

133. Jean Baudrillard, "Transpolitics, Transsexuality, Transaesthetics," trans. Michel Valentin, *Jean Baudrillard* (New York: St. Martin's Press, 1992), 13.

134. Andrew Ross, *No Respect: Intellectuals and Popular Culture* (New York: Routledge, 1989), 168.

135. Henry Hitchings, "More American Than Thinking," *Times Literary Supplement*, Feb. 22, 2002, 18–19.

136. Lucy Lippard, *Pop Art* (New York: Oxford University Press, 1966), 97–101; rpt. in Pratt, *Critical Response*, 26–28 (quote, 27).

137. Steven Kurtz, "Uneasy Flirtations: The Critical Reaction to Warhol's Concepts of Celebrity and of Glamour," in Pratt, *Critical Response*, 250, 253. The discussion Kurtz alludes to was published in *The Work of Andy Warhol*, ed. Gary Garrels (Seattle: Bay Press, 1989).

184

138. Jonathan P. Binstock, "Andy Warhol: Social Observer," in Binstock, *Andy Warhol: Social Observer*, 20.

139. John Yau, *In the Realm of Appearances: The Art of Andy Warhol* (Hopewell, N.J.: Ecco Press, 1993), 62.

140. Joseph Groell, quoted in Smith, *Conversations*, 34–35.

141. Hal Foster, "Death in America," *October* 75 (Winter 1996): 38–39. The interrupted sentence reads in full, "He posed as a blank screen, to be sure, but Warhol was very aware of these projections, indeed very aware of identification *as* projection; it is one of his great subjects."

142. Charles Stuckey, quoted in Garrels, *The Work of Andy Warhol*, 133.

143. John T. O'Connor, "Working with Warhol," in O'Connor and Liu, *Unseen Warhol*, 17.

144. Paul Alexander, *Death and Disaster: The Rise of the Warhol Empire and the Race for Andy's Millions* (New York: Villard Books, 1994), 210.

145. Jonathan Keats, "The Opposite of Sex," <www.salon.com>, Sept. 28, 2001.

When I was little and I was sick
a lot, those sick times were like little
intermissions. Innermissions.
Playing with dolls.

—*THE Philosophy of Andy Warhol*

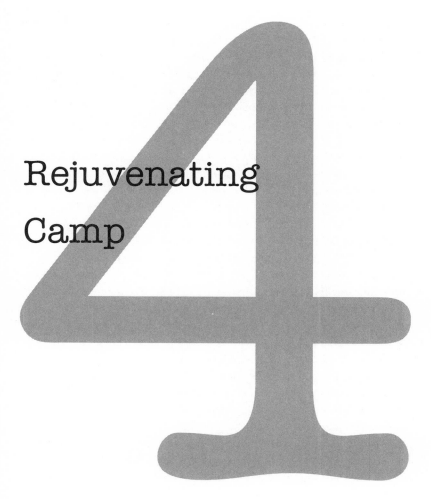

Rejuvenating
Camp

Warhol's biography adamantly refuses to cohere around matters of artistic semantics, sexual politics, and the life of the mind. His ruses, guises, and about-faces inevitably create a smoke-and-mirrors game for someone trying to assess his career or legacy. His habit of shifting from one artistic medium to the next, one vocation to the next, and one social arrangement to the next adds further haze to the proceedings. But where his trickster maneuvers cloud his biography in most respects, they directly illuminate one realm in particular, the realm of camp taste. For him camp was not a momentary flicker of recognition or a simple diversionary tactic, but a crucial means of surviving a queer working-class childhood. Into his adult years, camp continued to occupy a central position in his life; and he in turn occupies a central position in its rise and dissemination. Just as it was indispensable to him as a sensibility, so also is it indispensable as a topic for anyone hoping to arrive at a clear reading of his livelihood and influence.

What we now refer to as camp taste certainly predates the postmodern era—Susan Sontag traces its origins to the eighteenth century—and yet it did not pass into widespread practice and usage until the mid-1960s. A host of factors contribute to this emergence in Britain and the United States—among them, the output of gay filmmakers Kenneth Anger and Jack Smith, an increase in underground urban movie-houses, a social climate of experimentation and protest, shifts in public taste and in fifties-based forms of censorship, and the rise of an educated counterculture and of alternative sexual identities in the decade preceding the decriminalization of male homosexuality in Britain (1967) and the Stonewall riots in the United States (1969). No figure is more centrally located in the creation and distribution of camp artifacts than Warhol. His relation to camp might be said to parallel that of Freud to psychoanalysis: he didn't invent it, but he refined and disseminated it with amazing industry and dexterity. His life is like a microcosmic history of camp from inception to fruition: he begins as a kid concocting camp home remedies as if from a junior chemistry kit; ultimately, like some mad scientist bent on infiltrating the nation's water supply, he conspires to make camp available on a ubiquitous scale.

Camp is for Warhol a prevailing instinct, a medium more powerful than words. It's as if he was born with X-ray vision, giving an irradiating glow to the objects in his everyday surroundings. Where others saw a mass-produced cutout cartoon drawing of Dick Tracy or Popeye, Andy saw a celebrity male playmate created especially for him.[1] Where others saw a crudely rendered newsprint ad for Dr. Scholl's foot remedies, Andy saw the makings of a large silkscreen design. He might look at an

untrained and ungifted actor and see a potential Superstar. What others might regard as a boring movie was to him an invitation to a transcendent emptiness.

Such perceptions, while they do not exactly embody camp sensibility, much less define it, nonetheless point toward a structure of behavior that is inseparable from camp discourse and essential to a study of Warhol. They involve an extreme form of semantic substitution, "Let A equal not-A," where the second term—the secret boyfriend, the silkscreen, the Superstar—supplants the first as the more vigorous, engaging, and satisfying option. Such deliberate misunderstandings and irreverence are hallmarks of camp sensibility. Camp may be seen as a playful form of induced naivete, in which one form of knowledge (serious, self-sequestering, morally sensitive) is actively suppressed in favor of a form that lampoons and outmaneuvers it. The camp aficionado avidly forages through castoff items with a cheerful insouciance toward their official former uses. A game of Let's Pretend is enacted, in which the old items are infused with invigorating new content. In this way the 1930s anti-drug propaganda film *Reefer Madness* becomes a comically diverting entertainment to a post-sixties drug culture; or the lavish, recherché style of Busby Berkeley musicals comes to astound a new generation of viewers differently from past generations, with an added element of traitorous wit. Recalling Tony Tanner's study of naivete as an American theme, we might view camp as a latter-day reworking of Emerson's injunction to "wonder at the usual." Camp wonderment involves the imagination's journey from a state of enervation to one of captivation. A signature camp response is "just imagine!": just imagine the trouble these filmmakers went to in order to demonize marijuana and misinform the public! Just imagine the chutzpah and dedication that went into this blissfully silly, artificial, three-tier, white-on-white musical sequence! In its trickster-style rearrangements of intention and effect, camp contributes to the ludic aspect of postmodernism, where signifiers enjoy a temporary respite from what one critic has called "the tyranny of enforced signification."[2]

"Camp" is an omnibus term that has passed into general usage, ranging in its applications far beyond the queer-underground contexts in which it was first nourished. In its initial gay or proto-gay settings, camp served as a social rallying point as well as a form of psychological validation; it grew directly out of the experience of subcultural oppression. The textures and meanings of camp have changed significantly in its rise to mainstream accessibility. Camp—or something loosely resembling it—has become widely available as a set of attitudes nearly anyone can

adopt and mimic. Roughly translated, these attitudes declare, It's good because it's entertainingly bad; it's so corny and old-fashioned all you can do is laugh; it merits an affectionate disrespect. The television series *Batman* indicates that such commercialized or appropriated forms of camp had wide circulation in the sixties.[3] Warhol remarks in *Popism*, "The Batman image was very popular that year [1966] because the remake TV show had gone on in February, so camp was really being mass-marketed—everyone was in on the joke now."[4] Arguably, commercial camp reached a saturation point during the nineties, with mainstream video stores creating special sections devoted to camp viewership, and with offerings on network and cable television such as *Mystery Science Theater-3000, Beavis and Butt-head, Late Night with David Letterman*, and the HBO sitcom *Dream On*. Each of these shows promoted what might be called a sardonic form of spin control, in which a déclassé artifact, such as a B movie or a second-rate music video, was served up ironically, often derisively, by the show's hosts. These shows are no longer in production today, with the exception of *Letterman*, which has curbed the camp side of its appeal in recent years. Camp today has become one style among many, and its effects are commonly incorporated into works that, as a whole, do not fall under the camp rubric. At the same time, camp continues to take new directions and remains a strong presence in numerous contexts—not just drag queens but drag kings are in on the act, and they are transforming it; enterprises such as the Sisters for Perpetual Indulgence (San Francisco, et al.), the Tacky Tourists (Seattle), and Theater Offensive (Boston) have become local institutions; alternative enclaves such as the Radical Faeries provide spaces for a range of experimentation; dedicated artists such as Charles Busch, John Epperson (Lypsinka), and John Cameron Mitchell (Hedwig) have enjoyed crossover success with performances that are mind-, gender-, and genre-altering; and a host of new practitioners are refashioning camp to their own ends. José Esteban Muñoz examines the work of numerous such artists in *Disidentifications: Queers of Color and the Performance of Politics*.[5] For several decades deliberate camp effects have also surfaced in art-house settings, as is witnessed in the filmmaking careers of R. W. Fassbinder (*The Bitter Tears of Petra von Kant, Querelle*), David Lynch (*Blue Velvet, Mulholland Drive*), and Todd Haynes (*Poison, Far from Heaven*). By presenting camp elements in contexts that resist traditional camp responses, these directors have newly interrogated and problematized camp sensibility, often with startling results.

Scholarship about camp has tended to emphasize either its virtues

or vices, but not both in the same context. At the outset of her famous "Notes on 'Camp'" (1964), Susan Sontag confesses, "I am strongly drawn to Camp, and almost as strongly offended by it."[6] As the essay proceeds, though, Sontag describes and defends camp taste without articulating why it gives her such strong offense. In another well-known essay on camp, Andrew Ross characterizes the sensibility as a kind of latter-day Grand Guignol. Ross speaks of camp's manifest tendencies toward misogyny, derision, cynicism, sick humor, and decadence. His analysis dwells on aspects of cultural morbidity and aesthetic slumming, on the gay populace as a newly exploitable market, and on camp's alleged "necrophilic economy." Ross's essay culminates in the depiction of Andy Warhol as a kind of chic Mephistopheles, who produced a "ghoulish culture" through the "loveless exploitation" of would-be actors entering the Factory's bailiwick during the sixties.[7]

In the wake of such treatment, writers have attempted to reclaim the queer meanings of camp over against both its commercial appropriations by the dominant culture and its intellectual appropriations by Sontag and Ross. Critics such as Moe Meyer and Simon Watney insist on the *subjective* nature of camp appreciation, giving expression to what camp feels like from within an emerging queer sensibility. However, in doing so they maintain a one-sided dynamic—they emphasize the queer *virtues* of camp while overlooking what might be its vices, queer or otherwise.

Clearly it should not be necessary to come down either for or against camp in this way. For my purposes, the rich contradictions of camp taste make it a fertile ground for exploring the paradoxical nature of Warhol's legacy. To investigate this legacy I employ a point/counterpoint method. In what follows I use the artist's life and work as a means of examining camp in its most salutary, as well as harmful, tendencies. My intent is to pursue aspects of camp sensibility that have been overlooked on both sides of the equation, in hopes of giving new immediacy to what's at stake in how Warhol perceived, as well as influenced, the world around him.

Such a twofold method is warranted partly because the discourse surrounding Warhol—naif/sophisticate, vacuous fraud, shy exhibitionist, brilliant dumbbell, intellectual/unintellectual, genius/zero, Dracula/Cinderella, Saint/Devil—compels us toward new hybrid forms of valuation. The Factory associates who fashioned the campy nickname "Drella" for him understood the need for giving contradiction its due. Beyond this, the specific extremes I focus on are underdeveloped in camp discourse. From the earliest scholarly writings about camp taste,

189

critics have proclaimed its benefits and harms without substantively detailing or supporting their claims.[8] In this matter there is perhaps no hard or irrefutable evidence, but much can still be gained through inquiry that does not simply reassert various claims as axiomatic.

Since my aim is to convey subjective effects of camp appreciation, with an eye toward their sociological consequences, a great deal of the evidence I use to build my case on both sides is anecdotal and biographical. Incidents drawn from Warhol's biography, and from his memoirs, serve as the raw material for readings of camp's positive and negative valences. Although theoretical concerns inform my argument, and will help to structure it, I share Meyer's and Watney's qualms about the intellectual appropriation of camp, especially in the context of a human life and its social impact. An approach that is too systematic will reify its subject matter; on the other hand, an approach that is *un*systematic will devolve into a jumble of isolated particulars and fruitless speculation. Once more, the metaphor of storytelling comes to my aid: How does Warhol help to tell the story of camp's development, and vice versa? What do his stories tell us about the best and worst that camp represents? And what stories now need to be told in the wake of his career?

Camp Utopia

My sense of camp's utopian side draws sustenance from the anthology *The Politics and Poetics of Camp*, edited by Moe Meyer.[9] Meyer's book attempts to rescue camp both from the subtly de-homosexualizing discourse of camp theorists Sontag and Ross, and from the similarly de-homosexualized forms of camp that are appropriated and circulated by the dominant culture. Meyer's introduction reformulates camp as *queer parody*, with parody defined as "the process by which the marginalized and disenfranchised advance their own interests by entering alternative signifying codes into discourse by attaching them to existing structures of signification" (11). Although this definition is cumbersomely phrased, and cleanly avoids mention of parody's capacity for creating pleasure or humor, it does impart the political and empowering component of parody and helps distinguish it from mere staged ridicule or offhand caricature. Meyer uses the word *queer* in a dually oppositional sense, as having the potential not only to confront the sovereign rule of compulsory heterosexuality but also to offset or sidestep tendencies toward straight assimilation within the gay and lesbian movement. The term carries an implied challenge toward traditional gender separation and

the notion of a stable hetero/homo divide. Meyer sets his reclaimed sense of camp over against what he calls forms of "residual" or "appropriated" camp generated and consumed in the culture at large.

Cynthia Morrill's essay in Meyer's anthology lends important credence to the oft-made claim that camp holds curative or beneficial powers.[10] Where a host of writers from Sontag onward have been content merely to assert such powers, Morrill takes the trouble to specify and support this claim. She does this by recourse to theoretical writings about the related areas of humor and bliss. Morrill presents a useful critique of the masculinist and heterosexist logic underpinning Sigmund Freud's views on humor and Roland Barthes's views on readerly bliss. Freud, as Morrill reminds us, spoke of humor as "a psychic mechanism that 'saves' the humorist's ego . . . by means of 'a saving in expenditure of affect'" (122). Morrill writes, "Freud's theory [of humor] offers a means to identify and interrogate how the discourse of Camp may humorously mark and communicate the queer subject's *affective* response to the material effects of homophobia" (123). Similarly, Morrill locates clues about the beneficial effects of camp in Roland Barthes's formulation of bliss as an experience that "exceeds" representation and meaning. Writes Morrill: "Barthes's thoughts on *jouissance* can be redeployed to elucidate the discussion of Camp as an *affective* response—a *jouissance*-interruptus—of the queer subject that results from the homophobic effects of an un-queer ontology" (119). The final words here are especially resonant: "the homophobic effects of an un-queer ontology." Camp emerges in this formulation as a kind of interference or friction between two incompatible or antithetical worlds. More specifically, it arises to compensate an individual for the pain incurred from having to abide by the arbitrary laws of an inimical system. Morrill extracts from both Freud and Barthes corroborative evidence of the uncommonly strong reverberation camp provides to those who have borne the brunt of material effects of homophobia. While doing so, Morrill speculates on what Barthes's and Freud's theories would look like if they were not underwritten by male- and hetero-oriented notions of orgasm, in Barthes's case, and of the super-ego, in Freud's (118, 122). Such speculation further enables a reading of the affective nature of humor and bliss, and by extension camp, in the light of queer and feminist inquiry.

Building on Meyer and Morrill's foundation, I posit camp as queer parody employed in an attempt to transform and undermine the effects of baleful experience. Camp is a stratagem of the ego to reverse the valence of forces that curtail or negate its sense of dignity. It is a method of converting oppression, particularly queer oppression, into a nucleus

of self-affirmation. Its ironic laughter acts congenially within the psyche, creating buoyancy where before there was the bewildering weight of misunderstanding and grievance. Elements that "exceed" representation provide the auspices for an abjected individual's flight toward self-determining pleasure. A semiotic lock-down situation opens up into "play therapy." Surely not every form of camp can have this benefit in equal measure; but I would argue that no form, queer or appropriated, lacks at least the possibility of bringing this salutary effect, however minute or temporary it might be.

I say "particularly" queer oppression out of an interest in not isolating camp as an exclusively queer phenomenon, but to give a sense of how it is still characteristically queer. An example may help to illustrate this. Contrast the nature of camp reception available to an urban group of recreational drug users watching *Reefer Madness* today, with the nature of camp reception available to an incipiently gay young man in a time prior to the sixties. The *Reefer Madness* audience may find the film in a video-store section marked for camp consumption, and it will be able to laugh at the film's cheesy propaganda effects in a spirit of mutely rebellious comradery. Such an audience enjoys numerous forms of privilege that are unavailable to an isolated pre-1960s gay male. The oppression against the man's gayness is of a different order than that against drug users—more socially pervasive and psychologically intense. The gay man's sense of community is unrealized, and the franchise catering to his tastes doesn't yet exist. In the absence of tangible support, his need for validation is all the more severe. He uses what resources and instincts he can summon in order to creatively transform elements within his environment. This stymied subject position is shared by every queer male and female at some point in their development, and it never becomes a wholly outmoded form of experience. In such circumstances camp becomes a creative way of perceiving the world through special glasses, with special motives; it is not a semi-detached, armchair method of relating to an artifact that is already marked for one's consumption. It becomes an abjected individual's own private, instinctive, improvised way of combating queer oppression, isolation, and shame.

Such is the nature of Warhol's psychological investment in camp. We can readily see how the poverty and squalor of a childhood spent in rough ethnic neighborhoods of "Smoke City," as Pittsburgh was called,

would leave permanent scars on a queer, sensitive, artistically inclined, frequently bullied kid. As we saw earlier, the Warhola family was looked down upon even within the context of an Eastern European immigrant ghetto, since their Ruthenian ancestry carried various stigmas—a dispossessed people, brutish and untrustworthy—among their neighbors.[11] Compounding this are the ways that Andrew was isolated within the Warhola family unit. Andrew Warhola started life at the bottom of the social heap, one year before the Great Depression. One can imagine him quietly absorbing grievances that would take a lifetime to redress. Cultivating a rich inner fantasy life was not a leisurely diversion but crucial to his psychological survival. Since so little of what he endured in childhood can have corresponded to his subconscious sense of how things should be, it is no wonder that he had such a mainspring of energy to devote in later years toward reversing its effects. Camp enjoyment came to him in daily installments, like a bodily-injury insurance claim that he was able to draw on for the rest of his life.

Evidence of Warhol's camp appreciation of the world around him is witnessed in earliest childhood. Simon Watney's and Michael Moon's essays in *Pop Out: Queer Warhol* reveal Andrew's childhood play as an anticipatory form of the adult artist's camp fixation. The two critics glimpse in the young Andy an instinctive, and constitutively queer, need creatively to misconstrue and transform the meaning of objects he found at hand. Writes Watney,

> As for countless others, Andy's campness was a fundamental survival strategy. . . . The biographical literature is saturated with images of little Andrew cutting photographs out of magazines, drawing, and painting. He chose his mother's clothes from an early age, and so on. Such repeated anecdotes call attention to our inability to articulate together questions of precocious artistic talent—and precocious queerness. Little, queer, mommy's boy Andrew was predictably teased, bullied, hurt, and humiliated, but this does not in or of itself explain the imaginative passion with which he began to invent his own America, out of the elements that came most immediately to hand, from the radio, comics, Saturday morning children's cinema, and so on.[12]

Not all queer, derided mommy's boys are blessed with the same capacity Warhol had for imaginatively transforming his surroundings; camp is not a mandatory or genetic response, but more like a line of least resistance for the queer individual seeking refuge in a hostile environment. Michael Moon's essay makes the dynamics of Warhol's imaginative passion even more explicit, showing how the artist, left alone to

play with dolls and look at super-hero comics, fashioned them into a lexicon of queer self-validation. Moon proposes that the vision Warhol presents of himself in *Philosophy* amounts to a queer rewriting of the Freudian primal scene into a suspiciously benign and idyllic self-rehearsed myth. In Moon's account, the act of imaginative transformation becomes Andy's principle method first of surviving his childhood and then of surviving the *memory* of his childhood.

Such writings help us to see the coping mechanisms of Warhol's formative years as structuring and anticipating the passions of his adult livelihood. Having derived so much satisfaction from divining his playful "innermission," as he calls it, he evidently found no reason for abandoning it. It was rejuvenating in at least two senses of the word—releasing vital energy and invoking return to a juvenile arena of self-determining play. Later moments stretching through his entire life may be seen as part of an extensive, ongoing, one-man salvaging operation—Warhol's attempts to reclaim value from the world by transforming its received meanings. Such moments reveal camp as a kind of psychic jump-start, a way of snapping back to attention and setting off a spark between people. Interspersed here, I propose, are some of Warhol's best, most relaxed and magnanimous, most joyously self-forgetful moments:

—1954. Warhol applauds the mistakes his mother makes while writing out the text in his commercial assignments and private books.[13]

In this instance, a potential source of irritation becomes a way of embracing human foibles and affirming Julia's earnest, erratic contributions. If Andy had been a less tolerant son, or a more territorial artist, he might have berated his mother over her mistakes, or snubbed her, or flown into a rage. Instead he remains agreeable and sees his way to using imperfections to his advantage.

—1960. Henry Geldzahler describes his initial visit to Warhol's studio on Lexington Avenue: "Once I had gotten used to the flickering of the television set, the first thing I noticed was a pair of Carmen Miranda's platform shoes far higher than they were wide. Their placement on a shelf in his wood-paneled living room made a smile-provoking introduction to a camp sensibility."[14]

Wayne Koestenbaum has underscored how important domestic decor was for homosexual self-affirmation at a time when overt public displays were persecuted. McCarthyism sent gays indoors, where they developed interior schemes in both the psychological and ornamental sense. When Geldzahler visited Warhol's cluttered studio, not just a television but a radio and phonograph were all playing at once; Andy claimed this was to ensure that no thought or feeling strayed into his work. But the platform shoes created a different kind

of noise. By signaling a point of commonality in taste and style, the shoes helped to bridge the distance between the two gay men, who were soon to become the best of friends. Geldzahler does not merely note the shoes' extravagance, but recognizes the specific kind of performance they allude to, quickly grasps how that performance links him to Warhol, and smiles at the connection. It's as if the room is a disguised three-dimensional visual puzzle, and only homosexuals can solve it.

—Early 1960s. Emile de Antonio recollects: "David [Wynn] and I and Andy . . . used to go to 42nd Street with the double bills of the worst films made, and then we'd go somewhere and . . . talk about them."[15]

Apparent failures in the cinematic realm serve as the impetus for success in the realm of social connection. The account serves as a gauge of the close, congenial relations among the men, and as a reminder of the ways that camp lends itself not just to private consumption but to lively public exchange. It also provides a glimpse of New York's Forty-second Street when it was still raffish, culturally bottom-up rather than top-down. The project of refurbishing Forty-second Street has taken a wrecking ball to one form of camp and installed another kind in its place. Today, moments of self-reflexive parody interspersed in Disney's live musical version of *The Lion King*, on Forty-second Street off of Seventh Avenue, reveal how a mammoth corporation's ability to lightly mock its own image makes for good P.R. and promotes an illusion of objectivity.

—1963. Warhol's friends take him to Peerless Camera, where he spends $1,200 on a Bolex 8-mm camera. Victor Bockris reports, "He told anybody who would listen that he had no idea how to load or focus the camera, chortling gleefully, 'I'm going to make bad films!'"[16]

Here Warhol displays immense satisfaction at envisioning his own *inexperience* as a new creative outlet and vocational resource. The inaugural moment of an extensive underground film career begins with an explorer's sense of discovery. It also begins with a technical klutz's realization that he'll need assistance even just to get the camera up and working. For this reason and others, Warhol's eager sense of possibility at this moment may be as much social as artistic. Like a photojournalist with a new VIP press pass, Andy has now found the technical apparatus that will serve as his entrée into a host of previously forbidden realms. Anticipating worlds to conquer, he completely forgets his shyness and goes about boasting to everyone he sees.

—Early 1960s. "Warhol said that the first films he made with stationary objects were not least of all supposed to help the people in the audience to get to know each other."[17]

The social potential of camp taste extends from the circle of

Warhol's personal acquaintance into a wider sphere, where it could do party-hosting duties in his absence. He proposes approaching film not as an auteur item of fetish but as an ice-breaker among strangers. Later, when his films are used as a projected backdrop at Exploding Plastic Inevitable concerts, they acquire a kind of illuminated wallpaper function.

—Warhol, remarking on how he cast his movies: "If I ever have to cast an acting role, I want the wrong person for the part . . . it's more satisfying to get someone who's perfectly wrong."[18]

Warhol refutes the workings of the Hollywood star system to explore the possibilities of casting not only against type but against all other criteria as well. With cheerful brio, he turns a casting agent's nightmare into an alternative employment system. "Alternative" in this case also refers to the fact that his casts and crews received scant remuneration for their efforts.

—1964. A *Village Voice* editorial criticizing Warhol's film output refers to "films shot without lenses, films shot without film, films shot out of focus, films focusing on Taylor Mead's ass for two hours, etc." Mead's response was printed a week later: "Andy Warhol and I have searched the archives of the Warhol colossus and find no 'two-hour film of Taylor Mead's ass.' We are rectifying this undersight [*sic*] with the unlimited resources at our command." Soon Warhol produced a seventy-minute film entitled *Taylor Mead's Ass.*[19]

Earlier in his career Warhol had asked friends and acquaintances for ideas of what to paint; here he expands his polling demographic to include a hostile editorial. The practice is in line with his habit of embracing the very terms of invective that his critics used to dismiss him. For the duration of the film *Taylor Mead's Ass*, Mead does indeed gamely sport his behind for the camera. In one sequence he pretends to remove a variety of items from his anal sphincter, including vacuum cleaner accessories, the torso of a mannequin, a roll of industrial tape, and a publicity still of Rhett Butler and Scarlett O'Hara from *Gone with the Wind*.

—Ronnie Tavel, a Factory scriptwriter, recalls the inspiration behind the film *The Life of Juanita Castro* (1965): "the day that Castro said that he would like to see Hollywood make a movie of the Cuban Revolution, with Marlon Brando playing himself and Frank Sinatra playing Raoul . . . in that day the Cuban Revolution became camp, and Andy Warhol and Ronnie Tavel have now taken over that revolution themselves."[20]

Tavel wrote his script in a three-hour burst after reading the August 1964 *Life* magazine article, "My Brother Is a Tyrant and He Must Go," written by Fidel Castro's estranged, anti-Communist sister, Juana. *The Life of Juanita Castro* places the sister at the center of

the drama and assigns female actors for the roles of Fidel, his brother Raoul, and Che Guevara. Tavel is seen on-screen aggressively coaching his cast members on their lines, and much of the dialogue is heard twice over. Cast members were misinformed as to which of two cameras on the set was in use. Thus, when they step up for their monologue closeups, they are actually moving off-screen, and what viewers see instead are the listless reactions of the rest of the cast. The film broadly parodies the Cuban Revolution, Communist ideology, and Fidel Castro's masculine posturing and Hollywood aspirations; it also may be seen as a fillip to Susan Sontag's description of camp as "apolitical." *Juanita Castro* has turned up recently on a number of college course syllabi.

—1965. A longtime Factory associate, Ondine, describes the film *Vinyl:* "The acting in it is the world's worst, but Andy wanted that. So, his intentions were never to be subverted."[21]

Vinyl was "negatively" inspired by the Anthony Burgess novel *A Clockwork Orange*. It starred Gerard Malanga as a sadistic thug and marked the screen debut of Edie Sedgwick. During several lulls in the action, voice-over credits seem to prematurely announce the end of the film. *Vinyl* became a standard projected-backdrop feature at multimedia Exploding Plastic Inevitable concerts. The idea that Warhol's intentions could never be subverted is both revealing and misleading. It conveys a sense of the aesthetic largesse and political duplicity characteristic of camp taste, but it erroneously suggests that Warhol was the second-order master of all he purveyed. His last and most expensive film, *Andy Warhol's Bad* (1976), is an example of intentions painfully subverted. *Bad* recouped only about two-thirds of its $1.2 million budget, and it failed to grant Warhol his long-held wish to do work in Hollywood, and even to move his operations there. *Bad* also drove a wedge between him and the film's director, Jed Johnson, who for more than a decade was his live-in boyfriend.

—1966. At a show in Boston, a designer friend inadvertently insults one of Andy's Do-It-Yourself canvases, calling it an "ugly paint-by-numbers thing" and assuming that Warhol hadn't done it. Warhol plays along, looking at the canvas and saying, "Oh. How crazy. How did that get in here?"[22]

Where another artist might have expressed outrage or wounded sensitivity, Warhol responds conspiratorially, taking sides with the young designer over against his own handiwork. Rather than condescend to the designer, as a snob or a Socratic ironist would do, he concedes to the alertness of a less informed viewer and manages to learn from him. Recalling the incident later, he marvels at how the distance of time can make one's most intense former preoccupations seem entirely remote and alien.

—1966–84. When Warhol covers the walls of the Leo Castelli Gallery with a pink cow wallpaper design for a 1966 show, he seems to take his cue from an art critic's response to his earlier *Flower* paintings exhibit at the same gallery. The critic had written, "It is as if Warhol got hung up on the cliché that attacks 'modern art' for being like 'wallpaper,' and he decided that wallpaper is a pretty good idea, too." Similarly, Warhol's *Hammer and Sickle* paintings (1977) may be seen as an amiable way of accommodating the Marxist interpretations of his work by Italian critics; and his *Rorschach* series (1984) as a reply to Robert Hughes's 1982 *New York Review of Books* article, which refers to Warhol's silence as a "Rorschach blot."

These allusions are traced by the art historian Reva Wolf, who sees them as lighthearted rather than blistering or mean-spirited. The pattern, she notes, "gets played out regardless of whether the review in question is positive or negative, friendly or hostile."[23] In like manner, Warhol's 1978 *Oxidation* series (urine and semen on canvas) may be seen as a jovial takeoff on the drip-and-splash working methods of action painters, and his cow wallpaper as a way of spoofing how such painters fussed over the issue of where a canvas should end.

—1968. Warhol describes the editorial process behind an ersatz novel he produced, entitled *a*, which was cobbled together from tape-recordings of unscripted conversations: "Billy [Name] worked with Grove Press, making sure that the pages in the book matched the way the high-school typist had transcribed them, right down to the last spelling mistake. I wanted to do a 'bad book,' just the way I'd done 'bad movies' and 'bad art,' because when you do something exactly wrong, you always turn up something." After the novel was published, Warhol singled out his "favorite bad review."[24]

When one domain or genre is exhausted, another emerges on the horizon. Warhol further expands his camp empire by making his first major foray into the world of nonillustrated literature. The book that resulted looks as if it might have been *positively* inspired by Truman Capote's famous retort about Jack Kerouac's *On the Road*, "That's not writing—that's typing." As typing goes, it does have innovative features, including a recurrent double-column effect and a freelance approach to the shift key, the margin tabs, and the space bar. However, the works of Ronald Firbank aside, the camp effect is hard to sustain through the course of an entire novel, and Warhol's *a* has not gained a significant following. The critic Peter Gidal describes *a* as "the first novel not to have been read by its author."[25]

—1972. Fran Lebowitz begins writing film reviews for Warhol's *Interview* magazine; her column soon comes to be called "Best of the Worst."[26]

In another turnabout that is typical in the realm of camp, Lebowitz

was originally hired at *Interview* on the basis of her scathing review, in another publication, of Warhol's film *Women in Revolt*. A poison-pen attack thus serves as the impetus for bringing a new writer into the fold. (Lebowitz, however, remained an outsider in many respects.) Her column later developed into the feature "I Cover the Waterfront," which was the basis of her best-selling book *Metropolitan Life*. Her career as a New York humorist and writer is well established.

—1975. From *THE Philosophy of Andy Warhol:* "I always like to work on leftovers, doing the leftover things. Things that were discarded, that everybody knew were no good, I always thought had a great potential to be funny. It was like recycling work. I always thought there was a lot of humor in leftovers. When I see an old Esther Williams movie and a hundred girls are jumping off their swings, I think of what the audition must have been like and about all the takes where maybe one girl didn't have the nerve to jump when she was supposed to, and I think about her left on the editing-room floor—an out-take—and the girl was probably a leftover at that point—she was probably fired—so the whole scene is much funnier than the scene where everything went right, and the girl who didn't jump is the star of the out-take" (93).

This passage suggests an unusually active imagination, which not only fantasizes a girl who didn't jump, but also fashions for her a hypothetical past and future. Warhol's stance toward the girl is ambiguous: compassionate, in his taking such an extensive interest in her fate; cruel, in his choosing to laugh at her blunder, regardless of its having gotten her fired; and entrepreneurial, in his wanting to make her a star on his own terms. The passage, and its ambiguous stance toward the girl, has obvious parallels with the artist's relation to filmmaking and to his female leads. Edie Sedgwick, for instance, was one Superstar who developed a sharp resistance to the way Warhol's entire film empire seemed built on the logic of the out-take. She felt it didn't further her career, the way her stints as a fashion model and Manhattan's 1965 Girl of the Year had done. A debutante from a prominent New England dynasty, she was too ambitious to settle for what Warhol had to offer, but not self-possessed enough to handle meteoric early success on other terms.

Incidentally (and perhaps not coincidentally), the out-take scene described in Warhol's account bears an uncanny resemblance to a sequence in the Barbra Streisand film sequel *Funny Lady*, released in the same year as *Philosophy*.

—1976. The art and film critic Gregory Battcock shows Warhol his disparaging review of the artist's *Hammer and Sickle* series; Warhol "was tickled to death and showed everybody the article."[27]

This review didn't secure Battcock a new job, as the aforementioned review had done for Fran Lebowitz. However, Battcock did have a prior history of employment at the Factory and was a familiar figure there. He appeared in several of Warhol's mid-sixties films, *Drunk*, *Dracula*, and *Horse*, and had the starring role in *Eating Too Fast*, a.k.a. *Blow Job #2*. He spoke of Warhol's filming style as whimsical and unpredictable—a system in which actors engaged in a scene might not know whether the camera was running, and once the film was completed, they might never see it.

—1979. During Warhol's *Portraits* exhibit at the Whitney Museum: "Asked by a television reporter what he thought of a critic's remark that the paintings were terrible, Andy replied, chewing gum, 'He's right.'"[28]

By this point, Warhol's attempts to deflect criticism by embracing it are perhaps over-rehearsed. The criticism leveled at Warhol's celebrity portraits proved hard to live down. Although over the years he did portraits on a range of other subjects—from Jewish geniuses to drag queens of color—the ones that made the most impact during his lifetime were those he did of fellow revelers at Studio 54, and portraits that were commissioned by the famous and the would-be famous. His approach to portraiture has been used as a symbol of avarice and inflated self-regard, as in the Mike Nichols film *Working Girl* (1988), where the villainous boss (Sigourney Weaver) has a series of Warhol-like portraits of herself displayed in her home. Following a 1979 appreciation by Robert Rosenblum, numerous studies in the nineties have challenged the early critical dismissal of Warhol's portraits.[29]

—1983. Diary entry of July 5: "There was a party at the Statue of Liberty, but I'd already read publicity of me going to it so I felt it was done already."[30]

Here Warhol employs the media as a handy labor-saving device. His reputation established, he no longer requires the services of a look-alike, but can ride on the coattails of media simulation. Still, his absence was a loss for those who did attend the party. Tama Janowitz has said of Warhol, "Whenever he went anywhere, the whole atmosphere of the room changed. 'Here he is, he's in the room!' A sort of electricity went off. He was like the Statue of Liberty, he *was* New York. . . . When he died, something left the city."[31]

Warhol's love of sending things up is less evident during the last decade of his life, but he still maintained a constant lookout for inspired incongruities of timing, desire, and perception. In October 1986, four months before he died, he attended a Christie's auction with a friend who became visibly shaken and speechless after buying a platinum flute

for $200,000, five times its estimated value. The winning bid was followed by a flurry of excitement during which Warhol was mistaken as the buyer. As he tells it in his diary, "Then reporters came and asked why I wanted it, and to some of them I said because it had the World's Fair emblem on it so I needed it for my collection of World's Fair plastic knives and forks, and to some others I said I was buying it to melt down" (768). Whether it happened exactly that way or not, the incident shows Warhol still capable of rallying to a marvelous occasion. His inventive duplicity here gives further evidence of his perennial fondness for mistaken identity, for capitalizing on moments in the spotlight, for promoting heresies of taste, and for tossing spanners to the press. Among the other pro-camp elements on display here are the artist's avid interest in plastics, collectibles, and matched and mismatched sets, and in thriftiness, recycling, and the value of convertibility.

In a diary entry earlier that year he recorded being thrilled during a similarly bizarre moment at a surprise birthday party for his gay friend Wilfredo Rosado. Warhol, Rosado, and two others were seated at an Italian restaurant on Coney Island: "Then the lights went out, totally, and then they came in with a lighted birthday cake singing 'Happy Birthday' and these big butch fifty-year-old waiters came in, and Wilfredo groaned and resigned himself and braced for it, and then we waited and—they went right by us to another table! *(laughs)* It was so shocking. It was like when you think you're getting an Academy Award and it goes to somebody else. It was worth the whole evening. It was just great. We couldn't believe it. And then later on they did come for Wilfredo" (723). What better proof of how central camp was for Warhol than this rare moment of emotional expressiveness. For him to devote five consecutive sentences to describing his feelings is virtually unparalleled in the Warhol corpus. Curiously, though, he avoids first-person references in favor of "it," "you," and "we," even as he indulges in his habitual narcissism, here planting the impression that he has plenty of experience as a major-category Oscar nominee. (The Oscar reference also serves as a gloss on the gay appetite for camp spectacle.) His phrase, "It was worth the whole evening," comes as a clear indication of Warhol's belief in camp's redemptive power. He implies that even ordinary experience, an evening out with friends, has the effect of a burden if it doesn't include at least a moment of camp hilarity. The strong presence of affect in this entry, taken together with expressions and hints gleaned from the earlier incidents—"chortling gleefully," "more satisfying," "tickled to death"—help to establish a sense of the visceral subjective appeal of camp for Warhol, the way it took hold of and transported him,

no matter what else was happening at the time. Camp seems to permit him access not only to laughter but to a wide range of his other most humane and affable traits.

Such personal moments supply an emotional logic and texture to the more official history of Warhol's contribution to camp.[32] An overview of this history will help to further establish how his private sensibility comes to be translated into public taste, and how it fosters countless such moments for other men and women. As we have seen, in the mid-sixties Warhol devoted himself to creating films that farcically over-turned Hollywood convention. His films presented tawdry days in the lives of Factory Superstars, drag queens, and street hustlers; unedited real-time depictions of a man sleeping, or eating a banana, or receiving a blow job (*Sleep, Eat, Blow Job*); and eight solid, immobile hours of the Empire State Building in the act of being what Warhol called "a star" (*Empire*). Typically in Warhol's films the photography is blurred, the sound muffled, actors come on and off screen arbitrarily, and camera distance and shot length vary abruptly. In general, the scripts, camera work, editing, performances, and screening environments conspire against a viewer's becoming traditionally invested in continuity and credibility of plot, character, and dialogue. At the same time, Warhol cobbled together cast members and put them in locales in such a way that enticing or taboo material had every possibility for emerging. No matter how lackadaisically they were filmed, certain figures held allure whenever they appeared in the camera's viewfinder. Outstanding among them were the celebrated Edie Sedgwick, with her striking attractive-ness and all-American-model star power (*Beauty #2, Poor Little Rich Girl, Vinyl, Bitch, Restaurant*); and Joe Dallesandro, with his unmis-takably erotic masculine physique and presence (*Lonesome Cowboys*, and the trilogy directed by Paul Morrissey, *Flesh, Trash,* and *Heat*). As far as taboo subject matter or "dirt work" are concerned, the films stra-tegically oppose puritan-based social codes that still held sway in most American contexts during the sixties. Among the themes explored were mock-fellatio (*Blow Job, Eating Too Fast, Mario Banana, Harlot*); sadomasochism (*Vinyl*); food fights and seminude male wrestling (*The Loves of Ondine*); ensemble bathing (*Tub Girls*); sexual conquest (*I, a Man*, et al.); sexual couplings (*Couch*, et al.); and sex talk (*Blue Movie*, et al.). In *Bike Boy*, gay clerks fuss over a leather-clad biker who enters their store; the biker is also seen taking an extended shower. *Women*

in Revolt involves three drag queens and a former Mr. America who exploits his fame as a gigolo. In *My Hustler*, the neighbors of an aging queen try to seduce a man he has procured from Dial-A-Hustler. During one sequence in *Trash*, a socialite catches a heroin junkie in the act of burglarizing her apartment, turns the tables on him and forces him to disrobe. Ondine's performance as the Pope of Greenwich Village in *Chelsea Girls* is among the more notorious moments in Warhol's film oeuvre: he shoots up amphetamines, chats freely about his homosexuality, refers to fellating the figure of Christ on a crucifix, slaps a female confessor who calls him a phony, and finally leaves the set screaming "Turn off the fucking camera!"

Warhol screened such films in underground venues, for friends and drop-ins at the Factory, at parties, at college campuses, at out-of-the-way theaters, and at rock concerts. Warhol's laissez-faire directorial approach encouraged viewers to disregard his films' apparent disregard for the audience. As A. L. Rees has written, "Warhol's own anti-interpretative stance allowed for what Harold Bloom calls 'strong misreadings' to be made."[33] Such misreadings involved audience members' looking for ancillary pleasures in the margins, interacting with each other, behaving as at a party, or entering a state of rapt boredom. Actual showings of his films sometimes erupted in chaos.

During the sixties the most durable and organized form of reading (or misreading) in this vein came to be known more and more familiarly as camp, and the most assiduous scavengers for camp value were men and women nourishing queer sensibilities. These viewers did not take refuge, as Sontag did in her essay on camp, in "a deep sympathy modified by revulsion" (105); the experience was not primarily aesthetic but psychological and social. Simon Watney begins his essay "Queer Andy" by describing a Warhol screening that erupted not in a moderated colloquium but rather a police crackdown: "The first time I got busted was together with some two hundred people watching *Lonesome Cowboys* in its first week of screening in London in 1969."[34] A gay friend of mine recalls the police shutting down the same film in Atlanta. Another gay friend, who attended the opening run of *Lonesome Cowboys* in San Francisco that year, speaks of his sheer disbelief at what he saw on the screen. The moment that came most readily to mind was a scene in which a naked woman (Viva) stood up from a gravel road with pebbles still clinging to her behind. This struck my friend as so far afield from anything that could be depicted in a Hollywood film (the big-budget Westerns that year were *Butch Cassidy and the Sundance Kid* and *Paint Your Wagon*) that he was simply dumbfounded. Even decades

later he had a fresh sense of recall about the initial shock, amazement, and conspiratorial laughter generated in the theater.

Such accounts provide only the pale textual simulacra of events, feelings, and exchanges that occurred largely outside the scope of historical accounts, and for which the word "camp" is at best a retrofitted, weakly derivative, and reifying term. Queer camp in the sixties occurred in countless social exchanges and private moments of recognition that rarely entered an official record. For queer audiences caught up in the heyday of the sixties, exposure to Warhol's films had a primarily visceral impact, one that was too immediate and galvanizing to talk about in the dispassionate terms of intellectual inquiry.

Camp Dystopia

A great deal has already been written, in Moe Meyer's book and elsewhere, about distinctions between camp in its queer/un-queer and authentic/inauthentic forms. As we saw, Meyer takes special care to distinguish between authentic and ersatz forms of camp, the former couched as queer parody, the latter as camp in its commercial, deminoritized, residual, or appropriated forms. The critique I make here is less concerned with issues of queerness and authenticity than with those of social hygiene.

Earlier I likened camp enjoyment to a bodily-injury insurance settlement that helped compensate Warhol for the burdens of growing up queer. It's reasonable to ask whether such a reward system might also have had a debilitating effect over the long run—either for Warhol or for those he has inspired. Under what conditions might camp cease having benign effects? If it's employed as a survival strategy, does that demote it to the level of a mere coping mechanism in the absence of better alternatives? If it arose for Warhol as an "innermission" during a bout of childhood illness, in what ways might it have carried marks of childhood or of illness into his later life? Can the camp response turn limiting or destructive, becoming a vehicle not for self-empowerment but for self-indulgence or self-loathing? The above anecdotes from Warhol's life show him recurrently in a self-delighted mode, but the delight was not always one that others could share. Edie Sedgwick was the most vocal among those who felt badly used by his desire to make bad movies. Although I've detailed ways in which the anecdotes show him in a humane and tolerant light, other qualities darken the edges of the picture. The camera-buying venture arguably shows him in a burst of childish regression; his 1979 response to the TV reporter over his

Whitney show bears evidence of apathy and cynicism. When Warhol reacts with glee to news of yet another negative review of his work, it may leave the impression that he couldn't handle criticism, or that he wanted attention so badly he took even the barbs of his enemies as flattery. The qualities that Bob Colacello saw in Warhol during an unguarded moment—the smartness and unhappiness behind the dumbness and campiness—cue us to notice border tensions in the artist's public performance, and limitations inherent in his fondness for camp.[35] It stands to reason that, in addition to the unhappiness Warhol was able to *redeem* through camp, a measure of his unhappiness may have been directly *caused* by camp.

Even disregarding the issue of internalized homophobia, a queer subject working within an un-queer ontology (Cynthia Morrill's terms) can't be expected to produce consistently successful results. The system militates against it. Moreover, the attempt to "transform and undermine the effects of baleful experience" (my earlier formulation) is not always straightforwardly positive, either in terms of initial motive or eventual effect. It may both proceed from, and reinforce, a deluded, self-centered, or otherwise limited will. Efforts to convert queer oppression into self-affirmation may be gratifying in the short run, but they may simultaneously foster insularity, nearsightedness, or complacency. Like any other form of pleasure, camp has the potential for turning compulsive or addictive. Camp's "buoyancy" effect may become an end in itself, a prodigal impulse. The victory it claims may turn out to be Pyrrhic.

Raising such issues is inherently risky. Scholars of camp sometimes speak about the self-exploding argument, where their own seriousness or pedantry may be taken as unintentionally risible. Beyond this elementary risk lies a more formal problem: a probing disquisition on camp must at some level wreak conceptual violence upon a mode of taste known for its lightness, joviality, and spontaneity. What could be less spontaneous than a jeremiad about the evils of camp? I'm reminded of an old *Saturday Night Live* Schillervision mock-newsreel feature about scientific developments at the Comedy Institute. A test participant listens to a taped comedy specimen via headphone, and in a dull monotone, provides a doggedly earnest, spoken-word rendering of his immediate reactions: "I'm laughing . . . laughing . . . I'm *not* laughing . . . I'm laughing *very hard.*" A verbal exchange between one of the test subjects and a would-be comedian is depicted as a shouting-match bordering on a physical scuffle: the comedian keeps insisting he is funny, and the test subject violently opposes him on this point. The feature lam-

poons the idea that any study of comedy could be conducted on solid empirical grounds. Comedy, of which camp is a special case, remains largely subjective and unquantifiable; however, the rise of a comedy *industry* in recent decades in the United States is more tangible and measurable. The issues raised in this chapter are not part of a hard science, although they do have traceable consequences. By raising them in a critical context, I run numerous risks: the risk of *sounding* as if I have located a truly objective standpoint; and the risk of betraying the spirit of camp, while coming off like one of the test subjects in the newsreel, who make themselves so humorously unfunny in the very act of declaiming how unamused they are.

However, exploring the dystopian side of camp taste and its place in Warhol's life has intellectual risks beyond these. In doing so I am choosing to revive a robust editorializing tradition that fell into general scholarly disuse during the heyday of postmodern theory. When Fredric Jameson announced in *Postmodernism* that he wished to distance his project from "culture-and-personality diagnosis of our society and its art," such as is found in "psychologizing and moralizing culture critiques" (his example is Christopher Lasch's *The Culture of Narcissism*)[36] he marked out for scorn a mid-level realm of cultural diagnosis and effectively closed it off to others who dared to join him in his ascent into more rarefied theoretical atmospheres. From the intoxicating rush of such altitudes, it was possible to look at almost any legitimately moral discourse from the past and view it as illegitimately moralizing. But as Mandy Merck's rereading of *Diamond Dust Shoes* in *Pop Out: Queer Warhol* demonstrates, Jameson's approach to Warhol left him vulnerable at the more humble quotidian level of city sidewalks and thrift stores. Merck's essay critiques the efforts of both Jameson and Jean Baudrillard to expropriate Warhol to their own vested postmodern agendas.[37] Her essay contributes to an anthology that shows Andy Warhol very much at street level, not the vaunted "mascot of postmodernism" but rather a queer man going about his business, bringing homoerotic meanings into his art in every way he could. However, since Warhol's way of creating a platform for his art in the first place was to overturn the principles of modernism in every way he could, he is not as easily separated from postmodernism as might be assumed. One effect of his overturning established principles, and of his bringing so much double-coded gay content into his work, has been that scholars in successive waves, and in various disciplines, have needed to scramble to catch up with him. As they have adjusted their critical approaches to properly view his work at both macro and micro levels of

implication, the need for a more intermediary view provided by "culture-and-personality diagnosis of our society and its art" has not in fact atrophied—quite the reverse. What's happened is that such diagnosis has passed out of vogue among certain intellectuals, and fewer people who are capable of making such a diagnosis remain willing to do so. The task has largely been relegated to conservative scholars and liberal journalists, which means it is not a contender in graduate seminars and on undergraduate syllabi.

It might well be asked, though, whether Jameson's view that critical distance and affect have waned into insignificance is not absurdly portentous; and whether Warhol's saying "I want to be a machine" and "I don't care about anything" is not absurdly petulant. Warhol's talk of not caring, and the appropriation by Jameson and others of Warhol's talk of not caring, have helped to make certain forms of affect less available to intellectual discourse. Chief among the forms of affect rendered obsolete has been indignation, which is notably absent in both Warhol's emotional repertoire and Jameson's critical repertoire. However, newly supplied with some of the biographical dynamics behind Warhol's alleged not-caring, and newly apprised of some of the problems involved in Jameson's having absconded with Andy to the outer stratospheres of postmodern theory, people may well feel as if they've been sold an ideological bill of goods. This itself may make indignation seem both unfairly ostracized and newly available as a response.[38]

It is not, however, a reason for reviving every form of old-fashioned moralizing or indignation from the past. An additional risk in criticizing Warhol is that of seeming to collaborate with those who have attacked the artist from reactionary or homophobic positions. Given that he was working in the vanguard of queer consciousness and sensibility, Warhol inevitably broke taboos and violated public standards of decency. He set up an alternative enclave well-nigh *devoted* to such tasks. One needs to exercise caution before going into high dudgeon over offenses that were specially coordinated to give offense. Further, one needs to recognize the positive side of how vanguard communities experiment with codes of behavior. In *The Trouble with Normal*, Michael Warner makes an eloquent case for an "alternative ethical culture" that is present among queer communities, in spite of the fact that some "mainstream moralists" are unable to recognize it. He lists drag queens, Radical Faeries gatherings, and S-M workshops as examples of the kind of culture that is "often denounced as relativist, self-indulgent, or merely libertine." Warner argues that such communities do in fact have their own norms and their own ways of "keeping people in line."[39] As a re-

sponse to Warner's assessment, I would say that such norms are inevitably influenced by those of the wider society and bring a potential for influencing that society in return. Since Warhol's promotion of camp taste has undeniably made an impact outside of his alternative Silver Factory enclave, and the norms of that enclave do not easily translate to those of the wider society, there is a need for mediating and adjudicating between these two spheres. If such adjudication work limits itself to affirming only the positive outcomes of social experimentation, as most recent gay scholarship about Warhol has done, then the task of arriving at a fuller understanding is deferred, and word of the negative aspects emerges pell-mell, often from less qualified sources.

These are some of the main risks involved in proffering an analysis of camp's dystopian side. I choose to *hazard* them out of a countervailing sense that to avoid this issue also involves risks. To speak only about the benefits of camp is to promote a kind of liberation theology that makes no place for the problem of evil. And to speak only of the ways that camp benefited Warhol and his fan base is to leave one side of the paradox of his legacy unexplored. The utopian side is not a complete rendering.

If camp held re-juvenating powers for Warhol, it might also be said to have prevented him from developing a convincingly post-juvenile sensibility. Camp pleasure for him involved a kind of self-granted restitution for living in a society that otherwise banned his desires; however, such restitution could never be complete, and its consequences were not all positive. The tendency to impose one's own private, idiosyncratic response may be a sign of highly evolved creativity and self-assertion, but it can also signal a condition of solipsism, an inability to perceive and relate to other things as they are.

That I am focusing on the immature aspects of Warhol in what follows will not, I believe, show him up as stunted in a comprehensive way. As we have seen, varieties of sophistication and intelligence rarely appear without being alloyed with forms of naivete and ignorance; no doubt the same may be said about varieties of maturity and immaturity. It should be clear by now that Warhol was mature in a number of ways, although he did not always give himself credit in this department. If he had secretly sensed that he did not deserve the kind of recognition he began receiving in 1962, chances are his career wouldn't have gone much further. Instead of venturing out into other

realms, he might well have stayed with a proven formula, as many of his fellow pop artists did.

There is a poignant side to Warhol's being one of a kind and out of the norm. He did not lack for people to assist his art and publishing, his business ventures and travels; did not lack for acquaintances to hobnob with at Studio 54, and to tell his secrets to the next day. He got plenty of professional advice as an illustrator, pop artist, and filmmaker. He attended Catholic mass regularly and at various points sought out the assistance of a psychiatrist, a chiropractic specialist, and a personal trainer. But in spite of all these associations, he encountered few people who were willing or able to mentor him in the full sense of the term. Warhol did not receive criticism well, and as soon as he surrounded himself with a coterie of assistants and Superstars, he had new resources for ostracizing people who contradicted him. Anyone looking at his biography can see that he was a special case; but I suspect that his own awareness of this prevented him from accepting guidance from those who might have had the stature or pertinacity to offer it.

Warhol himself showed a passing awareness of his social immaturity, and yet the ways he voiced his concern often make the problem sound more formidable rather than less. An extended passage from his *Philosophy* provides clues not only about the downside of camp taste but about underlying lapses and flaws in Warhol's outlook. Immaturity is conveyed not just in what he says directly but in the very texture of his style—its patented self-indulgence, its refusal of other viewpoints, other contexts, other registers of discourse:

> I think I'm missing some chemicals and that's why I have this tendency to be more of a—mama's boy. A—sissy. No, a mama's boy. A "butterboy." I think I'm missing some responsibility chemicals and some reproductive chemicals. If I had them I would probably think more about aging the right way and being married four times and having a family—wives and children and dogs. I'm immature, but maybe something could happen to my chemicals and I could get mature. I could start getting wrinkles and stop wearing my wings. . . .
>
> What makes a person spend time being sad when they could be happy? I was in the Far East and I was walking down a path and there was a big happy party going on, and actually they were burning a person to death. They were having a party and they were happy, singing and dancing.
>
> Then the other day I was on the Bowery and a person in a flophouse jumped out of the window and died, and a crowd went around the body, and then a bum staggered over and said, "Did you see the comedy across the street?"

I'm not saying you should be happy when a person dies, but just that it's curious to see cases that prove you don't *have* to be sad about it, depending on what you think it means, and what you think about what you think it means.

A person can cry or laugh. Always when you're crying you could be laughing, you have the choice. Crazy people know how to do this best because their minds are loose. So you can take the flexibility your mind is capable of and make it work for you. You decide what you want to do and how you want to spend your time. Remember, though, that I think I'm missing some chemicals, so it's easier for me than for a person who has a lot of responsibility chemicals, but the same principle could still be applied in a lot of instances. (111–12)

The tone is meandering, drowsy, with moments of insipid rosiness; one thinks of Gidget doing quaaludes. The passage has a presiding spirit of *puer aeternus*, and yet there are intriguing ambiguities. Are his off-the-cuff remarks on marriage and family life an expression of junior-league cynicism, or perhaps a kind of Never-Never-Land envy? The phrase "what you think about what you think it means" signals a degree of mental dexterity, an ability to deal with speculation on a meta level. The word "wings" may appear to be a misprint for "wigs," but actually is a code word referring to his daily cosmetic makeover (6, 11). Overall, though, the passage presents a veritable catalog of Warhol's childish gambits: fatuous notions passing themselves off as insights; semi-induced helplessness; ploys for sympathy; half-baked ideas presented in wishy-washy language; a kind of gelatinous impressionability; a general refusal to interrogate assumptions; and the absence of verifiable method or healthy skepticism.

Such elements are camouflaged and ironized, of course, because the style itself begs for the reader's indulgence. The very lack of objectivity in Warhol's utterances hinders a reader's efforts to get an objective grip on them. Warhol speaks as a child, asking us to make allowances for his lack of maturity; but the voice is also that of a hipster, surrounding himself in an aura of coolness, as if lucid exposition were not just beyond but beneath him. The childishness is disarming, the hipsterism is off-putting; between the two of them, it takes fortitude, or perhaps churlishness, to resist his wiles. His lack of communicative ability may make us feel charitable toward him, but charity has its limits, and the impulse may become strained as we encounter examples of grossly limited thinking or feeling.

The style becomes easier to resist, and to diagnose, if we imagine the words spoken not in a cozy diary-like privacy but in an official public

forum such as a commencement or State of the Union address: "My fellow citizens, I think I'm missing some chemicals and that's why I have this tendency to be more of a—mama's boy. A—sissy. No, a mama's boy." To picture a spokesman like Walter Cronkite or Cornel West reading these words aloud is to gain an inkling of how far they are removed from the realm of social responsibility.

A resistant or skeptical reader is left with unanswerable questions: what does Warhol mean by "responsibility" or "reproductive" chemicals? By what authority does he interpret his psychological development in this way? Did musing about the origins of his homosexuality get him no further than this? Does he really think that maturity is a passive process, a quality that one "gets" because something "happens" to one's "chemicals"? Further, did traveling to Asia truly leave him no more enlightened about other cultures than this passage suggests? Can he and his editors really have thought the funeral group was "burning a person to death"? Why would he assume that people singing and dancing are necessarily "happy" and "having a party"? In this respect Warhol—cheerfully oblivious of his surroundings, of world history and its import, of national, ethnic, and religious difference—resurrects old stereotypes of Americans abroad. Here and elsewhere in his travels, it's as if he lacks a basic notion of sadder-wiser, much less a legitimate sense of tragedy. Far from creating a moment of "resistance," queer or otherwise, Warhol seems instead to promote an unwarranted self-involvement and a kind of dyslexia of taste and feeling.

Under scrutiny, the emotional freedom he espouses looks suspiciously bogus. "Always when you're crying you could be laughing, you have the choice." If laughter is consistently preferred over other responses, what choice is really involved? It would have been a genuine breakthrough, perhaps, if he had spoken about the option of crying at a comedy. "A person can cry or laugh . . . take the flexibility your mind is capable of and make it work for you." Warhol's words get at the core of camp taste as a potentially liberating force: viewer reaction is not foreordained but can be playful, impertinent, slyly witty. One critic has written, "A camp is a flip person who has declared emotional freedom."[40] But this begs the question, To what forms of emotional freedom does a flip person have access? Ostensibly, Warhol's utterance serves to remind us that human responses cannot be programmed or predicted and always involve an element of will and self-determination. But as it plays out in the passage and at recurrent moments in the artist's life, the true message seems to be, "Stay within your mental comfort zone. Misinterpret sensory data so that it validates your uninformed biases. Go with

your happy feelings in the face of all contrary evidence if it gives you a lift. If that sounds irresponsible, remember that I'm handicapped in this department so it can't be helped."

The problem is not just that Warhol himself was handicapped in this department, but that his career made the same handicap accessible and inviting to others. *Philosophy* never became a bestseller, nor did the "cry or laugh" passage itself turn into a next-generation rallying point. Nonetheless, the same message is promoted in a variety of other formats—in an artistic vision that finds electric chairs and so-called race riots every bit as noteworthy and glamorous as dollar bills or giant hibiscus blossoms; in a newsprint periodical that treats the opinions of Imelda Marcos as no less fascinating than those of Rudolf Nureyev or Aretha Franklin; and in a worldview that presents lack of discrimination as a virtue. In addition to saying "I like everything," and "I love every 'lib' movement there is," Warhol has said, "Well, the reason I don't sort of get involved in [politics] is because I sort of believe in everything."[41] A man who "sort of" believes in everything may be engaged, wittingly or not, in sort of trivializing and enfeebling everything.

Any number of factors might make people more reluctant to criticize him—his being enigmatic and postmodern, wealthy and famous, artistic and unconventional; his having been ostracized in the art world; his being a queer man with an oppressed, working-class childhood; his being already semi-aware of how irresponsible and inarticulate he could be. However, sympathy for a man's private sufferings or limitations need not blind us to the more detrimental aspects of his public legacy. Even as he is giving a tweak to the macho pretenses of a previous generation, Warhol hastens and intensifies the stymied sense of loss felt by a future generation. I know of painters who to this day still feel blackballed by Warhol's influence on the art world, and who can scarcely contain their frustration about having their work passed over in the wake of splashier, more cynical and image-based careers. However, it isn't this specific loss I'm thinking about at the moment, but a more free-floating experience of loss that has descended on a generation for which popism and Warhol-style detachment have been promoted almost like civic virtues. It's true that popism and detachment were pivotal for Warhol in terms of realizing his artistic ambitions and reaching a wide audience; but it's imperative to recognize the continuing effects they have had on that audience, and on the public sphere in general. Warhol's cryptic presence

and his predilection for camp offer clues as to how certain mental habits have insinuated themselves into the texture of contemporary life. His Forrest Gump–like pronouncements send out early warning signs about things like historical amnesia, the Twinkie defense, and hyperactive/ADD syndrome: "I really do live for the future, because when I'm eating a box of candy, I can't wait to taste the last piece. I don't even taste any of the other pieces, I just want to finish and throw the box away and not have to have it on my mind anymore."[42] Instead of giving these words to Walter Cronkite to speak, one might suggest engraving them on a tombstone, or substituting them as a speech delivered by Slim Pickens during his famous bronco-style descent on a live nuclear warhead at the end of *Dr. Strangelove*. These extreme forms of semantic relocation help to suggest that the camp context in which Warhol offered such perceptions is no more sturdy or "natural" than the words are when uttered outside of this context. Relocating his words in this way, it's easier to isolate Warhol's blankness, emotional remove, and self-absorption, and to see them as portending habits more widely available to today's paradigmatic slacker, channel-surfer, and Prozac case. The matter of Warhol's nutritional habits does also have its humorous biographical side: his father forbade desserts and soda pop when Andy was growing up. Then, when Andy was in his mid-twenties and his mother visited him in New York, she found his diet consisted mostly of candy and cake. There's an endearing, human-foible quality to this anecdote, like a kids' comic strip with Oedipal overtones. Nevertheless, it's disconcerting to hear Andy at age forty-seven still saying things like, "all I ever really want is *sugar*."[43]

On the underside of camp taste is a spirit of the enfant terrible—disruptive, stupidly impudent, indiscriminately sneering. To see how camp attitudes in the media are emulated by impressionable audiences today is to wonder whether the long-term effect is not principled irreverence so much as irrelevance. Under cover of protection for its playfulness, coolness, and wit, camp may serve as a pretext and justification for not thinking, not feeling, not exercising political will, and not fully engaging with anything as it asks or deserves to be engaged. This is the substance of the charge Alexander Cockburn raises against Warhol in his parody of the Nancy Reagan cover story for *Interview*. By substituting Adolf Hitler as Warhol's interviewee, Cockburn is not primarily insinuating that the First Lady was a fascist (although this message is also implied), but that Warhol and his editor were so fawning over celebrity that they no longer retained the critical faculties needed to make clear moral and political distinctions.

Even without editorial caricature, Warhol is fully capable of generating this impression. In the face of irremediably tragic news he recurrently fails to locate a humane social response. Earlier we saw his avoiding a friend at a party because he had AIDS, and his reaction to the news of Freddie Herko's suicide (wishing to have been told beforehand so he could film the event). Warhol once expressed a similar desire about Edie Sedgwick, if she were to take her life in this way; when he did hear of her death, by drug overdose, he wondered aloud whether he would inherit her money.[44] At a United Nations soiree a woman approached Warhol and told him her daughter committed suicide right after seeing his film *Chelsea Girls*. In his response—"I didn't know what to say to her"—there is no hint that he was nursing some private agony or struggling to find the right words of comfort or apology.[45] A friend of his was shocked to find that he wasn't upset to hear of John F. Kennedy's assassination. Warhol records in his memoir, "it didn't bother me that much that he was dead. What bothered me was the way the television and radio were programming everybody to feel so sad."[46] This response finds echo today in the aftermath of September 11, 2001—the ways people express their alienation from the media as a certificate of personal authenticity and as a substitute for a more considered or full-fledged engagement. These incidents aren't momentary lapses that Warhol tried later to redress; nor are they youthful indiscretions; nor part of a principled resistance to the status quo. The diaries reveal that Warhol is not a man without a private conscience; but accounts such as those above suggest a man without a clearly articulated *social* conscience. Instead of offering a critique of the prevailing mind-set of liberal humanism, Warhol more often behaves like someone who merely has an inadequate grasp of liberal humanism. However, as an alternative to regarding him as Mephistopheles for such acts, or denouncing him from on high, it's possible to see his potential for cruelty as stemming from credible human factors: residual class resentment, a working-class homosexual artist's gut-level need to transgress the rules, and a frustrated inner adolescent's need to act out. Given what Andy was saddled with from an early age, it may be surprising that his tendency toward cruelty didn't surface more often than it did. The harm it caused obviously was not only to other people but to himself, and may be seen as part of the cost of extending the trait of childlikeness into his adult years. The trait served him in a number of ways, which likely prevented him from noticing the ways it didn't serve him. A variation on Portnoy's Complaint: having to behave as if you are more mature than you are, while secretly wondering why you are not more mature.

Apropos of Warhol's comment about the media and JFK, we might well ask, At what point does camp taste become a way of "programming everybody" to feel happy? Many commentators have shown a suspicious reluctance to examine the consequences or downside of camp pleasure, as if camp were a happy pill with no side effects. In 1964 Sontag wrote about camp's "ingenious pleasures" and "democratic *esprit.*"[47] Relative to the old-style dandy, she wrote, the connoisseur of camp is "continually amused, delighted" (117). Camp, she maintained, is "a daring and witty hedonism . . . a mode of enjoyment, of appreciation—not judgment" (118). Wayne Koestenbaum picks up this joyous refrain three decades later without pausing to acknowledge how the stakes have changed in the interim. "Experiencing the camp glow is a way of reversing one's abjection," he writes in *The Queen's Throat.* "When we experience the camp rush, the delight, the savor, we are making a private airlift of lost cultural matter, fragments held hostage by everyone else's indifference."[48] Citing Sontag approvingly, Koestenbaum speaks of camp as "the anarchic jolt we experience in the face of artistic artifacts that try to be serious and fail" (117). In such discussions camp begins to sound like the fountain of youth and the elixir of happiness blended into the same intoxicating home remedy. Additionally, it has built-in leftist sanctions: it's a product of minority oppression, and it's considered subversive, even (big drum-roll) *counter-hegemonic.*

Overlooked in this poststructural frisson is the way that camp attitudes have become part of every American child's core education. Although televised camp offerings are by no means universally watched and admired, they contribute to an atmosphere of detachment and disdain that leaves few unaffected. What youngster today can afford to neglect the study of coolness, where proficiency is gauged in terms of superiority and savvy? It's not that these are the only traits such cultural forms promote. When *Mad* magazine was first published in 1953, it arguably fostered healthy forms of skepticism and irreverence among its adolescent target audience. It wasn't camp exactly, but it had many of the same features, and those features had an important political edge. It helped kids wise each other up in an era besotted with images of *Father Knows Best* and *Ozzie and Harriet.* In the intervening half-century, such forms of irreverence have proliferated to the point where they threaten to define and usurp civic sense rather than inform and modify it. A revised version of *A Clockwork Orange* might present the figure of Alex strapped down and forced to listen not to classical music but

to a round-the-clock barrage of *Comedy Central* and *MTV*. All irony, all the time, like an au courant retelling of the parable of Midas.

Even in the gay sector today, camp often seems to have far more to do with reflex cynicism than with a more robust or dynamic irreverence. A visit to almost any urban U.S. gay nightclub, where razor-sharp innuendo and drag-style schadenfreude never seem to go out of season, gives ample evidence of the caustic, bitter, abject side of camp. It's been updated to look more like *Will and Grace* or *Queer as Folk* than *The Boys in the Band*, but the difference is not as great as is often assumed. Much of this corrosiveness may be seen in terms of Batesian mimicry—a hard outer shell used toward the self-protection of a vulnerable species. Still, one cannot overlook the traditions of gay self-loathing, misogyny, and derisiveness that are closely linked with camp taste, and which will always prevent it from becoming an unambiguously progressive force. In spite of my idealized notion of camp, I sense that it's used less frequently in gay circles as a means of self-transformation than as a vehicle of denial, *gescheffting* (mechanized social relations), and protection-society cliquishness. I suspect most people are already aware of this, although not always certain how to circumvent it (*coming to a hot nightspot near you:* Gravitas *and* Social Responsibility).

Connected with this is a potential for escapism and self-delusion. In her discussion of Freud's essay on jokes and the unconscious, Cynthia Morrill speaks of humor as "saving" the humorist's ego from unpleasant confrontations with the material world (122). "Saving" in this context carries the sense not of redeeming but of mollifying. Although Morrill doesn't pursue it directly, she alludes here to the question of why certain people tell jokes compulsively, and how it can serve as a barricade against other, more painful or adult realities. As with the humorist, so also with the aficionado of camp: the habit may have more to do with emotional dependence and withdrawal than with a more creative, self-willed, or salutary response.

Rather than being a "daring" form of hedonism, one could say that camp and the attitudes that attend it have become obligatory and even virological in nature. The "continual amusement" Sontag refers to has become part of a national industry today, with its own novel forms of exploitation and conformity. The rise of camp taste has contributed to what the critics Ronald Collins and David Skover, recalling the soma-based dystopia envisioned by Aldous Huxley, describe as a "tyranny of pleasure."[49] In *The Death of Discourse*, Collins and Skover argue that one of the great losses in today's pleasure-driven media culture is discourse in the original Greek sense of the term—reasoned expression

in the service of the civic good (*agathon*), leading toward a greater end (*telos*), and involving the shaping of character (*paideia*) (xix). Scholars today are quick to point out the unequal distribution of civic good in Greek society, and the problems inherent in *telos*-based thinking. But in the absence of discourse about the positive side of these concepts, such deconstructionist insights themselves have an air of conspicuous consumption.

Ostensibly, camp is a retro sensibility that expresses affection, rather than simply affectation, as it finds new uses for an outworn concept or context. But it has come today also to epitomize a symptom of contemporary life which George W. S. Trow, in his essay "Within the Context of No Context," describes as "the urge to shed any context perceived as inhibiting and in conflict with the possibility of personal satisfaction."[50] Instances of this context-shedding impulse surface periodically in the national news and make it seem part of a shared postmodern affliction. Two examples come to mind: the pair of teenagers in California who were ushered out of a screening of *Schindler's List* after laughing and carrying on during a sequence in which a woman architect is summarily executed; and the two gunmen in the Columbine shootout who, according to eyewitnesses, went about their business in a joking and nonchalant manner. The family resemblance between these events, and the way that Warhol reads an Asian funeral, or a death at a flophouse, might well give us pause. Set against a utopian vision of camp as queer healing is a nightmare apparition of a society in which no form of signification has gravity, in either the ancient or modern senses of the term.

Postscript: Post-Camp

If camp offers a respite from the "tyranny of enforced signification," its rise to prominence creates a need for cultural forms that challenge the tyranny of unenforced signification. I alluded earlier to films that newly interrogate and problematize camp sensibility. Two of the more widely accessible of these are David Lynch's *Mulholland Drive* (2001) and Todd Haynes's *Far from Heaven* (2002). Relative to the trends I have described, both films present auspicious departures. I wish here merely to suggest them as possibilities of a glimpsed reality that supplements the preceding analysis.

The initial appearance of the heroine in both films may seem to encourage a camp response from viewers. In Lynch's film, Naomi Watts portrays the winner of a jitterbug contest in Canada, newly arrived in Los Angeles to seek her fame and fortune as an actress. In Haynes's film,

Julianne Moore plays a socially prominent housewife settled comfortably into an immaculate New England suburb. Everything about the two heroines—their grooming, fashion, and comportment, their clichéd dialogue, and their aura of dauntless 1950s optimism—seems to radiate a sincerity that a contemporary audience may well receive as overdetermined in a specifically campy way. However, as their narratives proceed, these apparently vacuous and robotic fifties heroines are plunged into emotional complexities that force them out of automaton mode and into a devastating and unresolvable inner landscape. Viewers are made to share this descent and to reexamine any of the routine camp modes they may have earlier engaged. A traditional camp response is referenced but then transposed into an aesthetic system that dismantles it. Audience members may feel initially secure in witnessing these women's fates from a safe distance, or in laughing at their corniness, but this security cannot be sustained through the course of the films.

At the same time, while they recreate period settings according to the parameters of cinema history, the films do not constitute a facile, throwback aesthetic, nor are they merely disabling camp sensibility while encouraging viewers to wallow in 1950s nostalgia. The key distinction lies in the characterization. While the two central characters develop, it is not fully accurate to say that they *deepen*, in the ways that great heroines from the nineteenth or twentieth centuries—Anna Karenina or Mrs. Dalloway, for instance—might be said to deepen in the course of their narratives. Instead of being viewed from the 360-degree realist lens of an omniscient narrator, or from an approach influenced by traditional depth or "epiphany" models, Lynch's and Haynes's heroines come to inhabit what might be called parallel realities. In *Far from Heaven* this effect is achieved by a shift in cinematic style, from picturesque autumnal idylls reminiscent of *Life* magazine circa 1959 to the shadowy internal landscapes of film noir.[51] In *Mulholland Drive* the heroine acquires a doppelgänger, an abjected self who is portrayed by the same actress. The relationship between these parallel realities or selves remains unresolved, as a play of competing surfaces rather than a fully "integrated" reality. It is as if one of Warhol's silkscreened movie idols, or a Cindy Sherman portrait, was translated back into motion-picture form, retaining a mannequin quality while still eliciting startlingly complex responses from a viewer. The two heroines, brilliantly realized by the actors Watts and Moore, present cinematic symbols of ideal 1950s womanhood while entering domains (e.g., explicit homo-eroticism, interracial romance) that were forbidden to female leads

during that decade's movies. They create a kind of stunt-double effect, in which the viewer is habitually aware of a more complicated off-screen reality that belies on-screen appearances. As such, they are like silhouette realities, flat and at the same time refractory, both summoning forth and forbidding traditional modes of viewership.

These two films offer promising, nonreactionary ways of illuminating both camp taste and its limitations. If camp, as Sontag asserts, "sees everything in quotation marks" (109), these films place the quotation marks within hard brackets. The camp effect is neither fully embraced, nor fully repudiated, but is resituated in a way that defies viewers to take refuge in dandyish condescension or derisive complacency. Ironically, only a sensibility versed in camp dynamics will recognize how camp-resistant the films are. *Mulholland Drive* and *Far from Heaven* do not neatly "synthesize" the utopian and dystopian sides of camp taste that I've explored here; they remain aesthetic and emotional experiences whose implications wait to be elaborated and contested in other spheres. Both Lynch and Haynes, who are sometimes described as genius-naifs, show a galvanizing ability to suggest possibilities of a postcamp, or postironic, outlook. Scott Long has written that camp is an "analytic of laughter";[52] what these films offer, among other things, is an analytic of camp.

Notes

The epigraph for this chapter comes from Andy Warhol, *THE Philosophy of Andy Warhol (From A to B and Back Again)* (New York: Harcourt Brace Jovanovich, 1975), 117.

1. Michael Moon's essay "Screen Memories" explicitly links Warhol's fondness for cutout cartoon playmates such as Dick Tracy and Popeye with his desire to make sexual contact with males. He quotes a second-hand interview in which Warhol reminisces about having fantasized about Dick Tracy's penis, and his desire to be seduced by Charlie McCarthy. He says his mother caught him while he was masturbating to a Popeye cartoon. The conversation, between Warhol and Ultra Violet, is recorded in her book *Famous for Fifteen Minutes* (1988), 154–55, and is reprinted in Moon's essay, "Screen Memories," in *Pop Out: Queer Warhol*, ed. Jennifer Doyle, Jonathan Flatley, and José Esteban Muñoz (Durham, N.C.: Duke University Press, 1996), 83.
2. Fred Pfeil, "Postmodernism as a 'Structure of Feeling,'" in *Marxism and the Interpretation of Culture*, ed. Cary Nelson and Lawrence Grossberg (Urbana: University of Illinois Press, 1988), 387.
3. See Sasha Torres, "The Caped Crusader of Camp: Pop, Camp, and the *Batman* Television Series," in Doyle et al., *Pop Out*, 247.
4. Andy Warhol and Pat Hackett, *Popism: The Warhol Sixties* (New York: Harcourt Brace Jovanvich, 1980), 194.

5. José Esteban Muñoz, *Disidentifications: Queers of Color and the Performance of Politics* (Minneapolis: University of Minnesota Press, 1999).

6. Susan Sontag, "Notes on 'Camp,'" *A Susan Sontag Reader* (New York: Vintage Books, 1983), 105; reprinted from *Against Interpretation* (New York: Farrar, Straus, and Giroux, 1966).

7. Andrew Ross, "Uses of Camp," *No Respect: Intellectuals and Popular Culture* (New York: Routledge, 1989), 165–70.

8. On the beneficial side, see Sontag, "Notes on 'Camp,'" 118–19: "[Camp] neutralizes moral indignation. . . . It is good for the digestion"; Richard Dyer, "It's Being So Camp as Keeps Us Going," *Body Politic* 10 (1977): 11: "Camp kept, and keeps, a lot of gay men going. . . . The whole camp stance is full of vitality"; Ross, "Uses of Camp," 144, 157: "Camp contains an explicit commentary on feats of *survival*. . . . [It] was part of a survivalist culture which found . . . a way of imaginatively communicating its common conquest of everyday oppression"; Scott Long, "The Loneliness of Camp," in *Camp Grounds: Style and Homosexuality*, ed. David Bergman (Amherst: University of Massachusetts Press, 1993), 79, 87: "In camp, [the homosexual] defuses by parody the devices of oppression. . . . [Camp's] laughter is both purifying and enabling"; and Robert Kiernan, *Frivolity Unbound: Six Masters of the Camp Novel* (New York: Continuum, 1990), 16: "Camp . . . elects to be uncritically affectionate, not in a spirit of perversity, but for the psychic relief that such amorality and such release of affection afford."

 On the harmful side, see elements of Ross's essay cited earlier; moments from Richard Dyer's essay ("it can . . . trap us if we are not careful in the endless pursuit of enjoyment at any price, in the rejection of seriousness and depth of feeling. . . . the camp sensibility is very much a product of our oppression. And, inevitably, it is scarred by that oppression," 12–13); and other sources such as Gareth Cook, "The Dark Side of Camp," *Washington Monthly*, Sept. 1995, 10–14, and Al LaValley, "The Great Escape," *American Film*, Apr. 1985, 29–34, 70.

9. Moe Meyer, *The Politics and Poetics of Camp* (New York: Routledge, 1994).

10. See Cynthia Morrill, "Revamping the Gay Sensibility," in Meyer, *Politics and Poetics of Camp*, 110–29.

11. Victor Bockris, *The Life and Death of Andy Warhol* (New York: Bantam, 1989), 11–12.

12. Simon Watney, "Queer Andy," in Doyle et al., *Pop Out*, 22–23.

13. Jesse Kornbluth, *Pre-Pop Warhol* (New York: Panache Press, 1988), 143.

14. Quoted in Bockris, *Life and Death*, 100.

15. Quoted in Patrick S. Smith, *Warhol: Conversations about the Artist* (Ann Arbor, Mich.: UMI Research Press, 1988), 190.

16. Bockris, *Life and Death*, 133.

17. Klaus Honnef, *Andy Warhol, 1928–1987: Commerce into Art*, trans. Carole Fahy and I. Burns (New York: Benedikt Taschen, 1990), 74.

18. Warhol, *Philosophy*, 83.

19. David Bourdon, *Warhol* (New York: Abrams, 1989), 189–90.

20. Quoted in Smith, *Conversations*, 307.

21. Ibid., 275.

22. Warhol and Hackett, *Popism*, 182.

23. Reva Wolf, "The Word Transfigured as Image: Andy Warhol's Responses to Art Criticism," *The Smart Museum of Art Bulletin, 1995–1996* (Chicago: University of Chicago, 1997), 11.
24. Warhol and Hackett, *Popism*, 287.
25. Peter Gidal, *Andy Warhol Films and Paintings: The Factory Years* (New York: Da Capo Press, 1991), 152.
26. Bob Colacello, *Holy Terror: Andy Warhol Close Up* (New York: HarperCollins, 1990), 104.
27. Quoted in Smith, *Conversations*, 326.
28. Quoted in Bockris, *Life and Death*, 318.
29. Robert Rosenblum, "Andy Warhol: Court Painter to the 70s," in *Andy Warhol: Portraits of the 70s*, ed. David Whitney (New York: Whitney Museum, 1979), 8–20. See also Glenn O'Brien, "A Portrait of the Portrait Artist," in *Unseen Warhol*, ed. John O'Connor and Benjamin Liu (New York: Rizzoli International, 1996), 10–13; Jonathan Flatley and Brian Selsky's essays in Doyle et al., *Pop Out;* and Nicholas Baume, ed., *About Face: Andy Warhol Portraits* (Cambridge, Mass.: MIT Press, 1999).
30. Andy Warhol, *The Andy Warhol Diaries*, ed. Pat Hackett (New York: Warner Books, 1989), 511.
31. Tama Janowitz, in *Unseen Warhol*, ed. O'Connor and Liu, 177.
32. This personal history omits numerous factors that are also central to the rise of camp taste, many of which are explored in more expansive accounts such as Ross's essay, and the anthologies *Camp Grounds: Style and Homosexuality,* ed. David Bergman (Amherst: University of Massachusetts Press, 1993), and *The Queer Sixties*, ed. Patricia Juliana Smith (New York: Routledge, 1999). Although Warhol enjoyed pretending that he had pulled his filmmaking career out of thin air, his work clearly builds on precedents such as those set by Kenneth Anger and Jack Smith.
33. A. L. Rees, "Warhol Waves: Andy Warhol and the British Avant-Garde," in *Andy Warhol: Film Factory*, ed. Michael O'Pray (London: British Film Institute, 1989), 124.
34. Watney, "Queer Andy," 20.
35. Colacello, *Holy Terror*, 118.
36. Fredric Jameson, *Postmodernism; or, the Cultural Logic of Late Capitalism* (Durham, N.C.: Duke University Press, 1991), 26.
37. See Mandy Merck, "Figuring Out Andy Warhol," in Doyle et al., *Pop Out,* 227–35.
38. Warhol and Jameson do not truly monopolize postmodern art and theory, respectively, but their work has still been influential and tone setting. As for indignation, in recent scholarly practice it has tended to follow officially sanctioned party lines and turns up in the form of inveighing against patriarchy, colonialism, racism, classism, and homophobia. In many respects this has given it the coerced aspect of institutionalized indignation.
39. Michael Warner, *The Trouble with Normal: Sex, Politics, and the Ethics of Queer Life* (New York: Free Press, 1999), 34–35.
40. Bergman, *Camp Grounds,* 50.
41. The three comments are found, respectively, in Emile de Antonio and Mitch Tuchman, *Painters Painting* (New York: Abbeville Press, 1984), 129–30;

Warhol, *Philosophy*, 45; and Richard A. Ogar, "Warhol Mind Warp," *Berkeley Barb*, Sept. 1–7, 1968, rpt. in Jonathan P. Binstock, "Andy Warhol: Social Observer," *Andy Warhol Social Observer* (Philadelphia: Pennsylvania Academy of the Fine Arts, 2000), 11.

42. Quoted in Honnef, *Andy Warhol, 1928–1987*, 93.

43. The biographical material is found in Bockris, *Life and Death*, 12–13, 65; Warhol's statement about sugar appears in *Philosophy*, 94. Another twist to the story comes in reading an interview Andy's mother did for *Esquire*, in which she describes how she overcame her reluctance about Andrei Warhola as a suitor: "He wants me, but I no want him. . . . He brings me candy, wonderful candy. And for this candy, I marry him." (Quoted in Colacello, *Holy Terror*, 13.)

44. Bockris, *Life and Death*, 178, 266.

45. Warhol and Hackett, *Popism*, 185.

46. Ibid., 60.

47. Sontag, "Notes on 'Camp,'" 116–17.

48. Wayne Koestenbaum, *The Queen's Throat: Opera, Homosexuality, and the Mystery of Desire* (New York: Vintage, 1993), 117.

49. Ronald K. L. Collins and David M. Skover, *The Death of Discourse* (Boulder, Colo.: Westview Press, 1996), 7.

50. George W. S. Trow, *Within the Context of No Context* (1980; rpt., New York: Atlantic Monthly Press, 1997), 72.

51. Haynes's film is an elaborate homage to the fifties melodramas of Douglas Sirk, who had navigated a similar path between external and internal realities. The difference lies in the later film's self-reflexive use of Sirkian devices, in its use of social content that was unavailable to Sirk, and the way, by refusing to present the 1959 setting through a jaded or ironic viewpoint, it serves both to highlight and undermine more current forms of jadedness and irony.

52. Long, "The Loneliness of Camp," 88.

I would give a lot to know some of the reasons why people of my generation took so long to grow up.

—Christa Wolf, "The Sense and
 Nonsense of Being Naive"

I believe that the members of my generation are the most innocent in our country's history, because we have been living in the '60s all our lives, either in fact or in fiction. Dumped in the '80s, we passed from innocence to experience without the intervening sobering knowledge of life. We are the youngest people in the world.

—John Weir, "Getting a Life"

Conclusion

Since people are going to be living longer and getting older, they'll just have to learn how to be babies longer. I think that's what's happening now. Some kids I know personally are staying babies longer.

—Andy Warhol,
 THE Philosophy of Andy Warhol

Is there any coherent way of assessing Warhol's legacy? It's sometimes said that he himself is the only person who might have cleared up the mess his estate became after his death. Perhaps a similar irony hovers over the task of sorting out everything else he has left us.

He has been alternately vilified and celebrated on numerous counts— for being pop, postmodern, queer; for removing affect from his work; for promoting androgyny; for focusing on taboos. He is regularly praised as well as blamed for transformations and upheavals of the past four decades. His presence is pervasive enough to make hash out of the task of clarifying individual lines of influence. At what points would such an undertaking begin or end? The quality of naivete, the focus of this study, is far from stable even within the space of the artist's own biography. By turns he is a crybaby, mama's boy, teacher's pet; a scrawny, sensitive child, bullied by his brother, his coal-miner father, and kids at school; the son of working-class, Carpatho-Rus immigrants, growing up in Depression-era Pittsburgh, trying to create an imaginative alternative to the squalor around him; a bedridden eight-year-old boy absorbed in playing with dolls and listening to his mother's indecipherable pidgin story-telling voice; a thirteen-year-old boy hiding for fear under his bed as the casket bearing his father's corpse is carted into the house for a three-day vigil; a high school student who recurrently asks his friends what used prophylactics are; a college student who fails a course in Thought and Expression, and who bursts into tears on learning he is close to being expelled; a wide-eyed young art school graduate trying to find work in Manhattan, courting nicknames like "Andy Paperbag"; a homosexual man obsessed by the fame, beauty, and talent of the young Truman Capote; a man whose love for a young set designer, Charles Lisanby, remains unrequited even after they travel around the world together; an artist who gives monosyllabic interviews; a filmmaker who parks a camera in front of the Empire State Building for eight hours; a pale, chic celebrity with a silver-blond wig and an expression of complete vacancy; a man whose mother lived with him for half of his adult life; a man eulogized as a holy fool. His stance of naivete serves for many decades as a foil against a host of adversaries— conservative art juries, entrenched commercial-art design standards, the New York School cult of masculinity, film-board censors, critics and intellectuals. Supported by fashion accessories, his stance helped him overcome his sense of unattractiveness and curry favor with beautiful men and women who entered the Factory. He also used his stance, not always cunningly, against friends and assistants, against associates who found themselves newly unwelcome at the Factory, and against a woman who shot and nearly killed him.

In ways that elude the capacities of lucid mapmaking, Warhol's presence continues to reverberate in the culture at large. Warhol's stamp remains indelible on the history of the celebrity interview. His paintings, film output, and promotion of drag culture establish him as one of the great purveyors of pop art, camp taste, and queer validation. His deromanticized naif provides a crucial precedent for performances as varied as those of David Byrne, David Bowie, Iggy Pop, Kathy Acker, Tama Janowitz, Jean-Michel Basquiat, Keith Haring, and Jeff Koons. Ultimately, through a series of cultural transactions fueled by myths and memories about the artist, Warholian naivete emerges as a structure of feeling, one of the pivotal informing sensibilities of postmodernism.

Since the days of Warhol's studiously uninformed early interviews, wiseacre declarations of ignorance and immaturity have become omnipresent in U.S. culture. The 1990s witnessed the *stupefying* prospect of a nation of youngsters doing perpetual impressions of media naifs from Jim Carrey to Beavis and Butt-head, Wayne and Garth, Howard Stern, Pauly Shore, Forrest Gump, and Homer Simpson, to name a few. Cinema multiplexes always seemed to feature at least one offering that announced its dopiness on the marquee: *Dumb and Dumber, The Coneheads, Airheads, The Stupids, Ernest Scared Stupid, Beavis and Butt-head Do America, The Man Who Knew Too Little, Jackass, Dumb and Dumberer.* Warhol is far from being the only tributary to the present flood-tide of cultivated (and semicultivated) naivete, but his example is still inseparable from what Avital Ronell calls "the Episteme of the Bimbo, Airhead, Brain-Dead, Hare-Brained, Etc.," and what *Playboy* has dubbed "the Golden Age of Stupid."[1] Warhol's line "I don't want to think" has assumed the force of a calling for a great many national heros and heroines who are generally less engaging and subtle at the activity than he was. A chorus of bestsellers warns us about the potential toxins released as the phenomenon of halted development and induced ignorance gains the status of a national pastime: *Dumbing Down: Essays on the Stripmining of American Culture*, edited by Katharine Washburn and John F. Thornton; Paul Fussell's *Bad, or the Dumbing of America;* and Robert Bly's *The Sibling Society.* Bly asks us to consider what has become of true adulthood, of true maturity, in a society where the body populace has been reduced to the level of squabbling siblings.

A further index of the golden age Warhol has helped to foster lies in the realm of book publishing, where legions of titles have sprung up in the trademarked *The Complete Idiot's Guide to* and *For Dummies* series. This marketing technique germinated in the early seventies, with a cottage-industry Volkswagen Bug repair manual jokingly targeted for

"the Compleat Idiot." The two current series, by contrast, are slickly produced, driven by chain-store visibility, and intensely intertextual. The same trumpet-blast Day-Glo cover format is used to hawk advice on everything from Web site design to midlife dating. Walking into a super-size bookstore, you might assume that the staff, inspired by a scene in Woody Allen's *Love and Death*, was gearing up for a mammoth international gathering of the Convention for Village Idiots. A banner on the front cover of recent titles in the *For Dummies* series offers the credential, "100 Million Dummies Books in Print." Can that many dummies be wrong? The back cover of books in *The Complete Idiot's Guide* series habitually reassures the reader, "You're no idiot, of course." This is a bold and possibly underresearched declaration, given the demographic group announced in the title. The series assumes that in an age of information overload, intense specialization, and rapid obsolescence, basically everyone is caught between feeling like an idiot and not wanting to feel this way. Judging from the series' popularity, readers today are more comfortable gauging their intelligence from the bottom up instead of the top down. There's a certain flattery value in reading over an idiot's shoulder rather than studying at the feet of a master. But the books should carry an explicit warning against the dangers of falling into the hands or tutelage of a Bozo.

Naivete may be a leisure industry enabled by the flush of postwar affluence and increased longevity. As Warhol suggests, if people can extend their adulthood, there's less urgency about reaching it in the first place. This notion, however, comes from a man who felt he lacked responsibility chemicals. The advice to expand and decelerate the process of maturation would sound better coming from someone who had reached a more advanced stage of social development. An epoch that has retarded the aging process is likely to have on its hands a lot of otherwise bright people who behave like the aging retarded. In face of present circumstances, there needs to be a movement for the promotion of Designated Adults—a band of brave citizens who, like the Apostle Paul only more so, demonstrate a capacity for doing away with childish things. Only veteran practitioners in such a program should be given the privilege to resume talk about the Inner Child, and only in such a way that it does not reinvoke the epithet, often used in the past by Europeans describing Americans, "They're just like children."

Even if such a program were to be adopted, the present age may still come to be seen by historians as an enormous tug-of-war between the forces of "duh" and "d'oh"—"duh" being slang for "how could you be so stupid?" and "d'oh" being a favored expression of the animated char-

acter Homer Simpson, generally conveying "how could I be so stupid?" As we go to press, new battalions of know-nothings and know-it-alls are going into active duty, equipping themselves for state-of-the-art forms of knowledge skirmish. In a region where ignorant armies clash by night, however, there may be some relief in imagining what transpires by day. It's possible that some members of the opposing armies might shake hands and share a smoke—and might even do so without the use of joy-buzzers or exploding cigars. My sympathies, though, lie with the draftees who are trying to work out their C.O. status.

If playing dumb may be seen as an act of will, a way of flouting the rules, it takes no less courage to refuse to play dumb. Such refusal says, I will not make it easy for you to underestimate my intelligence, no matter how charming it might seem for me to do so; I will not act falsely coy, no matter how much it appears to give me a social advantage; I won't pretend I'm invulnerable to pain, impaired at thinking, incapable of feeling.

The world would clearly be a grimmer, duller place without tricksters and fools in their many guises. Such figures are seen at every point of history, having a good laugh at the powers that be. Perhaps life would be unendurable without them: envision a world without Tristram Shandy or Lucille Ball; King Lear blustering away without the solace of his Fool; Margaret Dumont with no Marx Brothers in sight. What becomes of the epistemological eco-system, though, during an era in which fools appear to get the upper hand? Do the fools finally get their revenge upon the savants, providing not only a critique of their system but usurping it, overwhelming it, creating an open-ended Feast of Fools, a kingdom ruled and run by mockery alone? A sensible response to this scenario is to raise a countervailing voice of critique, after careful study designed to ascertain, to the best of our knowledge, what mortals these fools be.

Notes

The epigraphs for this conclusion are from the following: Christa Wolf, "The Sense and Nonsense of Being Naive," in *Critical Fictions: The Politics of Imaginative Writing* (Seattle: Bay Press, 1991), 236; John Weir, "Getting a Life," *Details*, Jan. 1993, 28 (Weir, Kenyon College class of 1982, is the author of *The Irreversible Decline of Eddie Socket*); Andy Warhol, *THE Philosophy of Andy Warhol* (New York: Harcourt Brace, 1975), 110.

1. Avital Ronell, *Stupidity* (Urbana: University of Illinois Press, 2002), 68.

Index

Kelly M. Cresap teaches in the Department of English at
the University of Maryland at College Park. His essays have
appeared in *The Queer Sixties*, *Blessed Bi Spirit*, and
Postmodern Culture. He is an occasional commentator for
National Public Radio's *Morning Edition* and was an editor
for the *Japan Times* in Tokyo. He is working on a book in
connection with his Web site, <www.laughingmuse.com>.

The University of Illinois Press
is a founding member of the
Association of American University Presses.

Composed in 9.5/13 ITC Century Book
with Futura display by Jim Proefrock
at the University of Illinois Press
Designed by Copenhaver Cumpston
Manufactured by Sheridan Books, Inc.

UNIVERSITY OF ILLINOIS PRESS
1325 South Oak Street Champaign, IL 61820-6903
www.press.uillinois.edu